Photographer's Guide to the
Leica D-Lux (Typ 109)

Photographer's Guide to the Leica D-Lux (Typ 109)

Getting the Most from Leica's Advanced Compact Camera

Alexander S. White

White Knight Press
Henrico, Virginia

Copyright © 2015 by Alexander S. White.

All rights reserved.

No part of this publication may be reproduced, stored in a retrieval system or transmitted in any form or by any means, electronic, mechanical, photocopying, recording or otherwise, without the prior written permission of the copyright holder, except for brief quotations used in a review.

The publisher does not assume responsibility for any damage or injury to property or person that results from the use of any of the advice, information, or suggestions contained in this book. Although the information in this book has been checked carefully for errors, the information is not guaranteed. Corrections and updates will be posted as needed at whiteknightpress.com.

Product names, brand names, and company names mentioned in this book are protected by trademarks, which are acknowledged.

Published by
White Knight Press
9704 Old Club Trace
Henrico, Virginia 23238
www.whiteknightpress.com
contact@whiteknightpress.com

ISBN: 978-1-937986-44-5 (paperback)
 978-1-937986-35-3 (e-book)

Printed in the United States of America

To my wife, Clenise.

Contents

Introduction ... 1

Chapter 1: Preliminary Setup — 3

Charging and Inserting the Battery. 3
Inserting the Memory Card . 4
Introduction to Main Controls . 6
 Top of Camera . 6
 Back of Camera . 7
 Front of Camera . 7
 Right Side of Camera . 8
 Left Side of Camera . 8
 Bottom of Camera . 8
Setting the Date, Time, and Language . 8

Chapter 2: Basic Operations — 10

Taking Pictures. 10
 Fully Automatic: Snapshot mode . 10
 Variations from Fully Automatic . 11
 Focus . 11
 Manual Focus . 12
 Exposure . 13
 Exposure Compensation . 13
 Flash . 14
Motion Picture Recording . 15
Viewing Pictures . 15
 Basic Playback. 15
 Playing Movies . 17

Chapter 3: The Recording Modes — 18

Choosing a Recording Mode . 18
Preliminary Steps Before Shooting Pictures . 19
Snapshot Mode . 19
Program Mode . 23

Aperture Priority Mode	24
Shutter Priority Mode	26
Manual Exposure Mode	28

CHAPTER 4: THE RECORDING MENU AND THE QUICK MENU 30

The Recording Menu 30
- Photo Style 32
- Picture Size 35
 - Extended Optical Zoom 35
- Quality 36
- AFS/AFF/AFC 38
- Metering Mode 38
- Burst Rate 40
- Auto Bracket 40
- Self-timer 40
- Highlight Shadow 40
- Intelligent Dynamic 41
- Intelligent Resolution 42
- Simultaneous Record w/o Filter 42
- iHandheld Night Shot 42
- iHDR 43
- Multiple Exposure 45
- Time Lapse Shot 46
- Stop Motion Animation 47
- Panorama Direction 48
- Shutter Type 48
- Flash 49
 - Firing Mode 49
 - Flash Mode 50
 - Flash Synchro 51
 - Flash Adjustment 52
 - Auto Exposure Compensation 52
 - Manual Flash Adjustment 52
- Red-eye Removal 53
- ISO (Sensitivity) 53
- ISO Limit Set 54
- ISO Increments 55
- Extended ISO 55
- Long Shutter Noise Reduction 55
- Intelligent Zoom 56
- Digital Zoom 56
- Color Space 56
- Stabilizer 56
- Face Recognition 57
- Profile Setup 58

Quick Menu 58

CHAPTER 5: PHYSICAL CONTROLS 60

Aspect Ratio Switch 60
Aperture Ring 61
Control Ring 61
- Step Zoom 62

Focus Switch 62
Shutter Button 63
Zoom Lever 63

Contents

On/Off Switch . 63
Shutter Speed Dial. 63
Exposure Compensation Dial . 64
The A Button . 64
Filter Button . 64
Viewfinder and Eye Sensor . 72
Control Dial and its Buttons . 73
 Control Dial . 73
 Direction Buttons . 73
 Up Button: ISO . 73
 Right Button: White Balance. 74
 Left Button: Autofocus Mode/MF Assist . 78
 Use of Left Button in Autofocus Mode. 78
 Face/Eye Detection . 78
 AF Tracking . 79
 49-Area . 80
 Custom Multi . 80
 1-Area . 82
 Pinpoint . 82
 Moving the Focus Frame or Focus Area . 83
 Use of Left Button in Manual Focus Mode. 83
 Down Button: Drive Mode. 83
 Burst Shooting . 84
 Auto Bracket . 86
 Aspect Bracket . 87
 Self-timer . 88
 Panorama . 89
 Center Button: Menu/Set . 90
Motion Picture Button. 91
AF/AE Lock Button. 91
Quick Menu Button . 91
Playback Button . 91
Display Button . 91
Function Buttons . 93
 Fn1/Delete/Cancel Button . 93
 Fn2/Wi-Fi Button . 94
 Fn3 Button . 95
 Assigning Functions to Function Buttons . 95
 Preview. 95
 Focus Area Set . 96
 Cursor Button Lock . 97
 AF Mode/MF . 97
 Restore to Default . 97

Chapter 6: Playback 98

Normal Playback. 98
Index View and Enlarging Images. 98
The Playback Menu . 99
 Slide Show . 99
 [Play] All . 99
 [Play] Picture Only/Video Only . 100
 Category Selection . 100
 Favorite. 101
 Playback Mode . 101
 Normal Play . 101
 Other Playback Modes. 101

Location Logging . 101
Raw Processing . 103
Title Edit . 105
Text Stamp . 106
Video Divide . 107
Time Lapse Video . 108
Stop Motion Video . 108
Resize . 108
Cropping . 109
Rotate . 109
Rotate Display. 110
Favorite . 110
Print Set . 110
Protect. 111
Face Recognition Edit. 111
Picture Sort . 111
Delete Confirmation . 112

Chapter 7: The Custom Menu and the Setup Menu 113

The Custom Menu . 113
 Utilize Custom Set Feature/Custom Set Memory . 113
 Silent Mode . 115
 AF/AE Lock . 115
 AF/AE Lock Hold . 115
 Shutter AF. 116
 Half Press Release. 116
 Quick AF. 116
 Eye Sensor AF . 117
 Pinpoint AF Time . 117
 Pinpoint AF Display. 117
 AF Assist Lamp . 117
 Direct Focus Area . 118
 Focus/Release Priority . 118
 AF + MF . 119
 Manual Focus (MF) Assist and MF Assist Display . 119
 MF Guide . 120
 Peaking . 120
 Histogram . 121
 Guide Line. 123
 Highlight . 123
 Zebra Pattern . 123
 Monochrome Live View . 124
 Constant Preview . 124
 Exposure Meter . 125
 Dial Guide . 125
 EVF Display Style . 125
 Monitor Display Style. 126
 Monitor Information Display . 126
 Recording Area . 126
 Remaining Display . 127
 Auto Review. 127
 Function Button Set . 128
 Zoom Lever . 129
 Control Ring. 129
 Zoom Resume . 129
 Quick Menu . 130

A button Switch.	130
Video Button	130
Eye Sensor.	131
The Setup Menu	131
Clock Set	131
World Time	132
Travel Date	132
Wi-Fi.	133
Beep.	133
Live View Mode.	133
Monitor Display/Viewfinder	133
Monitor Luminance.	134
Sleep Mode.	134
USB Mode.	134
TV Connection	135
Menu Resume.	135
Menu Information	135
Language	136
Version Display	136
Self Timer Auto Off	136
Number Reset.	137
Reset.	137
Reset Wi-Fi Settings.	137
Format.	137

Chapter 8: Motion Pictures — 138

Basics of D-Lux Videography	138
Quick Start for Motion Picture Recording	138
General Settings for Motion Picture Recording	139
Exposure	139
Focus	140
Other Settings	141
The Motion Picture Menu	141
Photo Style.	141
4K Photo	141
Recording Quality	142
AFS/AFF/AFC.	143
Picture Mode.	144
Continuous AF.	144
Metering Mode	144
Highlight Shadow	144
Intelligent Dynamic	144
Intelligent Resolution	144
Intelligent Zoom.	144
Digital Zoom.	144
Microphone Level Display.	144
Microphone Level Adjustment	145
Wind Cut.	145
Using External Microphones	145
Physical Controls	146
Recommendations for Recording Video	148
Motion Picture Playback and Editing	148
Editing with a Computer	149

Chapter 9: Wi-Fi and Other Topics — 151

- Using Wi-Fi Features — 151
 - Connecting to a Smartphone or Tablet Without NFC — 151
 - Connecting to a Smartphone or Tablet with NFC — 152
 - Controlling the Camera with a Smartphone or Tablet — 154
 - Sending Images and Videos to Smartphone or Tablet — 155
 - Uploading Images to Social Networks (Android Only) — 156
- Macro (Closeup) Shooting — 157
- Infrared Photography — 158
- Digiscoping and Astrophotography — 158
- Street Photography — 160

Appendix A: Accessories — 161

- Cases — 161
- Batteries — 162
- AC Adapter — 162
- Viewfinders — 163
- Add-on Filters and Lenses — 163
- External Flash Units — 163
- Automatic Lens Cap — 165
- Leica Hand Grip — 166
- External Microphones — 166

Appendix B: Quick Tips — 168

Appendix C: Resources for Further Information — 170

- Photography Books — 170
- Websites — 170
 - Digital Photography Review — 170
 - Official Leica Site — 170
 - Other Useful Sites — 170
 - Reviews of the D-Lux — 171
- Videos — 171

Index — 172

Introduction

This book is a guide to the operation, features, and capabilities of the Leica D-Lux (Typ 109) compact camera. In January 2015 I published a guide to the use of the Panasonic Lumix DMC-LX100, a model that is similar to this Leica camera in many ways. At first, I thought I would not produce a new guide book for the Leica D-Lux, because of those similarities. I thought the Panasonic LX100 book would be adequate to provide guidance for users of the Leica model.

However, I heard from a number of owners of the Leica model who were interested in a separate guide for their camera. And, upon looking further into the features of the 2 models, I found there are more differences between them than has been the case with earlier pairs of similar cameras, such as the Panasonic Lumix LX7 and the Leica D-Lux 6, or the Lumix LX5 and the Leica D-Lux 5. So, I decided to publish this guide for the D-Lux (Typ 109).

As is the case with the Lumix LX100, the D-Lux camera has many outstanding features. To begin with, the D-Lux uses a "four thirds" image sensor, the same size of sensor used in many "system" cameras that take interchangeable lenses, such as the Panasonic Lumix DMC-GH4 and the Olympus OM-D E-M1. This sensor is much larger than those of many compact cameras, and lets the D-Lux provide great image quality and beautifully blurred backgrounds.

The camera also has advanced features such as Raw image quality; complete manual control of exposure and focus; burst capability for continuous shooting; a large, 3-inch (7.5 cm) diagonal and very sharp (921,600 pixels) LCD screen; a high-quality Leica-branded lens with a wide 24mm equivalent focal length and a much brighter than ordinary f/1.7–f/2.8 maximum aperture; HD (high-definition) and 4K (sometimes called ultra-HD) motion picture recording. It also has a strong set of Wi-Fi features, enabling remote control from a smartphone and transfer of images from the camera to other devices over a wireless network.

The D-Lux has a solid feel, partly because of its metal body and classic appearance. Many photographers will welcome the inclusion of physical switches and dials to control many functions, so they don't have to navigate through menus to adjust exposure compensation, aperture, shutter speed, aspect ratio, and other settings. The camera is equipped with a hot shoe, which accepts external flash units that communicate with the camera for automatic flash control, and the camera has a built-in high-resolution electronic viewfinder for those who prefer to compose their images through a shaded window rather than peering at an LCD display that can be washed out in sunlight.

Also, the D-Lux includes a self-timer, macro (closeup shooting) mode, a wide range of shutter speeds (1/16000 second to 60 seconds plus longer time exposures), many different "filter effects" settings (such as miniature effect, soft focus, sepia, and monochrome, among others), and several options for capturing images with broad dynamic range, including a built-in HDR option. The camera is equipped with an autofocus system that provides faster autofocus performance than that of many comparable cameras.

Is anything lacking in the D-Lux? Some people would prefer a lens that goes beyond the 75mm equivalent of its maximum optical zoom; others would like the camera to be smaller, so it could fit easily into a pocket. Some users would like the camera to have a built-in flash unit, rather than the small, add-on flash that Leica provides with the D-Lux. The camera could use better audio recording features, such as a jack for an external microphone, to support its excellent video capability. It also lacks the ability to output an HDMI video signal while in recording mode.

But given that no camera can meet every possible need, the D-Lux is an outstanding example of an advanced compact camera. Upon its release, it received an enthusiastic welcome by photographers who use it sometimes to supplement a DSLR for occasions

when it's inconvenient to carry a heavy load of gear, and sometimes as the photographer's only equipment to record vacation and family scenes. If you carry this camera with you, you will be ready to record a breaking news event (with still photos or high-quality movies), to capture a scenic view that catches your eye, to grab spontaneous "street photography" shots, or to try new combinations of color effects, shutter speeds, and other settings from the D-Lux's wide array of possibilities.

This camera's quality and features have made it a winner by many measures. However, the documentation that comes with it does not always do justice to its capabilities. In addition, the documentation is split between a brief printed pamphlet and a much longer, but less convenient document that is provided on the CD that ships with the camera. I find it's a lot easier to learn about a camera's features from a single book, with illustrations, that takes the time to explain the features fully and clearly. That is the purpose of this book.

My goal is to provide a solid introduction to the D-Lux's controls and operation along with tips and advice as to when and how to use various features. This book does not provide advanced technical information. If you already understand how to use every feature of the camera and when to use it and are looking for new insights, I have included some references in the Appendices that can provide more detailed information. This book is geared to the beginning to intermediate user who is not satisfied with the documentation provided with the camera, and who is looking for a reference guide that provides some additional help in mastering the camera's features.

Chapter 1: Preliminary Setup

The box for your Leica D-Lux (Typ 109) should contain the camera itself, lens cap, lens cap string, battery, battery charger, neck/shoulder strap, USB cable, a CD with the Leica user's guide in PDF format, an abbreviated user's guide printed on paper, and 1 or 2 other pieces of paper, such as a warranty card. The box also should contain the small flash unit that can be attached to the camera's hot shoe.

There is no software provided in the box with the camera. However, the camera comes with a free license for Adobe Lightroom software. To obtain that program, you need to go to http://owners.leica-camera.com. At that website, open an account (unless you already have an account), and then enter the serial number for your D-Lux camera. You will then be provided information for downloading the software.

One of the first things you should do with your new camera is attach the lens cap string, a small loop supplied in a plastic envelope that is easy to overlook. Thread it through the small opening on the lens cap and then through the neck-strap bracket closest to the lens, as shown in Figure 1-1. Now your lens cap will be attached to the camera and can't be misplaced.

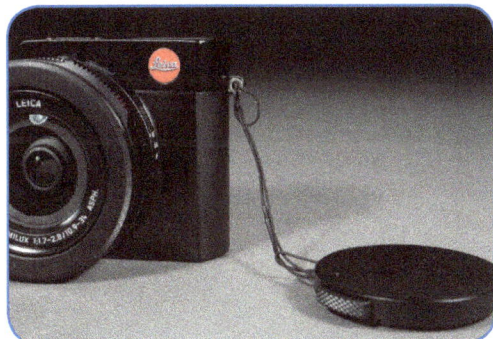

Figure 1-1. Lens Cap Attached to Camera

Some people don't like the removable lens cap provided with the D-Lux, because the cap has to be removed when you take a picture, may bother you as it dangles while you aim and focus, and has to be put back on the lens when you're done. I haven't found the cap to be a problem, because I'm used to cameras with removable lens caps. I see the point, though, because many small cameras have built-in lens covers that automatically open up when you turn on the camera and close back down when the camera is turned off. Leica provides an optional "automatic" lens cap with leaves that open and close while the cap stays on the camera; I will discuss that item in Appendix A.

As for the neck strap, it is useful when you're carrying the camera outside of its case, but I have found the strap to be a nuisance when placing the D-Lux into some cases, because of the strap's bulk. You might want to look for a wrist strap instead, which gives you a way to keep a tight grip on the camera but doesn't make it difficult to stow the camera safely in a case.

Charging and Inserting the Battery

The D-Lux ships with a rechargeable lithium-ion battery, no. BP-DC15. This battery has to be charged in an external charger; you can't charge it in the camera, even if you connect the camera to the optional AC adapter. So it's a very good idea to get an extra battery. I'll discuss batteries and other accessories in Appendix A. For now, here is the procedure to charge the battery.

You can only insert the battery into the charger one way; look for the set of 4 goldish-colored metal contact strips on the battery, then look for the corresponding set of contacts inside the charger, and insert the battery so the 2 sets of contacts will connect up, as shown in Figure 1-2. Then slide the battery all the way in so it is firmly seated in the charger.

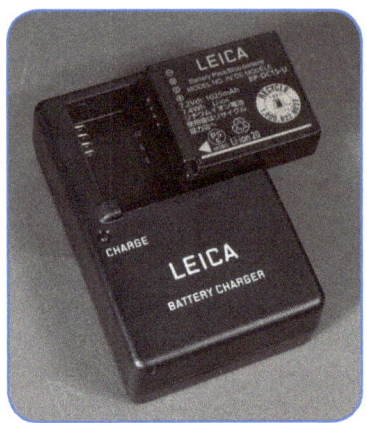

Figure 1-2. Battery Lined Up to Go Into Charger

With the battery inserted, plug the charger into a standard AC outlet or surge protector. The green light comes on to indicate that the battery is charging. When the green light turns off, after about 3 hours (190 minutes), the battery is fully charged and ready to use.

Once you have a charged battery, look for the small, ridged latch on the memory card/battery door on the bottom of the camera. Push the latch toward the center of the camera to release the door, and let it open up. To insert the battery, look for the sets of metal contacts on the battery and inside the battery compartment, and guide the battery accordingly, as shown in Figures 1-3 and 1-4. You may need to use the side of the battery to nudge the gray latching mechanism inside the battery compartment to the side, to allow the battery to slide in.

Figure 1-3. Battery Lined Up to Go Into Camera

Figure 1-4. Battery Inserted into Camera

Slide the battery all the way in until the gray internal latch catches above the battery and locks it in place. Then close the battery compartment door and slide the external latch back to the locking position.

Inserting the Memory Card

The D-Lux does not ship with a memory card. If you turn the camera on with no card inserted, you will see the message "No memory card" in the center of the screen. If you ignore this message and press the shutter button to take a picture, don't be fooled into thinking that the camera is somehow storing it in internal memory. Some camera models have a small amount of built-in memory so you can take and store a few pictures even without a card, but the D-Lux does not have that safety net.

To avoid the frustration of having a great camera that can't save images, you need to use a memory card. The D-Lux uses 3 varieties of card: Secure Digital (SD), Secure Digital High-Capacity (SDHC), and Secure Digital Extended Capacity (SDXC), representative samples of which are shown in Figure 1-5.

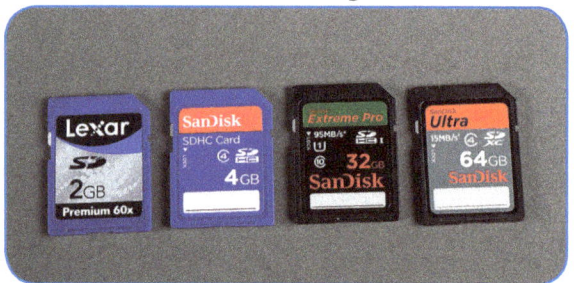

Figure 1-5. Cards: SD 2GB, SDHC 4GB, SDHC 32GB, SDXC 64 GB

All 3 types of SD card are the same size, about the size of a postage stamp. The standard card, SD, comes in capacities from 8 MB (megabytes) to 2 GB (gigabytes). The higher-capacity card, SDHC, comes in sizes from 4 GB to 32 GB. The newest type, SDXC, at this writing is available in a 48 GB, 64 GB, 128 GB, 256 GB, or 512 GB size, though its maximum capacity theoretically is 2 terabytes, or about 2,000 GB. Currently the 512 GB card is selling for $600.00, so that is impractical for most photographers. But a 128 GB card can be a good option, which I have used successfully in the D-Lux.

When choosing a memory card, there is one important point to bear in mind: If you want to use the excellent 4K motion picture recording capability of the D-Lux, you have to use a card in UHS Speed Class 3, for

ultra-high speed class 3. An example of one such card is shown in Figure 1-6. According to Leica, the only UHS cards that are compatible with the D-Lux are the UHS-I series. However, I have used a card in the UHS-II series with no problems. You will not be able to take advantage of the advanced features of the UHS-II card, but the card will still work well. Note that the speed class is different from the series. So, you can use a UHS-I card or a UHS-II card, as long as either one is certified for Speed Class 3.

I recommend you purchase a card of that speed class, because it will help with burst shooting as well as with 4K video.

If you're not planning to use the camera's 4K video features, you still should get a large-sized, high-speed card if possible. If you're planning to record a good deal of high-definition (HD) video or many Raw photos, you need a card with a fairly large capacity. There are several variables to take into account in computing how many images or videos you can store on a particular size of card, such as the aspect ratio you're using (1:1, 3:2, 4:3, or 16:9), picture size, and quality.

I installed a 32 GB SDHC card and formatted it in the camera to see how many images could be stored using various settings. I set the aspect ratio to 3:2 for all options. Table 1-1 shows the results.

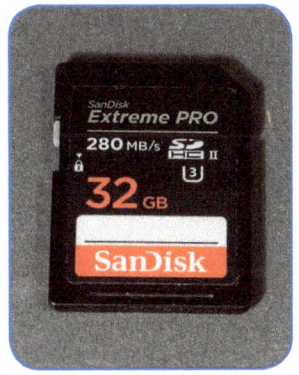

Figure 1-6. SanDisk Extreme PRO Card, UHS Speed Class 3

Table 1-1. Numbers of Available Images at Various Settings with 32 GB SDHC Card

Raw + JPEG Fine	1427
Raw	2097
JPEG Fine - Large	4466
JPEG Standard - Small	9999+

If you're interested in video, Table 1-2 shows some examples.

Table 1-2. Available Video Storage with Various Settings

MP4 4K 30p – 100M	42 minutes
MP4 60p – 28M	2 hours 30 minutes
MP4 30p – 10M	6 hours 25 minutes
MP4 VGA 30p – 4M	14 hours 10 minutes

Note, though, that there is an important caveat for video recording lengths with the D-Lux, as with most compact cameras designed primarily for still photography. There are built-in limitations on the length of any continuous video recording in most formats. In most cases, you can record only about 30 minutes of video in any one scene; you then have to stop and re-start your recording. With 4K video, the limit for continuous recording is 15 minutes. Also, as you may expect, some video formats consume memory very rapidly, so some smaller SD cards cannot record for the full amount of time that the camera would permit.

There are some other considerations to be discussed with regard to recording limits; I will discuss video recording in more detail in Chapter 8.

One other consideration is the speed of the card. I'm currently using a 32 GB SanDisk Extreme Pro card, rated at a transfer level of 280 MB/second. That speed is more than enough to get good results for recording still images and standard HD video with this camera. You should try to find a card whose speed is rated in Class 6 or higher if you're going to record HD video. The fastest cards are rated with the UHS designation, for

ultra high speed. As noted above, if you are planning to record 4K video, the highest quality format available, you need to use a card with a designation of UHS Speed Class 3.

Whatever type of SD card you get, once you have the card, open the same door on the bottom of the camera that covers the battery compartment and slide the card in until it catches. The card goes in with its label facing the battery, as shown in Figure 1-7.

Figure 1-7. SD Card Being Inserted into Camera

Once the card has been pushed down until it catches, close the compartment door and push the latch back to the locking position. To remove the card, you push down on it until it releases and springs up so you can grab it.

When the D-Lux is recording images or videos to an SD card, a red icon appears on the left side of the screen showing an arrow pointing to the right inside a little box representing the SD card, as shown in Figure 1-8.

Figure 1-8. Red SD Card Icon In Upper Left Corner of Display

When that indicator is visible on the display, it's important not to turn off the camera or otherwise interrupt its functioning, such as by taking out the battery or disconnecting an AC power adapter. You need to let the card complete its recording process.

Introduction to Main Controls

Before I discuss options for setting up the camera using the menu system and controls, I will introduce the main controls so you'll have a better idea of which button or dial is which. I won't discuss all of the controls here; they will be covered in some detail in Chapter 5. For now, I'm including a series of images that show the major items. You may want to refer back to these images for a reminder about each control.

Top of Camera

On top of the camera are some of the more important controls, as shown in Figure 1-9.

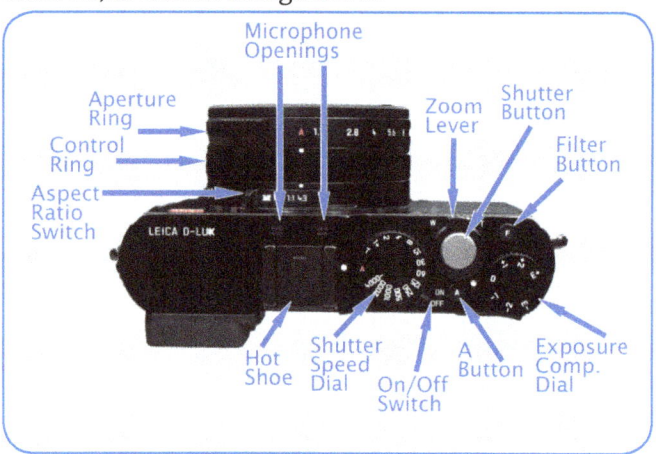

Figure 1-9. Controls on Top of Camera

The shutter speed dial is used to set the shutter speed when you are using Shutter Priority mode or Manual exposure mode. If you set it to the red A mark, the camera will choose the shutter speed, in Aperture Priority or Program mode. You press the shutter button all the way down to take a picture; press it halfway to cause the camera to evaluate focus and exposure. The zoom lever, surrounding the shutter button, is used to zoom the lens from the wide-angle (W) setting to the telephoto (T) setting. The exposure compensation dial is used to adjust exposure compensation. The on/off switch is used to turn the camera on and off. The A button is used to switch the camera into and out of Snapshot mode. The Filter button is used to select special picture effect settings for your images, such as miniature, soft focus, high dynamic, and others. The hot shoe is where you attach the small flash unit supplied

with the camera, or another external flash unit, as well as certain other accessories. The 2 microphone openings receive sounds to be recorded with videos. The aspect ratio switch is used to select the aspect ratio for your images. The control ring is used for focus and other operations, depending on current settings. The aperture ring is used to set the aperture when you are using Aperture Priority or Manual exposure mode. If you set the ring to its red A mark, the camera will select the aperture, in Shutter Priority or Program mode.

Back of Camera

Figure 1-10 shows the major controls on the camera's back. The viewfinder window is where you look to see the view through the camera's electronic viewfinder (EVF). The slit to its right is the eye sensor, which senses the presence of your head and switches between the EVF and the LCD screen display. The diopter adjustment dial lets you adjust the view in the EVF for your vision. The EVF button lets you set the EVF so it is automatically switched by the eye sensor, or so either the EVF or the LCD screen is active. This button also serves as the Fn3 button, and can be assigned to carry out another operation instead of EVF switching using the menu system.

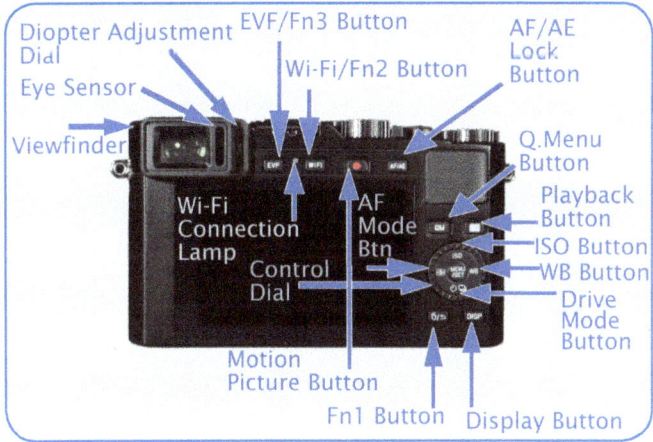

Figure 1-10. Controls on Back of Camera

The Wi-Fi button is used to initiate a wireless connection between the camera and a smartphone or other device for remote control or image transfer. This button also is designated as the Fn2 button, and can be assigned another operation through the menu system. The red Motion Picture button is used to start and stop the recording of a movie sequence. The Wi-Fi connection lamp lights up blue when the Wi-Fi function is turned on and blinks blue when the camera is sending data. The AF/AE Lock button is used to lock exposure and/or focus, depending on settings you make through the menu system. The Quick Menu (QM) button is used to activate the Quick Menu system, which gives you instant access to several important menu settings. The Playback button puts the camera into playback mode so you can review your recorded images and videos. The ridged control dial acts as a rotary wheel for moving through menu items and through options on various screens of settings, as well as for other purposes, such as moving through recorded images and videos. In addition, the 4 edges of this dial act as buttons (called the Up, Down, Left, and Right buttons in this book) when you press in on them. These buttons control the settings of ISO, White Balance, Drive Mode, and Autofocus Mode. The button in the center of the dial, called the Menu/Set button, is used to get access to the menu system and to select or confirm various menu options. The Fn1 button is a third function button that can be assigned to an operation through the menu system. The Display button is used to switch among the various displays of information in the EVF and on the LCD screen in both shooting and playback modes, and to move through the menus a full screen at a time.

Front of Camera

There are only a few items to point out on the camera's front, shown in Figure 1-11. The AF assist/Self-timer Lamp lights up to indicate the operation of the self-timer and also turns on in dim light to assist the camera's autofocus system, unless you disable it for that purpose through the menu system. The lens is a high-quality zoom lens with a maximum aperture of f/1.7 at the wide-angle setting, changing to a maximum of f/2.8 at the telephoto end of its range. The focal length of the lens varies from 10.9mm at the wide-angle range to 34mm at the telephoto setting. Ordinarily, though, these focal lengths are stated using "35mm-equivalent" figures, meaning the values that these figures would correspond to for a camera using a full-frame, 35mm image sensor. Therefore, the focal length range of the lens is ordinarily stated as from 24mm to 75mm.

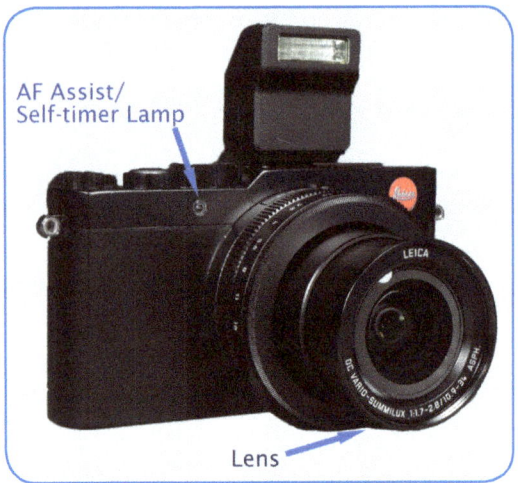

Figure 1-11. Items on Front of Camera

Right Side of Camera

Inside the door on the right side of the camera are the HDMI port and the USB/AV port, as seen in Figure 1-12. The HDMI port is where you plug in a micro HDMI cable to display images and videos from the camera on an HDTV set. The USB/AV port is where you plug in the camera's USB cable to transfer images and videos to a computer. You can also plug an optional audio-video cable into this port to connect the camera to a standard (non-HD) TV set to display images and videos. (Leica does not sell this sort of cable. A compatible cable is Panasonic model number DMW-AVC1, though it may be hard to find.) And, you can use this port to connect to a PictBridge-compliant printer to print images directly from the camera.

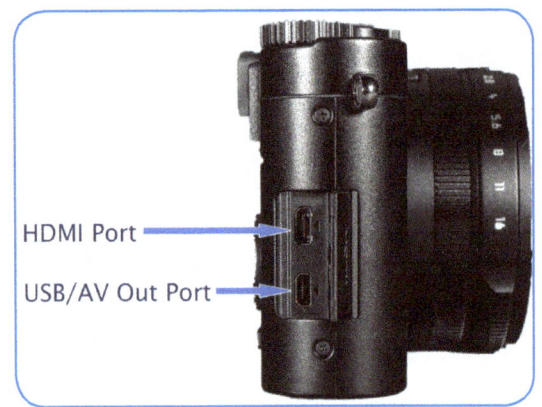

Figure 1-12. HDMI Port and USB/AV Port on Right Side of Camera

Left Side of Camera

As shown in Figure 1-13, on the left side of the lens is the focus switch, which slides to select Autofocus, Autofocus Macro, or Manual focus.

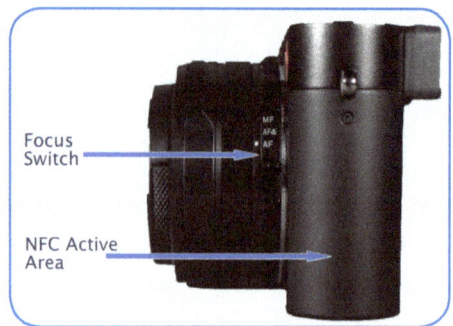

Figure 1-13. Focus Switch and NFC Active Area on Left Side of Camera

Low down on the left side of the camera body is the active NFC area, which is not marked by any icon or other indicator. That is the area where you need to touch the D-Lux against a smartphone or tablet that uses the near field communication protocol to establish a wireless connection. I will discuss that process in Chapter 9.

Bottom of Camera

Finally, as shown in Figure 1-14, on the bottom of the camera are the speaker, the tripod socket, the door for the battery and memory card compartment, and the small flap that is used to accommodate the cord for the AC adapter when it is connected to the camera, as discussed in Appendix A.

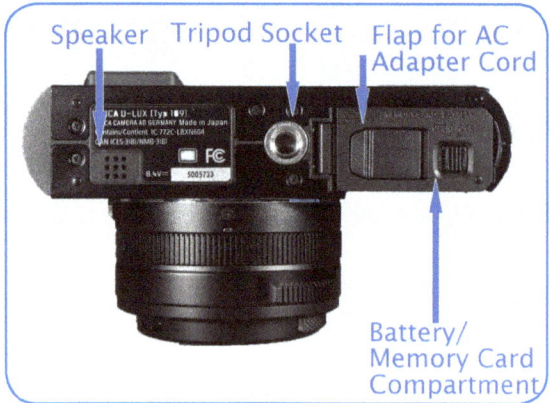

Figure 1-14. Items on Bottom of Camera

Setting the Date, Time, and Language

It's important to make sure the date and time are set correctly before you start taking pictures, because the camera records that information invisibly with each image, and displays it later if you want. Someday you may be glad to have the date (and even the time of day) correctly recorded with your archives of digital images.

To get these basic items set, remove the lens cap and move the camera's power switch, on the top of the camera, to the On position. Then press the Menu/Set button (in the center of the control dial on the camera's back). Push the Left button to move the selection into the column for choosing the menu type (Recording, Motion Picture, Custom, Setup, or Playback). The line at the left side of the display will turn yellow to indicate that the column of menu icons is now active, as shown in Figure 1-15.

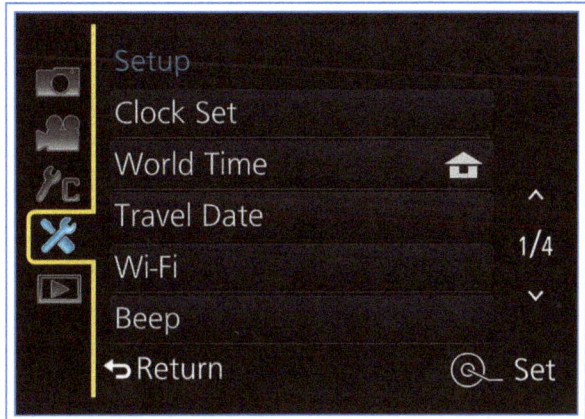

Figure 1-15. Setup Menu Tools Icon Highlighted in Left Column

Press the Down button to highlight the tools icon that represents the Setup menu, then press the Right button to place the red selection line in the list of Setup menu items.

By turning the control dial or pressing the Up and Down buttons, move the red line until Clock Set is underlined and highlighted at the top of the first Setup menu screen. Then press the Right button to get access to the clock and date settings, as shown in Figure 1-16.

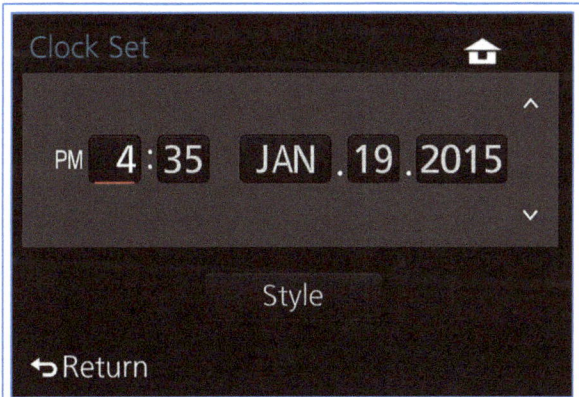

Figure 1-16. Clock Settings Screen

Navigate by pressing the Left and Right buttons or by turning the control dial, and select values with the Up and Down buttons. When you're done, press the Menu/Set button to save the settings. Then, using a similar procedure, navigate to the Language option on the third screen of the Setup menu, if necessary, and change the language the camera uses for menus and messages.

Chapter 2: Basic Operations

Taking Pictures

Now the camera has the correct time and date set and has a fully charged battery inserted, along with an SD, SDHC, or SDXC memory card. Let's look at some scenarios for basic picture-taking. For now, I won't get into discussions of what the various options are and why you might choose one over another. I'll just describe a reasonable set of steps that will get you and your camera into action and will record a good image or video on your memory card.

Fully Automatic: Snapshot mode

Here's a set of steps to follow if you want to set the camera to its most automatic mode and let it make most of the decisions for you. This is a good way to go if you're in a hurry and need to grab a quick shot without fiddling with settings, or if you're new at this and would rather set the camera to get good results without having to provide much input.

1. Look on top of the lens barrel for the switch that chooses one of the 4 aspect ratios: 3:2, 16:9, 1:1, or 4:3, seen in Figure 2-1. Unless you know you want one of the other 3 aspect ratios, slide the switch over to the first position on the right to select the 4:3 aspect ratio for now. That aspect ratio uses more of the sensor's pixels than any other setting.

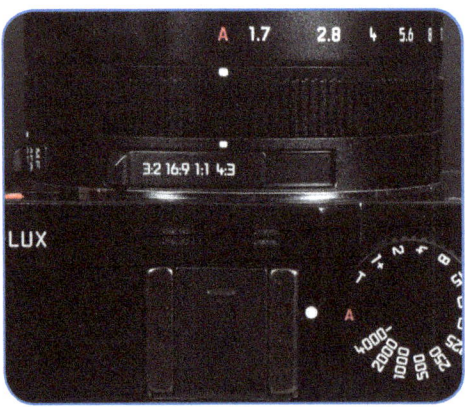

Figure 2-1. Aspect Ratio Switch Set to 4:3

2. Remove the lens cap and let it dangle by its string (or cup it in your hand to keep it from flapping around).

3. Move the power switch on the camera's top to the On position. The camera makes a whirring sound, the lens extends outward to its open position, and the LCD screen lights up.

4. Press the A button, on top of the camera to the right of the on/off switch. This sets the camera to the Snapshot mode of shooting. You should see a red icon with a white letter A in the upper left corner of the display, as shown in Figure 2-2. (If you don't see this icon, press the Display button at the lower right of the camera's back one or more times until the icon appears.)

Figure 2-2. A Icon for Snapshot Mode on Display

5. Press the Menu/Set button to enter the menu system, and press the Left button to move to the list of menu icons at the left of the display. Navigate to the camera icon for the Recording menu, then press the Right button to move the red line and highlight into the menu screen. Navigate to the Picture Size item, press the Right button to move to the list of choices, highlight L 12.5M, and select it by pressing the Menu/Set button.

6. Navigate to the Quality item on the Recording menu and select the top option, which shows an

arrow atop 2 rows of bricks, indicating Fine for this setting.

7. Find the focus switch on the left side of the lens barrel and notice it has 3 settings, reading from bottom to top: AF, AF Macro (with image of flower), and MF. Slide the switch to its uppermost position, selecting AF, for autofocus, as shown in Figure 2-3. With this setting, the camera will do its best to focus the lens to take a sharp picture within the normal (non-macro) focus range, which is from 1.6 foot (50 centimeters) to infinity. (Actually, in Snapshot mode, the camera will use the AF Macro setting even when this switch is set to the AF position, but I recommend you use the AF position for the switch, so it will be set there for use with other shooting modes.)

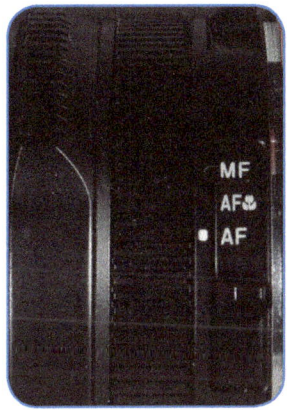

Figure 2-3. Focus Switch Set to AF Position for Autofocus

8. If you're taking a picture indoors, or it's dark enough that you think you might need the camera's flash, take the supplied flash unit out of its pouch, remove the hot shoe cover from the camera's hot shoe, and slide the flash into the shoe. Turn on the flash, and a flash icon should appear in the upper left corner of the display. (When you're done with the flash, turn it off and press the release lever on its left side to release it before pulling it out of the shoe. Then replace the hot shoe cover.)

9. Aim the camera at the subject and look at the screen (or into the viewfinder window) to compose the picture as you want it. Locate the zoom lever on the ring that surrounds the shutter button on the top right of the camera. Push that lever to the left, toward the W, to get a wider-angle shot (including more of the scene in the picture), or to the right, toward the T, to get a telephoto, zoomed-in shot.

10. Once the picture looks good on the display, press the shutter button halfway down. You should hear a beep and see a steady (not blinking) green dot in the upper right corner of the screen, indicating that the picture will be in focus, as shown in Figure 2-4. You also may see some green focus frames. (If you hear a series of 4 quick beeps and see a blinking green dot, that means the picture is not in focus. Try moving to a slightly different angle and then test the focus again by pressing the shutter button halfway down.)

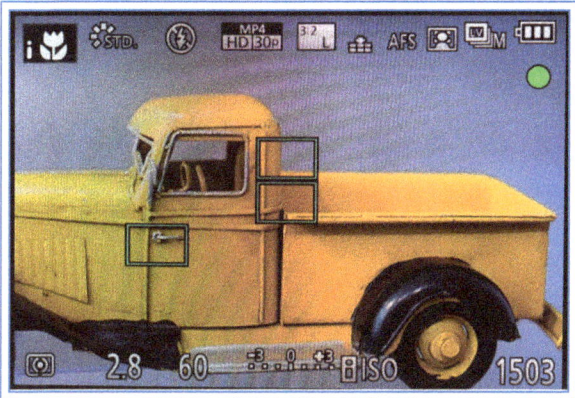

Figure 2-4. Green Focus Frames and Green Dot Indicating Sharp Focus

11. Press the shutter button all the way down to take the picture.

Variations from Fully Automatic

Although the D-Lux takes care of several settings for you when it's set to Snapshot mode, the camera still lets you make a number of adjustments to fine-tune the shooting process. I will discuss some of these options next. I will discuss other options, such as using Raw for the Quality setting, in Chapters 4 and 5.

Focus

One important decision you can make in Snapshot mode is to choose a focus mode. You have the option of setting the autofocus switch on the left side of the lens barrel to the AF setting for standard autofocus, the AF Macro setting for macro autofocus, or the MF setting, for manual focus. If you choose an autofocus setting, you also have the ability to select which of several types of autofocus operation you want the camera to use.

Be aware, though, that there is a quirk with the autofocus setting in Snapshot mode. As I noted in Step 7 of the list of steps for general picture-taking, if you

set the autofocus switch to either the AF Macro setting or the AF setting, the camera will use the AF Macro mode. In other words, you cannot use the standard AF setting in Snapshot mode; the camera automatically uses the AF Macro setting, unless you choose manual focus, as discussed below.

I'll discuss the various autofocus modes later in some detail. Here I'll discuss using the camera's menu system to select a standard autofocus option, assuming you have set the autofocus switch to the AF or AF Macro position.

As discussed earlier, enter the menu system by pressing the Menu/Set button, then press the Left button to move to the list of menu icons; make sure the red camera icon, for the Recording menu, is highlighted. Then press the Right button to put the red selection line into the list of menu items. Highlight the AFS/AFF/AFC item on the first screen of the menu, as shown in Figure 2-5.

Figure 2-5. AFS/AFF/AFC Menu Option Highlighted

Then press the Right button or Menu/Set to move to the list of 3 options for this setting, and make sure the AFS option is highlighted. That setting, for autofocus single, will cause the camera to focus on the subject when you press the shutter button halfway and keep the focus locked while you hold it in that position.

In Snapshot mode, you have limited options for selecting the area of the scene that the autofocus system uses to determine focus. When you first aim at the subject, you should see a white focus frame with small lines protruding in horizontal and vertical directions, as shown in Figure 2-6. (If you don't see this frame, press the Left button once, and the frame should appear.)

This frame indicates that autofocus tracking is in effect. Aim this frame at your subject and press the shutter button halfway. If the camera can lock on the subject, the frame will turn yellow and then green as focus is locked. Release the shutter button, and the yellow frame will follow a moving subject to maintain focus as the distance changes.

Figure 2-6. Tracking AF Frame Ready to Lock on Subject

When you are ready, press the shutter button all the way to take the picture. To release the frame and start focusing again, press the Menu/Set button.

If you would rather have the camera focus on a face, press the Left button and the camera will switch to using its face detection focusing system. It will then display a focus frame if it detects a human face. You can switch back and forth between autofocus tracking and face detection by pressing the Left button. (This switching works only in Snapshot mode; in other shooting modes there are several more choices for the autofocus area, as discussed in Chapter 4.)

Manual Focus

The other major option for focusing is to use manual focus, which requires you to adjust focus yourself. Many photographers like the amount of control that comes from being able to set the focus exactly how they want it. And, in some situations, such as when you're shooting in dark areas or areas behind glass, where there are objects at various distances from the camera, or when you're shooting a small object at a very close distance, and only a narrow range of the subject can be in sharp focus, it may be useful for you to be able to control exactly where the point of sharpest focus lies.

To use manual focus, go to the focus switch on the side of the lens and slide it all the way down to the MF position, as shown in Figure 2-7, which puts the camera

Chapter 2: Basic Operations | 13

into manual focus mode. The letters MF will appear in the upper right corner of the screen. Instead of relying on the camera to focus automatically, you now need to use the control ring (the large, un-numbered ring around the lens) to adjust the focus manually.

Figure 2-7. Focus Switch Set to MF Position for Manual Focus

When you start turning the ring, the camera will enlarge the display to assist you in deciding when focus is sharp, as shown in Figure 2-8. (In recording modes other than Snapshot, you need to use the MF Assist option on screen 4 of the Custom menu to activate this enlargement feature. See Chapter 7 for details on the MF Assist menu option.)

Figure 2-8. Enlarged Display for Manual Focus

You can use the 4 direction buttons to select the area that is enlarged, and you can turn the control dial (on the camera's back) to change the enlargement factor. To reset the frame to the center of the scene, press the Display button. To return to the normal-sized display, press the Menu/Set button. Continue turning the control ring until the part of the scene that needs to be in focus looks sharp and clear.

The camera also will add bright, colored pixels to the display to outline areas that are in sharp focus, using a feature known as Peaking. When an area of colored pixels appears at its strongest, the image should be in focus at that point. (The Peaking feature is automatically activated when the camera is in Snapshot mode. In other recording modes, you need to turn it on or off through the screen 4 of the Custom menu.)

Exposure

Next, I'll discuss some possibilities for controlling exposure, beyond just letting the camera make the decisions. In the Snapshot mode, the D-Lux is very good at choosing the right exposure. But there are going to be some situations in which you want to override the camera's automation.

Exposure Compensation

First, let's look at the control for adjusting exposure to account for an unusual, or non-optimal, lighting situation. Suppose you have the D-Lux set to Snapshot mode and you are photographing a fairly dark object, such as a model of a diving helmet, in front of a white background, as shown in Figure 2-9. The camera will do a good job of averaging the amount of light coming into the lens, and will expose the picture accordingly. The problem is, the very light background will likely "fool" the camera into closing down the aperture, because the overall picture will seem quite bright. But your subject, which is not nearly as light in color, will seem too dark in the picture.

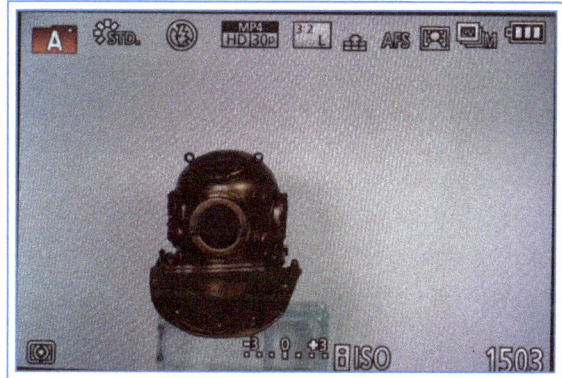

Figure 2-9. Subject In Need of Exposure Compensation

One solution, which the D-Lux makes very easy to carry out, is the exposure compensation control. One of the great features of this camera is the existence of this dial on top of the camera, which makes it simple to adjust the exposure at any time.

First, compose the image as you want. Then, simply turn the exposure compensation dial to the desired setting. The values range from −3 to +3 EV, with one-

third steps in between. EV stands for exposure value, a standard measure of brightness. If you move the value down to -3, the picture will be considerably darker than the automatic exposure would produce. If you move it to +3, the picture will be noticeably brighter. The camera's screen shows you how the exposure is changing, before you take the picture, and the scale at the bottom of the display shows the amount of exposure compensation that has been applied. In this case, after 2 2/3 EV of exposure compensation is added, the image becomes brighter and the helmet can be seen more clearly, as shown in Figure 2-10.

Figure 2-11. Supplied Flash Unit Attached to Hot Shoe of D-Lux

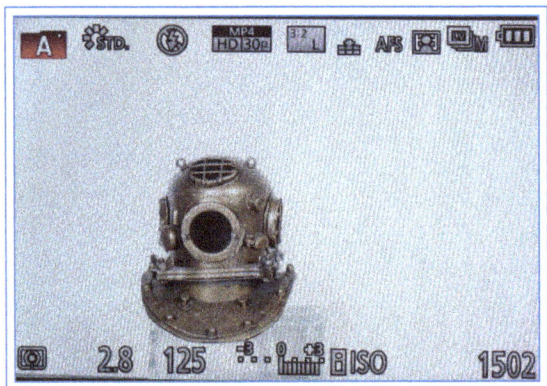
Figure 2-10. Exposure Compensation Adjustment Made

Once you've taken the picture, you should reset the EV compensation back to zero so you don't unintentionally affect the pictures you take later.

Flash

Later on, I'll discuss other topics dealing with exposure, such as other shooting modes, the Intelligent Dynamic setting, and others. For now I'm going to discuss the basics of using the D-Lux's own flash unit, because that is something you may need to use on a regular basis. Later, I'll discuss using other flash units, and other options for using flash, such as controlling its output and preventing "red-eye."

Of course, the D-Lux does not have a flash unit built in; you have to attach the supplied flash unit or an optional unit to the camera's flash shoe before any flash will fire. Even then, in some shooting situations the flash will never fire, depending on the settings of the camera.

Following is a description of the general use of the flash unit that comes with the camera. First, with the camera turned off, place the flash in the hot shoe as shown in Figure 2-11, and then turn on the camera and the flash.

You will see the flash icon appear at the top of the LCD screen, as shown in Figure 2-12, to the right of the icon for the mode setting, which, in Snapshot mode, is the letter A inside a red camera icon (unless the camera has detected a particular scene type, in which case it displays the icon for that scene type, such as macro or scenery, or portrait as in this case).

Figure 2-12. Flash Icon on Display in Snapshot Mode

The appearance of the flash icon will vary depending on several settings, which you can choose in some shooting modes, but not others. When you're using Snapshot mode, your choices of most functions, including flash, are limited. If the flash unit is attached, the camera will select what it believes to be the appropriate flash mode for the current conditions and will display an icon to announce that mode. (The available modes are discussed in Chapter 4.) If the flash is not attached or is turned off, you'll see the "flash off" icon at the top of the screen. That icon is a lightning bolt inside the universal negative sign, a circle with a diagonal line through it. There is no way to make any other flash settings in this situation. You don't have any choice, but that's presumably what you wanted when you chose Snapshot mode.

Motion Picture Recording

Next, I'll discuss steps for recording video with the D-Lux. Later, I'll discuss other options for movie recording, but for now I'll stick to the basics. With the camera turned on, press the A button (if necessary) to set the shooting mode to Snapshot, press the Menu/Set button to enter the menu system, and press the Left button followed by the Up or Down button, to highlight the Motion Picture menu, symbolized by the icon of a movie camera, as shown in Figure 2-13.

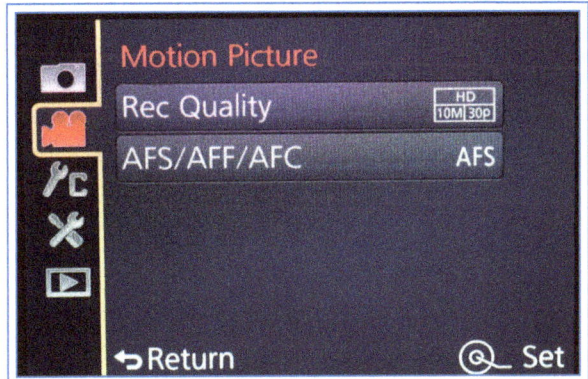

Figure 2-13. Movie Camera Icon Highlighted in Left Column

Press the Right button to go to the list of options. At the top of the screen, highlight Rec Quality and press the Right button, which displays a series of 2 screens with options for quality, starting with 4K, followed by FHD, HD, and VGA. On the second screen, highlight the HD setting at the top, as shown in Figure 2-14. Press the Menu/Set button to select this option, then press the Fn1/Return button to exit the menu system.

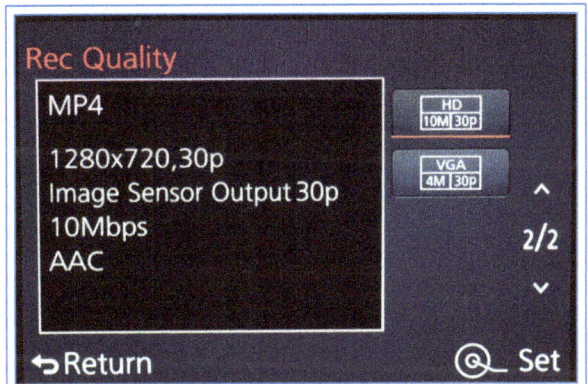

Figure 2-14. Recording Quality Menu Options Screen

Be sure the switch on the left of the lens barrel is set to AF for autofocus, unless you want to use manual focus. Now compose the shot the way you want it, and when you're ready, press the red button at the top of the camera's back, just above the LCD display.

You don't need to hold the button down; just press and release it. The LCD screen will show a blinking red dot as a recording indicator along with a countdown of recording time remaining, as seen in Figure 2-15. The camera will keep recording until it runs out of storage space or reaches a recording limit, or until you press the Motion Picture button again to stop the recording.

Figure 2-15. Red Dot Indicating Movie Recording in Progress

The D-Lux should do a nice job of changing its focus and exposure automatically as necessary, and you are free to zoom in and out as the movie is recording. (The sound of the zooming mechanism may be audible on the sound track, though, so you may want to keep the zooming to a minimum.)

I will discuss other options and considerations for motion picture recording in Chapter 8.

Viewing Pictures

Before I discuss more advanced settings for taking still pictures and movies, I'll talk about the basics of viewing your images in the camera.

Basic Playback

Playback is activated by pressing the Play button, the button at the top right on the back of the camera with a white triangle icon. When you press that button, if there are pictures or videos on the SD card, you will see one of them displayed. It will be whatever image or video was last recorded or last displayed; the camera remembers which item was most recently on display even after being turned off and then back on.

To move to the next picture or video, press the Right button; to move back one item, press the Left button. You can hold either of those buttons down to move

quickly through the images and videos. If you prefer, you can move through the items with left or right turns of the control dial. The display on the screen will tell you the number of the picture being displayed. (If it doesn't, press the Display button until it does.) This number will have a 3-digit prefix for the folder number, followed by a dash and then a sequence number. For example, the card in my camera right now is showing picture number 100-0014; the next one is 100-0015.

If you would rather see an index view of multiple pictures, use the zoom lever on the top of the camera. Move it to the left, toward the W, one time, and the display changes to show 12 images in 3 rows of 4, as shown in Figure 2-16.

Figure 2-18. Calendar Index Screen

You can also move the zoom lever to the right to retrace your steps through the options for multi-image viewing and back to viewing single images.

For now, move the zoom lever once to the left to see the 12-picture screen. Note that the Right and Left buttons now move you through the pictures on this screen one at a time, while the Up and Down buttons move you up and down through the rows. If you move to the last row or the last image, the proper button will move you to the next screen of images. Once you've moved the selector to the image you want to view, press the Menu/Set button, and that image is chosen for individual viewing.

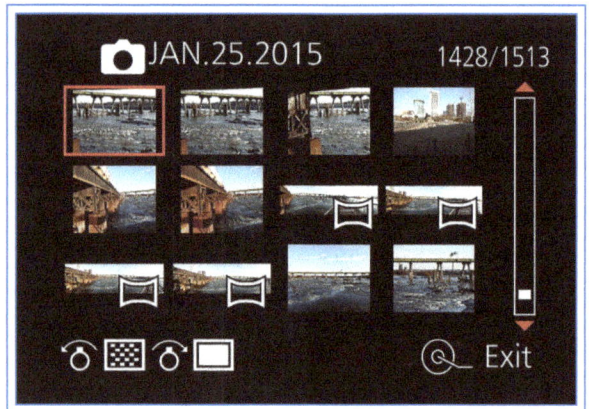

Figure 2-16. Index Screen with 12 Images

Move it to the left one more time, and it shows 30 pictures at a time, as shown in Figure 2-17.

Once you have the single image you want displayed on the screen, you have more options. Press the zoom lever once to the right, toward the T, to zoom the image to twice its normal size. Press it again to zoom to 4 times normal, as shown in Figure 2-19.

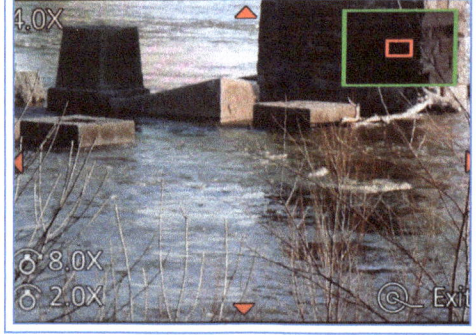

Figure 2-19. Image Enlarged with Zoom Lever

Figure 2-17. Index Screen with 30 Images

Give it one final leftward push and the screen shows a calendar from which you can select a date to view all images taken on that date, as shown in Figure 2-18.

Press the lever repeatedly to zoom up to 16 times normal size. Press the zoom lever back to the left to shrink the image down in the same increments. Or, you can press the Menu/Set button to return the image immediately to normal size.

While the zoomed picture is displayed, you can scroll it in any direction with the direction buttons. Also, you can review other images at the same zoom level by turning the control dial to navigate to the next or prior image, while the image is still zoomed.

Playing Movies

To play back movies, navigate through the images by the methods described above until you find an image that has a movie-camera icon with a red upward-pointing triangle at the upper left, as shown in Figure 2-20. (If you don't see this icon for a movie file, press the Display button until the screen that shows the icon appears.)

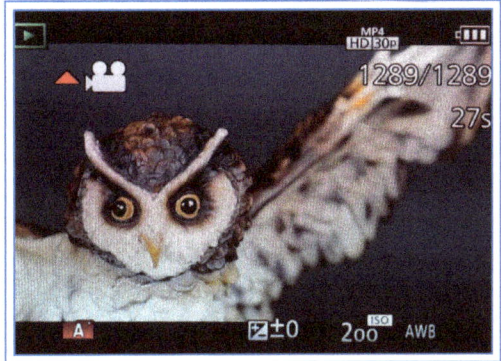

Figure 2-20. Movie Ready to Play in Camera

The red triangle indicates that you press the Up button to start the movie playing. With the first frame of the motion picture displayed on the screen, press the Up button to start playback.

After the movie starts to play, you can use the 4 direction buttons as a set of DVR controls; the camera will display an icon that shows the arrangement of those controls, as seen in Figure 2-21. The Up button is Play/Pause; the Right button is Fast Forward (or Frame Advance when paused); the Down button is Stop; the Left button is Rewind (or Frame Reverse when paused).

You can raise or lower the volume of the audio by turning the control dial to the right or left. You will see a volume display when you activate this control, which is also shown in Figure 2-21. (This volume control will not appear when the camera is connected to a TV set, because the volume is controlled by the TV's controls in that situation.)

If you want to play your movies on a computer or edit them with video-editing software, they will import nicely into software such as iMovie for the Macintosh, or into any other Mac or Windows program that can deal with video files with the extension .mp4.

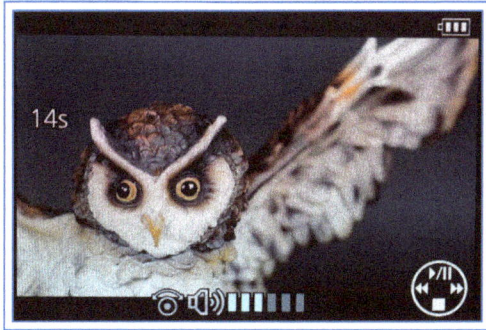

Figure 2-21. Movie Playback Controls on Display

MP4 is a file extension used by Apple Computer's QuickTime video software; QuickTime itself can be downloaded from Apple's website. You can edit these files on a Windows-based computer using Windows Movie Maker, Adobe Premiere Elements, or any one of a number of other programs.

To save a frame from a movie as a single image, play the movie to the approximate location of the image you want, then press the Up button, which acts as the Play/Pause button in this context. Then press the Left and Right buttons to maneuver to the exact frame you want to save. While you are viewing this frame, press the Menu/Set button to select it, then, when prompted, as shown in Figure 2-22, highlight Yes and press Menu/Set to confirm, and you will have a new still image at the end of the current group of recorded images.

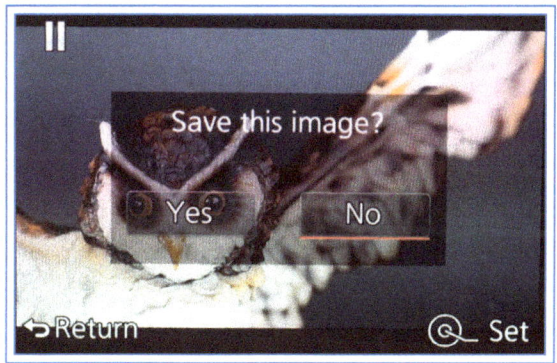

Figure 2-22. Confirmation Screen to Save Frame from Video

Press the Down button (Stop) to exit motion picture playback mode. Any saved still images will not be of the highest quality; each one will be of Standard quality and no larger than 2 MP in size. (If you want to save higher-quality still images from movie files, you can use the 4K Photo option, discussed in Chapter 8.)

Chapter 3: The Recording Modes

Up until now I have discussed basic settings for quick shots, relying heavily on Snapshot mode, in which settings are controlled mostly by the camera's automation. Like other sophisticated cameras, though, the D-Lux has many options for setting up the camera to take pictures and movies. One of the main goals of this book is to explain those options clearly. To do this, I need to cover several areas, including recording modes, menu items, and physical controls. In this chapter, I will discuss the camera's recording modes and how the selection of one of these modes affects your images.

Choosing a Recording Mode

Whenever you set out to capture still images or videos, an important first step is to select a recording mode, sometimes called a shooting mode. This "mode" is a general setting that controls the camera's behavior for adjusting exposure. As with most advanced cameras, the D-Lux provides a standard set of modes: Snapshot, Program AE (also known as Program), Aperture Priority, Shutter Priority, and Manual exposure. These last 4 are often known as the PASM modes, for the first letter of each mode.

The major distinguishing factors for the various modes are the degree of automation the camera uses for evaluating exposure and the settings that you, the user, make as opposed to those that the camera makes automatically. Table 3-1 gives a brief introduction to the modes and when you might want to choose each one.

Table 3-1. Recording Modes of the Leica D-Lux Camera

Mode	Exposure Setting(s) by Camera	Exposure Setting(s) by User	Situations for Using	How to Set
Snapshot	Shutter Speed, Aperture	None	Quick shots without time to change settings	Press A button on top of camera
Program	Shutter Speed, Aperture	None	General shots when you want to control many settings	Set shutter speed dial and aperture ring to red A marks
Aperture Priority	Shutter Speed	Aperture	Blurred background to reduce distractions or large depth of field to maintain large area of sharp focus	Set shutter speed dial to the red A mark and set aperture ring to desired value
Shutter Priority	Aperture	Shutter Speed	Fast shutter speed to stop action or slow shutter speed to blur action	Set aperture ring to the red A mark and set shutter speed dial to desired value
Manual Exposure	None	Shutter Speed, Aperture	To control motion blur and depth of field or for unusual exposure effects	Set aperture ring and shutter speed dial to the desired values

Some cameras have a mode dial with an array of options labeled P, A, S, M, and the like for selecting recording modes, but the D-Lux uses a different approach. As you can see from Table 3-1, to select one of the advanced

recording modes (Program, Aperture Priority, Shutter Priority, or Manual exposure), you set the shutter speed dial and aperture ring to different positions. To select Snapshot mode, you simply press the A button on top of the camera. When you do that, the automatic mode will take effect, regardless of the settings of the shutter speed dial and aperture ring. When you have finished using Snapshot mode, press the A button again, and the mode that was previously active will take effect again.

With that introduction to the recording modes, I will provide more detailed explanations of the modes in this chapter. First, though, I will include a brief reminder of the preliminary steps to take before shooting still images, no matter what recording mode you use. The steps don't have to be taken in this exact order, but this sequence is a useful one to remember in general terms.

Preliminary Steps Before Shooting Pictures

1. Check to be sure you have selected the aspect ratio you want—3:2, 16:9, 1:1, or 4:3—with the slide switch on top of the lens barrel. I generally use 3:2 or 4:3 for everyday shooting, but you may prefer one of the others. If you intend to use software to edit and tweak your photos later, you can always change the aspect ratio then.

2. Check to be sure you have selected the focus method you want: AF for autofocus, AF Macro for autofocus with close-ups, or MF for manual focus. Use the slide switch on the left side of the lens barrel.

3. Remove the lens cap (unless you are using the automatic lens cap, discussed in Appendix A).

4. Turn on the camera.

Now you're ready to select a recording mode. I'll discuss them all below.

Snapshot Mode

This is the mode to choose if you need to have the camera ready for a quick shot in an environment with fast-paced events when you won't have time to fuss with settings. It's also handy if you need to hand the camera to a stranger to take a picture of your group. Figure 3-1 is an image I captured using this mode, showing a view of the James River at Richmond, Virginia.

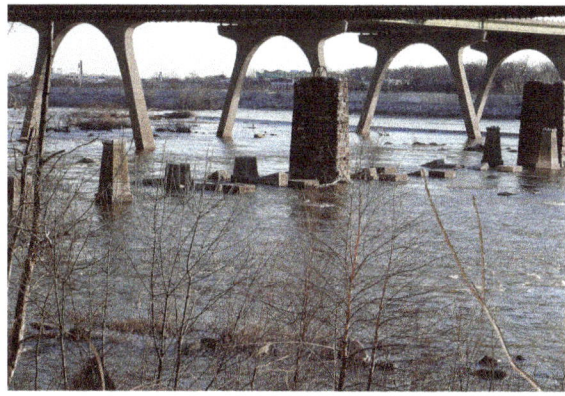

Figure 3-1. Sample Image Taken Using Snapshot Mode

To make this setting, you don't have to worry about the settings of the shutter speed dial or the aperture ring. Just press the A button, located on top of the camera directly behind the shutter button. (You may have to hold the button down for a second or 2, depending on the A button Switch setting on screen 8 of the Custom menu.) The camera will now be set to Snapshot mode.

In this mode, the camera limits the settings you can make, in order to simplify things. For example, you cannot adjust items such as White Balance, ISO, Photo Style, Metering Mode, Filter Effect, Autofocus Mode (setting the area for autofocus) and several others. In addition, as I discussed in Chapter 2, even if you select AF with the autofocus switch, the camera sets the focus mode to AF Macro. You can select the MF position for manual focus, though.

The camera turns on several settings, including Auto White Balance, scene detection, image stabilization, Quick AF, backlight compensation, Intelligent ISO, Intelligent Resolution, Intelligent Dynamic, and Intelligent Zoom, all of which are useful settings that will not unduly limit your options in most cases. I'll discuss all of those items in Chapter 4 in connection with Recording menu settings, except for scene detection and backlight compensation, which I will discuss here, because they are not menu options; the camera uses them automatically in the Snapshot shooting mode.

With scene detection, the camera attempts to figure out if a particular scene type should be used for the current situation. The camera uses its programming to try to detect certain subjects or environments. For example,

it looks for people; babies (if you have registered them using the Face Recognition menu option); night scenes; close-ups; sunsets; food; and portraits. It will identify scenes calling for the iHandheld Night Shot setting if that option is turned on through the menu system. That feature is discussed in Chapter 4. If the camera detects one of these factors, it displays an icon for that type of scene and adjusts its settings accordingly.

For example, in Figure 3-2, the camera detected a human face and displayed the icon for a portrait scene.

Figure 3-2. Portrait Setting Detected in Snapshot Mode

In Figure 3-3, the camera detected a closeup situation when I took a picture of a knight figurine, and it displayed the icon for a macro shot.

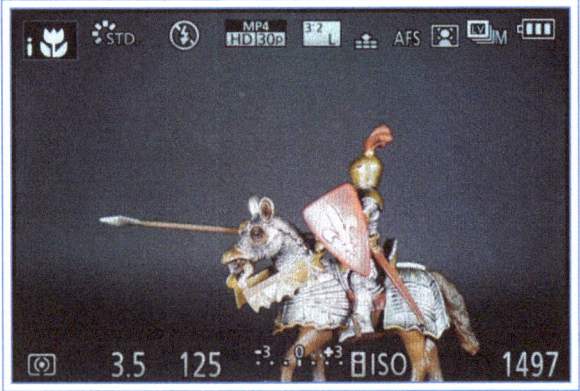

Figure 3-3. Macro Scene Detection Icon on Display

With backlight compensation, the camera will try to detect situations in which the subject of the photograph is lighted from behind. This sort of lighting can "fool" the camera's metering system into making the exposure too dark, because of the light shining toward the lens. The result would be a subject that is too dark, without backlight compensation. With this setting, the camera automatically adjusts its exposure to be brighter, to overcome the effects of the backlighting.

Even though the D-Lux makes various automatic settings in Snapshot mode, there are still several options that you can adjust using the menu system and, to some extent, the physical control buttons.

First, you can use the Recording menu to select certain settings, although your choices are sharply limited compared to the many options that are available with this menu when the camera is set to the more advanced shooting modes (Program, Aperture Priority, Shutter Priority, and Manual). In those other modes, there are 7 screens of options available on the Recording menu; in Snapshot mode, there are only 2 screens of options. I will discuss those options briefly below and in more detail in Chapter 4. The first screen of the Recording menu in Snapshot mode is shown in Figure 3-4.

Figure 3-4. Screen 1 of Recording Menu

The first setting on the Recording menu in this mode, Picture Size, shown in Figure 3-5, allows you to select the resolution of your images. For most purposes, I recommend that you choose the largest size (L), which varies from 10 megapixels (displayed on the screen as 10M) to 12.5M, depending on the aspect ratio setting.

Figure 3-5. Picture Size Menu Options Screen

The second setting on the Recording menu in this recording mode, Quality, shown in Figure 3-5, lets you select the format for your still images.

Figure 3-6. Quality Menu Options Screen

With the D-Lux, unlike some other compact cameras, you can use the advanced Raw format in the Snapshot mode. As I'll discuss in Chapter 4, the Raw format gives you powerful options for adjusting factors such as exposure, White Balance, and sharpness with post-processing software.

The other major option for Quality is the JPEG format, which uses compression to reduce the size of the file used to store the image, but still provides excellent quality. For general shooting, I recommend you choose the top option, Fine, designated by the icon of 2 rows of bricks, highlighted in Figure 3-6.

The third setting on the menu, AFS/AFF/AFC, lets you select how the camera's autofocus system operates—with single, flexible, or continuous focus adjustments. Unless you need the camera to continuously adjust its focus on a moving object, I recommend you choose the AFS setting.

The next menu option, Burst Rate, lets you set the rate for burst shooting. You activate burst shooting by pressing the Down button and selecting that option from the Drive Mode menu that appears. When burst shooting is activated, the camera will take a rapid series of shots while you hold down the shutter button. For now, I recommend the H setting, for high-speed bursts.

The next available menu setting lets you control the setting of the self-timer. You can set it to trigger the camera for a single shot after 10 seconds or 2 seconds, or to trigger a series of 3 shots after 10 seconds. This setting is not actually used until you activate the self-timer using the Down button. Use this setting according to your needs. If you are taking a group photo, use one of the 10-second settings; if you just need to trigger the camera on a tripod without touching it, to minimize camera shake, use the 2-second setting.

The remaining Recording menu options for Snapshot mode are found on screen 2 of the menu, shown in Figure 3-7. The first setting on this screen, iHandheld Night Shot, is designed to minimize motion blur that can result from using a slow shutter speed to get a sufficient exposure at night.

Figure 3-7. Screen 2 of Recording Menu

If the camera detects darkness and senses that it is handheld, the camera will raise its ISO setting in order to permit the use of a faster than normal shutter speed. Also, because using a higher ISO can increase the visual "noise" or grainy look in an image, the camera will take a burst of several shots and combine them internally into a final image. By blending the contents of several images together, the camera can reduce the noise in the final, composite result. This setting is a useful one to activate when shooting in low-light conditions without flash or a tripod.

Even if you turn this setting on with this menu option, the camera will not use it unless it detects conditions that it believes call for the use of this feature.

The next option on screen 2 of the Recording menu in Snapshot mode is iHDR. With this setting, as with iHandheld Night Shot, the D-Lux will take a burst of shots and combine them internally to create a final result, if the situation calls for that procedure. In this case, the situation that will trigger this special processing is strong contrast between the lightest and darkest parts of the scene, such as when one area is in deep shadow while another is in bright sunlight. I

will discuss high dynamic range, or HDR photography, further in Chapter 4. Essentially, with HDR, the camera combines differently exposed parts of multiple images in order to achieve a final result that appears to be properly exposed throughout much or all of its various areas. This setting can be useful when you are taking photographs in high-contrast lighting conditions.

The next option on the menu in this mode is Time Lapse Shot, which provides features for taking a series of photos at preset intervals to create a speeded-up view of a slowly unfolding action such as the opening of a flower. I will discuss this option in Chapter 4. The option immediately after Time Lapse Shot is Stop Motion Animation, which provides similar features that are oriented toward creating stop-motion video sequences, in which a clay figure or other object is animated through the use of multiple shots with slight variations between them. I will discuss this option in Chapter 4 also.

The final option on the Recording menu in Snapshot mode, Face Recognition, lets you set the camera to adjust its focus and exposure for a face you have previously registered in the camera's memory. I will discuss the use of this feature in Chapter 4.

In summary, when you choose Snapshot mode, the D-Lux still lets you make quite a few choices for your settings, but the extent of those choices is limited by comparison to the choices that are available in the more advanced (PASM) recording modes.

It may not be a bad thing to have a small number of menu options, though, because, after all, the purpose of Snapshot mode is for the camera to make quick, reasonably good decisions so you can spring into action with the shutter button on a split second's notice. You still have access to some powerful features, such as burst shooting and the Raw setting for Quality.

In summary, although the Snapshot shooting mode lets the camera make most of the technical decisions, you still have a fair amount of involvement in taking photographs (and movies). Especially when you're just starting out to use the D-Lux, don't shy away from using Snapshot mode as you explore the camera's capabilities. The automation in this mode is sophisticated and will often produce excellent results; the drawback is that you don't have as much creative control as you might like. But for ordinary picture-taking opportunities, vacation photos, and quick shots when you don't have much time to decide on particular settings, Snapshot mode is a wonderful tool to have at your fingertips.

I will end this discussion by providing a table with recommended settings for everyday photography using Snapshot mode:

Table 3-2. **Suggested Settings for Snapshot mode**

Physical Controls	
Aspect Ratio Switch	4:3
Focus Switch	AF
Recording Menu	
Picture Size	L 12.5M
Quality	JPEG-Fine (icon with 6 bricks)
AFS/AFF/AFC	AFS
Burst Rate	H
Self-timer	Use as desired
iHandheld Night Shot	On
iHDR	On
Time Lapse Shot	Use as desired
Stop Motion Animation	Use as desired
Face Recognition	Off

Program Mode

For Program mode, the most automatic of the advanced (PASM) recording modes, you set both the shutter speed dial and the aperture ring to their automatic settings, by moving the red A so it is lined up next to the indicator dot, as shown in Figure 3-8.

Figure 3-8. Camera Settings for Program Mode

Program mode is a very useful mode for quick shots when you want to let the camera make the initial settings, but you want to have the option to make additional settings to control the appearance of the image. In Figure 3-9, I used this mode for a shot of the river underneath a railroad bridge.

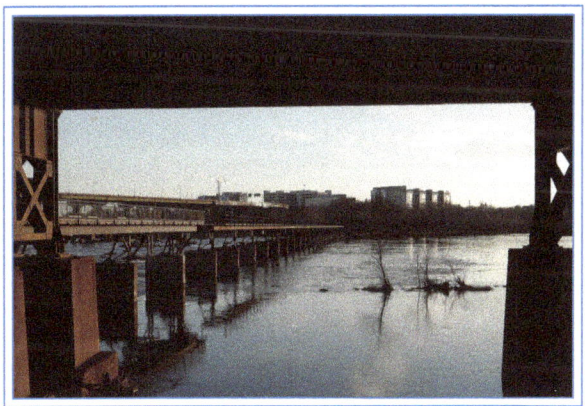

Figure 3-9. Sample Image Taken Using Program Mode

Once you have set the shutter speed dial and aperture ring to the A positions, the camera will display a P icon in the upper left corner of the display, as shown in Figure 3-10, to indicate the shooting mode. (If the red A icon is displayed, press the A button on top of the camera to remove it.)

Figure 3-10. P Icon indicating Program Mode

When you aim the camera at your subject, the exposure metering system will evaluate the light and choose both the shutter speed and aperture, which will be displayed in the lower left corner of the display when you press the shutter button halfway, as shown in Figure 3-11.

Figure 3-11. Shutter Speed and Aperture Values on Display

If these 2 values flash red, that means the camera is unable to find settings that will yield a proper exposure. In that case, you may need to adjust the ISO setting or change the lighting conditions by using flash or taking other appropriate steps.

If you want to alter the camera's settings by selecting a different shutter speed or aperture while keeping the same overall exposure, you can do that (if conditions permit) by using the feature known as Program Shift. After you press the shutter button halfway to evaluate exposure, you can turn the control dial (on back of the camera) within the next 10 seconds, and the camera will try to select another combination of shutter speed and aperture settings that will result in a normal exposure. For example, if the camera initially selects settings of f/4.5 and 1/125 second, when you turn the control dial, the camera may change the settings to f/5.0 and 1/100 second, or f/5.6 and 1/80 second. If you turn the dial in

the other direction, it may change the settings to f/4.0 and 1/160 second, or f/3.5 and 1/200 second.

Program Shift is useful if you want the camera to make the initial settings, but you want to tweak them to use a higher shutter speed to stop action, or a wider aperture to blur the background, for example. When Program Shift is in effect, the camera displays the P icon with a double-ended arrow, as shown in Figure 3-12.

Figure 3-12. Program Shift Icon on Display

In addition, if the Exposure Meter option is turned on through screen 6 of the Custom menu, the camera will show the shutter speed and aperture settings in 2 moving strips, as seen in Figure 3-13. Program Shift is not available when ISO is set to Intelligent ISO, and it is not available when recording motion pictures.

Figure 3-13. Program Shift in Effect with Exposure Meter Display

With Program mode, as with Snapshot mode, the camera will select both the shutter speed and the aperture. However, unlike Snapshot mode, with Program mode you can control many menu settings. You don't have to make a lot of decisions if you don't want to, however, because the camera will make reasonable choices for you as defaults.

Program mode greatly expands the choices available through the Recording menu. You will be able to make choices involving White Balance, image stabilization, ISO sensitivity, metering method, autofocus area, and others. I won't discuss all of those choices here; if you want to explore that topic, go to the discussion of the Recording menu in Chapter 4 and check out the many menu options that are available to you.

Besides unlocking many options in the Recording menu, choosing Program mode provides you with access to settings in the Custom menu that are not available in Snapshot mode, such as various focus-related settings, activating the histogram, and options for changing how the camera's display operates. I will discuss those options in Chapter 7. Program mode also enables the use of the Filter button to add picture effects to your images and the use of the Auto Bracket option in Drive Mode, as discussed in Chapter 5.

Using Program mode does involve some tradeoffs. The most obvious issue is that you don't have complete control over the camera's settings. You can choose many options, such as Photo Style, Quality, Picture Size, and ISO, but you can't directly control the aperture or shutter speed, which are set according to the camera's programming. You can exercise a good deal of control through exposure compensation and exposure bracketing (discussed in Chapter 5) and Program Shift (discussed above), but that's not quite the same as selecting a particular aperture or shutter speed at the outset. If you want that degree of control, you'll need to select Aperture Priority, Shutter Priority, or Manual exposure for your recording mode.

Aperture Priority Mode

This mode is similar to Program mode in the functions available for you to control, but, as the name implies, it also gives you control over the aperture. In this mode, you select the aperture setting and the camera will select a shutter speed that will result in normal exposure, if possible. The camera will choose a shutter speed anywhere from 60 seconds to 1/4000 second. (The range is 1 second to 1/16000 second when the electronic shutter is in use; that feature is discussed in Chapter 4.) If none of these values results in a normal exposure, the shutter speed and aperture values will

Chapter 3: The Recording Modes | 25

turn red and flash. In that case, you may need to adjust the ISO setting or change the lighting conditions.

The main reason to choose this mode is so you can select an aperture to achieve a broad depth of field, with objects in focus at different distances from the lens, or a shallow depth of field, with one area in sharp focus and other parts of the image blurred to reduce distractions. With a narrow aperture (higher f-stop number) such as f/8.0, the depth of field will be relatively broad; with a wide aperture such as f/1.7, it will be shallow, resulting in the possibility of a blurred background.

In Figure 3-14 and Figure 3-15, I made the same shot with 2 very different aperture settings. I focused on the flower in the foreground in each case.

Figure 3-14. Aperture Set to f/2.1

For Figure 3-14, I set the aperture to f/2.1, close to the widest possible value, f/1.7. With this setting, because the depth of field at this aperture was shallow, the items in the background are blurry. I took Figure 3-15 with the camera's aperture set to f/16.0, the narrowest possible setting, resulting in a broader depth of field, and bringing the background into sharper focus.

Figure 3-15. Aperture Set to f/16.0

These 2 photos show the effects of varying the aperture by setting it wide (low numbers) to blur the background or narrow (high numbers) to achieve a broad depth of field and keep subjects at varying distances in sharp focus. However, you should avoid using the narrowest aperture settings, such as f/16.0 and f/11.0, when it is important to show the clearest details in your image. At these highest aperture settings, the diffraction effect comes into play and reduces the level of detail to some extent. If you can use f/5.6, you are likely to achieve the greatest level of sharpness and detail, if other factors are equal. But, if you need to use a narrow aperture setting because of bright lighting conditions or because you need to use a slow shutter speed to blur the appearance of a waterfall, for example, you should not hesitate to make that setting.

To use Aperture Priority mode, turn the aperture ring until the chosen value is at the indicator dot and turn the shutter speed dial to its A setting, as shown in Figure 3-16.

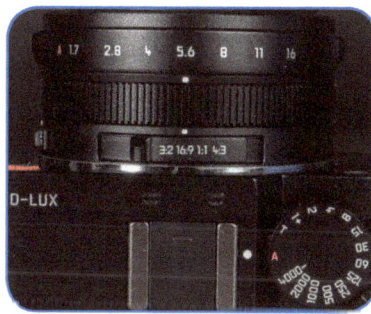

Figure 3-16. Camera Settings for Aperture Priority Mode

One of the nice features of the D-Lux is having a physical ring to set the aperture. As you turn the ring, it clicks into place for each f-stop, in 1/3 stop increments, and you can see the full-stop settings on the ring. If you have turned on the Exposure Meter option on screen 6 of the Custom menu, you can see the aperture (and shutter speed) in a graphic display on the camera's screen, as shown in Figure 3-17, as you turn the ring.

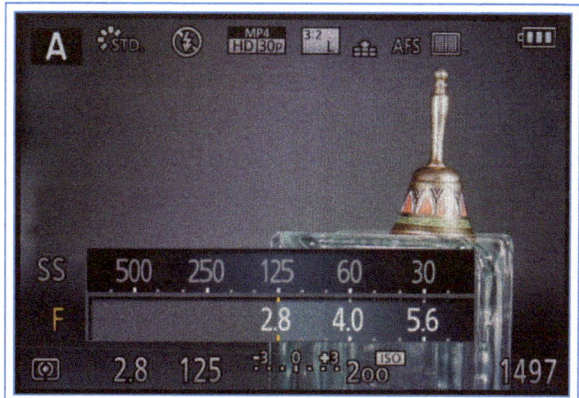

Figure 3-17. Exposure Meter Dials on Display

Even without the graphic display, the number of the f-stop will appear in the lower left corner of the screen as shown in Figure 3-18, where the value is f/2.8.

Figure 3-18. Aperture Value on Display - No Exposure Meter Dials

The shutter speed will be displayed also, but not until you have pressed the shutter button halfway down to let the camera evaluate the exposure.

Here is an important note about Aperture Priority mode that might not be immediately obvious: Not all apertures are available at all times. In particular, the widest-open aperture, f/1.7, is available only when the lens is zoomed out to its wide-angle setting (moved toward the W indicator). At higher zoom levels, the widest aperture available changes steadily, until, when the lens is fully zoomed in to the 75mm level, the widest aperture available is f/2.8.

To see an illustration of this point, here is a quick test. Zoom the lens out by moving the zoom lever all the way to the left, toward the W. Then select Aperture Priority mode and set the aperture to f/1.7 by turning the aperture ring all the way to the 1.7 setting. Now zoom the lens in by moving the zoom lever to the right, toward the T. After the zoom is complete, you will see that the aperture has changed to f/2.8, because that is the widest the aperture can be at the maximum zoom level. (The aperture will change back to f/1.7 if you move the zoom back to the wide-angle setting; so you need to check your aperture after zooming out as well as after zooming in, to make sure you will not be surprised by an unexpected aperture setting.)

Finally, you should note that, when the aperture is wider than f/4.0, the camera cannot set a shutter speed faster than 1/2000 second using the mechanical shutter.

Shutter Priority Mode

The next shooting mode is a complement to Aperture Priority mode. In Shutter Priority mode, you choose the shutter speed, and the camera will set the corresponding aperture in order to achieve a proper exposure of the image. In this mode, you can set the shutter for a variety of intervals ranging from 60 full seconds to 1/4000 of a second when using the mechanical shutter. However, if the aperture is wider than f/4.0 (such as f/1.7 or f/3.0), the camera cannot use a shutter speed faster than 1/2000 second with the mechanical shutter. In that case you would have to use the electronic shutter to set a faster shutter speed. I discuss the use of the mechanical and electronic shutter types in Chapter 4.

With the electronic shutter, the range is from 1 second to 1/16000 second. (The available shutter speed settings are different for motion pictures.) The camera will pick an aperture from its full range of f/1.7 to f/16.0, unless the lens is zoomed in. In that case, as discussed in connection with Aperture Priority mode, the widest aperture available is f/2.8.

If the camera cannot set an aperture to result in a normal exposure, the shutter speed and aperture values will flash red. If you are photographing fast action, such as a baseball swing or a hurdles event at a track meet, and you want to stop the action with a minimum of blur, you should select a fast shutter speed, such as 1/1000 of a second. You can use a slow shutter speed, such as 1/8 second or slower, to cause motion blur for effect, such as to smooth out the appearance of flowing water.

In Figures 3-19 and 3-20 I photographed the same action using different shutter speeds to illustrate the different effects. In both cases, I dropped a bunch of white plastic BBs into a flat vase. In Figure 3-19, using a shutter speed of 1/500 second, the camera froze the BBs in mid-air, letting you see each one individually. In Figure 3-20, using a shutter speed of 1/60 second, the BBs appear to form long streams of white, because that shutter speed was not fast enough to stop their action.

Figure 3-19. f/5.6, 1/500 sec, ISO 3200

Figure 3-20. f/8.0, 1/60 sec, ISO 1600

To use Shutter Priority mode, turn the aperture ring to its red A setting and select the shutter speed by turning the shutter speed dial, as shown in Figure 3-21.

Figure 3-21. Camera Settings for Shutter Priority Mode

It is easy to select any of the speeds printed on the dial; just turn the dial to a setting, such as 4000 for 1/4000 second, 60 for 1/60 second, or 2 for 1/2 second. For the values in between or beyond the printed ones, you need to use the control ring or the control dial. For example, to set a speed of 1/10000 second, turn the shutter speed dial to the 4000 setting, then turn the control ring (or control dial) until the 10000 value appears at the bottom of the display and on the graphic exposure dial, if the Exposure Meter option has been turned on. (Values faster than 1/4000 second are available only if the Shutter Type option on screen 4 of the Recording menu is set to Auto or Electronic, shown as ESHTR on the menu.) To set a value of 1/25 second, turn the dial to the 30 setting, then turn the control ring or dial to select 1/25 second. For a value of 15 seconds, turn the dial to the 1+ setting, then turn the control ring or dial until the 15" setting appears.

On the shutter speed display, be sure to distinguish between the fractions of a second and the times that are one second or longer. The longer times are displayed with what looks like double quotation marks to the right, as in Figure 3-22, which shows a shutter speed of 2.5 seconds.

Figure 3-22. Shutter Speed Setting of 2.5 Seconds on Display

One aspect of the camera's display that can be confusing is that some times are a combination of fractions and decimals, such as 1/2.5 and 1/3.2. I find these numbers hard to translate mentally into a time I can understand. Here is a table that translates these numbers into a more understandable form:

Table 3-3.	Shutter Speed Equivalents
3.2	1/3.2 = 0.31 or 5/16 second
2.5	1/2.5 = 0.4 = 2/5 second
1.6	1/1.6 = 0.625 = 5/8 second
1.3	1/1.3 = 0.77 = 10/13 second (0.8 sec)

When Shutter Priority mode is in effect, you cannot use the Intelligent ISO setting. If it was set, the camera will reset it to Auto ISO.

Manual Exposure Mode

The D-Lux has a fully manual mode for control of exposure, which is one of the great features of this camera. Not all compact cameras have a manual exposure mode, which helps you exert full creative control over exposure decisions. For example, there may be times when you want to purposely underexpose or overexpose an image to convey a particular feeling or to produce a special effect, such as a silhouette. Or, there may be a tricky situation in which your most important subject is deeply shadowed and you prefer to use manual settings of aperture and shutter speed rather than relying on exposure compensation in order to expose the subject properly. In Figure 3-23, I used this mode for another shot of the river, but this time I used manual settings for ISO, shutter speed, and aperture, and placed an infrared filter on the lens to see what kind of effect I could get. I like the dark, somewhat mysterious atmosphere that resulted.

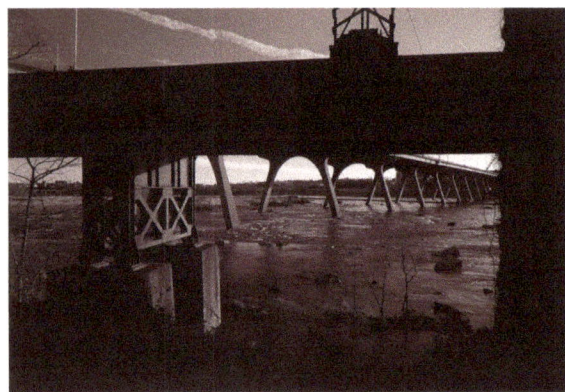

Figure 3-23. Sample Image Taken Using Manual Exposure Mode

I also find Manual exposure mode to be useful when taking individual shots to be combined in software to create HDR (high dynamic range) composite images. The HDR technique, which I will discuss further in Chapter 4, often is used when the scene is partly in darkness and partly in bright light. To even out the contrast, you can take a series of shots, some considerably underexposed and others overexposed. You then combine these shots in special software that blends differently exposed portions from several shots, resulting in a composite image that is well exposed through a wide range of lighting values.

The technique for using Manual exposure mode is not far removed from what I discussed in connection with the Aperture Priority and Shutter Priority modes. To control exposure manually, set the shutter speed dial to your chosen value and set the aperture ring to a particular aperture, as shown in Figure 3-24.

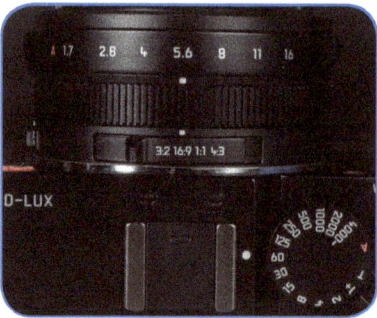

Figure 3-24. Camera Settings for Manual Exposure Mode

The camera will not change either of these settings. The camera will display the letter M on a black icon to indicate Manual exposure mode.

You also will see a small exposure scale at the bottom center of the screen, ranging from −3 EV to +3 EV. As you change the exposure settings, the camera will display tick marks below the scale if the exposure as metered is too bright or too dark. For example, in Figure 3-25, there are tick marks to the right, indicating that the exposure as metered is too bright.

Figure 3-25. Tick Marks Indicating Overexposure - Manual Exposure Mode

If no tick marks appear, that means the exposure is normal according to the camera's metering system. If the exposure gets too far out of the normal range in either direction, the shutter speed and aperture values will flash red when you half-press the shutter button to evaluate exposure and focus. Of course, you do not have to be concerned with the indication on this exposure meter, because you can make any settings you want; you may want a darker-than-normal image to create a silhouette, for example. But the EV (exposure value) scale is useful to help you decide what settings to make.

You also should note that the camera's display will not show the effects of your settings unless you set it to do so. That is, with normal menu options, even if you set the aperture and shutter speed to values that would produce a very dark image, the image on the display will appear basically normal, provided there is sufficient ambient light to produce a normal view. If you want to see the effects of your exposure settings, go to screen 5 of the Custom menu and turn on the Constant Preview option. Then the display will become darker or brighter as the settings change. (This feature works only with Manual exposure mode, not with Aperture Priority, Shutter Priority, or Program.)

A good feature of Manual mode is that you can set ISO to Auto ISO. If you do so, then, even though the camera cannot change the aperture or the shutter speed you have set, it can vary the ISO setting within the range permitted by the Auto ISO option (discussed in Chapter 4). Therefore, the camera may be able to achieve a normal exposure by setting the ISO to an appropriate level. This is a powerful feature, which amounts in effect to giving you a new recording mode, which might be called "Aperture and Shutter Priority" mode.

For example, you might use Manual exposure mode with Auto ISO when you are taking pictures of a person working with tools in a dimly lighted workshop. You might use a narrow aperture such as f/8.0 in order to keep the work in focus, and a fast shutter speed such as 1/250 second to avoid motion blur. You can make both of those settings and be assured that they will not vary. The camera will automatically adjust the ISO to achieve the best exposure possible, given the lighting conditions.

In other situations, such as when you purposely want to underexpose or overexpose an image, just set ISO to a specific numerical value and adjust the shutter speed and aperture to achieve the exposure you need. You cannot use Intelligent ISO in Manual exposure mode.

Another distinguishing feature of Manual exposure mode is that it gives you an additional option for setting the shutter speed. With Shutter Priority mode, you can set the shutter speed anywhere from 60 seconds to 1/4000 second (when using the mechanical shutter). With Manual mode, you have the additional option of setting the shutter speed dial to the T setting, for time exposure. Then, when you press the shutter button, the shutter opens up and does not close again to end the exposure until you press it again, up to a limit of about 120 seconds. You can use this feature to take extra-long exposures of trails of cars' headlights, for fireworks, or to turn night scenes into unusual daylight vistas. Of course, it is advisable to use a solid tripod and to trigger the camera remotely when taking an exposure of this length. The time exposure feature is not available if you are using the electronic shutter, which is discussed in Chapter 7. If you use the T setting in Shutter Priority mode, the camera will set the shutter speed to 60 seconds.

As noted earlier, in other shooting modes the camera cannot set the aperture to f/1.7 and other low values when the lens is fully zoomed in. The same situation is true with Manual exposure mode; you cannot set the wide-open aperture of f/1.7 when the lens is zoomed all the way in to the 75mm setting. Also, as with other modes, the camera cannot set a shutter speed faster than 1/2000 second using the mechanical shutter when the aperture is wider than f/4.0.

Chapter 4: The Recording Menu and the Quick Menu

Much of the power of the D-Lux lies in the many options provided in the Recording menu, which gives you control over the appearance of your images and how they are captured. This menu is not the only source of creative tools for this camera; there are several important settings that can be controlled with physical buttons and dials, as I will discuss in Chapter 5, and there also is the convenient Quick Menu, which gives you ready access to several often-used options. I will discuss both the Recording menu and the Quick Menu in this chapter.

The Recording Menu

As I have discussed earlier, the main menu system of the D-Lux incudes 5 separate menus: Recording, Motion Picture, Custom, Setup, and Playback. I'll discuss the Playback menu in Chapter 6, the Custom and Setup menus in Chapter 7, and the Motion Picture menu in Chapter 8.

When you press the Menu/Set button, you will initially see the main menu screen, as shown in Figure 4-1.

Figure 4-1. Screen 5 of Custom Menu

The actual screen that is displayed depends on the setting of the Menu Resume item on screen 3 of the Setup menu. If that option is set to On, then the menu screen you last used will appear; if that option is set to Off, the camera will display the first screen of the Recording menu. In Figure 4-1, screen 5 of the Custom menu is active.

If, as in this example, the Recording menu screen is not displayed, press the Left button. That action will move the highlight into the left column of the menu screen, as shown in Figure 4-2, where you can navigate up and down with the direction buttons or the control dial to highlight the icons for the various menu systems.

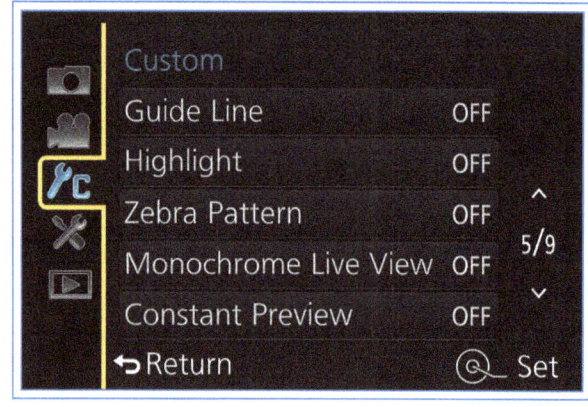

Figure 4-2. Custom Menu Icon Highlighted in Left Column

For now, use the buttons to highlight the red camera icon at the top of the line of icons, indicating the Recording menu, as shown in Figure 4-3.

Chapter 4: The Recording Menu and the Quick Menu | 31

Figure 4-3. Recording Menu Icon Highlighted in Left Column

Then press the Right button to move back over to the main part of the screen, with the Recording menu items. A red line should highlight the first item on the first menu screen, which is Photo Style, as shown in Figure 4-4. (If another item on the Recording menu was previously selected, you may have to navigate back to the first screen.)

Figure 4-4. Photo Style Option Highlighted on Menu Screen

As I discussed earlier, the menu options will change depending on the recording mode in effect. If you're using Snapshot mode, the Recording menu options are limited to just 2 screens, because that mode is for a user who wants the camera to make most of the decisions without input. For the following discussion, I'm assuming you have the camera set to one of the advanced (PASM) modes, because in those modes all 7 screens of the menu are available.

On the menu screen you will see a fairly long list of options, each occupying one line, with its name on the left and its current setting on the right. (In some cases, the current setting is not shown because it involves multiple options.) You have to scroll through 7 screens to see all of the items. If you find it tedious to scroll using the Up and Down buttons, here's a tip for navigating the main menu system on the D-Lux: You can use the zoom lever on top of the camera to speed through the menus one full screen at a time, in either direction. You also can press the Display button to move through the menu screens, but only in the forward direction. You can tell which numbered screen you are on by checking the numbers at the right of the screen, which show the screen numbers as 1/7, 2/7, through 7/7.

Depending on the location of a particular menu option, you may be able to reach that option more quickly by reversing direction with the direction buttons, and wrapping around to reach the option you want. For example, if you're on the top line of screen 1 of the menu, at Photo Style, you can scroll up to reach the bottom option on screen 7 of the menu, Profile Setup.

Some menu lines may have a dimmed, "grayed-out" appearance at times, meaning they cannot be selected under the present settings. For example, as shown in Figure 4-5, if Quality is set to Raw, you cannot set Picture Size, which is automatically set to the maximum value when Raw is selected, so the Picture Size line is dimmed.

Figure 4-5. Picture Size Dimmed when Quality Set to Raw

Also, if you have set Quality to Raw, you cannot make several other settings, including HDR, Intelligent Zoom, and Digital Zoom. If you want to follow along with the discussion of the options on the Recording menu, set Quality to Fine, which is the setting represented by the icon of an arrow pointing down onto 2 rows of bricks, as shown in Figure 4-6.

Figure 4-6. Fine Setting Highlighted for Quality Menu Option

To do so, scroll down using the Down button until the Quality line is highlighted, then press the Right button to pop up the sub-menu. Scroll up or down as needed to highlight the top icon with the 6 bricks, and then press the Menu/Set button to select that option.

With that setting, you will have access to most of the options on the Recording menu. I'll start at the top, and discuss each option on the list.

Photo Style

This first item on the Recording menu gives you several options for a setting that alters the overall appearance of your images. This setting yields differing results in terms of warmth, color cast, and other attributes.

The Photo Style settings are not available in Snapshot mode. However, they are available when you're recording a movie in an advanced shooting mode.

To select a Photo Style setting, highlight Photo Style on the Recording menu and press the Right button or Menu/Set to move to the screen that shows the current setting in the upper right, as shown in Figure 4-7.

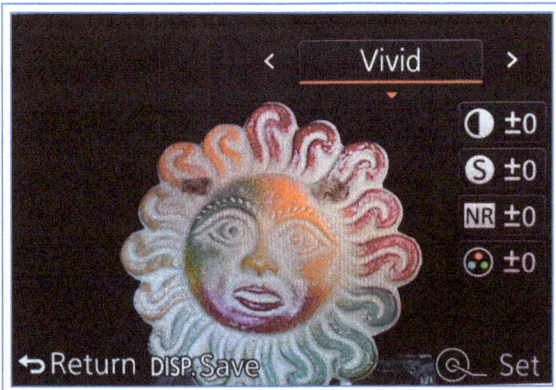

Figure 4-7. Vivid Setting for Photo Style Highlighted on Display

Then use the Left and Right buttons or the control dial to scroll through the available settings: Standard, Vivid, Natural, Monochrome, Scenery, Portrait, and Custom. When your chosen setting is highlighted at the top right of the screen, as shown in Figure 4-7, where the Vivid setting has been highlighted, press the Menu/Set button to select it, then press the Fn1 button to exit to the shooting screen. Or, if you prefer, after highlighting the new setting, just press the shutter button halfway to select the setting and return to the shooting screen.

If you want to go further and fine-tune the setting, the D-Lux's menu system lets you adjust the 4 parameters that are used to create the Photo Style settings: contrast, sharpness, noise reduction, and saturation. To make adjustments to those parameters, press the Down button when the main setting (such as Vivid or Natural) is highlighted in red, as in Figure 4-7. A new highlight will then appear in the block that contains the value for one of the 4 adjustable parameters, as shown in Figure 4-8.

Figure 4-8. Sharpness Adjustment Highlighted for Vivid Setting

In this case, the second line is highlighted, which means you can adjust the sharpness setting; the word Sharpness appears for a few seconds at the top left of the screen, indicating that that value can now be adjusted.

Once you have placed the red line under one of the 4 parameters, press the Left and Right buttons or turn the control dial to change the value of that parameter up to 5 levels, either positive or negative. A red scale in the center of the screen will reflect those changes, as shown in Figure 4-9. Press Menu/Set or press the shutter button halfway to save the changes. The camera will remember those settings even when it is turned off.

Chapter 4: The Recording Menu and the Quick Menu | 33

Figure 4-9. Sharpness Adjustment Scale for Vivid Setting

There is one additional point to make about the Monochrome setting for Photo Style. Monochrome means there is no color in the image, only shades of black, white, and gray. Therefore, the saturation adjustment does not work to increase or decrease the saturation of colors for the Monochrome setting. Instead of the saturation adjustment, the camera provides 2 additional parameters at the bottom of the list: color tone and filter effect, as shown in Figure 4-10.

Figure 4-10. Monochrome Setting in Effect

With color tone, a positive adjustment makes the monochrome effect increasingly bluish or "cooler," while a negative adjustment makes it increasingly yellowish or "warmer."

The filter effect adjustment lets you add a virtual filter, simulating the effect of a glass filter, which can be used on a camera's lens for black-and-white photography to enhance contrast and for other purposes. You can choose from a yellow, orange, red, or green filter, or choose the last setting, which turns the filter effect off.

Figure 4-11. Yellow Filter Adjustment Highlighted for Monochrome Setting

For example, Figure 4-11 shows the screen when the yellow filter effect is selected. The yellow, orange, and red effects provide increasing amounts of contrast for blue subjects, and can be used to enhance the appearance of a blue sky. The green effect can be used to reduce the brightness of human skin and lips or to brighten the appearance of green foliage.

When you set Photo Style to Monochrome with Quality set to Raw, the picture you take will show up as black-and-white on the camera's LCD screen, but, when you import the image file into software that reads Raw files, the image may show up in color, depending on how the software interprets the Raw data from the sensor. With the Adobe Lightroom software provided with the camera, Raw images taken with Photo Style settings do not retain the Photo Style appearance, but you can convert them to other settings using the software.

Before I provide descriptions of how the Photo Style settings affect your images, I am providing a chart in Figure 4-12 that shows the same scene photographed with each of the various settings, for a general comparison of the effects produced by those settings.

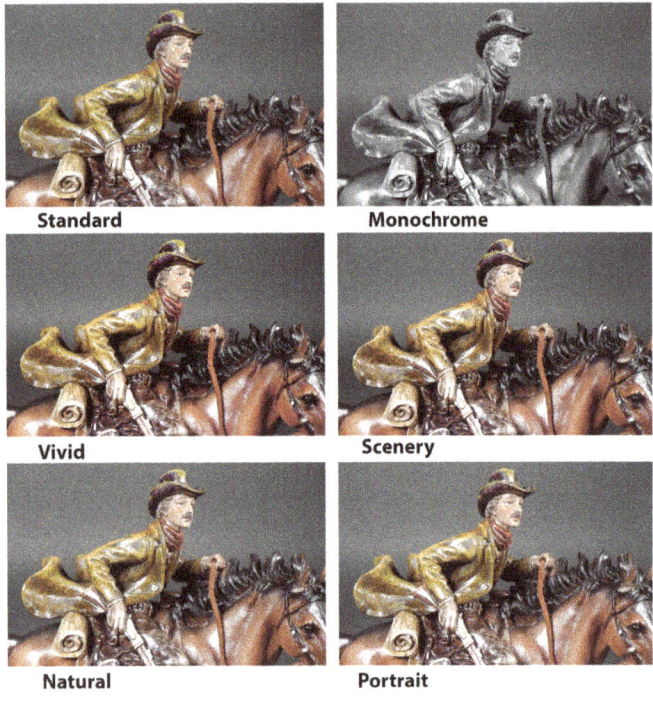

Figure 4-12. Photo Style Settings Comparison Chart

Here are summaries of each of the Photo Style settings:

Standard: No change from the normal setting; good for general photography. The camera uses moderate sharpening and contrast to provide a clear image for everyday purposes.

Vivid: Increased saturation (intensity or vividness) and contrast of the colors in the image to make the colors "pop" out in dramatic fashion.

Natural: Reduced contrast to produce a softer, more subdued appearance.

Monochrome: Standard settings, but monochrome image, with all color removed (that is, saturation reduced to zero), unless you use the color tone adjustment to add a yellow or blue tone. You also can use the filter effect setting to add a yellow, orange, red, or green filter effect.

Scenery: Increased emphasis on the blues and greens of outdoor scenes, with increased saturation of those hues.

Portrait: Emphasis on flesh tones.

Custom: Finally, the Custom slot is available for you to store a setting that you have customized using your own preferred settings for the parameters that can be adjusted individually (contrast, sharpness, saturation, and noise reduction, as well as color tone and filter effect for the monochrome setting). To use this option, first select any one of the basic Photo Style settings (Standard, Vivid, Natural, Monochrome, Scenery, or Portrait), then press the Down button and proceed to adjust any or all of the parameters for that setting as you want them. Next, press the Display button, as prompted by the DISP. Save message on the display, as shown in Figure 4-13.

Figure 4-13. Screen Showing Message to Press Disp. to Save Custom Photo Style

The camera will display the message shown in Figure 4-14, asking you to confirm that you want to overwrite the current Custom setting with the settings you just made.

Figure 4-14. Confirmation Message for Saving New Custom Setting

If you highlight Yes and press Menu/Set, the settings you have made will be stored in the Custom slot of the Photo Style setting.

After you have stored the Custom setting, you can recall it at any time by selecting Custom for your setting. You can alter the Custom setting in the future by choosing

Chapter 4: The Recording Menu and the Quick Menu

a different set of settings and storing it to the Custom slot, overwriting the previous entry.

Picture Size

This second item on the Recording menu controls the number of megapixels (MP or M) in the images you record with the camera, up to and including its maximum of 12.5M. The maximum MP setting is affected by the aspect ratio that you have set. You can set the aspect ratio to one of 4 settings using the switch on top of the lens barrel: 3:2, 16:9, 1:1, or 4:3. If you set the aspect ratio to 4:3, the maximum Picture Size setting is the full 12.5M, as shown in Figure 4-15, though it does not use the full horizontal extent of the available pixels.

Figure 4-15. Picture Size Set to L with Aspect Ratio Set to 4:3

If you set the aspect ratio to 3:2, the camera achieves that image shape by cutting off some pixels vertically but adding some horizontally, so the maximum setting for Picture Size is 12M. At the 16:9 setting, even more vertical pixels are lost but horizontal ones are added, and the maximum Picture Size is 11M. At the 1:1 aspect ratio, the camera uses the full amount of vertical pixels, but crops pixels from both sides, resulting in a maximum image size of 10M.

The higher the M setting, the better the overall quality of the image, all other factors being equal. However, you can create a fuzzy and low-quality image with a high M setting with no trouble at all; the M setting does not guarantee a great image. But if all other factors are equal, a higher M count should yield noticeably higher image quality. Also, when you have a large M count in your image, you have some leeway for cropping it; you can select a portion of the image to enlarge to the full size of your print, and still retain acceptable image quality.

On the other hand, images with high M counts eat up your storage space more quickly than those with low M counts. If you are running low on space on your SD card and still have a lot of images to capture, you may need to reduce your Picture Size setting so you can fit more images on the card.

Also, note that the camera has a 16.8M image sensor. Not all of those megapixels are used for any single aspect ratio. The camera crops the image from the sensor to produce the various image shapes for each aspect ratio setting. However, because the camera has about 4 megapixels more than necessary for any single aspect ratio, it is able to maintain a relatively full angle of view for each aspect ratio. As a result, no aspect ratio is subject to severe cropping, as would be the case if the camera did not have the extra megapixels available.

As noted earlier, the Picture Size setting is dimmed and unavailable when you have selected Raw for the Quality setting. However, if you select Raw & Fine or Raw & Standard, with which the camera records both a Raw and a JPEG image, the Picture Size option is available for setting the size of the JPEG image.

Extended Optical Zoom

Another point to consider is how much zoom you need or want. You might not think that picture size is related to zoom, but with the D-Lux it is. The camera has a feature called Extended Optical Zoom, designated as EX in the user's manual illustrations. When you set the Picture Size to 3 MP (S), for example (with aspect ratio of 4:3), you will find that you can zoom in farther than you can with Picture Size set to its maximum. You will see an EX designation appear on the menu screen to the left of the Picture Size setting of S, as shown in Figure 4-16.

Figure 4-16. EX Indicator for Picture Size Setting of S

You also will see that the zoom scale goes beyond the normal limit of 75mm, as you move the zoom lever on top of the camera toward the T setting, for Telephoto, as shown in Figure 4-17.

Figure 4-17. Zoom Scale Extending to 150mm with EX in Effect

Depending on the Picture Size setting, the scale will extend to a zoom level of as much as twice normal, or about an equivalent of 150mm. (If you turn on Intelligent Zoom or Digital Zoom, discussed later in this chapter, the zoom range will extend even farther; for now, I am assuming that both of those options are turned off.)

This feature needs further explanation. The lens of the D-Lux has an actual, physical focal length range of 10.9 millimeters (mm) to 34mm, which you can see engraved on the end of the lens casing. This means that, at its full wide-angle (un-zoomed) setting, the lens's actual focal length is 10.9 mm. As with most digital cameras today, the camera's documentation converts this figure to the "35mm-equivalent," that is, to the focal length for the lens that would be the equivalent of this lens on a camera that uses 35mm film. In this case, that focal length is 24mm, which is still a very wide setting for a standard lens. The 35mm equivalent value for the fully zoomed setting of the D-Lux's lens (34mm) is 75mm. So the 35mm equivalent zoom range for this lens is 24mm to 75mm.

Normally, the maximum zoom value for the D-Lux's lens is 75mm, or 3.1 times the unzoomed setting of 24mm. However, when you set Picture Size to a value lower than Large, such as Small (3M), the camera lets you zoom in farther on the subject you are viewing using the zoom lever. The camera takes the normal area that the optical zoom "sees" and then blows it up to a larger size, which is possible because the lower megapixel setting means the camera is using a lower resolution and can present a larger zoomed image. Extended Optical Zoom has a maximum power of 6.2 times the normal lens's magnification.

To sum up the situation with Extended Optical Zoom, whenever you set the Picture Quality to a level below Large, you get a bit of additional zoom power because of the reduced resolution. In reality, you could achieve the same result by taking the picture at the normal zoom range with Picture Size set to the full 12.5M and then cropping the image in your computer to enlarge just the part you want. But with Extended Optical Zoom, you get the benefit of seeing a larger image on the display when you're composing the picture, and the benefit of having the camera perform its focus and exposure operations on the actual zoomed image that you want to capture, so the feature is not useless. You just need to decide whether it's of use to you in a particular situation.

I'll discuss Intelligent Zoom and Digital Zoom later, as other Recording Menu options.

Quality

The next setting on the Recording menu is Quality. It's important to distinguish the Quality setting from the Picture Size setting. Picture Size concerns the image's resolution, or the number of megapixels in the image. Quality has to do with how the image's digital information is compressed for storage on the SD card and, later, on the computer's hard drive. There are 3 levels of quality available in various combinations: Raw, Fine, and Standard, as shown in Figure 4-18. From the top, the 5 icons stand for Fine, Standard, Raw & Fine, Raw & Standard, and Raw.

Figure 4-18. Quality Menu Options Screen

Raw is in a category by itself. There are both pros and cons to using Raw in this camera. First, the cons. A Raw file takes up a lot of space on your memory card, and, if you copy it to your computer, a lot of space on your hard drive. In addition, there are various functions of the D-Lux that don't work when you're using Raw, including panorama shooting, Digital Zoom, Resize, Cropping, Title Edit, Text Stamp, Favorites, Print Set (printing directly to a photo printer), Aspect Bracket, and White Balance Bracket. You also cannot get the benefit of using the Filter button to add picture effects to your images, though you can turn on those effects when shooting with Raw for Quality. (The resulting image will show the picture effect when displayed in the camera, but not when opened on a computer.)

You also cannot shoot in Raw quality with the iHandheld Night Shot or HDR options. You cannot use the SH setting of burst shooting (40 frames per second) when using Raw quality, and any burst shooting will be slowed down when shooting in Raw.

Finally, you may have problems working with Raw files on your computer because of incompatibility with editing software, though those problems can be overcome by getting updates for your program.

On the other hand, using Raw files has several advantages. The main benefit is that Raw files give you an amazing amount of control and flexibility with your images. When you open up a Raw file in a compatible photo-editing program, the software gives you the opportunity to correct problems with exposure, White Balance, color tints, and other settings. If you had the aperture of the camera too narrow when you took the picture, and it looks badly underexposed, you can manipulate the exposure adjustments in the software and recover the image to a proper brightness level. Similarly, you can adjust the White Balance after the fact, and remove unwanted color casts. You can even change the amount of fill lighting. In effect, you get a second chance at making the correct settings, rather than being stuck with an unusable image because of unfortunate settings when you pressed the shutter button.

The drawbacks to using Raw files are either not too severe or they are counterbalanced by the great flexibility Raw gives you. The large size of the files may be an inconvenience, but the increasing size of hard drives and SD cards, with steadily dropping prices, makes file size much less of a concern than previously. I have heard some photographers grumble about the difficulties of having to process Raw files on the computer. That could be an issue if you don't regularly use a computer. I use my computer every day, so I don't notice. I have had problems with Raw files not loading when I didn't have the latest Camera Raw plug-in for Adobe Photoshop or Photoshop Elements, but with a little effort, you can download an updated plug-in and the software will then process and display your Raw images. The D-Lux comes with a license for Lightroom, a program for processing Raw files, so you don't have to buy any additional software to process Raw files.

You certainly don't have to use Raw, but you may be missing some opportunities if you avoid it.

The other 2 settings for Quality—Fine and Standard— are levels of compression for computer image files that use the JPEG standard. Images saved with Fine quality are subjected to less compression than those saved with Standard quality. In other words, Standard-quality images have their digital data "compressed" or "squeezed" down to a smaller size to allow more of the files to be stored on an SD card or computer drive, with a corresponding loss of image quality. The more compression an image is subjected to, the less clear detail it will contain. So unless you are running out of space on your storage medium, you probably should leave the Quality setting at Fine to ensure the best quality. (Of course, you may prefer to shoot in the Raw format for maximum quality.)

With the D-Lux, besides choosing one of the individual Quality settings (Raw, Fine, or Standard), you also have the option of setting the camera to record images in Raw plus either Fine or Standard. If you choose that option, the camera will record each image in 2 files— one Raw and the other a JPEG file in either Fine or Standard quality, depending on your selection. If you then play the image back in the camera, you will see only one image, but if you copy the files to your computer, you will find 2 image files—one with a .jpg extension and one with an .rwl extension. The Raw file will be much larger than the JPEG one. In a few examples I just looked at on my computer, the Raw files from the D-Lux were all about 15 MB and the corresponding JPEG files were between about 3 and 6 MB. (Note that MB stands for megabytes, a measure

of file size, as distinguished from MP or M, meaning megapixels, a measure of the number of pixels in an image.)

Why would you choose the option of recording images in Raw and JPEG at the same time? Say you're taking pictures of a one-time event such as a wedding or graduation. You may want to preserve them in Raw for the highest quality and for later processing with photo-editing software, but also have them available for quick review on a computer that might not have software that reads Raw files. Or, you might want to be able to send the images to friends or post them to social media sites without translating them from Raw into a JPEG format that most people can easily view on their computers. In addition, you might want to take advantage of the Filter button picture effects, which alter the appearance of JPEG images but not Raw ones, but you might want to have the Raw versions available for flexibility of editing.

The Raw plus JPEG option is open to you if space on your SD card is not a major consideration. If you have a high-capacity card or multiple cards available, you may want to take advantage of both ways to record images.

AFS/AFF/AFC

This next menu option lets you choose how the autofocus system operates when the autofocus switch is set to the AF or AF Macro position. With AFS, for autofocus single, when you press the shutter button halfway, the camera locks focus on the subject and keeps it locked while the button is held there, even if the subject moves. With AFF, for autofocus flexible, the camera locks focus, but will adjust focus if the subject (or the camera) moves. With AFC, for autofocus continuous, the camera does not lock focus, but adjusts it continuously as the subject or camera moves.

If you are shooting images of a landscape or other stationary subject, AFS will work well. The camera will lock focus and keep it there, and the battery will not be drained by adjusting focus. If you are shooting handheld shots at a fairly close distance, though, you might want to use the AFF setting because the camera will adjust the focus if the camera moves slightly, and the focus could be thrown off by that movement, especially when the focus distance is small or the lens is zoomed in.

If you are shooting pictures of children or pets moving around unpredictably, you may want to use the AFC or AFF setting and let the camera continue to adjust focus as needed. With these settings, the camera's battery will be drained faster than with AFS, but it may be worth it to capture an action shot in sharp focus.

Metering Mode

The next option on the Recording menu lets you choose what method the camera uses to meter the light and determine the proper exposure. The D-Lux gives you a choice of 3 methods: Multiple, Center-weighted, or Spot. If you choose Multiple, the camera evaluates the brightness at multiple spots in the image shown on the display, and calculates an exposure that takes into account all of the various values. With Center-weighted, the camera gives greater emphasis to the brightness of the subject(s) in the center of the screen, while still taking into account the brightness of other areas in the image. With Spot, the camera evaluates only the brightness of the subject(s) in the small spot-metering area.

The Leica user's manual recommends Multiple mode for "normal usage," presumably on the theory that it produces a reasonable choice for exposure based on evaluating the overall brightness of everything in the scene. However, if you want to make sure that one particular item in the scene is properly exposed, you may want to use the Spot method, and aim the spot metering area at that object or person, then lock in the exposure. The Spot option is useful when you are photographing a performer on stage who is lit by a spotlight. For a shot with a central subject of prime importance, such as a portrait, the Center-weighted option may work best.

To make this selection, scroll to the line for Metering Mode, then press the Right button to activate the sub-menu with the 3 choices, as shown in Figure 4-19. The first icon, a rectangle with a pair of parentheses and a dot inside, represents Multiple mode; the second, a rectangle with a pair of parentheses inside, represents Center-weighted; and the third, a rectangle with just a dot inside, represents Spot.

Chapter 4: The Recording Menu and the Quick Menu

Figure 4-19. Metering Mode Menu Options Screen

With Multiple or Center-weighted, metering is quite simple: Point the camera at the subject(s) you want and let the camera compute the exposure. If you choose Spot as your metering technique, the process can be more involved. Presumably, you will have a fairly small area in mind as the most important area for having the correct exposure; perhaps it is a small object you are photographing for an online auction.

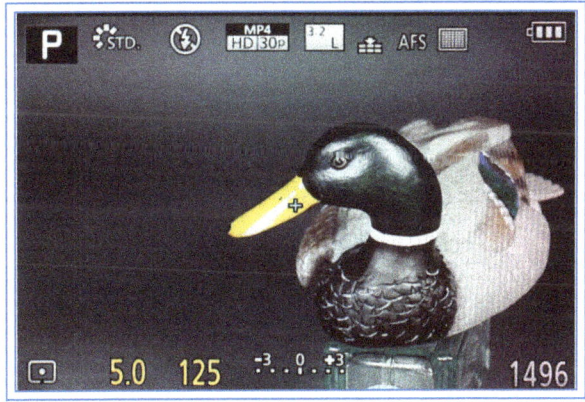

Figure 4-20. Spot Meter Cross on Display

The LCD screen or viewfinder will display a small cross in the center of the display, as shown in Figure 4-20, and you need to be sure that the cross is over the most important object.

If your subject is not in the center of the screen, you may need to lock the exposure while the Spot-metering cross is on the subject, and then move the camera so the subject is in the proper part of the scene. To do this, just press the shutter button halfway while the cross is on the subject, and hold it in that position while you move the camera back to the final position for your composition. (You also can use the AF/AE Lock button for this function, as discussed in Chapter 5.)

As another option, there is a sparsely-documented feature of the camera that lets you move the little cross around the camera's screen so you can place it right over the area of the picture that you want properly exposed. This will work only if, in addition to using the Spot metering mode, you are using one of the autofocus settings that lets you move the autofocus area, such as 1-Area or Face/Eye Detection, as discussed in Chapter 5. In that case, whenever you move the focusing target, the Spot-metering target moves along with it, so the target serves 2 purposes at once. For example, Figure 4-21 shows the display when both Spot metering and 1-Area autofocus are in effect.

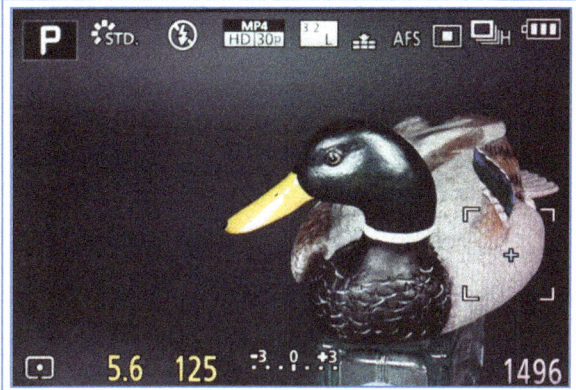

Figure 4-21. Spot Meter Cross with One-Area Focus Frame

The Metering Mode setting is not available in Snapshot mode. When Multiple metering is selected and the Autofocus Mode is set to Face Detection, the camera will attempt to expose a person's face correctly, assuming a face has been detected. The current setting for Metering Mode is indicated by an icon in the lower left of the display, as shown in Figure 4-21.

Next, I will discuss the items on screen 2 of the Recording menu, shown in Figure 4-22.

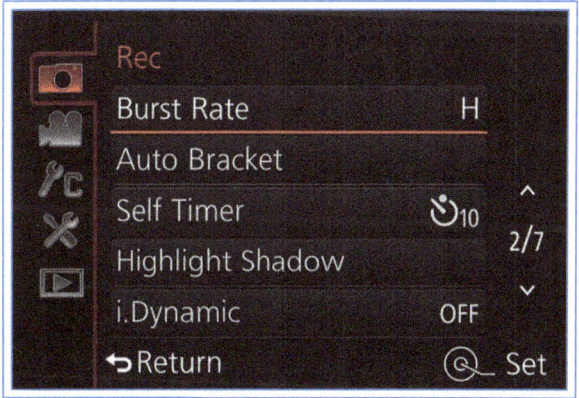

Figure 4-22. Screen 2 of Recording Menu

Burst Rate

This first item on screen 2 of the Recording menu controls the rate for burst shooting. The main control for selecting burst shooting is the Down button, which activates the Drive Mode settings, including the self-timer, bracketing, and panorama shooting, as discussed in Chapter 5. When you press the Down button and activate burst shooting from the Drive Mode menu, you have the option to set the burst rate from that menu. However, if you want, you can set the burst rate ahead of time from this Recording menu item. In that way, you will save a step when you press the Down button to select burst shooting from the Drive Mode options.

The choices for burst rate are SH, H, M, and L, for super-high, high, medium, and low. I will discuss those settings in Chapter 5, in connection with the Drive Mode options.

Auto Bracket

The Auto Bracket feature lets you set the D-Lux to take a series of images with one press of the shutter button, at different exposure settings. In this way, you will have several images to choose from, increasing your chance of having one that is exposed the way you want it.

The standard way to get access to this feature is to press the Down button and use the Drive Mode menu to make the various settings, including the EV differential between exposures and the number of exposures. You can also make those settings using this menu option. In addition, you can make some settings with this menu option that are not available from the Drive Mode menu.

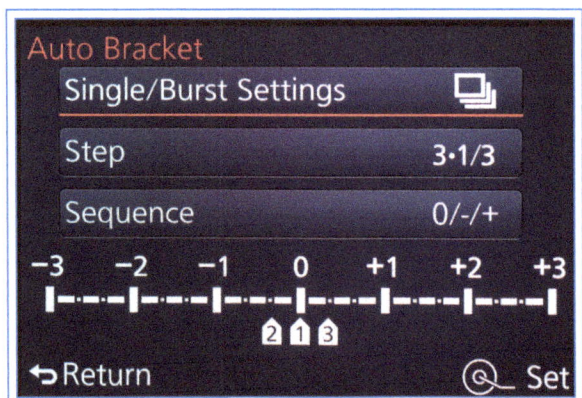

Figure 4-23. Auto Bracket Settings Screen

Those settings, shown in Figure 4-23, control whether the camera takes the multiple exposures in a single burst or requires you to press the shutter button for each one. The settings also let you select the EV interval and choose the order in which the exposures are made.

To set the single or burst option, select the Single/Burst Settings item at the top of the menu. With Burst, the camera will take the specified number of exposures (3, 5, or 7) with one press of the shutter button. With Single, the camera will take only one shot in the sequence with each press of the shutter button, so you can make any needed adjustments to the scene between exposures.

To control the order in which the shots are made, choose the Sequence option. If you select 0/–/+, the default option, the first exposure will be made at the normal exposure, the second will be at a reduced EV setting, and the next will be at an increased EV setting. If you choose –/0/+, the other option, the exposures will be made in increasing order of EV value.

I will discuss the other options, for choosing the EV interval between the exposures and the number of exposures, in Chapter 5 in connection with Drive Mode.

Self-timer

The next menu option is another one that lets you adjust settings that are normally made through the Drive Mode menu after pressing the Down button. With this option, you can set the self-timer to a delay of 2 seconds or 10 seconds for a single shot, or to a delay of 10 seconds with a series of 3 shots. In Chapter 5, I will discuss how to make these settings from the Drive Mode menu.

Highlight Shadow

This menu option gives you a powerful tool for adjusting the highlights and shadows in your images. When you select this menu option, the camera displays a screen like that shown in Figure 4-24, with 7 small icons at the bottom available for selection.

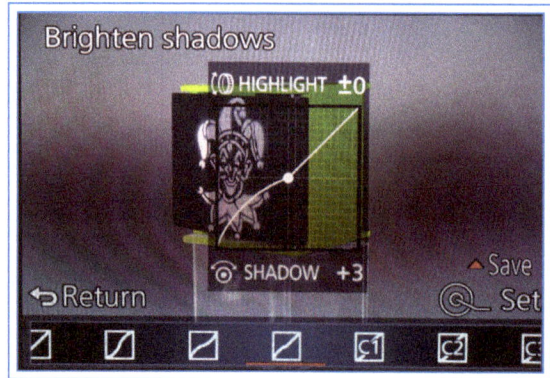

Figure 4-24. Highlight Shadow Menu Options Screen

(For this illustration I have scrolled to the fourth icon, so all 7 icons are visible.) Each small icon represents a different curve shape for the larger graph in the center of the screen, which includes a line that represents the adjustments to highlights and shadows for your images. When the line is a straight diagonal, no adjustments are present. When the upper part of the line bulges to the left, highlights are increased. When it bulges to the right, the brightness of highlights is lowered. Similarly, the lower part of the line bulges to the left or right to increase or decrease the brightness of shadow areas.

The first 4 icons are presets for standard (no adjustments), higher contrast (highlights brighter and shadows darker), lower contrast (highlights darker and shadows brighter), and brighten shadows. The last 3 icons represent custom settings 1, 2, and 3.

If you want to use one of the 4 presets, just select it. If you want to make other adjustments, you can select any one of the 7 icons and make adjustments to the settings. To make the highlights brighter, turn the control ring (around the lens) to the right; to make them darker, turn it to the left. To make the shadows brighter, turn the control dial (on the back of the camera) to the right; to make them darker, turn it to the left. When you have adjusted the curves as you want, press the Up button to save the settings. You will then see the screen shown in Figure 4-25, prompting you to select custom 1, 2, or 3 as the slot in which to save your settings.

Figure 4-25. Screen to Save Custom Highlight Shadow Setting

Highlight any one of those and press the Menu/Set button to save the settings. Then, whenever you want to recall those settings, just go to the Highlight Shadow menu option and select the custom 1, 2, or 3 icon, depending on which slot you used to save your custom settings.

This option can be useful if you are often faced with situations with your subject partly in shadow and partly in bright light. It can be particularly helpful because you can see the effects of the adjustments you make on the live view, as you turn the dials to adjust highlights and shadows. Of course, the D-Lux also has other options to deal with that situation, such as the HDR setting, discussed later in this chapter, and the Intelligent Dynamic setting, discussed next.

INTELLIGENT DYNAMIC

The last option on screen 2 of the Recording menu is shown as i.Dynamic, which I will refer to here as Intelligent Dynamic. This option gives you another way to accomplish what the Highlight Shadow option does—that is, to deal with a situation in which there is considerable contrast between the dark and bright areas of the scene. This option, unlike the previous one, does not let you make precise adjustments to the shadow and highlight curves. Instead, it adjusts contrast and exposure generally; it lets you set the intensity of the camera's adjustments to a level of Low, Standard, or High. You also can leave the option turned off, or you can set it to Auto and let the camera make the adjustments based on its analysis of the scene.

Figure 4-26. Left: i.Dynamic Off, Right: i.Dynamic High

Figure 4-26 is a composite image with 2 views of the same bridge, partly in sunlight and partly in deep shade. As you can see, in the left image, with Intelligent Dynamic turned off, the contrast is quite stark. In the right image, with Intelligent Dynamic set to High, the contrast is evened out and the shadowed areas are brightened noticeably. This is a good setting to use when you are taking photos in an area with both sunlight and shade.

The next items to be discussed are on screen 3 of the Recording menu, shown in Figure 4-27.

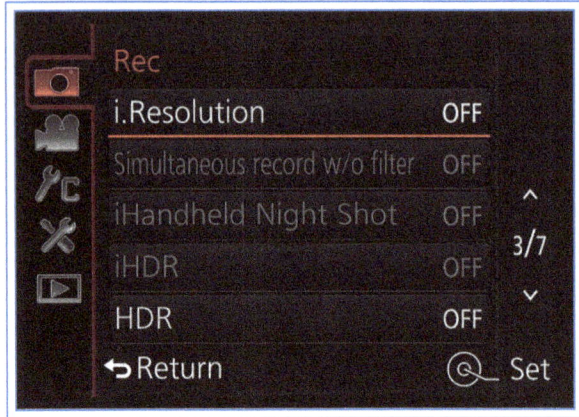

Figure 4-27. Screen 3 of Recording Menu

INTELLIGENT RESOLUTION

The first setting on the next screen of the menu is shown as i.Resolution, which I will call Intelligent Resolution. This option can be set to Off, Extended, Low, Standard, or High, as shown in Figure 4-28.

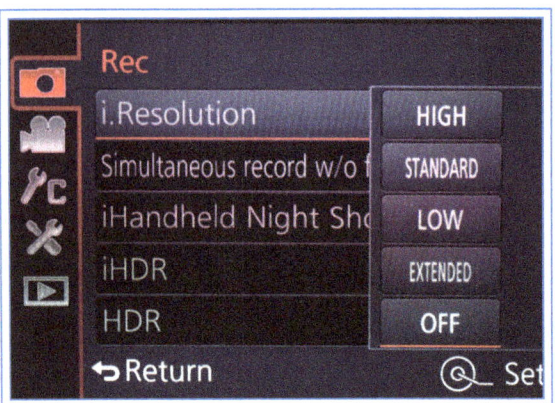

Figure 4-28. i.Resolution Menu Options Screen

This setting increases the apparent resolution in images by providing additional sharpening through in-camera digital manipulation. It does seem to improve image quality somewhat in certain situations. I recommend that you try shooting with it turned on and off to see if it provides actual benefits for your shots. I do not often use it myself, because I prefer to shoot with Raw quality and add sharpening with my editing software.

SIMULTANEOUS RECORD W/O FILTER

This option can be turned either on or off, but it is available for selection only when you have activated the picture effects that can be applied using the Filter button on the top right of the camera and Quality is not set to Raw. If you turn this option on, then, when you take a picture using one of the special effects, such as Expressive, Retro, Miniature, or Soft Focus, the camera also takes an image at the same time that does not use that effect. This feature offers excellent protection against accidentally taking a picture with the Filter feature turned on, resulting in an image that is not usable for ordinary purposes because of the special coloration or other effects. I always keep this option turned on.

As noted above, you have to have one of the Filter button effects turned on and Quality set to Standard or Fine in order to turn this menu option on. If you do that, then, when all Filter button effects are turned off, this option will be turned off. However, if you have not purposely turned this option off, it will turn itself back on automatically as soon as you activate a Filter button effect. So, I recommend that you turn on a Filter button effect, turn on this menu option, and then turn off the Filter button effects. In this way, this option will be available when needed.

iHANDHELD NIGHT SHOT

This setting, highlighted on the menu in Figure 4-29, is available for selection only when the camera is set to Snapshot mode.

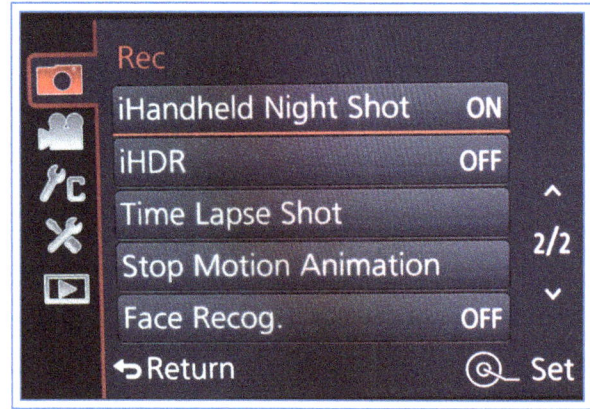

Figure 4-29. iHandheld Night Shot Option Highlighted on Menu

This option is designed to minimize the motion blur that can result from taking a handheld shot at the slow shutter speed that is likely to be needed to get a sufficient exposure at night. If the camera detects darkness and senses that it is handheld, the camera will raise its ISO setting in order to permit the use of a faster than normal shutter speed. Also, because using a higher ISO can increase the visual "noise" or grainy look in an image, the camera will take a burst of several shots and combine them internally into a final image. By blending the contents of several images

together, the camera can reduce the noise in the final, composite result. This setting is a useful one to activate when shooting in low-light conditions without flash or a tripod. When this setting is in use and activated, the camera displays an icon like that shown in the upper left corner of Figure 4-30, with a message saying that multiple images will be taken.

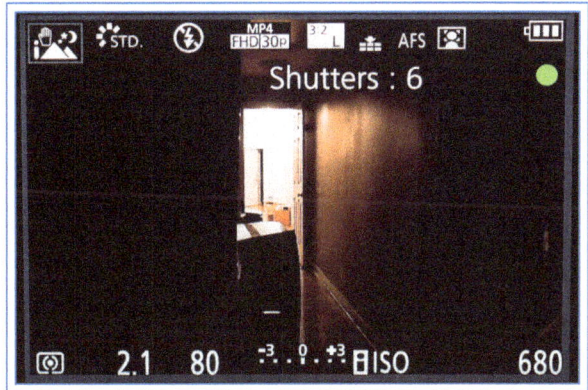

Figure 4-30. iHandheld Night Shot Icon on Display

You cannot decide when to capture an image with this feature yourself—all you can do is turn it on and see if the camera determines that conditions call for it to be used. It does not hurt to leave it turned on if you will be shooting in dark conditions, in case the camera finds a situation that would benefit from its use.

iHDR

The next menu option, iHDR, whose menu setting is highlighted in Figure 4-31, is another one that is available only when Snapshot mode is in use and only when the camera determines that its use is called for. In this case, the option is triggered when the camera detects a scene with strong contrast between the dark and light areas. When the camera makes that determination, the D-Lux will take a burst of shots and combine them internally to create a final result. In this situation, the camera will place on the screen a message saying HDR Shutters 3 to let you know that the shutter will fire 3 times, so you should try to hold the camera steady while it takes the burst of shots.

Figure 4-31. iHDR Option Highlighted on Menu Screen

I will discuss high dynamic range, or HDR photography, further in the next section of this chapter. Essentially, with HDR, the camera combines the most normally exposed parts of multiple images in order to achieve a final result that appears to be properly exposed throughout most or all of its various areas. This setting can be useful when you are taking photographs in highly contrasty conditions.

HDR

The option discussed directly above, iHDR, is activated only when the camera determines that it is needed, in Snapshot mode. If you want to use the D-Lux's built-in HDR capability on your own terms, you can set the camera to one of the PASM modes and choose the HDR option on screen 3 of the Recording menu. Before I discuss how to use this option, I will provide some background on HDR in general.

HDR (high dynamic range) photography was developed to deal with the fact that cameras, whether using film or digital sensors, are not able to record images that retain clear details when the brightness of the scene includes wide variations. If part of the scene is in dark shadows and another part is brightly lighted, the scene has a "dynamic range" that may exceed the ability of the camera to deal with both the dark and the bright areas and still look presentable to the human eye.

A few years ago, the primary way to deal with this issue was to take multiple shots of the scene using different exposure settings, so the photographer would have a range of shots, some exposed to favor dark areas, and some for bright areas. The photographer would merge those images using Photoshop or special HDR software to blend differently exposed portions from all of the

shots. The end result is a composite HDR image that can exhibit clear details in all parts of the image.

More recently, camera makers have incorporated some degree of HDR processing in their cameras to help the cameras even out areas of excessive brightness and darkness to preserve details, without the need to use software to merge multiple shots. With the D-Lux, Leica has provided several settings that, to one degree or another, attempt to process shots of scenes with wide dynamic range to produce a pleasing result. I discussed earlier the Highlight Shadow, Intelligent Dynamic, and iHDR options. The HDR option is the most direct approach to using traditional HDR techniques. It lets you set up the camera to take a burst of shots at different exposure levels, and the camera combines the multiple images internally to create a composite image with overall exposure that attempts to even out the areas of heaviest contrast.

To use this option, first select the Set item from the sub-menu for HDR. You will then see a menu with choices of Dynamic Range and Auto Align. Select Dynamic Range, press the Menu/Set button, and you will see the screen shown in Figure 4-32, letting you choose the difference among the 3 shots that the camera will take.

Figure 4-32. HDR Interval Setting Screen

You can choose Auto, which causes the camera to set the difference, or an EV interval of 1, 2 or 3 stops. Use the higher settings for scenes involving relatively large degrees of contrast, such as a view including a shaded area next to an area in bright sunshine.

When you have set the interval, move to the Auto Align option on the menu and set it either on or off. If it is turned on, the camera will do its best to align the 3 shots automatically when it processes them internally. However, in doing so, it will crop them slightly in order to delete the outer edges of areas that are not in alignment. This setting is useful for handheld shots. If you are using a tripod, it is better to leave Auto Align turned off.

When the settings are all made, go back to the main HDR menu and set HDR to On. Then aim at the subject and press the shutter button. You will hear the shutter fire 3 times and a composite image will be saved to the memory card.

To test this feature, I took several shots of a potted plant in conditions with bright light and shadows. In Figure 4-33, I took a shot with no special settings. In Figure 4-34, I used the HDR setting at an interval of EV1, and in Figure 4-35 I used an interval of EV3. Then, for Figure 4-36, I took a series of images using Manual exposure mode at various exposure levels, and combined them using Photomatix Pro HDR software. As you can see, the camera did a fairly good job of reducing the heavy contrast, with more even exposure using the HDR settings. The composite image from the HDR software did a better job, but that is to be expected. The in-camera HDR option is a very useful one when you are confronted with a scene with sharp contrast between light and dark areas.

Figure 4-33. HDR Series: HDR Off

Figure 4-34. HDR Series: HDR EV1

Chapter 4: The Recording Menu and the Quick Menu

Figure 4-35. HDR Series: HDR EV3

Figure 4-36. HDR Series: Photomatix Composite Image

Next, I will discuss the options on screen 4 of the Recording menu, shown in Figure 4-37.

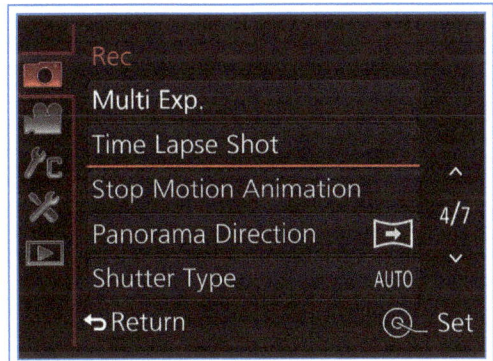

Figure 4-37. Screen 4 of Recording Menu

MULTIPLE EXPOSURE

The Multiple Exposure option lets you create double, triple, or quadruple exposures. The steps to take are a bit unusual, because you actually carry out the picture-taking through the Recording menu system.

On the Recording menu, scroll to Multiple Exposure and press the Right button, which takes you to a screen with the word Start highlighted, shown in Figure 4-38.

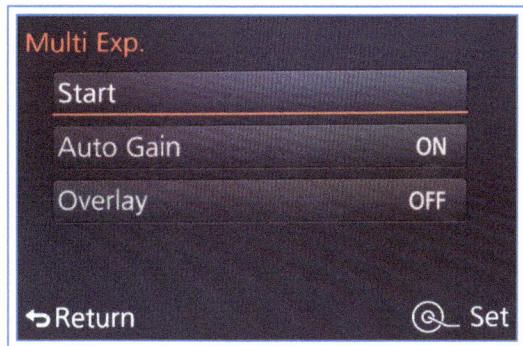

Figure 4-38. Multiple Exposure Options Screen

Unless you want to overlay new images on an existing Raw image, as discussed below, make sure the Overlay option is set to Off. Then press the Menu/Set button to select Start. The screen will have the word End displayed; you can press the Fn1 button to end the process if you have had second thoughts.

If you are going to proceed, then compose and take the first picture. At this point the screen will display the image you just took along with the choices Next, Retake, and Exit, as shown in Figure 4-39.

Figure 4-39. Multiple Exposure Display After One Shot

If you're not satisfied with the first image, scroll to Retake and select that option with the Menu/Set button, then retake the first image. If you're ready to proceed to taking a superimposed image, leave Next highlighted and press the shutter button halfway down, or, if you prefer, press the Menu/Set button to select Next. Either action produces the interesting effect of leaving the first image on the screen and making the screen live at the same time to take a new image.

Compose the second shot as you want it while viewing the first one, and press the shutter button fully to record that image. You can then repeat this process to add a third image, retake the second image, or exit the

whole process. You can then add a fourth image if you want. When you are done, you will have a single image that combines the 2, 3, or 4 superimposed images you recorded.

Before you take the images using the Multiple Exposure procedure, the menu gives you the option of setting Auto Gain on or off. If you leave it on, the camera adjusts the exposure based on the number of pictures taken; if you turn it off, the camera adjusts the exposure for the final superimposed image. In my experience, the On setting produces results with clearer images of the multiple scenes; Off produces images that may have excessive exposure.

If you want to, you also have the option of starting with a Raw image that was taken earlier by this camera. It has to be a Raw image, not a JPEG one. To do this, first set the Overlay option of the Multiple Exposure menu item to On. Then, from the Multiple Exposure screen, highlight Start and press the Menu/Set button. The camera will display your images in playback mode. Scroll through them until you find the Raw image you want to use as the first image in the multiple exposure series. When it is displayed, press the Menu/Set button to select it as the first image of the series. Then line up the next image, with the Raw image displayed on the screen, and press the shutter button to take the next image; it will be overlaid over the existing Raw image. You can then proceed with the rest of the sequence, as before.

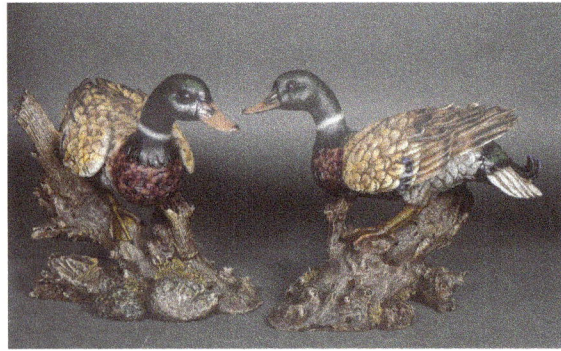

Figure 4-40. Multiple Exposure Final Image

Figure 4-40 shows the final result of using the Multiple Exposure feature to include 2 shots of the same duck figurine in a single composite image.

Time Lapse Shot

The Time Lapse Shot option lets you shoot a time-lapse series of photographs. You probably have seen sequences in the movies or on television in which an event that takes a fair amount of time, such as a sunset, a flower opening, clouds moving across the sky, or a parking lot filling up with cars, is shown in a speeded-up series of images, so it appears to happen in a few seconds.

The D-Lux has a strong capability for taking a time-lapse series. The camera can use its time-lapse feature with any shooting mode, including Snapshot. If you use the more advanced shooting modes, you have access to all of the major settings for your images, including Raw quality, White Balance, ISO, and others.

To use this feature, highlight the Time Lapse Shot option on the Recording menu and press the Right button to move to the setup screen, shown in Figure 4-41.

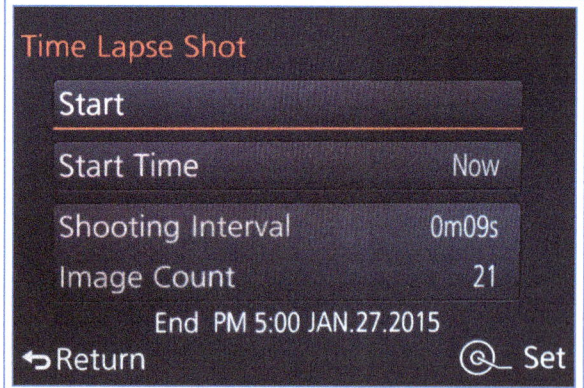

Figure 4-41. Time Lapse Shot Settings Screen

On that screen, use the direction buttons to navigate through the various options. Select a start time, the interval between shots, and the total number of shots. The interval can be set to any value from 1 second to 99 minutes 59 seconds. One point to bear in mind when setting the interval is that, if the lighting is very dim, the camera may need to set a long shutter speed. For example, if the camera is set to use a shutter speed of 1 minute, which requires a long time for in-camera processing after the exposure is made, this system will not succeed if the interval between shots is set to less than 2 minutes. The total number of shots can be any number up to 9,999.

When you have made all of the settings as you want them, press the Menu/Set button, then select Start from the main options screen. The camera will display a message prompting you to press the shutter button when you're ready to start the sequence.

When you press the shutter button, the camera will take the images at the specified intervals and will

repeat the process until the total number of images has been recorded. Of course, if the battery runs down or the memory card fills up, the process will end prematurely. At any time, you can press the Fn2 button and the camera will display a screen asking if you want to continue, pause, or end the process.

When the sequence is complete, either after the full series has been taken or after an interrupted series, the camera will display a message asking if you want it to create a movie using the recorded images. If you say yes, it will take some time to process the movie, which you can then play like any movie.

If you say no to creating the movie, assuming you have a detailed display screen selected in playback mode, the first image in the series will be displayed with indications like those in Figure 4-42, showing that you can press the Up button to play back the sequence quickly, like a short movie. If you press the Down button, you will see a playback triangle icon, indicating that you can display the images sequentially one by one using the Left and Right buttons.

Figure 4-42. Time Lapse Shot Playback Screen

If you don't create a movie from the shots at this point, you can do so later, using the Time Lapse Video option on screen 2 of the Playback menu, as discussed in Chapter 6.

STOP MOTION ANIMATION

This next feature is similar to the Time Lapse Shot option, because it involves taking a series of still images that the camera combines into a movie. The difference is that this option is intended for use in animating objects, such as clay figures or puppets. You also could use it to make an animated movie based on drawings, as is done for cartoons and animated feature films. You need to move the figure or change the drawing very slightly for each new shot. You will need a large number of images to create a movie of any length. For example, if the final movie is to be shown at 30 frames per second, you will need to take 30 images for every second of the movie, changing the position or other aspect of the subject slightly for each successive image.

When you select this option, you will see a screen with options for Start, Auto Shooting, and Shooting Interval. The interval option will not be available unless you first select Auto Shooting. If you select Auto Shooting, the camera will capture images on its own at the interval you specify, from 1 second to 60 seconds. Otherwise, you will have to trigger the camera yourself when you are ready for each shot. Because it is critical to keep the camera absolutely still throughout the image-taking process, it is advisable to use the Auto Shooting option so you will not have to touch the camera to take each shot. If you do not use Auto Shooting, you can control the camera from a smartphone or tablet by remote control, as discussed in Chapter 9.

You also may want to use the optional AC adapter, discussed in Appendix A, to make sure the camera does not lose power during the shooting. (However, if the camera does turn off, you can resume the series of shots when it is turned back on. It will prompt you to do so if the series has been interrupted.)

Figure 4-43. Stop Motion Screen Showing Number of Shots

While the shooting series is in progress, the camera will display an icon showing a series of frames at the right side of the display with the cumulative number of shots taken so far, as shown in Figure 4-43. It also will display an overlaid image of the previous 2 shots, to

help you line up the next shot properly with the figure or drawing in the proper position.

When you have finished your series of shots, press the Menu/Set button and go back to the Stop Motion Animation menu item. Press Menu/Set when that item is highlighted, and the camera will ask whether you want to stop the shooting series. If you say yes, it will ask if you want to create the video now. If so, it will prompt you for the settings to use, including recording quality, frame rate, and whether to run the sequence forward (normal) or in reverse. For the best quality, you should select 30 frames per second for the frame rate (in the United States), but 15 frames per second will still provide a reasonably smooth flow of action. Select OK when the settings are made as you want, and the camera will create the video. You can play it back in the camera by pressing the Up button.

If you don't create a movie from the shots at this point, you can do so later using the Stop Motion Video option on screen 2 of the Playback menu, as discussed in Chapter 6. As with the Time Lapse Shot option, you can view the shots in playback mode as a quick sequence using the Up button or individually after pressing the Down button.

Panorama Direction

The next menu option lets you select the direction for panoramic shots—left, right, up, or down. This option is a convenience, so you can have the direction pre-selected. The actual panorama shooting is controlled through the Drive Mode option, which you get access to by pressing the Down button. You can select the direction from the Drive Mode screen also, if you prefer. I will discuss the procedure for panorama shooting in Chapter 5, along with other Drive Mode options.

Shutter Type

The D-Lux is equipped with 2 different types of shutter—electronic and mechanical. With this menu option, you can set up the camera to choose the shutter type automatically, or you can select one or the other shutter type for use. The 3 options for this setting are Auto, MSHTR, and ESHTR. With Auto, the camera will choose the shutter type based on the current settings and conditions. With MSHTR or ESHTR, it will use only the mechanical or electronic shutter, depending on your selection.

For most purposes, the mechanical shutter is the better option. With that choice, the camera operates a physical iris with leaves that open and close to allow light to pass through to the sensor. With the electronic shutter, the circuitry in the camera starts and stops the exposure, with no mechanical parts involved. So, in some cases, the electronic shutter can produce a faster shutter speed than the mechanical one. Also, because of the lack of moving parts, the camera can remain silent when the electronic shutter is activated. However, using the electronic shutter can result in a "rolling" effect that distorts images or videos, especially if the camera or subject is moving horizontally.

If you select Auto or ESHTR, the shutter speed can be set as fast as 1/16000 second; with MSHTR, the fastest speed available is 1/4000 second. However, even if you select MSHTR, if you then select burst shooting and set the burst rate to SH for super high, the camera will use the electronic shutter to achieve the high speed for that shooting.

In some other cases, too, there are limitations on the ability of the camera to use certain shutter speeds with the mechanical shutter. For example, when the camera is set to an aperture value wider than f/4.0 (such as f/2.0), the fastest shutter speed available with the mechanical shutter is 1/2000 second. In Manual exposure mode, if you have Shutter Type set to Auto and set a shutter speed of 1/4000 second while aperture is set to a value wider than f/4.0, the camera will automatically switch to the electronic shutter so it can set the shutter speed you selected. The camera will place an icon with an E for electronic shutter in the top center of the display, as shown in Figure 4-44. If you have Shutter Type set to MSHTR, the shutter speed will be reduced to 1/2000 second.

Figure 4-44. Electronic Shutter E Icon on Recording Screen

I usually leave this setting at Auto so the camera will use the electronic shutter when needed, but will use the mechanical shutter in most cases. One reason to turn on the ESHTR option would be if you want the camera to be completely silent for a shooting session. Another way to do that is with the Silent Mode option on screen 1 of the Custom menu. In that case, the camera will automatically use the electronic shutter, even if the MSHTR option was selected on the Recording menu.

Screen 5 of the Recording menu is seen in Figure 4-45.

- Figure 4-45. Screen 5 of Recording Menu

FLASH

The first item on screen 5 of the Recording menu, simply called Flash, is the gateway to several options for using either the supplied flash unit or an optional external unit. This item will be dimmed and unavailable for selection unless you have a flash unit attached to the camera's hot shoe and turned on. The Flash item does not even appear on the menu in Snapshot mode. In that shooting mode, the camera will make its flash settings based on its programming, with no input from you.

For the Flash menu item to be available, the flash unit that is attached does not need to be completely compatible with the D-Lux camera, but it must communicate with it to some extent through the hot shoe. For example, when I attach a Canon 430EX II flash to the camera, the Flash menu item becomes available and the flash fires when the shutter button is pressed, but that flash unit does not communicate with the camera for purposes of TTL (through-the-lens, or automatic) flash exposure. For this discussion, I will assume you have attached the small flash unit that is supplied with the D-Lux. When that unit is attached and turned on, the Flash item is available. When you

highlight it and press the Right button or the Menu/Set button, the camera will display the screen shown in Figure 4-46. That screen has 2 sub-screens, as indicated by the 1/2 at the right side of the screen. I will discuss the items on those 2 screens next.

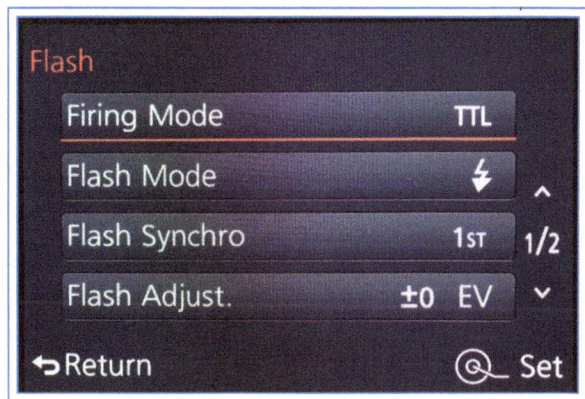

Figure 4-46. Main Options Screen for Flash Menu Item

Firing Mode

The first sub-option for the Flash menu is Firing Mode. This option is available for selection only if you have attached and turned on a flash that is completely compatible with the D-Lux. In practice, the only unit I have found that lets me use this menu item is the unit supplied with the camera. I have tried attaching several other units, some of which will fire properly with TTL flash with this camera, but I have not found any units for which the camera will activate the Firing Mode menu option. For example, I tried the Panasonic DMW-FL220, an older unit that is compatible with several Panasonic and Leica cameras. That unit works well for automatic exposure with the D-Lux, but the camera will not display the Firing Mode menu option when that unit is attached to the hot shoe. Even with the Leica CF22 flash, which works well with the D-Lux camera, this menu option remains dimmed and unavailable.

When you are using the flash supplied with the camera, the Firing Mode menu option lets you choose whether to have the camera set the flash exposure automatically using its metering system (TTL) or to set the output of the flash manually (Manual). If you select TTL, the camera will do its best to achieve a normal exposure by regulating the flash output based on the camera's metering system.

If you choose Manual, the flash will fire at the output level it has been set to, regardless of the lighting conditions. It will be up to you to adjust the output of the flash unit to achieve a good exposure. The current

output setting of the flash unit will be displayed on the camera's recording display screen, to the right of the flash mode icon. For full output, the indication will be 1/1. Using the Manual Flash Adjustment menu option, discussed below, you can change this setting to a lower level, down as low as 1/64 of full power, as shown in Figure 4-47.

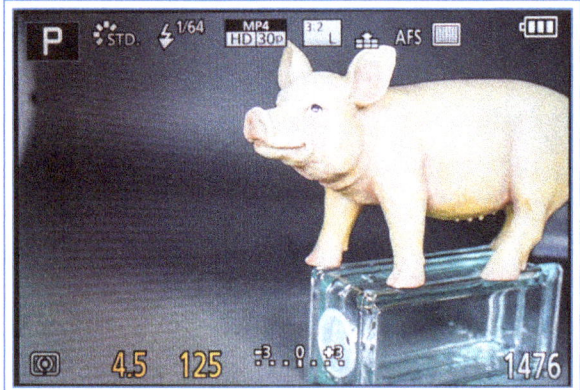

Figure 4-47. Icon Showing Flash Level Set to 1/64

For everyday use, you will probably want to select TTL, so the camera will communicate with the flash to calculate the best exposure. But if you are faced with an unusual situation when you want to adjust the output of the flash for a manual exposure, choose Manual and then use the Manual Flash Adjustment option. If you are using a flash other than the supplied unit, make such adjustments on the flash itself, if possible.

Flash Mode

This next sub-option lets you set the flash mode for your shot. In this context, the mode means the procedure by which the flash fires. There are 5 options for this setting, as shown in Figure 4-48: Forced On, Forced On with Red Eye, Slow Sync, Slow Sync with Red Eye, and Forced Off.

Figure 4-48. Flash Mode Options Screen

If you choose Forced On, sometimes referred to as fill-flash, the flash will fire every time you press the shutter button, if the flash is operating properly and no other settings interfere. This is the mode to choose when you are certain you want the flash to fire, such as when you are taking snapshots in a dimly lighted area. It also is the mode to choose when you want to use flash to soften the shadows or brighten the scene slightly when you are taking a shot, especially a portrait, outdoors in sunlight. A bit of fill-flash can offset the harsh shadows and highlights from direct sunlight. For example, Figure 4-49 consists of 2 images I took outdoors.

Figure 4-49. Left Image: No Flash; Right Image: Fill-flash

For the left image, I left the flash turned off; for the right one, I used the Forced On setting. The right image has more even lighting, because the on-camera flash overcame the contrast caused by the direct sunlight and deep shadows on the subject.

The next option, Forced On with Red Eye, is for use when you are aiming the camera with flash directly at a person's face. In that situation, the flash can bounce off the person's retinas and light up blood vessels, resulting in the unpleasant "red eye" effect that is common in flash snapshots. With this setting, the camera will fire a pre-flash before the main flash, to narrow the subject's pupils before the image is captured and thereby reduce the risk of the red eye effect. This setting is available only if you have chosen TTL for the Firing Mode setting.

The next setting, Slow Sync, is for use in dark conditions when you want to give the ambient light time to illuminate the background. With a normal flash shot, the exposure may last only about 1/60 second, enough time for the flash to illuminate the subject in the foreground, but not enough time for natural lighting to reveal the background. So, you may end up with an image in which the subject is brightly lit but the background is black. With Slow Sync, the camera will

use a relatively slow shutter speed so that the ambient lighting will have time to register on the image.

For example, Figure 4-50 is a composite with 2 images taken at the same time and in the same conditions except for the flash mode.

Figure 4-50. Left image: Forced Flash; Right Image: Slow Sync

The left image was taken with the shutter speed set at 1/60 second, in normal flash mode (Forced On). The background is quite dark, because the exposure was too short to light up the area beyond the mannequin. The right image was taken in Slow Sync flash mode, which caused the camera to use a shutter speed of one second, allowing time for the ambient lighting to illuminate the room so the background showed up quite clearly.

The Slow Sync option is available on the Recording menu only when the camera is set to Program or Aperture Priority mode, because those are the only advanced shooting modes in which the camera selects the shutter speed. In Snapshot mode, the camera may use the Slow Sync option, but you cannot select the setting yourself in that mode.

Slow Sync with Red Eye is the same as Slow Sync, except that the camera fires a pre-flash to try to reduce the red eye effect. It is available only when TTL is selected for Firing Mode, or you are using a flash unit, like the Leica CF22, that communicates fully with the D-Lux and is set to TTL mode on the flash itself.

The final option for Flash Mode is Forced Off. This setting is useful when you are in a museum or other location where the use of flash is restricted. Of course, you also have the option of removing the flash unit from the camera or turning off the power on the flash unit, but it is convenient to have this other way to make sure the flash will not fire when you don't want it to.

Flash Synchro

The next sub-option for the Flash menu item, Flash Synchro, is one you may not have a lot of use for unless you encounter the particular situation it is designed for.

The Flash Synchro menu option has two settings—1st and 2nd. Those terms are references to 1st-curtain sync and 2nd-curtain (also known as rear-curtain) sync. The normal setting is 1st, which causes the flash to fire early in the process when the shutter opens to expose the image. If you set it to 2nd, the flash fires later, just before the shutter closes.

The 2nd-curtain sync setting can help you avoid a strange-looking result in some situations. This issue arises when you are taking a relatively long exposure, such as 1/4 second, of a subject with taillights, such as a car or motorcycle at night, that is moving across your field of view. With 1st-curtain sync, the flash will fire early in the process, freezing the vehicle in a clear image. However, as the shutter remains open while the vehicle continues on, the camera will capture the moving taillights in a stream that seems to extend in front of the vehicle. If, instead, you use 2nd-curtain sync, the first part of the exposure will capture the lights in a trail that appears behind the vehicle, while the vehicle itself is not frozen by the flash until later in the exposure. Therefore, with 2nd-curtain sync in this particular situation, the final image is likely to look more natural than with 1st-curtain sync.

Figure 4-51 illustrates this concept with a composite image showing a remote-controlled truck with a red taillight. The truck was moving from right to left. I shot both pictures with the built-in flash, using an exposure of 1/4 second in Shutter Priority mode. In the top image, the flash fired quickly, and the light beam continued on during the long exposure to make streaks of bright light appear on top of the truck.

In the bottom image, using the 2d setting, the flash did not fire until the truck had traveled to the left, overtaking the place where the light had made its streaks visible. If you are trying to convey a sense of natural motion, the 2d setting for Flash Synchro, as seen here, is likely to give you better results than the default setting.

Figure 4-51. Top: First-Curtain Flash; Bottom: Rear-Curtain Flash

To sum up the situation with the 1st and 2nd Flash Synchro settings, a good general rule is to always use the 1st setting unless you are sure you have a real need for the 2nd setting. Using the 2nd setting makes it harder to compose and set up the shot, because you have to anticipate where the main subject will be when the flash finally fires late in the exposure process.

The Flash Synchro setting is not available for selection in Snapshot mode.

Flash Adjustment

The Flash Adjustment sub-option is available when Firing Mode is set to TTL or a compatible flash unit is attached, in TTL mode. This item lets you adjust the intensity of the flash when the camera is determining the flash exposure automatically. If the exposure seems too bright or too dark, you can use this setting to adjust it downward or upward in small increments. The adjustment screen for this item is shown in Figure 4-52.

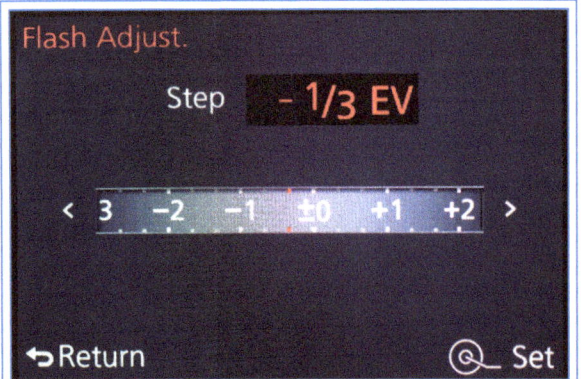

Figure 4-52. Flash Adjustment Setting Screen

Use the control dial or the Left and Right buttons to dial in the amount of positive or negative EV adjustment you want. Of course, you also have the option of using regular exposure compensation, causing the camera to adjust the exposure using settings other than flash. (See the discussion of Auto Exposure Compensation below for how that option works.) This choice is up to you; it depends on what effect you are looking for. I rarely find a reason to increase the flash output, but I find that it can be useful to decrease the flash output to reduce the harshness of the lighting for a portrait in some cases.

If you have set Firing Mode to Manual, you can adjust the intensity of the flash using the Manual Flash Adjustment option, discussed below. As I noted earlier, that option appears to be available only with the flash unit supplied with the camera.

Auto Exposure Compensation

The first item on screen 2 of the Flash sub-options is Auto Exposure Compensation, which you can turn either on or off. This option controls the way the flash setting is affected when the flash is in TTL mode and you turn the exposure compensation dial. If you want the exposure compensation adjustment you make with the dial to be effective when using flash, turn this menu option on. Then, when the camera takes the shot, it will try to adjust the flash to give effect to the exposure compensation amount you selected.

If you leave this option turned off, then, when you adjust the exposure compensation dial and use TTL flash, the camera will adjust the exposure with aperture and shutter speed, but it also will adjust the flash to counteract that change. The result may be an exposure that does not reflect the adjustment made with the dial. In other words, the flash output will be automatically adjusted in the reverse direction from the exposure compensation. Depending on the ambient lighting, the result may be to cancel the effect of the flash.

I recommend leaving this option turned on so your exposure compensation choices will be effective, unless you have a particular reason to turn it off.

Manual Flash Adjustment

As I noted earlier, this option is available only when you have set the Firing Mode option to Manual. In that case, you can use this menu item to increase or decrease the intensity of the flash, assuming the flash is compatible with the camera's circuitry. As I also noted

earlier, I have found that the only flash unit that allows you to set the Firing Mode option is the small unit that is supplied with the D-Lux.

This adjustment works in a similar way to the Flash Adjustment option, discussed earlier. The difference is that, in this case, you are setting the intensity of the flash manually, rather than adjusting the intensity as set by the camera based on its autoexposure metering. This option could be useful if you are faced with an unusual situation in which you are trying to achieve a particular result, such as by using a minimal amount of flash in a dark environment, and you do not want to rely on the camera's metering system.

Red-eye Removal

This setting on the Recording menu is not to be confused with Red-eye Reduction, which is an aspect of how the flash fires. As I noted earlier, "red eye" is the unpleasant phenomenon that crops up when a flash picture is taken of a person, and the light illuminates his or her retinas, causing an eerie red glow to appear in the eyes. One way the D-Lux (like many cameras) deals with this problem is with the Red-eye Reduction setting for the flash, which causes the flash to fire twice: once to make the person's eyes contract, reducing the chance for the light to bounce off the retinas, and then a second time to take the picture.

The D-Lux has a second line of defense against red-eye, called Red-eye Removal. When you select this option, which can be turned either on or off, then, whenever the flash is fired and Red-eye Reduction is activated, the camera also uses a digital red-eye correction method, to actually remove from the image the red areas that appear to be near a person's eyes. This option operates only when the Face Detection setting is turned on.

I do not usually use this option, because I process my images using Photoshop or other software, and it's easy to fix red eye at that stage. But I did test it, and it did a good job of removing red eye from a mannequin's eyes on which I had pasted red dots to simulate red eye. Figure 4-53 shows how the eyes looked with and without the Red-eye Removal option activated. So, for snapshots at a party, for example, this option can be quite useful.

Figure 4-53. Red Eye Removal Composite Image

ISO (Sensitivity)

The next 3 settings on the Recording menu—ISO Limit Set, ISO Increments, and Extended ISO—concern sensitivity, or ISO, one of the more important settings on the D-Lux. ISO is a measure of how sensitive the camera's digital sensor is to light. With the D-Lux, the ISO setting itself is not made through the Recording menu. Instead, you use the Up button on the camera's back, labeled ISO, to make the actual setting of the ISO value. You can use the 3 settings on the Recording menu to control how the camera sets the ISO. Before I explain how those settings work, I will include brief background information about ISO.

On the D-Lux, the available ISO settings range from 100 up to 25000, though the range varies in some situations. With the lower settings, the camera produces the best image quality, but exposures require more light. With higher settings, the camera can produce good exposures in dim light, but there is likely to be an increasing amount of visual "noise" in the image as the ISO value increases.

Generally speaking, you should shoot your images with the camera set to the lowest ISO possible that will allow the image to be exposed properly. (One exception to this rule is if you want, for creative purposes, the grainy look that comes from shooting at a high ISO value.) For example, if you are shooting indoors in low light, you may need to set the ISO to a high value (say, ISO 800) so you can expose the image with a reasonably fast shutter speed. If the camera were set to a lower ISO, it would need to use a slower shutter speed to take in enough light for a proper exposure, and the resulting image would likely be blurry and possibly unusable.

With that background, here are the details on the ISO sensitivity setting. As noted above, the ISO setting on the D-Lux is not made through the Recording menu. However, because you need to know about this setting in order to understand the 3 ISO-related settings that are made through this menu, I will discuss ISO in this chapter, rather than in Chapter 5, which discusses settings made with the camera's physical controls.

The ISO setting is available only when the camera is set to one of the advanced (PASM) shooting modes. To make the setting, press the Up button, marked ISO, and a horizontal menu will appear at the bottom of the display, as shown in Figure 4-54.

Figure 4-54. ISO Menu on Display

You can scroll through the values on this menu either by pressing the Left and Right buttons or by turning the control dial. The possible numerical values are 200, 400, 800, 1600, 3200, 6400, 12500, and 25000, unless you change some menu settings, discussed below, to add values below 200 and intermediate values.

When you set a numerical value for the ISO, you cannot use the ISO Limit Set option (discussed below). When you set ISO to Auto ISO, the camera automatically adjusts ISO, up to the maximum value set with ISO Limit Set, if any has been set, based on the brightness of the scene. When you use the Intelligent ISO setting, the camera adjusts the ISO based on the movement of the subject as well as the brightness, so the camera can set a higher shutter speed to stop the motion. Intelligent ISO is available with the Snapshot, Program, and Aperture Priority modes, but not with the Shutter Priority or Manual exposure modes.

When would you want to use a numerical value for the ISO setting, rather than setting it to Auto ISO or Intelligent ISO? One example is if you want the highest quality for your image, and you aren't worried about camera movement, either because you are using a tripod so a slow shutter speed won't result in blur, or the lighting is bright enough to use a fast shutter speed. Then you could set the ISO to its lowest possible setting of 200 (or 100 if Extended ISO is turned on) to achieve high quality. On the other hand, if you definitely want a grainy, noisy look, you can set the ISO to 3200 or even higher to introduce noise into the image. You also might want a high ISO setting in order to be sure you can use a fast shutter speed to stop action or in low light. In many cases, though, you can just leave the setting at Auto or Intelligent and let the camera adjust the ISO as needed.

It is important to be aware of how much a high ISO value can affect the quality of your images. Figure 4-55 is a composite in which the left image was taken at ISO 200 and the right one was taken at ISO 25000.

Figure 4-55. Left Image: ISO 200, Right Image: ISO 25000

As you can see, the right image shows considerable deterioration, both in the figurine itself and in the plain background. You can use this high setting when absolutely necessary to get a shot, but it's advisable to avoid the highest ISO values when possible.

ISO LIMIT SET

ISO Limit Set, whose screen is shown in Figure 4-56, is the first ISO-related selection on the Recording menu.

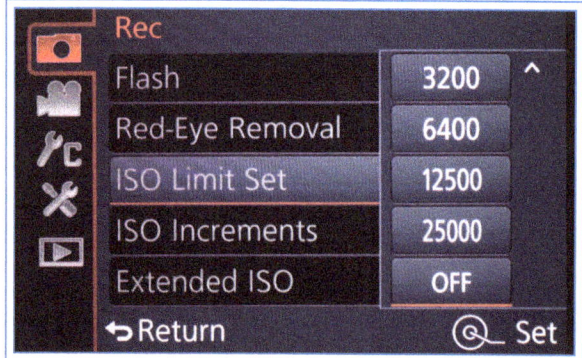

Figure 4-56. ISO Limit Set Setting Screen

This option lets you set an upper limit for the value the camera will choose for ISO, when you have set the ISO level to either Auto ISO or Intelligent ISO, as discussed above. The choices for this setting are 400, 800, 1600, 3200, 6400, 12500, 25000, or Off. If you choose Off, then the ISO limit is automatically set to 3200. This option does not have any effect for motion picture recording. If you want to make sure the camera will use a relatively low ISO to preserve image quality, you can set this value down to 400 or 800. If you are shooting in dark conditions and your priority is to make sure you can capture the image even if image quality suffers, you might want to set a high limit, such as 12500.

ISO Increments

Using this option, as seen in Figure 4-57, you can expand the range of values available for the setting of ISO.

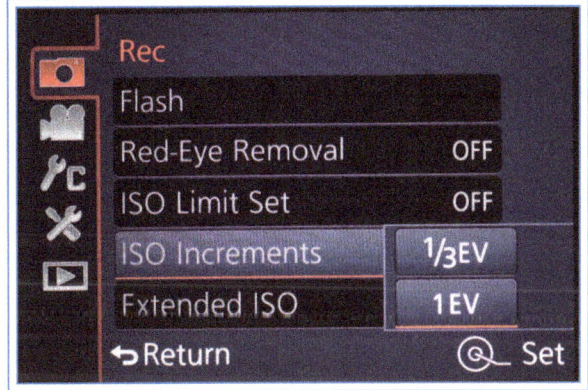

Figure 4-57. ISO Increments Options Screen

Normally, when you set ISO to a numerical value, you can use only 200, 400, 800, 1600, 3200, 6400, 12500, or 25000. However, if you select the increment of 1/3 EV instead of the normal 1 EV for this menu option, then several interpolated values for ISO are added, such as 250, 320, 500, 640, 1000, and others. You can then set these values from the menu that appears when you press the Up (ISO) button.

Note that this menu option applies only to the settings you make yourself. Even if the ISO Increments option is set to 1 EV, the camera can still set intermediate ISO values when Auto ISO or Intelligent ISO is in effect and the camera is choosing the ISO value. I have never found a need to use the 1/3 EV option, so I leave this setting at its default value of 1 EV.

Extended ISO

The third ISO-related option on the Recording menu, Extended ISO, can be turned either on or off. When it is turned on through this menu item, you get access to the lowest ISO level of 100, which is not available otherwise. If you have set the ISO Increments option, discussed above, to 1/3 EV, then you will also get access to the ISO settings of 125 and 160. The ISO value of 100 is considered "extended" because it is not a value that is native to the sensor. Therefore, using it does not increase the dynamic range or improve the image quality; it just acts to reduce the light sensitivity of the sensor. Using this value (and the other values below 200) can be useful when you need to reduce the light sensitivity so you can use a slower shutter speed or wider aperture than you could otherwise.

The next menu items to be discussed are on screen 6 of the Recording menu, shown in Figure 4-58.

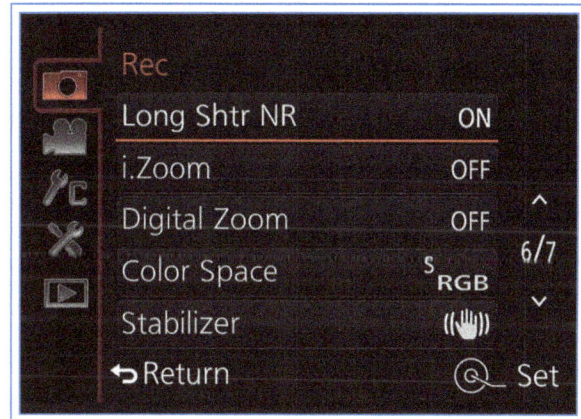

Figure 4-58. Screen 6 of Recording Menu

Long Shutter Noise Reduction

When you take a picture using a shutter speed of several seconds, the image sensor may generate an excessive amount of visual noise because of the way its photosites react to long exposures. If you turn on the Long Shutter Noise Reduction menu option, the camera will use noise-reduction processing that lasts as long as the exposure itself to reduce the noise. For example, if your exposure lasts for 12 seconds, the camera will continue processing the image for another 12 seconds after the exposure ends. This action will delay your ability to take another shot, and the processing can reduce the details in your image. If you don't want to experience this delay or if you want to deal with the

possibility of noise some other way (such as using software to reduce it), turn this option off.

Intelligent Zoom

The Intelligent Zoom, or i.Zoom option is related to the i.Resolution feature, discussed earlier, although you do not have to turn on i.Resolution in order to take advantage of i.Zoom. When i.Zoom is turned on, the camera automatically takes advantage of the i.Resolution processing in the zoom range to improve the appearance of the image, so you can zoom to a higher level of magnification without image deterioration, using either normal optical zoom or Extended Optical Zoom. For example, without the i.Zoom setting, the limit for the optical zoom is 3.1x; with i.Zoom turned on, the maximum is 6.2x. The question of image quality in this situation is a matter of judgment; as with i.Resolution, I recommend that you try this setting to see if you are satisfied with the quality of the images. If so, you can then use an effective zoom range up to 150mm, rather than the 75mm of the optical zoom alone.

The i.Zoom feature is not available in conjunction with certain types of shooting that involve special processing, including panorama shots, shots with the Raw format, shots involving bursts, including HDR, or shots using the Filter button picture effects of Impressive Art, Toy, or Toy Pop.

Digital Zoom

With Digital Zoom, unlike Extended Optical Zoom, Leica notes that the image quality "deteriorates" as magnification increases. As with many digital cameras, Digital Zoom is available on the D-Lux as a way of enlarging the pixels that are displayed so the image appears larger; there is no additional resolution available, so the image can quickly begin to appear blocky and of low quality. Experts often recommend staying away from this sort of zoom feature. As with Extended Optical Zoom, it might occasionally help you in viewing a distant subject. Digital Zoom has a maximum power of 12.5 times the normal lens's magnification. When you combine all of the zoom options, including Digital Zoom and using a smaller picture size, there is a maximum total zoom power of about 25 times normal, or 600mm. Digital Zoom is not available in Snapshot mode or with Raw quality, burst shooting, or with the Filter button effects of Impressive Art, Toy, Toy Pop, or Miniature.

Color Space

With this option, you can choose to record your images using the sRGB "color space," the more common choice and the default, or the Adobe RGB color space. The sRGB color space has fewer colors than Adobe RGB; therefore, it is more suitable for producing images for the web and other forms of digital display than for printing. If your images are likely to be printed commercially in a book or magazine or it is critical that you be able to match a great many different color variations, you might want to consider using the Adobe RGB color space. I always leave the color space set to sRGB, and I recommend that you do so as well unless you have a specific need to use Adobe RGB, such as a requirement from a printing company that you are using to print your images.

If you are shooting your images with the Raw format, you don't need to worry so much about color space, because you can set it later using your Raw-processing software.

Stabilizer

The D-Lux is equipped with an optical image stabilization system that counteracts the effect of camera shake on the image. This system has 3 possible settings, as shown in Figure 4-59, from top to bottom: Normal, Panning, and Off.

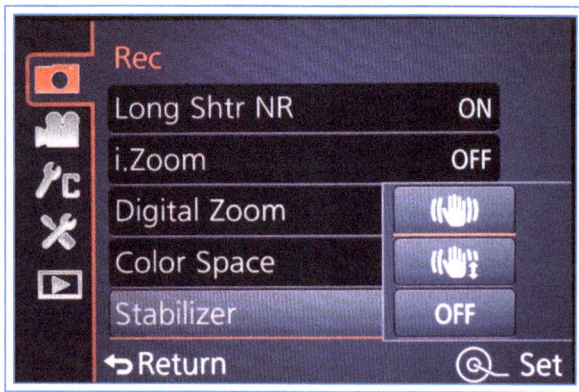

Figure 4-59. Stabilizer Options Screen

With the Normal setting, the camera corrects for both horizontal and vertical motion. With the Panning setting, the camera assumes that you are moving the camera from side to side in order to pan over the scene, so it does not attempt to correct for horizontal

motion, only vertical. I generally leave this setting at Normal when I am handholding the camera. If I have the camera on a tripod, the setting is unnecessary and possibly could cause some distortion as the camera tries to correct for camera movement that does not exist.

The Normal stabilization setting is not available when you are shooting panoramas. The Stabilizer menu option is not available for selection in Snapshot mode.

The final Recording menu items to be discussed are found on screen 7 of the menu, shown in Figure 4-60.

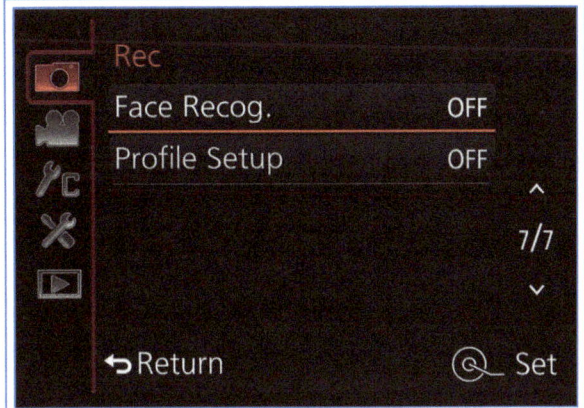

Figure 4-60. Screen 7 of Recording Menu

FACE RECOGNITION

With the Face Recognition option, you can register the faces of up to 6 people so the camera will recognize them when Face Recognition is turned on. Here are the essential steps to follow. First, go to the Face Recognition menu item and select the third option, Memory, as shown in Figure 4-61.

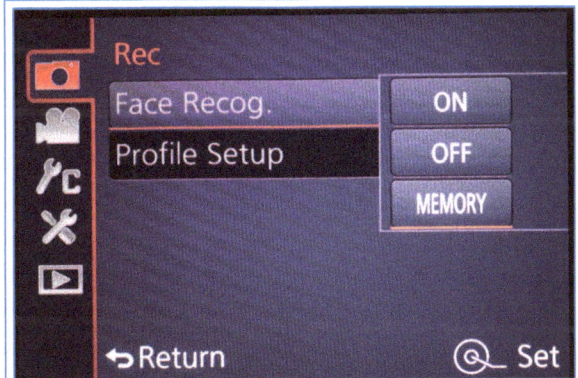

Figure 4-61. Face Recognition Main Options Screen

Press Menu/Set to go to the screen in Figure 4-62.

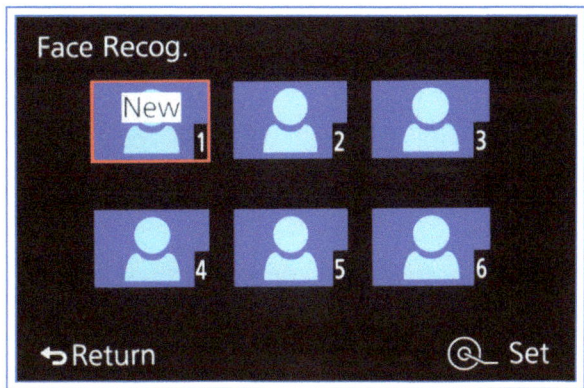

Figure 4-62. Blue Boxes for Saving Faces for Recognition

Move the red highlight to the first available blue block that says New, and press Menu/Set; you will see the screen shown in Figure 4-63, which prompts you to position the face to be registered in the yellow frame.

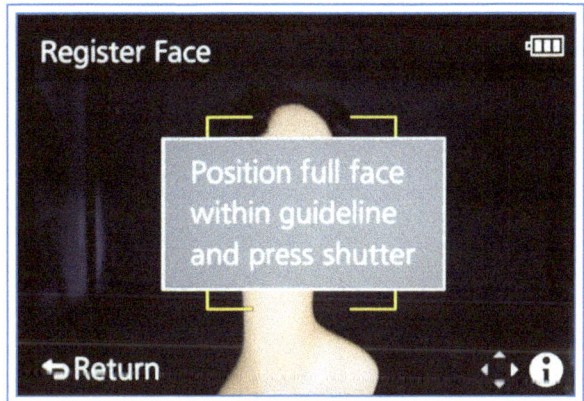

Figure 4-63. Prompt Message to Position Face for Recognition

When you have the face properly positioned, press the shutter button to take a picture. If the registration fails, you will see an error message. If it succeeds, you will see a screen like that in Figure 4-64. You can then proceed to enter data for the person, including name and birthdate.

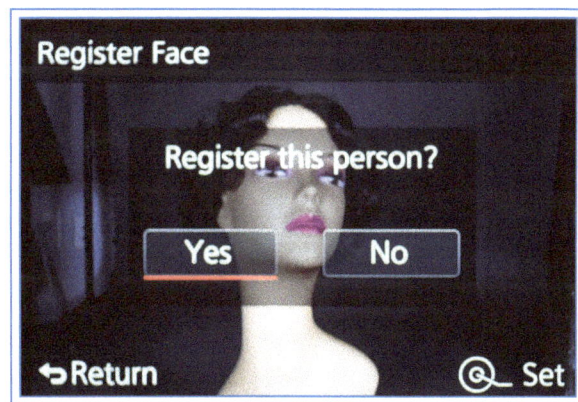

Figure 4-64. Message After Successful Face Registration

Once you have one or more faces registered, you can turn Face Recognition on through the Recording menu

whenever you want the camera to try to recognize those faces. When it does, it will place a frame over the face and display the name, if one was entered into the camera's memory, as shown in Figure 4-65. The camera will adjust its focus and exposure for the recognized face or faces. It can recognize up to 3 faces at a time.

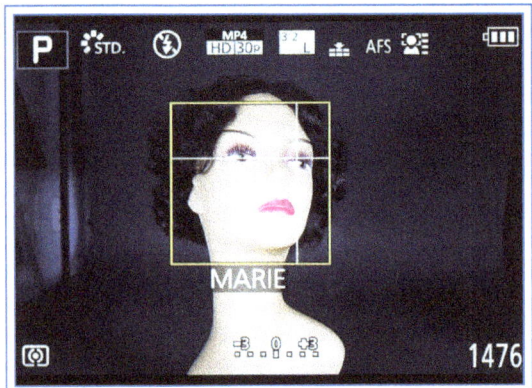

Figure 4-65. Display When Camera Recognizes Face

If you want to, you can add additional images for any person, taken from different angles and in different lighting, to increase the camera's ability to recognize that person. To do that, choose the Memory option and then select the person for whom you want to add images. You also can edit the person's information, including name and birthdate.

I do not often use this feature, but I can appreciate how useful it could be if, for example, you are taking photos at a school event and you want to make sure the camera focuses on your child when you are aiming at a group of children.

If you don't want the camera to use face recognition, just turn this menu item off.

Profile Setup

This final option on the Recording menu lets you set up profiles for 2 babies and 1 pet, so the camera will display the name and age of the baby or pet when you take a picture of him or her. For example, you can enter a profile for a baby named Charles, born November 10, 2014. Then, whenever you take a picture of Charles, you can recall that profile and the camera will display his name and his age as of the date the picture is taken. So, if you take his picture on December 20, 2015, the camera will display: Charles 1 year 1 month. This information will be recorded with the image, and it will display in playback mode with the detailed information

screen, but it will not become a permanent part of the image unless you use the Text Stamp option on the Playback menu, as discussed in Chapter 6.

This menu option does not cause the camera to recognize a pet or baby; it just lets you call up the profile you have entered for Baby 1, Baby 2, or Pet. So, you actually could enter any name and birthdate in any of those 3 profiles. When you call up the profile and take a picture with the profile activated, the camera will record the name and age, regardless of the actual subject matter of the image.

Quick Menu

The D-Lux has another menu system with settings for recording images and videos. (I will discuss the menu for movie settings in Chapter 8.) This menu system is called the Quick Menu. It is not part of the regular menu system; instead, you get access to it by pressing the QM button, located to the upper left of the control dial on the camera's back. When you press the QM button while the camera is in recording mode, a mini-version of the camera's menu system opens up, with several options in 2 lines, one at the top of the screen and one at the bottom, as shown in Figure 4-66.

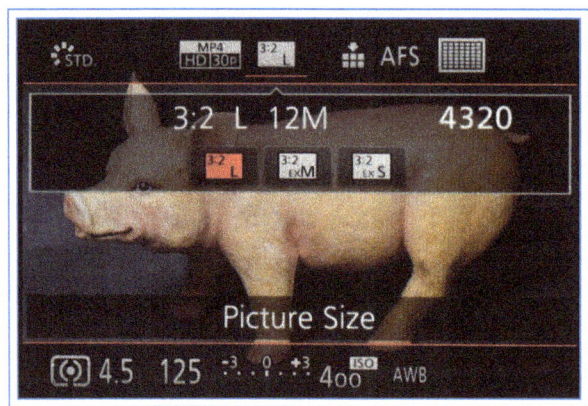

Figure 4-66. Quick Menu Screen

Navigate through these menu options by pressing the Left and Right buttons or by turning the control dial until you find the category you want. The name of the setting that is currently active will appear near the top of the screen for items in the bottom row, and near the bottom of the screen for items in the top row. For example, in Figure 4-66 the Picture Size icon is highlighted at the top of the screen, and its name appears near the bottom of the screen. The highlight will wrap around between the bottom and top of the

screen, so you can keep turning the control dial or pressing the Left and Right buttons to cycle through all of the items continuously.

If the item you highlighted is at the top of the screen, you can then press the Down button to move down to the row or rows of icons with settings for that item. If the highlighted item is at the bottom of the screen, press the Up button to move to the row or rows of icons with settings. For example, Figure 4-67 shows the display after I pressed the Down button to move to the settings for the Picture Size item.

Figure 4-68. Monitor Information Display

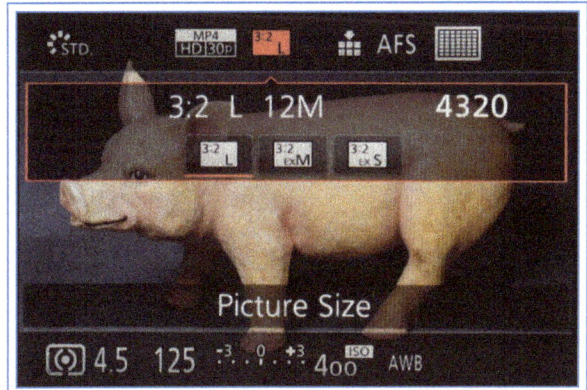

Figure 4-67. Quick Menu Screen with Highlight in Picture Size Settings

Once you have highlighted the icons with settings, move left and right through the sub-menu with the buttons or dial. When you have highlighted the setting you want to make, you can then move to another item in the Quick Menu to make another setting. When you have finished making settings, press the Menu/Set button or the QM button to exit from the Quick Menu to the recording screen. You also can press the shutter button halfway to return to that screen.

The menu options vary according to what mode the camera is in; not surprisingly, the Quick Menu offers the largest variety of choices when the camera is in Program, Aperture Priority, Shutter Priority, or Manual mode. It offers a smaller variety in Snapshot mode, though it still offers several choices.

The Quick Menu works differently when you are using the information-only display in recording mode. (That screen is turned on through the Monitor Information Display item on screen 6 of the Custom menu.) When you have selected that screen with the Display button, pressing the QM button places a red highlight line on the screen, as shown in Figure 4-68.

You can turn the control dial or use the 4 direction buttons to move the highlight to the various items on the information screen. When one of those items is highlighted, press the Menu/Set button, and you can then adjust the setting for that item. (The highlight will not move to the exposure compensation block, because that setting is adjusted with the dial on top of the camera; the information in that block will change as you turn the exposure compensation dial.)

In my experience, the Quick Menu is a very useful alternative to the Recording menu. This system is, in fact, quite quick, and lets you make certain settings very efficiently that otherwise would require a longer time, in part because you can see all of the available options at the same time on the screen as soon as you press the QM button.

For example, I find that the Quick Menu is an excellent way to get access to the Quality setting to select Raw or Fine quality for still images. Access to the feature is very fast this way, and, even better, when you later press the QM button again to go back to change the Quality setting again, the Quality option is still highlighted, and it takes just 2 or 3 button presses to change from Raw to Fine or vice-versa.

You can customize the settings included on the Quick Menu using the Quick Menu item on screen 8 of the Custom menu. I will discuss that process in Chapter 7.

Chapter 5: Physical Controls

Not all settings that affect the recording of images and videos are on the Recording menu. Several important functions are controlled by physical buttons and switches on the D-Lux. I have already discussed some of them, but to make sure all information about these controls is included in one place, I'll discuss each control, some in greater detail than others. I'll start with the 3 items that are visible on the top of the lens barrel, as shown in Figure 5-1.

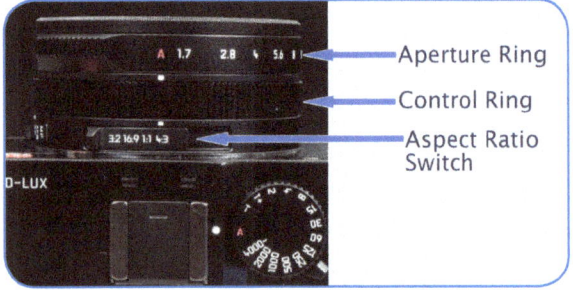

Figure 5-1. Aspect Ratio Switch, Control Ring, and Aperture Ring

Aspect Ratio Switch

This switch on top of the lens barrel has 4 settings: 3:2, 16:9, 1:1, and 4:3, representing the ratio of the width of an image to its vertical height. This setting does not affect just the shape of the image; it also helps determine how many megapixels (MP) an image contains. When the aspect ratio is set to 4:3, the maximum resolution of 12.5 MP is available. When the aspect ratio is set to 3:2, the greatest possible resolution is 12 MP. At 16:9, the greatest possible resolution is 11 MP. At the 1:1 ratio, the largest resolution available is 10 MP. If you want to view the scene using the entire area of the LCD screen, choose 3:2, which is the aspect ratio of the screen. With 4:3, there will be black bars at the sides of the screen as you compose your shot; with 16:9, there will be black bars at the top and bottom of the screen; with 1:1, there also will be black bars.

Figures 5-2 through 5-5 illustrate the different shapes for images taken with the D-Lux's various aspect ratio settings. In Figure 5-2, the aspect ratio is set to 3:2. This aspect ratio crops the image slightly in the horizontal direction and somewhat more in the vertical direction. Figure 5-3 is an image taken with the 16:9 setting, which uses the maximum number of available horizontal pixels but the smallest number of vertical pixels of all aspect ratio settings. For Figure 5-4, the aspect ratio switch was set to the 1:1 position, which uses the maximum number of vertical pixels, and crops the horizontal pixels to match the number of vertical pixels. Finally, the 4:3 setting was used for Figure 5-5. This setting uses the maximum number of vertical pixels, but crops the pixels in the horizontal direction.

Figure 5-2. Aspect Ratio 3:2

Figure 5-3. Aspect Ratio 16:9

Figure 5-4. Aspect Ratio 1:1

Figure 5-5. Aspect Ratio 4:3

It's important to note that, even though the D-Lux does crop the image at least slightly with all aspect ratios, this cropping is not as severe as it is with some other cameras, because this camera uses an image sensor with 16.8 megapixels overall, but only uses up to 12.5 megapixels for any one image size, which gives the camera considerable leeway to produce the various aspect ratios without severely cropping any of them.

Aperture Ring

The aperture ring is the large ridged ring that surrounds the lens and is marked with aperture (f-stop) numbers from 1.7 (widest aperture) at the left to 16 (narrowest aperture) at the right. This ring is similar to the rings found on some traditional film cameras and their lenses. Its operation could hardly be more simple and intuitive: Just turn the ring until the selected aperture is next to the white selection dot in front of the aspect ratio scale. Besides the aperture values that are designated on the ring, you can turn the ring to intermediate values in 1/3-stop increments, such as f/2, f/2.5, f/4.5, f/7.1, f/9.0, f/13, and others. You can feel a gentle click as the ring stops at any of the values that can be selected.

In addition to selecting apertures, as discussed in Chapter 3, the aperture ring, along with the shutter speed dial, is used to select a recording mode. For example, to select Program mode, you set this ring and the shutter speed dial both to their A settings. For Shutter Priority Mode, set this ring to its A setting and set the shutter speed dial to a specific value. For Manual exposure mode, set this ring and the shutter speed dial both to specific values.

As I noted in Chapter 3, when the lens is zoomed in, the maximum aperture decreases. So, even if the aperture ring is set to the f/1.7 position, if the lens is then zoomed all the way in, the aperture value will change to f/2.8, which is the widest aperture available at that zoom setting. In that case, the aperture value will not agree with the setting on the ring.

Control Ring

The control ring is the unmarked ring located between the aperture ring and the aspect ratio switch. This control adds a great deal of convenience to the operation of the D-Lux through its ability to be customized according to your preferences.

Whenever the camera is set to manual focus mode, the control ring is used to adjust focus. Just turn the ring to adjust the distance at which the camera sets its focus. The display will vary according to settings you make for manual focus through the Custom menu.

When the camera is set to an autofocus mode, the control ring can control other options, according to how it is set through the Control Ring option on screen 8 of the Custom menu, as discussed in Chapter 7. If you use the default setting, the ring controls various functions depending on the shooting mode. In Shutter Priority and Manual exposure modes, turning the control ring selects shutter speeds other than those printed on the shutter speed dial, such as 1/1300 second and 1/5 second. In Snapshot mode and Program mode, the ring operates the step zoom feature, discussed below. When you are shooting with the panorama setting of Drive Mode, turning the control ring selects a Filter button effect, unless you are using manual focus.

If you use the Control Ring menu option to select a setting other than the default, the ring can control a single setting, such as ISO, zoom, White Balance, or Filter button effects. If you do that, the new setting will take effect for all recording modes, including when you are shooting panoramas, except when manual focus is in effect. With manual focus, the control ring always controls focus.

STEP ZOOM

With this feature turned on, when you turn the control ring the lens zooms, but only to a series of specific focal lengths: 24mm, 28mm, 35mm, 50mm, 70mm, and 75mm. (Additional values are available if any of the extended zoom settings are turned on.) This setup allows you to select one of these specific settings easily. If you want to zoom the lens continuously instead, you can use the zoom lever, which will select any focal length, not just the designated steps. (You can set the zoom lever to use step zoom through screen 7 of the Custom menu, if you want.)

Next, I will discuss an important control that sits by itself on the left side of the lens barrel. This control, the focus switch, is seen in Figure 5-6.

When you move the switch on the lens to select this mode, the focusing range changes to a macro range. Instead of the normal focusing range of 1.6 foot (50 cm) to infinity at wide angle or telephoto, with the Autofocus Macro setting the lens can focus as close as 1.2 inch (3 cm) at wide angle and 12 inches (30 cm) at telephoto.

It is usually a good idea to turn the flash off when using macro focus, because the flash may not be useful at such a close range unless you diffuse it with translucent plastic or other material. It also is important to use a sturdy tripod for macro shooting when possible, because any camera motion can blur an image drastically at such a close distance. You also should use the self-timer, probably set to 2 seconds, to avoid causing blur by touching the camera during the exposure. As an alternative, you can control the camera remotely from a smartphone, as discussed in Chapter 9.

Figure 5-7 is an example of a macro shot of an orchid, taken using a tripod with the focus switch set to Autofocus Macro and with the lens zoomed all the way out to its wide-angle setting limit of 24mm.

Figure 5-7. AF Macro, f/1.7, 1/80 sec, ISO 200

Next, I will discuss the several controls on the top of the camera, as shown in Figure 5-8.

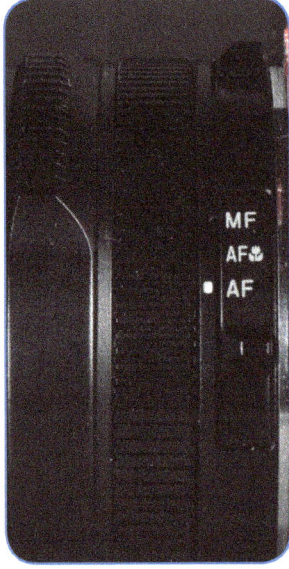

Figure 5-6. Focus Switch

Focus Switch

The focus switch has 3 positions: Autofocus, Autofocus Macro, and Manual Focus. I have previously discussed Autofocus and Manual Focus. The third setting, Autofocus Macro, needs some additional discussion.

Chapter 5: Physical Controls

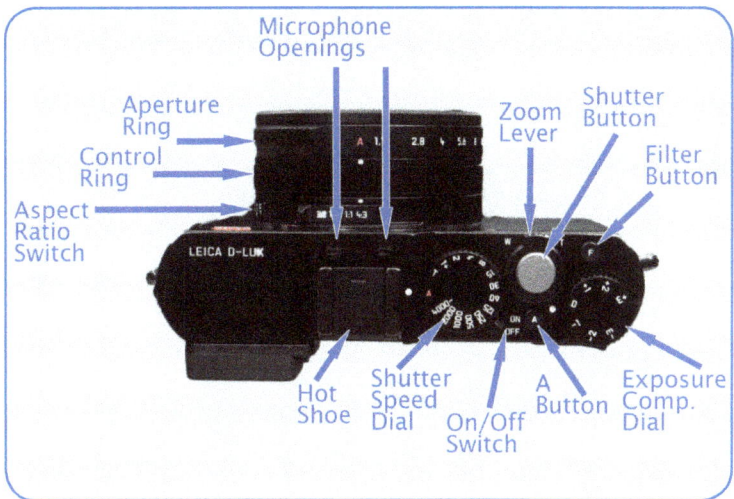

Figure 5-8. Controls on Top of Camera

Shutter Button

This control is the most important one on the camera. With the default settings, you press it halfway to check focus and exposure, and press it the rest of the way to record the image. You can press it halfway to wake the camera up from Sleep Mode, or to return to recording mode from a menu screen or from playback mode. You can press this button to take a still image while recording a video sequence, in most situations. When the camera is set for burst shooting or auto bracketing, you hold this button down to fire a burst of shots. When the shutter speed is set to T, for time exposure, in Manual exposure mode, you press this button once to open the shutter, and press it a second time to end the exposure. When you have turned on the 4K Photo option through screen 1 of the Motion Picture menu, pressing the shutter button starts and stops a 4K video recording. With that option selected, you cannot use the shutter button to take still images.

You can change the behavior of this button in a couple of ways using options on the Custom menu. With the Shutter AF item, you can disable the function of focusing when the button is pressed halfway. With the Half Press Release item, you can set the camera so a half-press of the shutter button will release the shutter. I will discuss those options in Chapter 7.

Zoom Lever

The zoom lever is the ring with a ridged handle that encircles the shutter button. The lever's basic function is to change the lens's focal length to various values ranging between wide-angle, by pushing it to the left, toward the W indicator, and telephoto, by pushing it to the right, toward the T indicator. When you are viewing pictures in playback mode, the lever enlarges the image on the LCD screen when pushed to the right, and selects different arrangements of thumbnail images to view when pushed to the left. Also, you can use this lever to speed through the menus a full page at a time, either forward or backward.

On/Off Switch

The on/off switch is at the rear of the camera's top, next to the shutter speed dial. Slide it forward to turn the camera on and pull it back to turn it off. If you leave the camera unattended for a period of time, it automatically powers off, if the Sleep Mode option is turned on through screen 2 of the Setup menu. I'll discuss the Setup menu in Chapter 7, but this option can be set to be off altogether so the camera never turns off just to save power, or to turn the camera off after 1, 2, 5, or 10 minutes of inactivity. You can cancel the Sleep Mode shutdown by pressing the shutter button halfway.

Shutter Speed Dial

The shutter speed dial is the largest control on top of the camera. You use this dial, in conjunction with the aperture ring, to set the recording mode and, in some modes, to set the shutter speed. When you set this dial and the aperture ring to their A positions, the camera is set to Program mode. When you set this dial to the A position and the aperture ring to a specific aperture, the camera is set to Aperture Priority mode. When you set this dial to a specific shutter speed and the aperture ring to the A position, the camera is set to Shutter Priority mode. When you set both this dial and the aperture ring to specific values, the camera is in Manual exposure mode. (Of course, if you press the A button, the camera will switch into Snapshot mode, no matter what position this dial is in.)

To set a shutter speed that is printed on the dial, such as 1/30 second or 1/2000 second, just turn the dial to that value, in those cases 30 or 2000. To set intermediate shutter speeds, you have to turn the

control ring around the lens or the control dial on back of the camera. For example, to set the shutter speed to 1/400 second, turn the shutter speed dial to the 500 mark, then turn the control ring (or the control dial) until 400 appears at the bottom of the display. To set speeds faster than 1/4000 second, choose the 4000 mark, then turn the control ring or control dial to select a faster speed. To set speeds from 1 second to 60 seconds, choose the 1+ indicator on the shutter speed dial, then turn the control ring or the control dial to select the desired speed. Speeds of 1 second or slower appear on the display with double quotation marks after them, as in 4" for 4 seconds.

To use the T setting for a time exposure, the camera must be set to Manual exposure mode. (If you use the T setting in Shutter Priority mode, the camera will set the shutter speed to 60 seconds.) Then, press and release the shutter button to start the exposure, and press and release it again to end the exposure. The maximum exposure time with this setting is about 120 seconds.

Exposure Compensation Dial

The second most prominent control on top of the camera is the exposure compensation dial at the right side of the control area. This dial provides a welcome simplicity for adjusting exposure settings. All you have to do is turn the dial to a positive or negative value to adjust the exposure to be brighter or darker than it would appear using the settings metered by the camera. You can use this adjustment in any shooting mode except Manual exposure mode. You will see the effects of the adjustment on the camera's display as you turn the dial. In Chapter 4, I discussed the Auto Exposure Compensation item, a sub-option of the Flash item on screen 5 of the Recording menu. If you turn that option on, then the camera adjusts the flash output so any exposure compensation adjustment you make takes effect and is not counteracted by the flash.

The A Button

This small button, directly behind the shutter button, has only one purpose—to switch the camera into and out of Snapshot mode. No matter what other mode the camera is currently set to—Program, Aperture Priority, Shutter Priority, or Manual exposure—just press this button quickly and the camera switches immediately into Snapshot mode. Press it again to switch back to the mode that was previously in effect. If you want, you can change the behavior of this button so you have to press it and hold it down for about a full second for the recording mode to change. With that setting, there is less danger of accidentally pressing the button and switching modes when you don't want to. That behavior is controlled by the A Button Switch option on screen 8 of the Custom menu.

Filter Button

This small button to the right of the shutter button provides a powerful feature for the D-Lux. When you press this button, the camera displays a group of icons representing 22 picture effects you can apply to your images and videos. There also is a 23rd choice called No Effect. When you do not want any special effects applied to your images and videos, you should select this option, or else all of your shots will have one of the 22 effects added. If you want some insurance against accidentally leaving one of the effects activated, you can turn on the Simultaneous Record Without Filter option on screen 3 of the Recording menu. When that option is on, the camera will take 2 images when a Filter button effect is selected—one with the effect and one without it—so you don't have to worry about ruining an image by applying an unwanted effect.

After you press the Filter button, you will see a screen that lets you browse through the icons for the 22 effects and the icon for No Effect. You can choose from 3 possible arrangements of the icons by pressing the Display button repeatedly.

Figure 5-9. Filter Effect Menu - Normal Display

With the Normal display, as shown in Figure 5-9, the camera displays a vertical line of icons at the right.

Chapter 5: Physical Controls | 65

As you scroll up and down through that line using the Up and Down buttons or the control dial, the camera highlights the selected icon and displays a large view at the left of the screen that applies that effect to the live view of the current scene that the camera is aimed at.

Figure 5-10. Filter Effect Menu - Guide Display

With the Guide display, as shown in Figure 5-10, the setup is the same, except that, at the left of the screen, instead of displaying the appearance of the effect, the camera displays a brief description of the effect.

Figure 5-11. Filter Effect Menu - List Display

With the List display, as shown in Figure 5-11, the camera displays more icons on each screen, in rows and columns. As you scroll through them using all 4 direction buttons or the control dial, the camera displays the name of the effect at the top of the display.

When you have scrolled through the Filter button effect icons and highlighted the one you want to use, press Menu/Set to select it and return to the recording screen. The camera's display will now show the name of the effect at the left, and the appearance of the scene on the display will reflect the chosen effect.

Figure 5-12. Sepia Filter Effect As Seen on Recording Display

For example, Figure 5-12 shows the display when the Sepia effect has been selected.

For each effect, you can adjust some setting, such as its intensity. To do this, press the Right button and the camera will display a scale like that seen in Figure 5-13. Use the control dial to adjust the setting along that scale. The normal setting is in the middle. For 3 of the settings (Miniature, One Point Color, and Sunshine), there are additional adjustments you can make by pressing the Fn1 button. I will discuss the adjustments for all of the effects in the descriptions of the individual options.

Figure 5-13. Filter Effect Adjustment Scale

You can use the Filter button effects with any one of the PASM shooting modes and when recording motion pictures. You cannot use them with Snapshot mode. When you activate any of the effects, you cannot adjust the camera's White Balance, Photo Style, Highlight Shadow, Intelligent Dynamic, HDR, or Color Space. Also, the flash is forced off. However, you can set Quality to Raw. If you do that, the image that is displayed on the camera's screen will show the selected effect, but when you load the Raw file into post-processing software, the effect may not appear,

depending on whether the software recognizes it. I have not yet found any software that does recognize it, so, if you want to have the benefit of shooting in Raw but also use the picture effect, I recommend you use the Raw & Fine option for Quality, so you will have both a Raw and a JPEG image for each shot.

You also can shoot panoramas with Filter effects, but the following effects are not available: Toy, Toy Pop, Miniature, and Sunshine. You can select an effect by pressing the Filter button, or, for panorama shooting only, by turning the control ring around the lens. If you do that, a list of text icons will scroll along the bottom of the display; just turn the control ring until the effect you want is highlighted, then press the shutter button halfway to return to the recording screen. (The Control Ring menu option must be set to Default for this function to be available.)

Following are details about each of the 22 settings, with an example image for each.

Expressive. This setting increases the saturation and intensity of colors in the image to give a vivid appearance. When you press the Right button, the scale that appears lets you adjust the strength of this effect. This effect can be used to provide extra punch to your images without distorting their appearance.

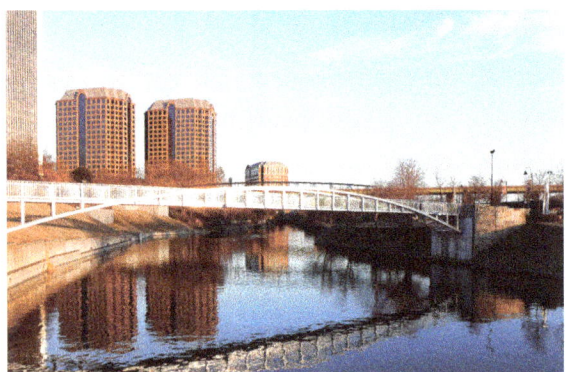

Figure 5-14. Example of Expressive Effect

For example, in Figure 5-14, I used this setting to add emphasis and color to an image of city buildings on the waterfront. This setting heightened the contrast between the reddish buildings and the blue sky.

Retro. This option adds a yellowish or reddish color cast to give a faded look to the image, like the appearance of an old color print that has faded over time. With the adjustment slider, you can alter the color tone from yellowish at the left of the scale to reddish at the right.

Figure 5-15. Example of Retro Effect

For Figure 5-15, I used this setting to add an antique atmosphere to a photo of 2 round buildings at the local botanical garden.

Old Days. This effect is intended to give a "nostalgic" look by lowering the saturation of colors and reducing contrast for an old-fashioned look. With the adjustment slider, you can vary the contrast. In Figure 5-16, I used this setting to give an aged appearance to an historic house with a rustic feel.

Figure 5-16. Example of Old Days Effect

High Key. A high key image is one with bright, light colors and a light background. With the D-Lux, the camera increases brightness and emphasizes highlights. With the adjustment slider, you can add a slight color cast ranging from pinkish at the left to bluish at the right. This setting can be useful for brightening a dark scene. For Figure 5-17, I used this setting to brighten a still life image that was taken in dark conditions..

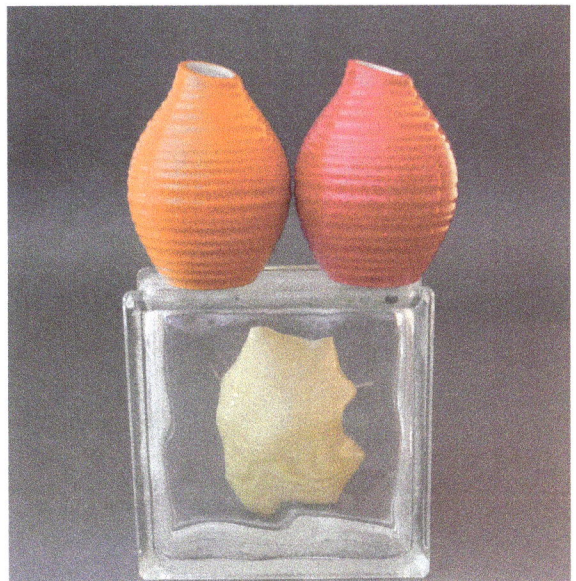

Figure 5-17. Example of High Key Effect

Low Key. With this setting, the camera darkens the overall image in a way that places an emphasis on any bright or highlighted areas. This option can be used for dramatic effect to isolate a small bright area within a scene. As with the High Key setting, you can add a color tone ranging from reddish to bluish.

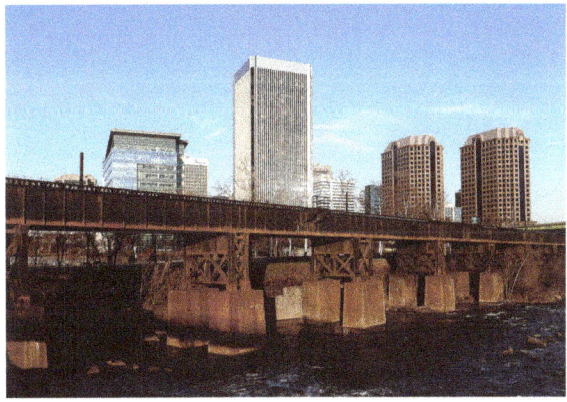

Figure 5-18. Example of Low Key Effect

For Figure 5-18, I found this option to be useful for adding a sense of drama and contrast to a shot of the city skyline at the river.

Sepia. With this option, the camera renders the image in monochrome, but with a sepia (brownish) tone, simulating the appearance of some old-fashioned photographs. With the adjustment slider, you can change the level of contrast. For Figure 5-19, I tried this setting with a pathway into a garden. The Sepia setting adds a look of history or nostalgia.

Figure 5-19. Example of Sepia Effect

Monochrome. This setting gives you another way, other than the Photo Style menu option, to capture an image in traditional black and white. The adjustment slider lets you add a color tone, ranging from yellowish to bluish.

Figure 5-20. Example of Monochrome Effect

For Figure 5-20, I tried this setting with a shot of the same historic house shown earlier, to give the feeling of a postcard view.

Dynamic Monochrome. This option is another way to take a monochrome image, in this case with enhanced contrast to give a more dramatic appearance than an ordinary monochrome setting does. The adjustment slider alters the amount of contrast.

Figure 5-21. Example of Dynamic Monochrome Effect

For Figure 5-21, I used this setting with a view of an antique cannon, in an attempt to emphasize the strong geometric patterns of the subject.

Rough Monochrome. With this setting, the camera again records a monochrome image, but this time with the appearance altered to add grain by inducing visual noise, like the noise that results from using a high ISO setting. This option can be good for street photography or for other situations when you want the somewhat primitive look of a grainy image. The adjustment slider lets you reduce or increase the amount of graininess.

Figure 5-22. Example of Rough Monochrome Effect

For Figure 5-22, I used this setting for another view of the Civil War cannon. I felt that this setting was good for emphasizing the shape of the cannon and its wheels.

Silky Monochrome. This option gives you another way to take a monochrome image. In this case, the camera puts the image slightly out of focus to add a soft or dreamy look. With the adjustment slider, you can alter the amount of defocusing that is used. The left side of the scale provides a sharper, less defocused image.

Figure 5-23. Example of Silky Monochrome Effect

For Figure 5-23, I used this setting for a photo of the garden path shown earlier, in an attempt to give it a somewhat impressionistic appearance.

Impressive Art. This setting provides one of the more dramatic effects for your images. The camera increases contrast and color saturation dramatically. With the adjustment slider, you can vary the color level all the way down to monochrome at the left of the scale and a high degree of intensity at the right.

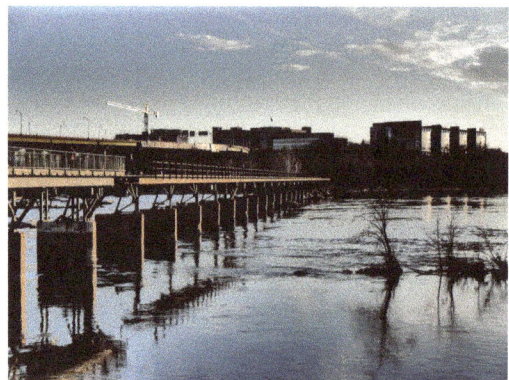

Figure 5-24. Example of Impressive Art Effect

For Figure 5-24, I found that this setting added considerable emphasis to another view of city buildings across the river.

High Dynamic. With this option, the camera uses special processing to even out the dynamic range of the image to some extent, to reduce the contrast between dark and light areas. This setting provides an appearance somewhat like that of an in-camera HDR shot, but without the benefit of taking multiple images from which to combine areas with different exposure levels. As with the previous setting, you can vary the

color intensity from monochrome to intense color using the adjustment slider.

Figure 5-25. Example of High Dynamic Effect

For Figure 5-25, I tried using this setting for another shot of the garden path from the prior examples, to show the differences among these effects. The High Dynamic effect eased the contrast, showing the subject with a less shadowy appearance.

Cross Process. This setting is straightforward in its operation. All it does is add a specific color cast to your images—either green, blue, yellow, or red. With the adjustment slider, you can choose one of those colors. For this setting, the slider does not move across a continuous scale; instead it moves to one of 4 blocks representing those colors. Just move the slider to highlight one of those blocks, and your images will take on that color as an overlay.

Figure 5-26. Clockwise: No Effect, Green, Blue, Yellow, Red

For Figure 5-26, I put together a composite image using all 4 settings for photos of a copper kettle, along with an image taken with no effect, to illustrate how the different options affect the appearance of a metallic object.

Toy Effect. The Toy effect sets the camera to simulate the images taken by a camera that is designed to purposely degrade its pictures by using a cheap lens and other non-standard approaches, for creative effect. There is a field of photography called Lomography in which artists and photographers produce images that might be called defective, but whose defects are prized for their unusual appearance. With the D-Lux, this effect uses vignetting and contrast adjustments to produce the toy-camera effect. With the adjustment slider, you can add a color cast, ranging from orange (warmer colors) at the left of the scale to blue (cooler colors) at the right.

Figure 5-27. Example of Toy Effect

In Figure 5-27, I used this setting for a view of the same house I used earlier, to see how it would compare. I felt that this setting worked well to give a feel of an old-fashioned vignette or possibly an aged postcard.

Toy Pop. With this setting, the camera combines the vivid, bright appearance of the Expressive setting with the vignetting of Toy Effect, discussed above. In this case, the adjustment slider controls the amount of vignetting. At the left of the scale, the vignetting is reduced so more of the image is bright; at the right, the vignetting increases to darken more of the corners. For Figure 5-28, I felt that this setting was a good one to place a vignette around the round buildings shown earlier, to give them a vintage appearance.

Figure 5-28. Example of Toy Pop Effect

Bleach Bypass. This option causes images to have increased contrast and lowered color saturation, to produce a bleached, washed-out appearance. You can reduce the contrast by moving the adjustment slider to the left or increase it by moving the slider to the right.

Figure 5-29. Example of Bleach Bypass Effect

For Figure 5-29, I again took a view of the round buildings, to see how this setting compares to others. This option provides another way to produce a neutral, desaturated effect, giving a somewhat aged appearance.

Miniature Effect. This is one of the most interesting of the 22 picture effects the D-Lux offers. This setting produces an image that looks as if it were taken of a high-quality tabletop model. Such photographs generally have some areas in sharp focus and some areas blurry, because of the closeup nature of the photograph or because of the use of a tilt-shift lens. This effect is used for some television commercials and programs, often combined with the use of time-lapse photography to add interest to a speeded-up scene.

This effect yields good results from a high vantage point looking down on a street or intersection, or on any area that can be placed in the center of the shot and has moving objects, such as automobiles, railroad cars, boats, or the like.

To use this effect, you first have to set the area that will be in sharp focus. To do this, the camera provides additional adjustments beyond using the Right button. First, press the Fn1 button and the camera will place a red rectangle on the screen, as shown in Figure 5-30.

Figure 5-30. Red Rectangle Ready to Adjust for Miniature Effect

Move the rectangle up and down by pressing the Up and Down buttons, and vary its width by turning the control dial. To turn it 90 degrees so it is positioned vertically, press the Right or Left button. Then, you can move the frame with the Right and Left buttons or resize it as before. Try to position and size it to cover the area that you want to keep in focus, such as a street with cars on it, and press the Fn1 button again to move back to the recording screen. Now you can press the Right button to bring up the adjustment slider. With this setting, the slider varies the color intensity from low at the left to higher at the right.

You can use this setting for motion pictures, but no audio will be recorded and the movie will be recorded at a slow speed, and it will play back at a speed 10 times faster than normal. So, if you record the Miniature Effect movie for 20 minutes, it will play back in 2 minutes, with a greatly speeded-up appearance.

For Figure 5-31, I shot an image of some items in a garden from a high vantage point, to give the impression of a model setup.

Figure 5-31. Example of Miniature Effect

Soft Focus. With this effect, the camera defocuses the image to give it a soft, dreamlike appearance. You can use the adjustment slider to vary the degree of defocusing.

Figure 5-32. Example of Soft Focus Effect

For Figure 5-32, I used this setting to give a somewhat dreamy aura to an indoor garden area.

Fantasy. With this option, the camera alters the intensity of colors and adds a bluish color cast to the scene, with the idea of producing a hazy, fantasy-like appearance. With the adjustment slider, you can vary the intensity of the colors. For Figure 5-33, I took a shot of a house under a blue sky and clouds, to give the scene an aura of fantasy with this effect.

Figure 5-33. Example of Fantasy Effect

Star Filter. This setting produces rays of light wherever there are points of bright light in the scene. This is a good option to use if you want to add a sparkling, holiday-like appearance to a scene with festive lights, for example. With the adjustment slider, you can change the length of the rays of light from short at the left of the scale to longer at the right.

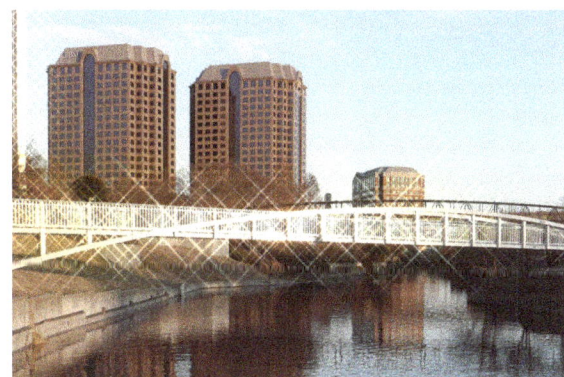

Figure 5-34. Example of Star Filter Effect

For Figure 5-34, I took a shot of a bridge on a sunny day; this setting added the rays of light from the reflections off of the shiny metal of the bridge.

One Point Color. This is another one of my favorite effects because, like the Miniature effect, it can produce dramatic, striking images. The purpose of this effect is to choose a single color, such as red, blue, yellow, or any other, and set the camera so that only objects of that color will retain their color. All other objects in the scene will appear in black and white. If this is done with a suitable subject, the effect of isolating a single item or area in color can be quite impressive.

To use this option, you need to take an extra step. After you select it, press the Fn1 button and the camera will place a small square with 4 arrows on the display. Using the 4 direction buttons, move that square over an

object with the color you want to retain in the image. As you do this, the camera will react by leaving that object in color, along with any other objects of that color, and turning the rest of the scene to black and white. For example, in Figure 5-35, the square is resting on a yellow area on a multi-colored parrot figure, and the yellow areas are the only ones that appear in color on the selection screen.

Figure 5-35. One Point Color - Color Selection Screen

Once you have found the color you want to retain, press the Menu/Set button to lock it in. Then press the Right button to bring up the adjustment slider. If you move the slider to the right, the camera will include more objects of approximately the same color as the one you selected; if you move it to the left, the color range will be narrower.

Figure 5-36. Example of One Point Color Effect

For Figure 5-36, I used this setting for another view of the house shown earlier, to see the effect of having a blue sky over a monochrome scene.

Sunshine. Finally, the Sunshine option lets you add a solar flare effect to your image. After you select this option, press the Fn1 button and you will see a red circle on the display. You can move that circle around the screen using the 4 direction buttons and resize it using the control dial. When you have it sized and located as you want, press Menu/Set to lock it in. Then, press the Right button and you can select yellow, red, blue, or white for the color of the flare. Press Menu/Set, and the effect will be locked in with your selections. You can move the flare outside the edges of the image to avoid having the large, bright ball in the scene.

For Figure 5-37, I used this option to add a solar flare beside an outdoor fountain.

Figure 5-37. Example of Sunshine Effect

Next, I will discuss the controls and other items found on the back of the camera, as shown in Figure 5-38.

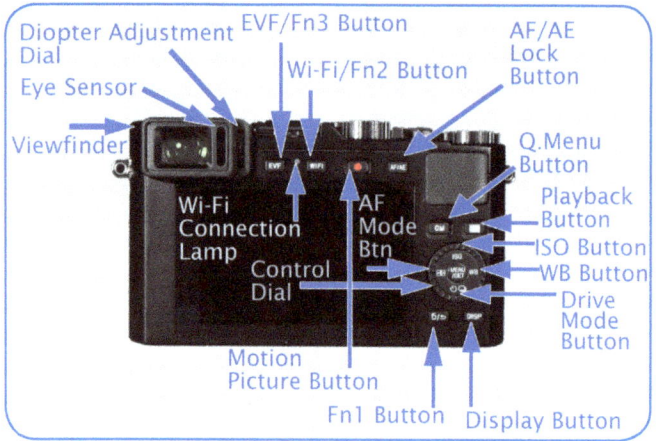

Figure 5-38. Controls on Back of Camera

Viewfinder and Eye Sensor

The viewfinder window at the left of the camera's back is where you can see the recording display and playback display when the viewfinder is in use. The vertical slot at the right of the window is the location of the eye sensor. That device senses when your head is near the viewfinder and switches the display from the LCD screen to the viewfinder, if the camera is set that way. This setting is made with the EVF/Monitor Switch option under the Eye Sensor item on screen 9 of the Custom menu. If that item is set to EVF/Monitor Auto,

the view switches between the viewfinder and the LCD screen automatically when your head (or anything else) approaches the eye sensor. Otherwise, it can be set to EVF or Monitor, to keep the viewfinder or LCD screen permanently activated. You also can select any of these options by pressing the EVF button, also known as the Fn3 button, to the right of the viewfinder window, assuming the Fn3 button is set to its default function. You can control the sensitivity of the eye sensor using the Sensitivity sub-option of the Eye Sensor menu item.

You also can set the camera to use its autofocus to focus on the scene when your eye approaches the eye sensor. That option is controlled using the Eye Sensor AF option on screen 2 of the Custom menu.

You can adjust the view through the viewfinder for your eyesight using the diopter adjustment dial to the right of the eye sensor. If you wear glasses, you may be able to adjust this dial so you can see clearly through the viewfinder without your glasses.

The information displayed in the viewfinder is controlled by pressing the Display button. There are 4 different screens with various information; I will describe those screens in the discussion of the Display button, later in this chapter.

Control Dial and its Buttons

One of the most important control groups on the D-Lux is the set of 5 buttons on the back of the camera, arranged on a circular platform with a ridged dial around the outside, known as the control dial. The edges of the control dial act as buttons that you press to activate various functions. In the center of the control dial is a fifth button. I generally refer to the 4 outer buttons as direction buttons (Left, Right, Up, and Down), and to the center button as the Menu/Set button.

Control Dial

The control dial is the ridged dial whose 4 edges act as the direction buttons. As a dial, this control is important in itself. You turn this dial to navigate through menu screens and settings and to adjust the values of various settings. When the camera is in Program mode, you can turn this dial to use the Program Shift feature, by which the camera finds a new pair of aperture and shutter speed values to maintain the same exposure it has set. When you are setting the shutter speed, you can turn this dial (or the control ring) to set values that do not appear on the shutter speed dial, such as 1/3200 second.

You can turn this dial to adjust the size of the focus frame when the focus mode permits that adjustment, the size of the frame used for the Miniature setting of the Filter button effects, or the size of the light source for the Sunshine effect. This dial is used to adjust the settings for the Highlight Shadow option on screen 2 of the Recording menu. In playback mode, turning this dial moves through your recorded images, and it is used to adjust the audio volume during a slide show or motion picture playback.

Direction Buttons

The direction buttons act like cursor keys on a computer keyboard, letting you navigate up and down and left and right through menu options. However, the buttons' functions do not stop there. Each of the 4 direction buttons performs at least one additional function, as indicated by the icon or label next to the button. I will discuss those functions for each button in turn.

Up Button: ISO

The Up button doubles as the ISO button. Pressing this button when the D-Lux is in recording mode gives you immediate access to the menu for selecting the ISO sensitivity value for your photography. I discussed the ISO setting in Chapter 4, in connection with the ISO-related items on the Recording menu—ISO Limit Set, ISO Increments, and Extended ISO. You cannot make the basic ISO setting using the menu system; instead, you need to press the Up button and select a value from the menu that appears, as shown in Figure 5-39.

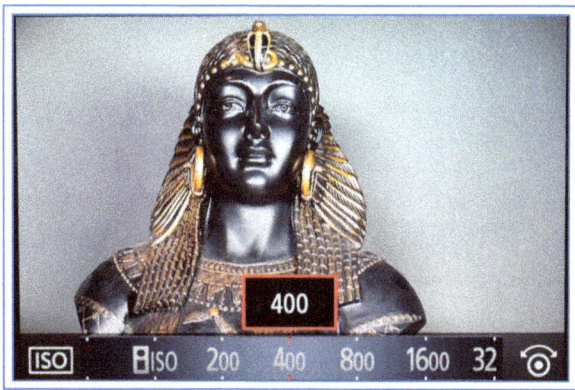

Figure 5-39. ISO Menu

(You also can use the Quick Menu system, as discussed in Chapter 4.) In Snapshot shooting mode, the camera uses the Intelligent ISO setting and the ISO button has no effect for controlling ISO.

In playback mode, the Up button is used to start playing a motion picture, a panorama, or a burst of SH, Time Lapse, or Stop Motion shots when the initial frame is displayed on the screen. The button also serves as a play/pause button once a movie has started playing, and it has various duties to move among settings on certain screens, such as the screen for saving Highlight Shadow values on the Recording menu, the screen for setting a custom White Balance setting, and the screen for saving a Custom Multi frame for AF Mode.

Right Button: White Balance

The Right button has the important duty of calling up the menu for selecting the camera's setting for White Balance. The White Balance menu option is needed because cameras record the colors of objects differently according to the color temperature of the light source that illuminates those objects.

Color temperature is expressed in Kelvin (K) units. A light source with a lower K rating produces a "warmer," or more reddish light. A source with a higher rating produces a "cooler," or more bluish light. Candlelight is rated about 1,800 K, indoor tungsten light (ordinary light bulb) is rated about 3,000 K, outdoor sunlight and electronic flash are rated about 5,500 K, and outdoor shade is rated about 7,000 K. If the camera is using a White Balance setting that is not designed for the light source that illuminates the scene, the colors of the recorded image are likely to be inaccurate.

The D-Lux, like most digital cameras, has an Auto White Balance setting that attempts to set the proper color correction for any given light source. The Auto White Balance setting works well, and it will produce good results in many situations, especially if you are taking snapshots whose colors are not critical.

If you need more precision in the White Balance of your shots, the D-Lux has settings for common light sources, as well as options for setting White Balance by color temperature and for setting a custom White Balance based on the existing light source.

You get access to this setting by pressing the Right button, which calls up the White Balance menu screen at the bottom of the display, as shown in Figure 5-40.

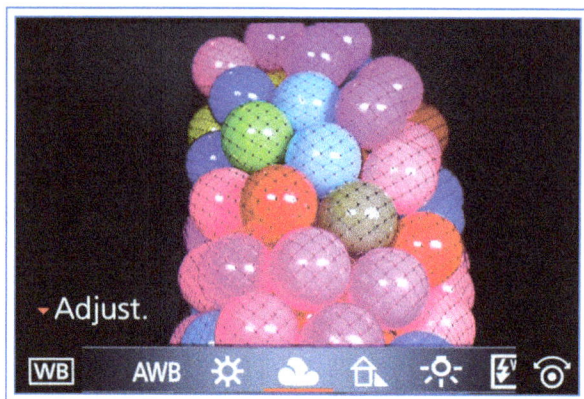

Figure 5-40. White Balance Menu

This menu includes the following choices for the White Balance setting, most of them represented by icons: Auto White Balance (AWB); Daylight (sun icon); Cloudy; Shade; Incandescent; Flash; White Set 1; White Set 2; White Set 3; White Set 4; and Color Temperature. (Only the first 6 options are shown in Figure 5-40; you need to scroll to the right to reach the others.)

Most of these settings are self-explanatory. You may want to experiment to see if the named settings (Daylight, Shade, Incandescent, etc.) produce the results you want. If not, you'll be better off setting the White Balance manually. To do that, you can use any one of the 4 White Set options, which let you measure the White Balance based on the light that is actually illuminating your subject, and save a custom setting to that numbered slot in the camera's memory. Then, you can use that custom setting whenever you are faced with the same lighting situation in the future.

To set White Balance manually, press the Right button to activate the White Balance menu and scroll to select one of the 4 White Set icons, as shown in Figure 5-41.

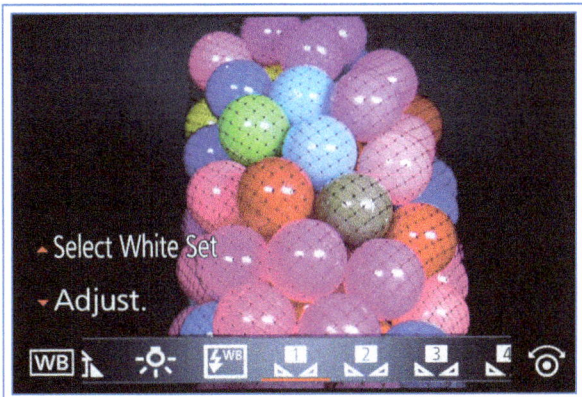

Figure 5-41. White Set Icon Highlighted

Press the Up button, and a yellow rectangle will appear in the middle of the display, as shown in Figure 5-42.

Figure 5-42. Yellow Frame for Setting Custom White Balance

Aim the camera at a white or gray surface illuminated by the light source you will be using, and fill the rectangle with the image of that surface. Then press the Menu/Set button (or you can press the shutter button if you prefer) to lock in that White Balance setting. The camera will display a Completed message if the setting was successful. Now, until you change that setting, whenever you select that preset value (White Set 1 or another slot, as the case may be), it will be set for the White Balance you have just set. This system is useful if you often use a particular light source and want to have the camera set to the appropriate White Balance for that source.

To set the color temperature directly by numerical value, choose the Color Temperature option from the White Balance menu, as shown in Figure 5-43.

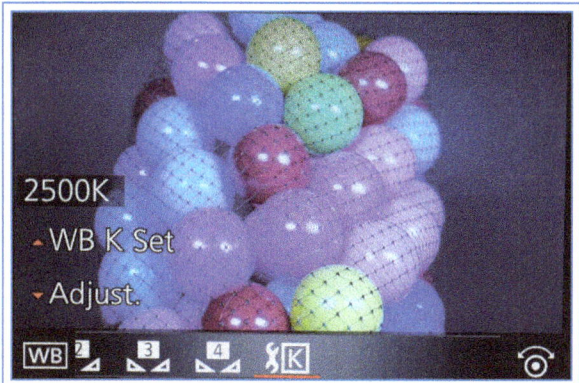

Figure 5-43. Color Temperature Icon Highlighted

Press the Up button to pop up a screen with a value such as 2500K displayed. You then can press the Up and Down buttons or turn the control dial to adjust that value anywhere from 2500K to 10000K in increments of 100K, as shown in Figure 5-44, where the value is set to 4400K.

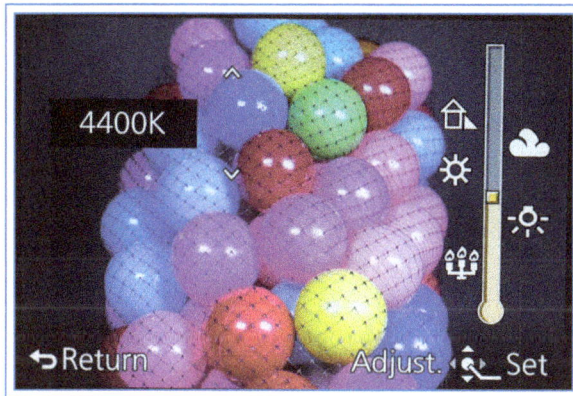

Figure 5-44. Color Temperature Setting Screen

One issue with this approach is that you have to know the color temperature of your light source in order to make this setting. One way to find that value is to use a color temperature meter like the Sekonic Prodigi meter shown in Figure 5-45.

Figure 5-45. Sekonic Prodigi Color Meter

That meter is helpful when you're striving for accuracy in your White Balance settings, but it is fairly expensive, and you may not want to use that option. In that case, you can still use the Color Temperature option, but you will have to do some guesswork or use your own sense of color. For example, if you are shooting under lighting from incandescent bulbs, you can use 3,000 K as a starting point, because, as noted earlier, that is the approximate color temperature of that light source. Then you can try setting the color temperature figure higher or lower, and watch the camera's display to see how natural the colors look. As you lower the color temperature, the image will become more "cool" or bluish; as you raise it, the image will appear more "warm" or reddish. Once you have found the best setting, leave it in place and take your shots.

Once you have made the White Balance setting, either using one of the preset values such as Daylight, Incandescent, or Cloudy, or using a custom-measured setting or a color temperature, you still have the option of fine-tuning the setting to an additional degree.

To make this further adjustment, after you make your White Balance setting, before pressing the Menu/Set button to return to the recording screen, press the Down button, and you will be presented with a screen for fine adjustments, as shown in Figure 5-46.

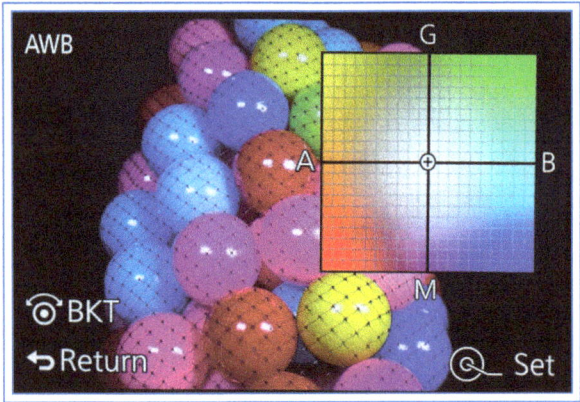

Figure 5-46. White Balance Adjustment Axes

You will see a box containing a pair of axes that intersect at a zero point, marked by a circle with a plus sign inside it. The 4 ends of the axes are labeled G, B, M, and A, for green, blue, magenta, and amber.

You can now use all 4 direction buttons to move the circle away from the center toward any of the axes, to adjust these 4 values until you have the color balance exactly how you want it. The camera will remember this value whenever you select the White Balance setting that you fine-tuned. When you have fine-tuned the setting using this screen, the White Balance icon on the camera's display changes color and/or adds an indicator to indicate what changes you have made along the color axes. If there was an adjustment to the amber or blue side, the icon changes color accordingly. If there was an adjustment to the green or magenta side, the icon will have a plus sign added for green or a minus sign added for magenta.

Figure 5-47. White Balance Icon Showing Blue Adjustment

For example, Figure 5-47 shows the icon, in the bottom right corner of the screen, after the White Balance setting was adjusted toward the amber and magenta sides of the axes. If you want to reset the adjustment axes to the zero point, press the Display button and the circle will return to the center of the adjustment area.

One more note: If you're shooting with Raw quality, you don't have to worry about White Balance so much, because, once you load the Raw file into your software, you can change the White Balance however you want. This is one of the advantages of using Raw. If you had the camera's White Balance setting at Incandescent while shooting under a bright sun, you can just change the setting to Daylight in the Raw software, and no one need ever know about the error of your shooting.

Before I discuss White Balance bracketing, I am going to include a chart in Figure 5-48 that shows how the different White Balance settings affect the images taken by the D-Lux. The images in this chart were taken under artificial light balanced for daylight, with the camera set for each available White Balance setting, as indicated on the chart. In my opinion, the best results were obtained with the Auto White Balance, Daylight, Color

Temperature, and White Set settings. The Flash setting also appeared to match the actual color temperature quite closely, and the Cloudy and Shade settings did not do badly. The Incandescent setting is the only one that yielded a result that clearly is incorrect.

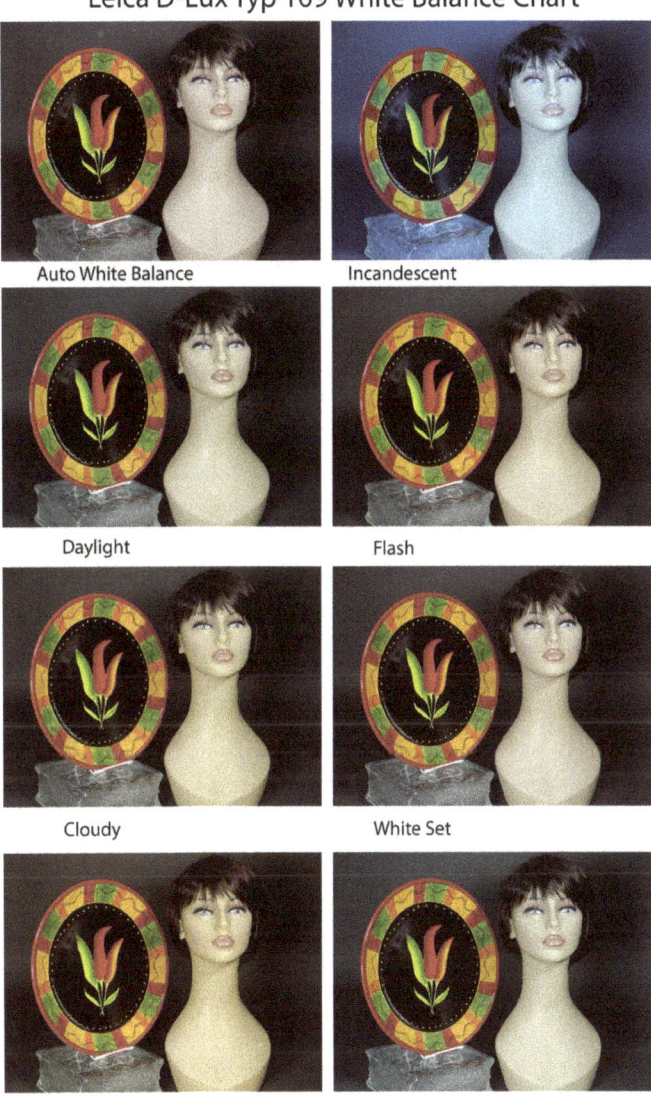

Figure 5-48. White Balance Chart for Leica D-Lux

There is one other aspect of White Balance that needs to be discussed. Later in this chapter I'll discuss exposure bracketing, also known as Auto Bracket, a feature by which the D-Lux automatically takes several pictures at varying exposure settings, so you can have multiple options to choose from. You can do something similar with White Balance—set the camera to take 3 images at once with different White Balance settings, to give you a better chance of having one image with perfect color balance. I'm discussing this option here rather than in the section on Auto Bracket, because this option is accessed from the White Balance setting screen.

Here is how to set up White Balance bracketing. After pressing the Right button to select White Balance, highlight the icon for a main setting, such as Daylight, Incandescent, White Set 1, or any other choice. Then press the Down button to move to the fine adjustment screen, which I discussed above. First, make any adjustments you want to make, such as tweaking the White Balance to the blue side by pressing the Right button a few times. (Of course, you may not need to make any such adjustments.)

Then, you need to decide on which axis to set the bracketing: the amber-blue axis, or the magenta-green axis. If you want to use the amber-blue axis, turn the control dial to the right; if you want to use the magenta-green axis, turn the dial to the left. As you turn it in either direction, you will see small circles appear on the chosen axis. The circles will spread apart as you continue to turn the dial. The final positions of those circles indicate the differences among the 3 shots that the camera will take. If you have also set an adjustment to the White Balance setting using the adjustment screen, the White Balance bracketing will take the adjustment into account and bracket the exposures with the adjustment factored in.

For example, Figure 5-49 shows how White Balance bracketing is set up to take 3 shots with the greatest possible differences along the amber-blue axis.

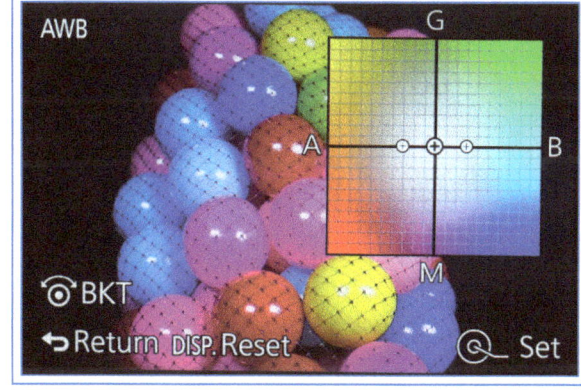

Figure 5-49. White Balance Bracket Setting Screen

Once the circles are set up as illustrated here, press the Menu/Set button, and the camera will return to the White Balance screen. Then press that button again or press the shutter button halfway to return to the live view.

Figure 5-50. White Balance Bracket Icon on Display

As shown in Figure 5-50, the display will then show the BKT icon just above the icon for the White Balance setting, in the lower right corner of the display. Now, when you press the shutter button, the camera will take 3 pictures with different White Balance adjustments, from more amber to more blue. You will only hear the sound of the shutter once, though; the camera alters the White Balance settings electronically. To cancel the bracketing, return to the adjustment screen and press the Display button.

This function does not work in Snapshot mode. It also does not work with Raw images or with certain other settings, including HDR, Multiple Exposure, and Time Lapse. It also will not work with motion picture or panorama shooting.

Besides giving access to White Balance settings, the Right button has some miscellaneous functions. For example, when playing movies and slide shows, the Right button acts as a navigation control to move through the images, and it is used to navigate among the various portions of screens with settings, such as the Highlight Shadow and Photo Style screens. When you have activated a picture effect with the Filter button, you can press the Right button to get access to a screen for making an adjustment to that setting.

Left Button: Autofocus Mode/MF Assist

The Left button is marked with an icon that represents the focus mode used by the camera. In this context, focus mode means the area where the camera directs its focus. Pressing the button has different effects depending on whether the camera is in an autofocus mode or manual focus mode.

Use of Left Button in Autofocus Mode

When you press the Left button with the focus switch set to the AF or AF Macro position, the camera displays a line of icons representing the 6 choices available for the AF Mode setting: Face/Eye Detection; AF Tracking; 49-Area; Custom Multi; 1-Area; and Pinpoint, as shown in Figure 5-51.

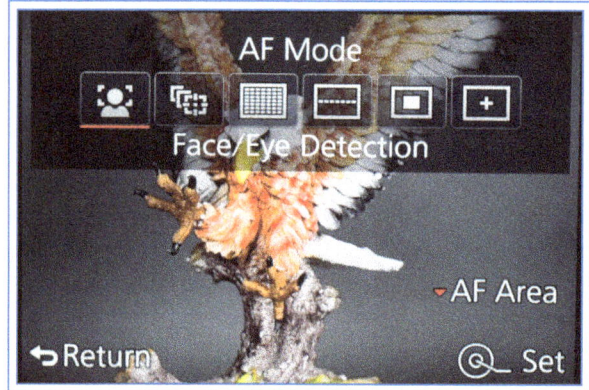

Figure 5-51. AF Mode Options Screen

Use the control dial or the Left and Right buttons to highlight the choice you want, then press the Menu/Set button or press the shutter button halfway to select that setting and return to the recording screen.

In Snapshot mode, only 2 of these options are available: Face/Eye Detection and AF Tracking. When you press the Left button, the camera switches between those 2 settings. Following are details about all 6 options that are available in the PASM recording modes.

Face/Eye Detection

When you select this setting, the camera does not display any focusing brackets or rectangles until it detects a human face. If it does, it outlines the general area of the face with a yellow rectangle. Then, after you press the shutter button halfway down, the rectangle turns green when the camera has focused on the face. If the camera detects more than one face, it displays white rectangles for secondary faces, as shown in Figure 5-52.

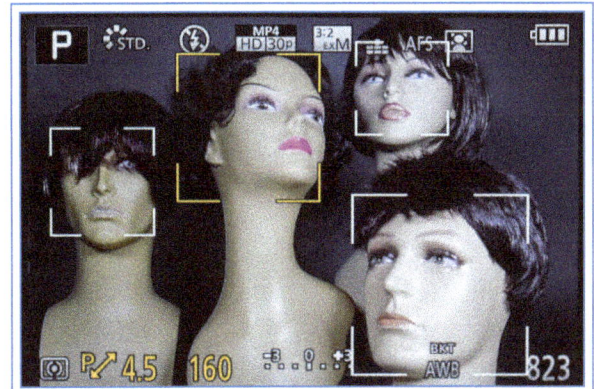

Figure 5-52. Display When Multiple Faces Are Detected

Any faces that are the same distance away from the camera as the face within the yellow rectangle will also be in focus, but the focus will be controlled by the face in the yellow rectangle. If Metering Mode is set to Multi, the camera will also adjust its exposure for the main detected face.

With this setting, the camera also will look for human eyes, and will place a set of crosshairs across the closest eye it finds and will fix focus there. If you want, you can change the face that the camera focuses on. To do that, when the camera is displaying frames over detected faces, press the Left button, then the Down button, and the camera will display a frame with arrows on the sides. You can turn the control dial to change the size of the frame, and use all 4 direction buttons to move it around the screen. (You also can use the other methods for moving the focus frame, discussed later in this section, after the discussion of the Pinpoint option for AF Mode.)

When the focus frame is sized and located as you want, press the Menu/Set button to lock it in place. The camera will then shift its focus to the area inside that frame. You might want to use this option if you are aiming at 2 faces, but you want to focus on the one that is farther away from the camera. Ordinarily, the camera will focus on the closest face, but if you move the frame over the other face, the camera will direct its focus there. You also can use the movable frame to change the focus to a different eye than the one the camera detected. To reset the frame to its original position, press the Display button while the frame is movable.

AF Tracking

This next setting for AF Mode allows the camera to maintain focus on a moving subject. After you press the Left button, highlight the second icon, which is a group of offset focus frames, designed to look like a moving focus frame. Press the Menu/Set button or half-press the shutter button to select this option.

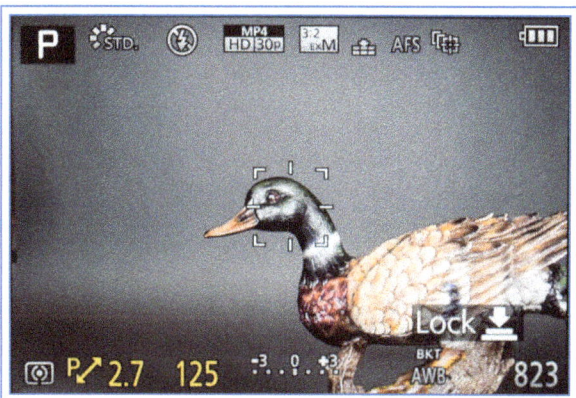

Figure 5-53. AF Tracking Frame Ready to Lock on Subject

The camera will then display a special white focus frame, with spokes sticking out of it, in the center of the display, as shown in Figure 5-53. Move the camera to place this focus frame over your subject and press the shutter button halfway, then release the button. If the camera can identify a subject at this location, the frame will turn yellow. The camera will then do its best to keep that target in focus, even as it (or the camera) moves. The yellow bracket should stay close to the subject on the display. When you are ready, press the shutter button to take the picture. If you want to cancel AF Tracking, press the Menu/Set button.

If the camera is not able to maintain focus on the moving subject, the focus frame will turn red and then disappear. AF Tracking will not work with certain settings, such as Time Lapse Shot, the Monochrome setting of Photo Style, and several Filter button effect settings, including all of the Monochrome options; the camera will use 1-Area mode instead.

When would you use AF Tracking? The idea here is to reduce the time it takes for you to focus on a moving subject and to make sure the camera focuses on the subject you are interested in. If you are trying to snap a picture of your restless 4-year-old or your fidgety Jack Russell Terrier, AF Tracking can give you a head start, so the camera's focus is close to being correct and the focusing mechanism has less to do to achieve correct focus when you suddenly see the perfect moment to press the shutter button.

49-Area

This next option for Autofocus Mode causes the camera to focus on up to 49 small focus zones within the overall autofocus area, which is the same area as that of the current aspect ratio setting. The camera then looks within the focus zones and selects however many subjects it detects that are at the same distance from the camera and can be focused on.

To make this setting, select the third icon on the AF Mode menu, which looks like a screen with multiple focus points. Then, when you push the shutter button down halfway, the camera will display green rectangles to show you which of the multiple focus areas it has selected to focus on, as shown in Figure 5-54.

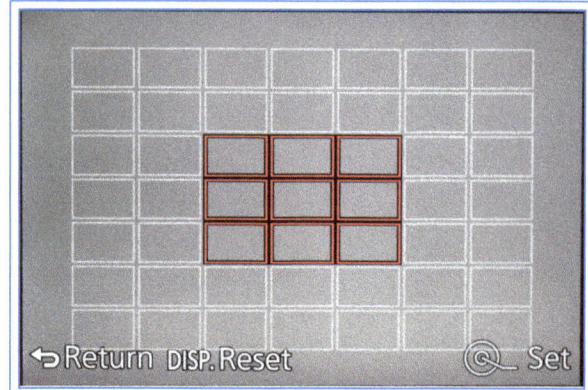

Figure 5-55. Setup Screen for 49-Area Focus Mode

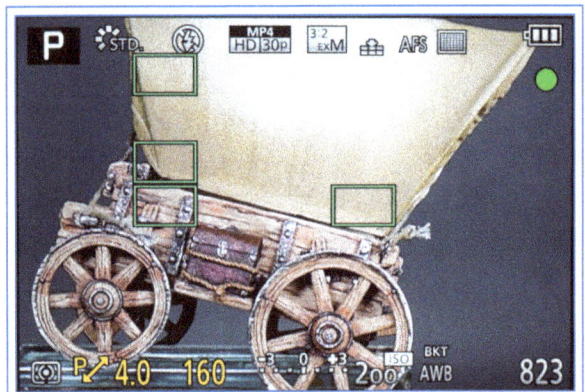

Figure 5-54. Green Focus Frames for 49-Area Focus Mode

The name of this setting is somewhat misleading, however, because, even though the camera has 49 focus zones, it will only use a few of those zones at any one time in this mode. By default, the camera uses the 9 zones in the center of the screen. So, with the default setting, if you focus on a scene with a prominent object at the far right, the camera will choose whatever object it can find in the center of the display to focus on, and will ignore the object at the right.

If you want the camera to direct its focus somewhere other than the center of the scene, press the Down button while the 49-Area icon is highlighted on the menu screen, and then move the block of focus zones where you want them, using a procedure similar to that for moving the area for Face/Eye Detection, as shown in Figure 5-55.

Whenever this AF Mode setting is in use, the camera displays a small white cross on the screen to indicate the center of the block of focus zones it is currently using. The blocks near the center of the overall focus area have 9 zones each, but the blocks near the edges of the display area have only 6 or 4 blocks.

The 49-Area method can be useful if your subject is likely to be located within a predictable area, and you want to have the option to adjust that area somewhat. It is a good mode to use when you are shooting landscapes or general scenes that do not require you to focus on faces or on any one particular object.

Custom Multi

This setting lets you create a custom-tailored focus zone out of the 49 available blocks. For example, you can create a horizontal focus area that is 7 blocks across, or a vertical one of the same size. You can create a zone that has 21 blocks arranged in 3 lines of 7, either horizontally or vertically. Or, you can create a completely free-form zone with any arrangement of blocks. Somewhat oddly, with this last option you can create a focus area that uses all 49 of the focus zones, resulting in a true 49-Area focus mode, unlike the mode with that name, which can use only up to 9 areas. The process for using this option is a bit complicated, so I will lay out the steps below.

1. From the recording screen, press the Left button to get access to the AF Mode menu and scroll to the fourth icon from the left, with the label Custom Multi below it, as shown in Figure 5-56.

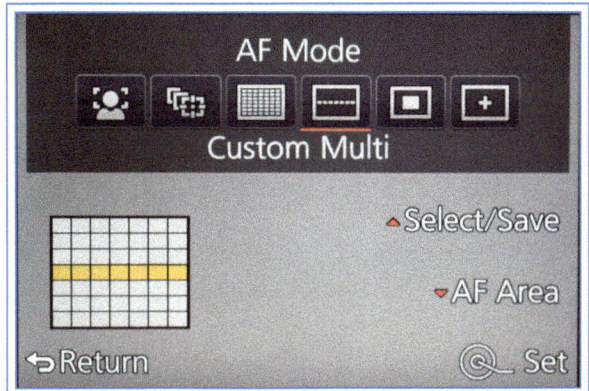

Figure 5-56. Custom Multi AF Mode Option Highlighted

2. Press the Up button to move to the line of possible patterns for the focus zone, as shown in Figure 5-57.

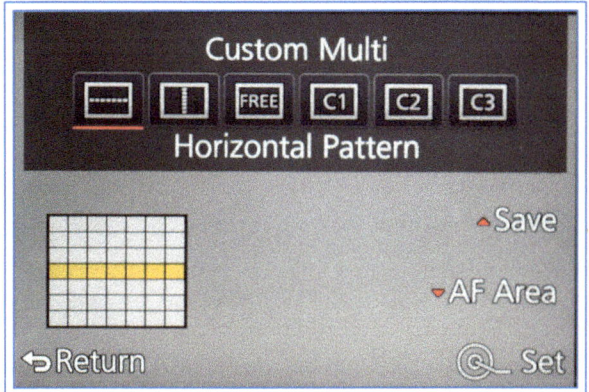

Figure 5-57. Custom Multi Patterns Screen

3. Scroll through these icons to select the one you want. The last 3—C1, C2, and C3— are for custom patterns you can create and save to these slots.

4. When you have selected either horizontal, vertical, or free-form for the shape, press the Down button to move to the AF Area option. There you will see a screen with all 49 blocks, some of which will be highlighted in red for the horizontal or vertical choices, but all of which will be blank for the free-form option.

5. For the horizontal or vertical option, turn the control dial to the right to increase the size of the focus area, up to 3 lines of blocks, or turn it to the left to reduce it back to a single line of blocks. You can move the line or lines across the display by pressing the appropriate direction buttons. When you have the focus area positioned where you want it, press the Fn2 button, above the LCD screen, to set the focus area in place. The blocks will display for a moment and then disappear, and this focus area will be in effect.

6. For the free-form option, after pressing the Up button, scroll to the icon that says Free, then press the Down button to move to the AF Area screen. You will then see a display with all 49 blocks, none of which are highlighted, with a cross in the center block. Use the direction buttons to move the cross to a block you want to add to the focus pattern, and press the Menu/Set button to highlight it. Figure 5-58 shows this screen after several blocks have been selected in this way. The blocks do not have to be contiguous; they can be in any pattern, up to and including selecting all 49 blocks. When you have finished selecting blocks, press the Fn2 button to lock in the pattern you have created.

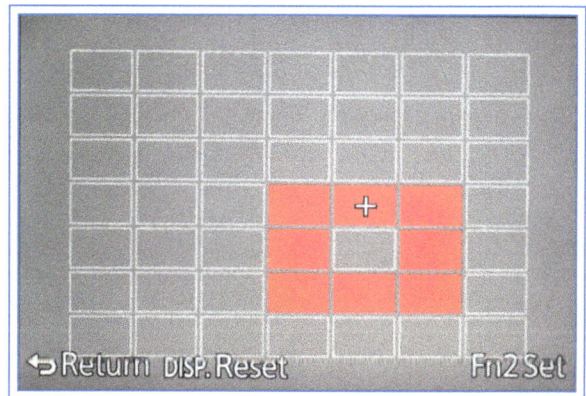

Figure 5-58. Custom Multi AF Pattern Setup Screen

7. To create and save a custom focus pattern, use the same procedure as in Step 5 or Step 6. When you have finished, press the Left button to bring the AF mode menu back on the screen. Then scroll to the Custom Multi option. Press the Up button to move to the line of options, and scroll to the focus pattern you just created, whether horizontal, vertical, or free-form, then press the Up button. The camera will display a screen like that in Figure 5-59, asking which Custom slot you want to save it to. Highlight the one you want and press Menu/Set, then select Yes when asked if it should overwrite the existing settings. To select the saved pattern in the future, just select C1, C2, or C3, depending on what slot the pattern was saved to.

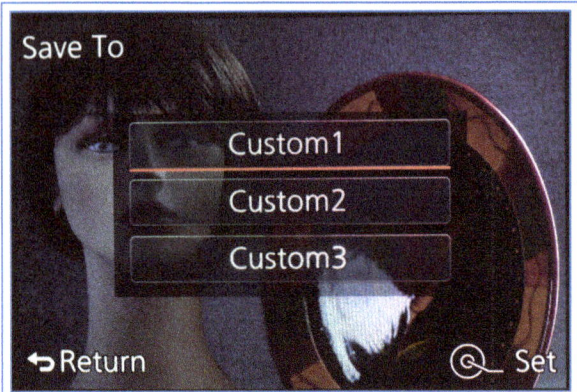

Figure 5-59. Screen to Save Custom Multi AF Area

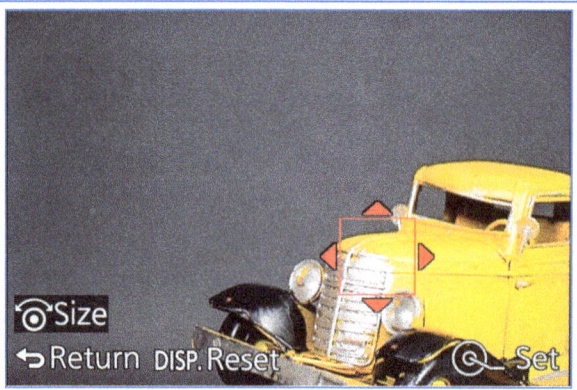

Figure 5-61. 1-Area AF Frame Ready to Move

The Custom Multi option is quite powerful if you have a need for specially shaped focus zones. You might want to use a horizontal zone if you are focusing on a group of artifacts that are displayed in a straight line, to make sure the camera does not accidentally focus on an object outside of that line. You also might want to create a pattern that uses all 49 focus zones, so the camera will focus on the closest object, regardless of whether it is in the center of the image, or in a particular sector of the image.

1-Area

This AF Mode setting is selected with the next-to-last icon on the AF Mode menu, as shown in Figure 5-60. With this option, the camera uses a single focus frame, which by default is in the center of the screen. You can customize the setting by moving the single frame to any position on the display and changing its size.

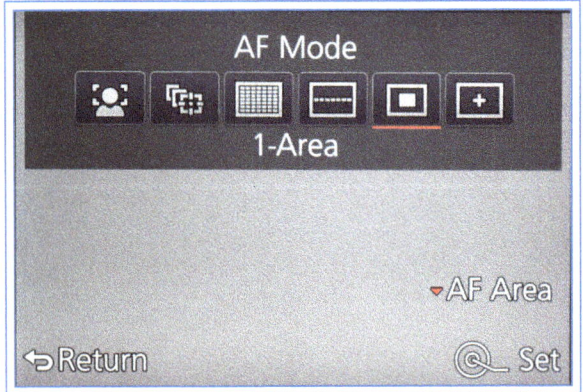

Figure 5-60. 1-Area AF Mode Highlighted

When you have highlighted the 1-Area icon on the AF Mode menu, press the Down button to move directly to setting the location of the autofocus frame using the direction buttons, as shown in Figure 5-61. You can change the size of the frame by turning the control dial.

When you have finished moving and resizing the focus frame, press the Menu/Set button to fix the frame in place. To move the frame back to the default location in the middle of the screen or reset its size to normal, press the Display button at the bottom right of the camera. If the frame has been moved and resized, you have to press Display once to reset the location and once more to reset the size.

The 1-Area method is a very good one to use for general shooting, because it lets you quickly position the focus area just where you want it. It is particularly helpful when you need to make sure the camera focuses on a fairly small item that is not in the center of the scene.

Pinpoint

Finally, the last icon at the right of the line of AF Mode icons is used to select the Pinpoint option. With this setting, you can move a single focus frame around the display and resize it, and the camera will enlarge the focus area to help you get the focus frame positioned precisely where you want it.

After pressing the Left button to bring up the AF Mode icons, highlight the Pinpoint icon and press the Down button to move to the AF Area screen. Move the focus area around the display using the 4 direction buttons and resize it using the control dial, then press the Menu/Set button to set the focus area's location and size. Then, while the focus frame is still movable, with arrows displayed, you can enlarge the display by turning the control dial, to assist you in getting the focus area set exactly where it is needed.

You can control the amount of enlargement for this display using the Pinpoint AF Display item on screen 3 of the Custom menu. If you select Full for that item, the image will be enlarged from 3 times to 10 times

and the enlargement will fill the display. If you select PIP, for picture-in-picture, the enlarged area will not take up the entire display, and the enlargement will only range from 3 times to 6 times. When the display is enlarged, you can vary the amount within the specified range by turning the control dial. When the focus frame is located just where you want it, press the Menu/Set button to exit to the recording screen.

When you focus on an item using this setting, place the small white cross over the subject and press the shutter button halfway. The camera will enlarge the display at that area for a short time while you keep the shutter button half-pressed, to help you determine whether focus is sharp. The length of time that the display remains enlarged with this option is determined by the Pinpoint AF Time option on screen 3 of the Custom menu; the time can range from 0.5 second to 1.5 second. The display then returns to normal size so you can evaluate the entire scene before pressing the shutter button to take the picture.

Moving the Focus Frame or Focus Area

With all of the AF Mode options except AF Tracking, you have the ability to move the focus frame. With the D-Lux, it is not difficult to do this, even after you have returned the camera to the recording screen. Just press the Left button to call up the menu of AF Mode choices and select the current AF Mode option. Then press the Down button to go to the screen for moving the frame, move it with the direction buttons and resize it with the dial if necessary, then press Menu/Set and you're ready to focus again with the frame in a new location.

For a faster way to move the focus frame (or broader focus area, for the 49-Area or Custom Multi setting), there are 2 other options. First, you can set one of the Function buttons to the Focus Area Set option through screen 7 of the Custom menu, as discussed in Chapter 7. Then, if you press that Function button, the screen for moving the focus area will appear immediately. Second, you can turn on the Direct Focus Area option on screen 3 of the Custom menu. Then, from the recording screen, as soon as you press any of the 4 direction buttons, the focus area moving screen will appear. (A drawback of that option is that you cannot then use the direction buttons to call up options such as White Balance, ISO, and Drive Mode. You can use the Quick Menu to activate those items, though, or you can assign Function buttons to those settings.)

Use of Left Button in Manual Focus Mode

If you press the Left button when the focus switch is set to the MF position for manual focus, the button activates the MF Assist frame so you can move it around the screen to determine the area to concentrate on for adjusting manual focus. Pressing the button also can immediately enlarge the manual focus area, depending on the setting of the MF Assist option on screen 4 of the Custom menu.

Besides giving access to the AF Mode and MF Assist settings and navigating through menu and settings screens, the Left button has various miscellaneous duties. For example, in Snapshot mode, you can press this button to switch between Face/Eye Detection and AF Tracking for focus mode. In playback mode, this button acts as a navigation control to move through images and videos.

Down Button: Drive Mode

The last of the cursor buttons to be discussed, the Down button, provides access to Drive Mode, which includes settings for the camera's burst shooting, bracketing, panorama, and self-timer options.

When you press the Down button, you will see a line of icons, as shown in Figure 5-62.

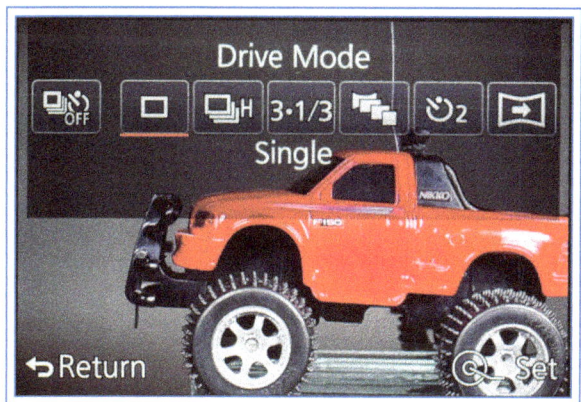

Figure 5-62. Drive Mode Menu

Scroll through them with the control dial or the Left and Right buttons. As you highlight each one, the camera places a label underneath it listing its function. From left to right, these icons have the following functions: burst shooting off; single shooting; burst shooting on; Auto Bracket; Aspect Bracket; self-timer; panorama shooting. I will discuss all of these functions below.

The first 2 icons on the Drive Mode menu have the same function—to turn off all burst shooting, including the

self-timer. There is no functional difference between the 2; you can select either one when you want to make sure the camera is not set to use the panorama, burst, bracketing, or self-timer options. There are some camera settings, such as Intelligent Zoom, Digital Zoom, and Date Stamp, that do not function when one of the burst shooting options is selected, so, if you find a feature is not working, you may want to select the first or second Drive Mode icon to disable all burst features and see if that removes the conflict.

The third icon is used to activate burst shooting, which I will discuss now.

Burst Shooting

Burst shooting, sometimes called continuous shooting, is a mode in which the camera takes a continuous series of images while you hold down the shutter button. This capability is useful in many contexts, from shooting an action sequence at a sporting event to taking a series of shots of a portrait subject to capture changing facial expressions. I often use this setting for street photography to increase my chances of catching an interesting image.

To activate burst shooting, press the Down button, then scroll to the third icon from the left. It looks like a stack of frames with the letters SH, H, M, or L beside it, for super-high, high, medium, or low speed bursts. Once this icon is highlighted, press the Up button to get access to more settings, and you will see icons with all 4 of those speed notations, as shown in Figure 5-63.

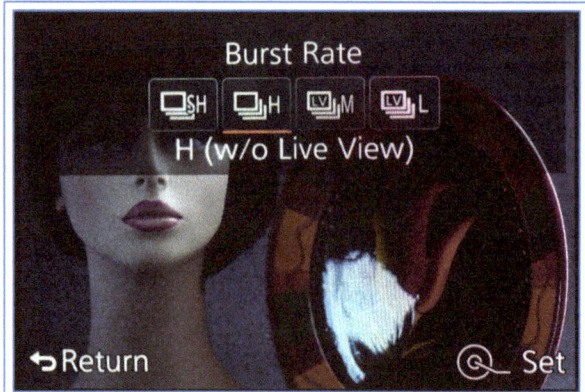

Figure 5-63. Burst Rate Selection Screen

Scroll through those icons to select the one you want to use, then press the Menu/Set button to activate it and return to the recording screen. I will discuss these 4 options in turn.

Super-high. If you select SH for super-high, the camera will take a very fast burst of shots at a speed of 40 frames per second (fps), but with several limitations. The images cannot be of Raw quality, they are limited to Small for the Picture Size setting, and the burst will stop after 60 images are taken. In addition, the only autofocus mode available is AFS, for single autofocus, though you can use manual focus if you want. The focus, exposure, and White Balance settings will be fixed with the first shot, and there will be no updated live view of the current scene on the camera's display. The camera will use the electronic shutter.

Despite these limitations, the SH setting for burst mode is quite powerful. The ability to take a burst of 60 shots, even at the relatively small size of about 3 MP, depending on aspect ratio, lets you do a high-speed study of a sports action such as golf swing, or of any other fast-moving action. For example, Figure 5-64 is a composite image with several shots from a burst I took with the SH setting of a group of birds vying for the best position at a bird feeder.

Figure 5-64. Series of Shots Taken in SH Burst Mode

When you take a burst of shots with the SH setting, the camera saves them in a group, so you do not have to scroll through as many as 60 images. When you press the Playback button, you will see a screen like that in

Figure 5-65, showing that you can press the Up button to play the burst as a group, using Burst Play.

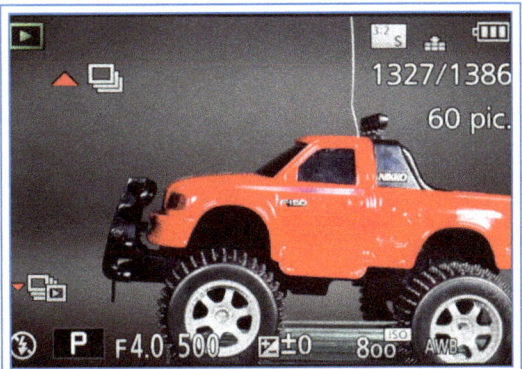

Figure 5-65. Display for Playing Back SH Burst Images as Group

If you press that button, the camera will display the images rapidly, almost like a movie.

Figure 5-66. Options for SH Burst Playback

If you press the Down button, you will see a screen like that shown in Figure 5-66, which gives you the option to display the images individually. You can then scroll through all of the images from the burst in normal playback mode, using the normal playback controls.

The next burst option is H, for high-speed shooting. As you might expect, reducing the speed to this level increases the capability of the feature. With this setting, there still is no updating live view on the camera's display during shooting, but most of the other restrictions are lifted. So, you can shoot with Raw quality and the camera can adjust its focus during shooting. If the focus mode is set to AFS or MF, the exposure and White Balance settings will be fixed with the first shot. However, if you set the focus mode to AFF or AFC, the camera can adjust focus, exposure and White Balance for each shot (depending on conditions), at the expense of a loss in speed of shooting. The maximum speed available is 11 fps with single autofocus or manual focus, and 6.5 fps with flexible or continuous autofocus.

With the next lower speed, M, for medium, the camera can provide an updating live view throughout the shooting, and otherwise can perform the same as with the H setting with respect to focus and exposure. The maximum speed drops to 7 fps with single autofocus or manual focus and stays at 6.5 fps for continuous or flexible autofocus.

Finally, with the lowest speed, L, for low, the speed drops to 2 fps with all focus modes.

With all burst shooting, the specifications for speed and numbers of images will vary according to conditions. When conditions are dark and the camera has to use a slower shutter speed, that factor alone will slow down the shooting. Other factors that affect shooting capacity and speed include image quality and the speed and capacity of the memory card in the camera. I carried out some indoor experiments with my camera using a very fast card, the SanDisk Extreme PRO 32 GB, rated in UHS Speed Class 3. Table 5-1 gives the results of my tests.

Table 5-1. Results of Burst Shooting Tests with Leica D-Lux Camera

Burst Mode	Image Quality	Image Size	Focus Mode	No. Images Before Slowdown	Remarks
H	Raw & JPEG	L	AFS	24	
H	Raw	-	AFS	26	
H	Fine	L	AFS	98	
H	Raw & JPEG	L	AFC	28	Average focusing
H	Fine	L	AFC	480+	Average focusing
M	Raw & JPEG	L	AFC	28	Good focusing
L	Raw & JPEG	L	AFC	40	Good focusing

My results did not always agree with the expected results according to the specifications, though Leica makes it clear that results will be affected by shooting conditions. Based on these results, my recommendation is to use the slower speeds when you don't need super-fast shooting. For example, if you are taking a portrait and would like to capture changing expressions but don't need to freeze an action as you might at a sporting event, try using the L or M setting to increase your chance of getting usable shots, especially if you are using continuous autofocus.

If you are shooting sports or other fast-moving events, you should get good results with the H setting, especially if the action is at a constant distance and you can use single autofocus. As noted in the table above, I did not get great results with focus adjustments using the H setting, though the dim lighting for my shots probably was a contributing factor. Also, I was using the Release setting for the Focus/Release Priority option on screen 3 of the Custom menu. With that option, the camera uses predictive focusing and gives more priority to speed of shooting than to accuracy of focusing. With the Focus setting for Focus/Release Priority, focusing results may be better, depending on other conditions.

Of course, you also can use the SH setting when you need a really fast burst for a very limited time, with small image size.

The burst-shooting options are available in every shooting mode for still images, including Snapshot. However, there are several limitations on the use of burst shooting. You cannot use it with flash, or with the Rough Monochrome, Silky Monochrome, Miniature, Soft Focus, Star Filter, or Sunshine Filter button effect settings. You also cannot use it with some of the other special settings such as Multiple Exposure, White Balance Bracket, Time Lapse Shot, iHandheld Night Shot, and HDR, or during motion picture recording.

After shooting with any of the burst options, you are likely to see for at least a few seconds the red icon indicating that the camera is writing images to the memory card; while that icon is displayed, you should not try to take any more pictures, and you should not open the battery compartment cover or otherwise interfere with the camera's operation.

Finally, it is worthwhile to mention here one of the outstanding features of the D-Lux camera—the 4K Photo menu option, available on screen 1 of the Motion Picture menu. With that setting, you can quickly set up the camera to record 4K, ultra-high-definition video footage that is optimized for saving still frames from the video. In effect, the 4K Photo setting gives you another option for burst shooting at a rate of 30 fps (for U.S. cameras; for cameras sold in some other areas the rate is 25 fps). The individual frames saved from this recording mode are likely to be of high quality, with a size of 8 megapixels and excellent sharpness. So, if you are able to use a fast SD card (UHS Speed Class 3), don't forget to consider this other option when you need an extended burst of high-quality shots.

Auto Bracket

The fourth icon from the left on the Drive Mode menu represents the Auto Bracket option, which sets up the camera to take multiple images with one press of the shutter button with different exposure settings, giving you an added chance of getting a usable image. If you're shooting with Raw quality, exposure is not so much of an issue, because you can adjust it later with your software, but it's always a good idea to start with an exposure that's as accurate as possible.

Also, you can use this feature to take several differently exposed shots that you can merge into a single HDR image, in which the images combine to cover a wider range of lights and darks than any single image could. This merging can be accomplished using software such as Photoshop (use the command File-Automate-Merge to HDR) or a more specialized program such as PhotoAcute or Photomatix Pro. For HDR shooting, I suggest you set the interval between the exposures to the full range available, which is 1 EV. If possible, you should use a tripod so all of the images will include the same area of the subject and can be easily merged in the software.

After you highlight the Auto Bracket icon, press the Up button to move the highlight to the screen for setting the number of exposures and the EV (exposure value) interval between shots, as shown in Figure 5-67.

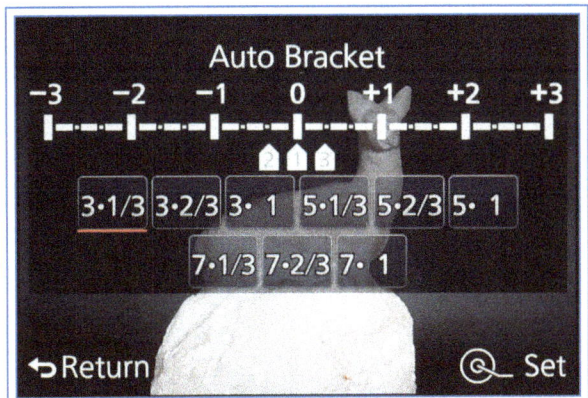

Figure 5-67. Auto Bracket Setting Screen

Then turn the control dial or press the Left and Right buttons to scroll through the 9 possible options. These options let you choose 3, 5, or 7 images, taken at EV intervals of 1/3, 2/3, or 1. For example, if you select the 5•2/3 option, the camera will take 5 images with an interval of 2/3 stop between them. You will hear multiple shutter sounds as the exposures are recorded.

As I discussed in Chapter 4, you can use the Auto Bracket option on screen 2 of the Recording menu to set the options for Auto Bracket, including the number of images and the EV interval, as well as 2 other options. With that menu item, you can set the camera to take the multiple shots either as a burst, as described above, or singly, if you want to have the camera pause after each exposure so you can evaluate the scene, adjust costumes or props, and the like. In that case, you have to press the shutter button to take each shot in the series. You also can specify the order of the images, choosing either the default order of normal exposure, followed by lower and then higher, or the order going from lowest exposure to highest.

The Auto Bracket procedure is not available with Snapshot mode or when shooting movies, nor with several other settings, the same as those specified earlier for burst shooting. Auto Bracket is not canceled when the camera is turned off, so be sure to cancel it when you have finished using the feature.

Aspect Bracket

This next icon on the Drive Mode menu lets you take multiple images with one press of the shutter button, all with different aspect ratios. You don't have to select anything other than the function itself, because there are 4 aspect ratios available with the D-Lux—3:2, 16:9, 1:1, and 4:3—and the camera automatically records your image using all 4 of these settings.

To activate the Aspect Bracket procedure, select this icon, shown in Figure 5-68, and press the Menu/Set button or half-press the shutter button to select it and return to the recording screen.

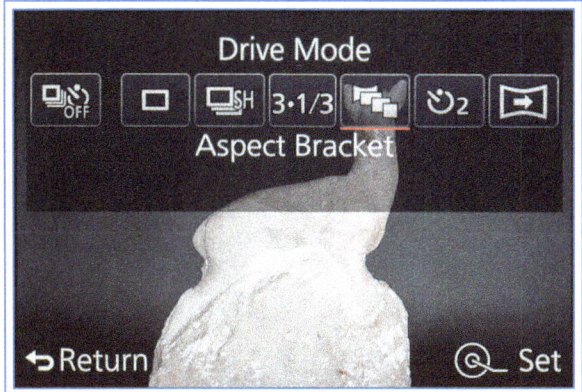

Figure 5-68. Aspect Bracket Icon Highlighted

Now you will see a screen like that shown in Figure 5-69, with 4 different colored rectangles outlining the frames for the 4 aspect ratios. When you press the shutter button, the camera will record the same scene 4 times, using each of those aspect ratios.

Figure 5-69. Aspect Bracket Shooting Screen

One thing that can be a bit confusing about Aspect Bracket is that you will hear only one shutter activation, so it will sound as if only one picture is being taken, but the camera actually records 4 images at the same time with the single shutter sound.

Aspect Bracket cannot be used at the same time as White Balance Bracket, and Aspect Bracket is not available when you are shooting with Raw quality. It also conflicts with various Filter button effects and some other settings. However, you can use the flash

with this setting. Aspect Bracket remains in effect when the camera is powered off and then back on.

Self-timer

The next-to-last icon in the line of Drive Mode options represents the self-timer. When you activate the self-timer, the camera delays for the specified number of seconds (10 or 2) after you press the shutter button before taking a picture. The 10-second setting is of great use when you need to place the camera on a tripod and press the shutter button, and then run around to join a group of people the camera is aimed at. The 2-second setting is helpful when you need to avoid jiggling the camera by pressing the shutter button as the exposure is taken. This is the case when taking extreme closeups or other shots in which focus is sensitive.

To activate the self-timer, scroll to the next-to-last Drive Mode icon and press the Up button to select further settings. You will see the display shown in Figure 5-70, with 3 options. These selections are, from left to right, 10-second self-timer; 10-second self-timer with 3 images taken; and 2-second self-timer. Select the setting you want with the Left and Right buttons or by turning the control dial. (You also can press the Up button to cycle through the choices.) You can then press Menu/Set or half-press the shutter button to return to the recording screen.

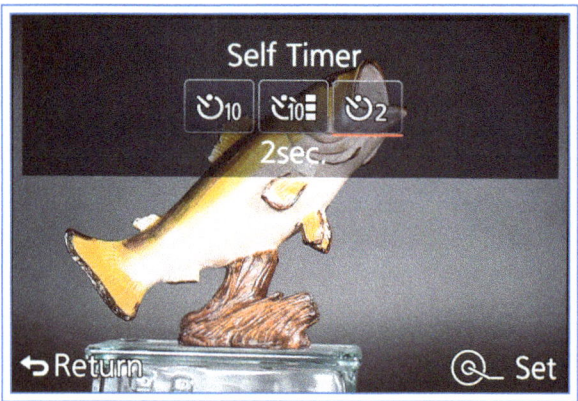

Figure 5-70. Self-timer Setting Screen

The camera's display will have an icon in the upper right corner showing the current self-timer setting, as shown in Figure 5-71.

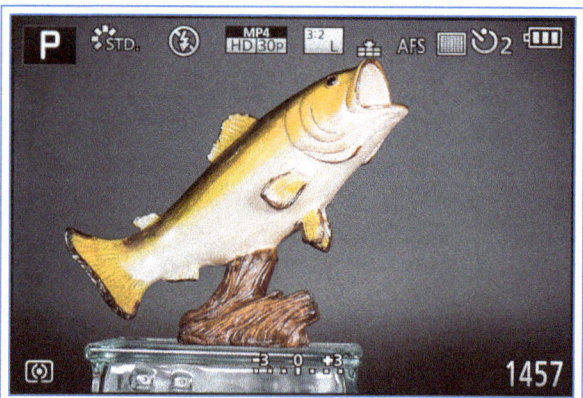

Figure 5-71. Self-timer Icon on Recording Display

Now you can wait as long as you want before actually taking the picture (unless the camera times out by entering Sleep Mode or you take certain other actions, such as turning on the 4K Photo option). Compose the picture, and then press the shutter button. The AF assist lamp, which does double duty as the self-timer lamp, will blink and the camera will beep until the shutter is automatically tripped at the end of the specified time. The beeps and blinks speed up for the last second as a warning, when the timer is set to 10 seconds. For the 2-second option, the camera just beeps 4 times and blinks 5 times as it counts down. You can cancel the shot while the self-timer is running by pressing the Menu/Set button.

If you choose the option with which the camera takes 3 pictures after the 10-second timer runs, the 3 shots will be spaced about one second apart, so tell your subject(s) to maintain their pose until all 3 images have been captured.

You can choose the self-timer options from the Self Timer item on screen 2 of the Recording menu. However, to activate the self-timer, you still have to select its icon from the Drive Mode menu. The self-timer can be set to remain active even after the camera has been powered off and back on. To make that setting, go to screen 4 of the Setup menu and set the Self Timer Auto Off option to Off. If, instead, you set that option to On, the self-timer will be deactivated when the camera is powered off. I use the 2-second self-timer often, because I do a lot of shooting from a tripod and I like to avoid camera shake whenever possible. Therefore, I usually leave that menu option turned off, so the self-timer will be active when I turn the camera on for a new shooting session.

You cannot use the self-timer option for taking multiple images when the camera is set for White Balance Bracket or Multiple Exposure, or the shutter speed is set to T for time exposure. You cannot use the self-timer at all when recording motion pictures or using the 4K Photo or Time Lapse Shot options.

Panorama

The final icon at the right of the Drive Mode selections is for shooting panoramas. The D-Lux has an excellent capability for automating the capture of panoramas. If you follow the fairly simple steps involved, the camera will stitch together a series of images internally to create a wide (or tall) view of a scenic vista or other subject that lends itself to panoramic depiction. Just select the Drive Mode icon that looks like a long, squeezed rectangle with an arrow inside, seen at the far right in Figure 5-68. You will see a message telling you to press the shutter button and move the camera in the direction of the arrow that appears on the screen, as shown in Figure 5-72.

Figure 5-72. Message to Press Shutter for Shooting Panorama

At that point, you can press the shutter button, pan the camera, and likely get excellent results. However, the camera also lets you make several choices for your panoramic images using the Recording menu. Once the message telling you to press the shutter button has disappeared from the display, press the Menu/Set button, and you will go to the menu screen.

Navigate to the Recording menu, which limits you to fewer choices than in most other shooting modes because several options are not appropriate for panoramas. For example, the Picture Size, AFS/AFF/AFC, Highlight Shadow, i.Dynamic, HDR, and several other settings are dimmed and unavailable. The Quality setting will be available, but you cannot select Raw or Raw & JPEG for that setting. In addition, you will not be able to zoom the lens in; it will be fixed at its wide-angle position. (If the lens was zoomed in previously, it will zoom back out automatically when you switch the Drive Mode to the panorama selection.) The setting of the aspect ratio switch will have no effect on the panorama. You cannot shoot panoramas while the camera is set to Snapshot mode. You can use the Filter button picture effects, but the Toy, Toy Pop, Miniature, and Sunshine effects are not available for panoramas.

One menu option that will be available is Panorama Direction, which lets you choose Up, Down, Left, or Right for the direction in which you will move the camera. However, you also can select the direction from the Drive Mode menu. When the panorama icon is highlighted, you will see a small up arrow next to the label More Settings. If you press the Up button, the camera will display a menu with the 4 direction arrows. Highlight the one you want and press Menu/Set to select it and return to the recording display.

There is no setting available for the size of a panoramic image. A horizontal (landscape) panorama has a maximum size of 8172 by 1920 pixels, which is a resolution of about 15.6 megapixels (MP). (This figure is larger than the camera's maximum resolution of 12.5 MP, because, with the panorama settings, the camera is taking multiple images and stitching them together.)

A vertical panorama at the Standard setting can be as large as 2560 by 7680 pixels, or about 19.6 MP.

You can use the direction settings with different orientations of the camera to get different results than usual. For example, if you set the direction to Up and then hold the camera sideways while you sweep it to the right, you can create a horizontal panorama that has 2560 pixels in its vertical dimension rather than the standard 1920.

One other setting you can make when shooting panoramas is exposure compensation, using the exposure compensation dial. In the context of shooting panoramas, this feature can be useful because the camera will not change the exposure if the camera is pointed at areas with varying brightness. For example, if you start sweeping from a dark area on the left, the camera will set the exposure for that area. If you then sweep the camera to the right over a bright area, that part of the panorama will be overexposed and possibly

washed out in excessive brightness. To correct for this effect, you can reduce the exposure using exposure compensation. In this way, the initial dark area will be underexposed, but the brighter area should be properly exposed. Of course, you have to decide what part of the panorama is the most important one for having proper exposure.

Another way to deal with this issue is to point the camera at the bright area before starting the shot and press the shutter button halfway to lock the exposure, and then go back to the dark area at the left and start sweeping the camera. In that way, the exposure will be locked at the proper level for the bright area.

Once you have made the settings you want, follow the directions on the screen. Press and release the shutter button and start moving the camera at a steady rate in the direction you have chosen. I tend to shoot my panoramas moving the camera from left to right, but you may have a different preference. You will hear a steady clicking as the camera takes multiple shots during the sweep of the panorama. A white box and arrow will proceed across the screen; your task is to finish the camera's sweep at the same moment that the box and arrow finish their travel across the scene, which should take about 4 seconds. If you move the camera either too quickly or too slowly, the panorama will not succeed; if that happens, just try again.

Generally speaking, panoramas work best when the scene does not contain moving objects such as cars or pedestrians, because, when items are in motion, the multiple shots are likely to capture images of the same object more than once in different positions.

It is advisable to use a tripod if possible so you can keep the camera steady in a single plane as it moves. The camera displays a straight horizontal line, which can help you hold it level. In addition to exposure, as discussed above, focus and White Balance are fixed as soon as the first image is taken for the panorama.

When a panoramic shot is played back in the camera, it is initially displayed at a small size so the whole image can fit on the display screen. You can press the Up button to make the panorama scroll across the display at a larger size, using the full height of the screen.

Figure 5-73 is a sample panorama that I shot from left to right using a tripod.

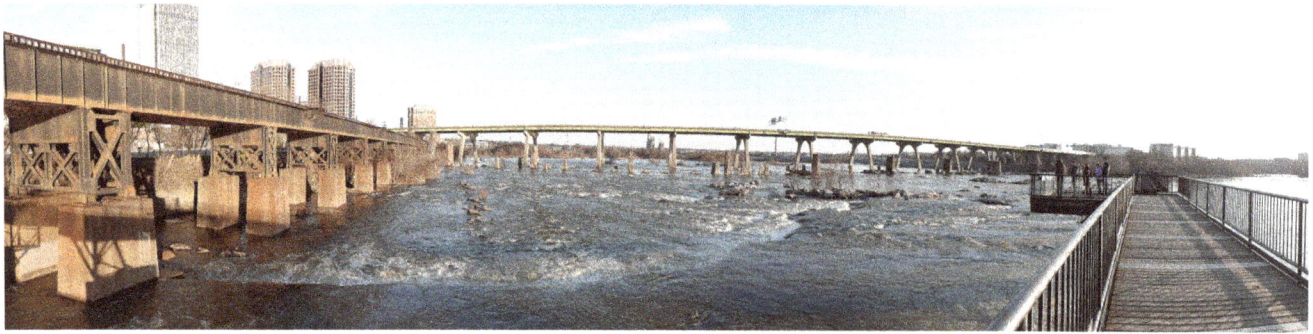

Figure 5-73. Panorama: James River, Richmond, Virginia

Besides activating Drive Mode, the Down button has various other duties. For example, pressing this button takes you to the screen for fine-tuning a White Balance setting, and it provides access to the screen with options for setting the location of focus points from the AF Mode screen. When you are playing a slide show or a movie, the Down button acts like a Stop button on a DVR to stop the playback completely. When you use the Video Divide function from the Playback menu, the down button is used to "cut" a movie at your chosen dividing point. When you are viewing a group of images that were taken with the super-high burst, Time Lapse, or Stop Motion options, you can press the Down button to view the images individually rather than as a group.

Center Button: Menu/Set

The last button to discuss among those in the control dial assembly is the button in the center of the dial, labeled Menu/Set. You use this button to enter and exit the menu system, and to make or confirm selections of menu items or other settings. In addition, when you are playing a motion picture and have paused it, you can press the Menu/Set button to select a still image to be saved from the motion picture recording.

Motion Picture Button

The next control to be discussed is the red Motion Picture button. You press this button once to start recording a movie, and press it again to stop the recording. You can use this button no matter what shooting mode the camera is set to. In Chapter 8, I will provide details about how the various menu and control settings affect the recording of movies.

If you are not going to be recording motion pictures for a while (or ever), you can disable the use of this button, to keep from pressing it by accident and starting a recording. To do that, go to screen 8 of the Custom menu and set the Video Button option to Off. Then, if you press the button, the camera will display an error message and will not start a motion picture recording. I have pressed the red button by accident several times, and I appreciate having the ability to lock out its operation in this way.

AF/AE Lock Button

The AF/AE Lock button is located at the upper right of the camera's back, to the right of the Motion Picture button. Using the AF/AE Lock item on screen 1 of the Custom menu, you can set this button to lock both autofocus and autoexposure, or just one or the other. Then, you can just press this button to lock whichever of those settings have been selected through the menu. Press it again to unlock. You cannot lock exposure with the button when the camera is set to Manual exposure mode, and the button does not function at all in Snapshot mode. When the camera is recording motion pictures, the button can lock only focus, not exposure, and it can only lock focus once. Zooming the lens cancels either type of lock.

Quick Menu Button

The Quick Menu button, located to the upper left of the control dial and labeled QM, has only one function—to activate the Quick Menu. I discussed that menu system in Chapter 4. Once you press this button, you have instant access to several of the important settings on the camera. You can customize the available choices using the Quick Menu option on screen 8 of the Custom menu, as described in Chapter 7.

Playback Button

This button, located to the upper right of the control dial, is marked by a small white triangle. You press this button to put the camera into playback mode. Press it again to switch back into recording mode. When the camera is placed into playback mode, the lens barrel will retract automatically after about 15 seconds, because the lens is not needed during playback operations.

Display Button

The Display button is at the bottom right of the camera's back, to the lower right of the control dial. It has several functions, depending on the context. Its primary function is to switch among the several available display screens for the LCD screen or the viewfinder, in both recording mode and playback mode.

In recording mode, following are the screens you see on the LCD monitor from repeated presses of the Display button, when the Monitor Display Style option on screen 6 of the Custom menu is set to its bottom option, for the monitor style layout. The items displayed are slightly different if that menu option is set to the other setting, for live viewfinder style display layout.

Figure 5-74. Recording Display: Full Information

1. As shown in Figure 5-74, full display, with battery status, Picture Size, Quality, aspect ratio, Photo Style, flash status, ISO (if set to a specific value), exposure compensation scale, movie quality and format, recording mode, metering mode, focus mode, number of pictures or length of video that can be shot with the remaining storage, the histogram (discussed later), if it is turned on through screen 4 of the Custom menu, and the

exposure meter display if that option is turned on through screen 6 of the Custom menu.

2. Blank display except for the focus area (if using a focus mode that displays a focus area, such as 1-Area AF or AF Tracking). The aperture, shutter speed, and exposure compensation scale also will display briefly when exposure is evaluated.

3. As shown in Figure 5-75, full information with level gauge, as well as histogram, exposure meter, and focus area if applicable.

Figure 5-75. Recording Display: Full Information and Level Gauge

4. As shown in Figure 5-76, level gauge with focus area if applicable.

Figure 5-76. Recording Display: Level Gauge and Focus Frame

5. As shown in Figure 5-77, monitor information screen, with no live view, if that option has been activated through screen 6 of the Custom menu.

Figure 5-77. Recording Display: Monitor Information

6. Blank screen (black, with no information).

In Snapshot mode, the Display button produces the screens listed above, but the histogram does not appear, even if it was turned on through the Custom menu. There also are other items that will appear on the information screens, such as the Guide Line grid if selected on screen 5 of the Custom menu, and icons for items such as the self-timer when they are activated.

The viewfinder uses the same display screens as those discussed above, except that it does not include the monitor information screen or the blank screen. The items displayed are affected by the EVF Display Style option on screen 6 of the Custom menu.

If the camera is set for playback, repeated presses of the Display button produce the following screens.

1. As shown in Figure 5-78, image with image number, Picture Size, Quality, flash status, recording mode, aperture, shutter speed, exposure compensation, ISO, and White Balance.

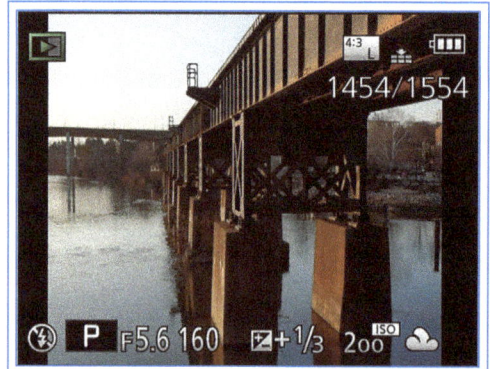

Figure 5-78. Playback Display: Basic Information

2. As shown in Figure 5-79, a smaller image with the same information, plus date and time of image

capture and some other settings, including focus mode and Photo Style.

Figure 5-79. Playback Display: Thumbnail and Information

3. As shown in Figure 5-80, the smaller image with basic recording information and the histogram, discussed in Chapter 7.

Figure 5-80. Playback Display: Thumbnail and Histogram

4. Just the recorded image, with no other information, but flashing the highlights in areas that are overexposed. (This screen appears only if the Highlight option is turned on through screen 5 of the Custom menu. The highlights also will flash on the detailed information screens; this screen is added so you can see the overexposed areas without interference from information items.)

5. Just the recorded image with no other information, and with no flashing highlights.

If you are playing back a motion picture, the display is similar, except for some added information that applies to that mode, including an icon showing that you can press the Up button to start the motion picture playing.

After about one minute of no activity with the controls, the camera removes the playback information from the screen. To restore it, press the Playback button or the Display button.

The Display button also has several other functions: You can press it to restore the focus frame to normal after you have moved it off center or resized it when using the 1-Area focus mode or one of the other modes that allows you to move or resize the focus point or points. If you need a reminder of the current date and time, with the camera in recording mode, press the Display button enough times to cycle back to the screen with the most recording information, and the date and time will appear on the lower left of the screen for about 5 seconds. Also, when you are viewing a menu screen, you can press the Display button to cycle through the menu by a full screen at a time, the same way you can by pressing the zoom lever to the right.

Function Buttons

The D-Lux has 3 Function buttons, designated Fn1, Fn2, and Fn3, and labeled with their primary functions. Each of these buttons has an assigned function by default, and each button also can be programmed to handle any one of a large number of possible operations. To program a button for a new assignment, use the Function Button Set option on screen 7 of the Custom menu, which is discussed in Chapter 7. Some of the items that can be assigned to these buttons are not available through any menu or other control, while some of them are options that can also be selected through the menu system or through another control. I will discuss all of those possible assignments later in this chapter. First, I will discuss the pre-assigned duties of the buttons.

Fn1/Delete/Cancel Button

The Fn1 button, located to the lower left of the control dial, has several functions. First, as shown by the trash can icon on it, it acts as the Delete button. When the camera is set to playback mode, press this button while an image is displayed, and you are presented with several options on the camera's display: Delete Single, Delete Multi, and Delete All, as shown in Figure 5-81.

Figure 5-81. Delete Options Screen

Use the direction buttons or the control dial to navigate to your choice. If you select Delete Single, the camera will display a confirmation screen; if you confirm the action, the camera will delete the currently displayed image (unless it is protected, as discussed in Chapter 6).

If you select Delete Multi, the camera presents you with a display of recent pictures, up to 9 at a time per screen, as shown in Figure 5-82.

Figure 5-82. Delete Multiple Selection Screen

You can move through them with the direction buttons or the control dial and press the Menu/Set button to mark any picture you want to be included in the group for deletion, up to 100 in total. You can press Menu/Set a second time to unmark a picture for deletion. When you have finished marking pictures for deletion, move the highlight to the OK block at the left of the display and press Menu/Set to start the deletion process; the camera will ask you to confirm, and one more press of Menu/Set will delete the marked images. Delete All deletes all images on the memory card, unless you have marked some as Favorites and choose to delete all except Favorites (indicated by stars), as prompted by the camera. You can interrupt a deletion process with the Menu/Set button, though some images may have been deleted before you press the button.

The Fn1 button also acts as a Cancel or Return button. When you are viewing menu screens, you can press this button to cancel out of a selection or other event, such as the use of the Format command on the Setup menu to erase and re-format a memory card. When the Fn1 button can be used to cancel an action and return to a previous screen, the camera displays an arrow that curves back to the left, as shown in Figure 5-82.

There are other situations in which the Fn1 button has a preset role. With the Miniature setting of Filter button effects, you press this button to move to the screen for sizing and locating the area of the scene to be in sharp focus. With the One Point Color effect, you press this button to select the color to be retained in the image. With the Sunshine effect, press this button to move to the screen for sizing and locating the light source. With the Multiple Exposure feature, you can press the Fn1 button to end the process. When any of the above settings are in use, any other function assigned to this button will not operate.

Fn2/Wi-Fi Button

The Fn2 button is located to the left of the red Motion Picture button, just below the hot shoe. As you can see from its label, it is assigned by default to activate the camera's Wi-Fi functions. I will discuss those functions in Chapter 9. The button also has some miscellaneous functions. When you are setting up the AF area using the Custom Multi option, in which you select one or more of 49 possible focus zones, you press this button to lock in your selections after highlighting the desired zones. When you are using the Time Lapse Shot feature from the Recording menu, you can press the Fn2 button at any time to interrupt the time-lapse shooting sequence. If you use the 4K Photo option to record motion pictures in a format that lets you save a high-quality still photo from the footage, the Fn2 button can be used to create a marker for the still photo while you are recording the motion picture. In any of these cases, the Fn2 button will not be available for any other assigned function.

The blue Wi-Fi connection lamp, located next to the Fn2 button, lights up when the Wi-Fi function is turned on and blinks when the camera is sending data.

Fn3 Button

The Fn3 button, located just to the right of the viewfinder window, does not have any permanently assigned functions; it carries out only whatever function is assigned to it. By default, it is assigned as the EVF button and is so labeled, but that assignment can be changed, as discussed below.

Assigning Functions to Function Buttons

As I noted above, you can assign any one of numerous functions to any of the 3 Function buttons, Fn1, Fn2, and Fn3. That function will then be carried out whenever you press the assigned button. Of course, the function will be carried out only if the present context permits. For example, if you assign the Fn1 button to activate the HDR option, and then press the Fn1 button while the camera is in Snapshot mode, nothing will happen, because the HDR option is not available in that recording mode. Similarly, as noted above, if you assign the Fn1 button to activate the level gauge option, and then press that button while using the Miniature setting of Filter effects, the level gauge will not appear, because the Fn1 button is permanently assigned to activate the frame that sets the area of the scene to be maintained in sharp focus with the Miniature setting. The Fn1 button cannot be assigned to the Wi-Fi function. Either of the other 2 Function buttons can be assigned to Wi-Fi, though the Fn2 button is the natural one for it, because it is located next to the Wi-Fi connection lamp.

With those caveats, Table 5-2 lists the options that can be assigned to any one of the 3 Function buttons.

Table 5-2. Options That Can Be Assigned to Function Buttons Fn1, Fn2, and Fn3

Recording Menu and Recording Functions Not on Menu			
Wi-Fi (Fn2 or Fn3 only)	EVF/Monitor	AF/AE Lock	AF-ON
Preview	Level Gauge	Focus Area Set	Cursor Button Lock
Photo Style	Picture Size	Quality	AFS/AFF/AFC
Metering Mode	Highlight Shadow	i.Dynamic	i.Resolution
HDR	Shutter Type	Flash Mode	Flash Adjust.
i.Zoom	Digital Zoom	Stabilizer	Sensitivity
White Balance	AF Mode/MF	Drive Mode	Restore to Default
Motion Picture Menu			
4K Photo	Motion Picture Setting	Picture Mode	
Custom Menu			
Utilize Custom Set feature	Silent Mode	Peaking	Histogram
Guide Line	Zebra Pattern	Monochrome Live View	Rec Area
Zoom lever			

Most of the settings in this table are self-explanatory; they are menu options that also can be activated from the Recording menu, the Custom menu, or the Motion Picture menu. For example, if a button is assigned to the Photo Style option, then pressing the button calls up a menu or settings screen for that option on screen 1 of the Recording menu. The screen that is called up by pressing the Function button may look different from the screen that is called up from the menu, but it will let you make the basic selection of the menu option. I will not discuss those assignments here; you can find details about those settings in Chapter 4 for the Recording menu, Chapter 7 for the Custom menu, and Chapter 8 for the Motion Picture Menu.

However, there are several possible button assignments that are not found on the regular menus. I will discuss those functions below.

Preview

The first non-menu setting, Preview, lets you see the effects of the current aperture and shutter speed settings on the final image before you take a picture. Ordinarily, when you aim the camera at a subject, the live view on the camera's display is set to provide a clear view of the scene, without giving effect to the current settings. For example, suppose you are using Manual exposure mode for an indoor shot of 2 objects at different distances. Suppose you have set the aperture

to f/16 to keep both items in focus with a broad depth of field and you have set the shutter speed to 1/250 second. If you aim the camera at the subjects, you will see a view like that in Figure 5-83, which does not show the effects of these settings.

Figure 5-83. Preview Option Off

Now, if Preview is assigned to the Fn1 button, press that button once and you will see a screen like that in Figure 5-84.

Figure 5-84. Preview Option On for Aperture

For this view, the Preview feature has caused the camera to close the aperture down to the actual setting of f/16, which shows the effect of the broad depth of field, bringing the background into sharper focus. The message on the screen, Shtr Speed Effect On Fn1, means that, if you press Fn1 again, the camera will display the effect of the shutter speed setting, as shown in Figure 5-85.

Figure 5-85. Preview Option On for Shutter Speed

In this case, the Preview display in Figure 5-85 shows that this shutter speed would result in a dark image. (In addition, though this effect is not noticeable in the image shown here, if a slow shutter speed were set, the image on the LCD display would smear if the camera moved, as the preview showed how the slow shutter speed would cause motion blur.) With this view, the camera displays the message, Shtr Speed Effect Off Fn1, meaning if you press Fn1 again, the Preview display will end.

If you have turned on the Constant Preview option through screen 5 of the Custom menu, the Preview function will not work in Manual exposure mode, because the preview feature will already be in effect. (The Constant Preview option works only in Manual exposure mode.)

Focus Area Set

If you assign this option to a Function button, when you press the button, the camera will immediately display a screen for adjusting the current focus setting. The actual result of pressing the button will depend on the current setting. For example, if you are using autofocus with the 1-Area AF Mode setting, pressing the assigned button will place the focus frame on the display with arrows, ready to be moved using the direction buttons. If the current AF Mode setting is Custom Multi, pressing the assigned button will call up the screen for selecting the pattern of focus zones for that area. If you are currently using manual focus, pressing the button will call up a screen for adjusting the MF Assist area.

This option can be useful if you often adjust the area where the camera focuses, so you don't have to go through extra steps to reach the screen to adjust that area.

Cursor Button Lock

When this function is assigned to a button, pressing that button locks out the operation of the 4 direction buttons, the Menu/Set button, and the control dial while the camera is in recording mode. You might want to use this feature if you don't want the current settings to be disturbed by the accidental press of a button or turn of the control dial. Once you have pressed this button, you will not be able to use the menu system or make any settings using the buttons or dial until you press the assigned Function button again to cancel the lock. The lock remains in place even when the camera is powered off and then on, so, if you find you cannot use the Menu/Set button when the camera is first turned on, try pressing the Function buttons to see if the direction buttons and control dial have been locked with this feature.

AF Mode/MF

With this setting, if you are using autofocus, pressing the assigned Function button calls up the screen for selecting an autofocus mode (Face/Eye Detection, 1-Area, Custom Multi, etc.). If you are using manual focus, it calls up the screen for adjusting the position of the MF Assist focus frame. This option assigns the same functions that are assigned by default to the Left button. You might want to use this assignment for a Function button if you have activated the Direct Focus Area option on screen 3 of the Custom menu, which causes the 4 direction buttons to be used only for moving the autofocus frame or manual focus frame. With that option, the Left button would no longer give you access to the AF Mode/MF options, so you could use this assignment to cause a Function button to take over those duties.

Restore to Default

If you choose this option for a given Function button, that button will be restored to its default setting. Those defaults are as follows: Fn1—Preview; Fn2—Wi-Fi; Fn3—EVF/Monitor Switch.

Chapter 6: Playback

You may not spend a lot of time viewing images and videos in the camera, but it's still useful to know how the playback functions work. You may need to examine an image closely in the camera to check focus, composition, and other aspects, or you may want to share images with friends and family. In this chapter I'll discuss the playback operations of the D-Lux, including options for printing images.

Normal Playback

I'll start with an overview of basic playback. First, you should be aware of the setting for Auto Review on screen 7 of the Custom menu. This setting determines whether and for how long the image stays on the screen for review when you take a new picture. If your major concern is to check images right after they are taken, this setting is all you need to use. As discussed in Chapter 7, you can leave Auto Review turned off or set it to 1, 2, 3, 4, or 5 seconds, or to Hold. If you choose Hold, the image will stay on the display until you press the shutter button halfway to return to recording mode.

To control how images are viewed later, you need to use the options available in playback mode. For ordinary review of images, press the Playback button, marked by a small triangle, to the upper right of the control dial. Once you press that button, the camera is in playback mode, and you will see the most recent image that was viewed in playback mode or the most recent image that was captured. To move back through older images, press the Left button or turn the control dial to the left. To see more recent images, press the Right button or turn the control dial to the right. To speed through the images, hold down the Left or Right button.

Index View and Enlarging Images

In playback mode, you can press the zoom lever to view an index screen of images and videos or to enlarge a single image. When you are viewing an individual image, press the zoom lever once to the left, and you will see a screen showing 12 images, one of which is outlined by a red frame, as shown in Figure 6-1.

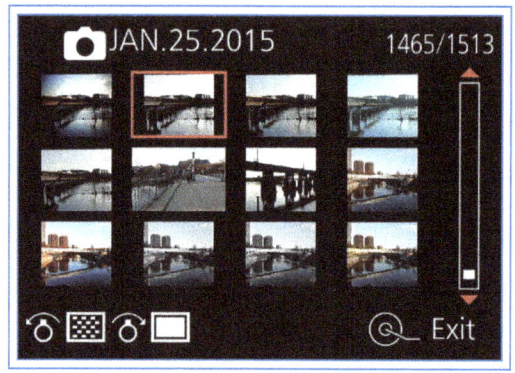

Figure 6-1. Index Screen with 12 Images

Press the zoom lever to the left once more to see an index screen with 30 images.

You can press the Menu/Set button to view the outlined image, or you can move through the images on the index screen by pressing the 4 direction buttons or by turning the control dial.

When you are viewing the 30-image index screen, one more press of the zoom lever to the left brings up a calendar display, as shown in Figure 6-2.

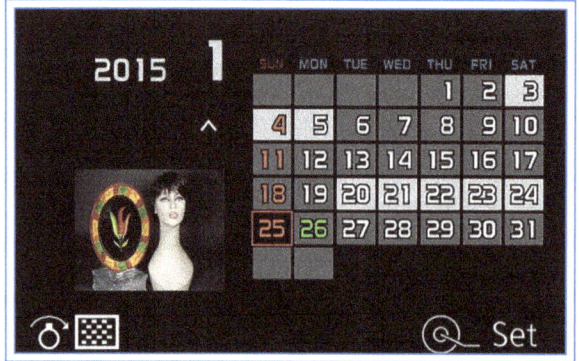

Figure 6-2. Calendar Index Screen

On that screen, you can move the highlight to any date with a light gray background and press the Menu/Set

button to bring up an index view with images from that date.

When you are viewing a single image or video, one press of the zoom lever to the right enlarges the image (or first video frame). You will briefly see a display in the upper right corner showing a green frame with an inset red frame that represents the area of the image that is filling the screen in enlarged view, as in Figure 6-3.

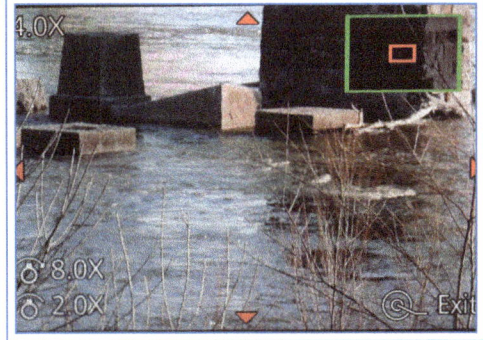

Figure 6-3. Image Enlarged in Playback

If you press the zoom lever to the right repeatedly, the image will be enlarged to greater levels, up to 16 times normal. While it is magnified, you can scroll in it with the 4 direction buttons; the red frame will move around inside the green frame. To reduce the image size again, press the zoom lever to the left as many times as necessary or press the Menu/Set button to revert immediately to normal size. To move to other images while the display is magnified, turn the control dial.

The Playback Menu

The Playback menu is represented by a green triangle icon, the last one at the bottom of the line of icons at the left of the main menu screen, as seen in Figure 6-4.

Figure 6-4. Green Triangle for Playback Menu Highlighted

This menu has 4 screens of options that control how playback operates and give you access to special features. The first menu screen is shown in Figure 6-5.

Figure 6-5. Screen 1 of Playback Menu

Slide Show

The first option on the Playback menu is Slide Show. Navigate to this option, then press Menu/Set or the Right button, and you are presented with the choices All, Picture Only, Video Only, Category Selection, and Favorite, as shown in Figure 6-6.

Figure 6-6. Slide Show Options Screen

(The Favorite option is on the second screen of this menu item, and appears only if you have already marked some images as Favorites. That option is discussed later in this chapter.) Following are details for each of these choices.

[Play] All

If you choose All from the Slide Show menu, you are taken to a menu with the choices Start, Effect, and Setup, shown in Figure 6-7.

Figure 6-7. Slide Show Setup and Start Screen

You can choose Start to begin the slide show, or you can select Effect or Setup first and make some selections. Setup lets you choose a duration of 1, 2, 3, or 5 seconds for each still image, but you can only set the duration if Effect is set to Off. If you select any effect, the camera will automatically set the duration to 2 seconds per still image.

You can also choose to set Sound to Off, Auto, Music, or Audio, but only if some effect is selected. If no effect is selected, the Sound option can be set only to Audio or Off. With Off, no sound is played. With the Auto setting, the camera's music is played for still images, and motion pictures have their own audio played. The Music setting plays music as background for all images and movies, and the Audio setting plays only the movies' audio tracks.

Also, you can set Repeat On or Off. Note that you can set a duration even when there are videos included along with still images; the duration value will apply for the still pictures, but not for the videos, which will play at their normal, full length.

For effects, you have the following choice of styles: Natural, Slow, Swing, Urban, or turning effects off altogether. If you choose Urban, the camera not only plays "urban" music, it uses a somewhat more dramatic visual style, with a variety of transitions, including converting some color images to black and white. So choose Urban only if don't mind having a slide show with altered images. If you choose Category Selection for your choice of images and videos to play, then the camera gives you another choice of effect: Auto, in which the camera chooses an appropriate effect according to the category of each given image or video. (Categories are discussed later in this chapter.)

Once the slide show has begun, you can control it using the direction buttons as a set of playback controls, the same as with playing motion pictures. The Up button controls play/pause; the Left and Right buttons move back or forward one slide; and the Down button is like a stop button; pressing it ends the slide show. A small display showing these controls appears briefly on the screen at the start of the show. After it disappears, you can press the Display button to make it appear again.

[Play] Picture Only/Video Only

These next 2 options for playing the slide show are self-explanatory; instead of playing all images and videos, you can play either just still images or just videos. The only difference between the options for these 2 choices is that, as you might expect, you cannot select an effect or a duration setting for a slide show of only videos; the slide show will just play all of the videos on the memory card, one after the other. You can use the Setup option to choose whether to play the videos with their audio tracks or with the sound turned off.

Category Selection

Rather than having the slide show play all of the pictures and/or videos available, with the Category Selection option you can set the camera to select the items for the show by category. You don't get to place your pictures and videos in categories of your own making; the camera has a pre-defined list of 9 groups that it considers "categories," and it plays all of the images or videos in whichever single category you select. Note that some of the categories overlap with others—that is, an image might be in more than one category. Here are the categories:

- All images and videos that used Face Recognition; if you select this option, the camera will prompt you to select a particular person whose face was recognized.

- All images and videos taken with scene detection of Portrait, Night Portrait, or Baby.

- All images and videos taken with scene detection of Scenery or Sunset.

- All images and videos taken with scene detection of Night Portrait, Night Scenery, or Handheld Night Shot.
- All images and videos taken with scene detection of Food.
- All images with a Travel Date.
- All images taken with the SH burst shooting setting.
- All images taken with the Time Lapse Shot feature and videos created from them.
- All images taken with the Stop Motion Animation feature and videos created from them.

Favorite

The final option for selecting the images to play in a slide show is to play all of the images and videos that you have marked as Favorites. In order to use this option, you have to have first used the Favorite setting in the Playback menu to mark one or more images or videos as Favorites. I will discuss that process later in this chapter.

PLAYBACK MODE

The second option on the Playback menu, Playback Mode, is similar to the Slide Show option, in that it provides several choices for which images and videos are played. This option, though, controls which items are viewed when you are viewing them outside of a slide show. The D-Lux offers 5 choices for this option: Normal Play, Picture Only, Video Only, Category Play, and Favorite Play.

Here are the details for each of these choices:

Normal Play

Normal Play is the playback mode for ordinary display of your images. This mode is automatically selected whenever the camera is first turned on or switched into playback mode. With this mode, you scroll through the images individually using the Left and Right buttons or by turning the control dial left and right. Whenever an image is displayed on the screen, you can press the Fn1/Delete button to initiate the deletion process, and choose to delete a single image, multiple ones, or all images. You can press and hold the Left or Right button to speed through the images at a steady pace.

You can enlarge an image by pressing the zoom lever repeatedly to the right, with magnification ranging from 2x up to 16x, as discussed earlier. Reverse the process by moving the lever to the left. If you then keep pressing the lever to the left, you will reach screens that display 12 images, then 30 images, then the Calendar display, from which you can select images from any given date on which images were taken.

Other Playback Modes

The Picture Only, Video Only, Category Play, and Favorite Play options work for playback just as they do for the Slide Show option, as discussed earlier.

LOCATION LOGGING

The next option on the Playback menu provides a way for you to add location information to the images saved to your memory card, using a smartphone. To do this, you have to first establish a Wi-Fi connection between the D-Lux and the smartphone; I discuss that process in Chapter 9. Essentially, to do that you need to press the Wi-Fi button or use the Wi-Fi option on screen 1 of the Setup menu, as shown in Figure 6-8.

Figure 6-8. Wi-Fi Option Highlighted on Setup Menu

You also need to download the Leica Image Shuttle app to your smartphone. Once the Wi-Fi connection is established, follow the steps below.

1. Open the Leica Image Shuttle app on the smartphone and wait for the camera to display a message saying it is under remote control.

2. In the Image Shuttle app, select the Function icon, the third from the left at the bottom of the screen, as shown in Figure 6-9; on the next screen, shown in Figure 6-10, select Geotagging.

Figure 6-9. iPhone Screen for Leica Image Shuttle App

Figure 6-11. iPhone - Geotagging Screen

4. When you select that icon and confirm by selecting Synchronize on the next screen, shown in Figure 6-12, the camera will synchronize its time with the smartphone so that the GPS data the phone receives will match up to the photos taken at the same time. Once the synchronization is complete, you can disconnect the camera from the smartphone by terminating the Wi-Fi connection.

Figure 6-10. iPhone Screen - Geotagging Option

3. On the Geotagging screen, shown in Figure 6-11, select the first icon at the left of the smartphone's screen, which looks like a clock.

Figure 6-12. iPhone Screen for Confirmation of Synchronization

5. On the smartphone, if necessary, select the second icon on the Geotagging screen, which looks like a triangular Play button, as shown in Figure 6-11. The camera will display a message saying it is getting location data. Leave the smartphone in this status while you take photos with the D-Lux. The smartphone will be recording location data that can later be synced with the images you are capturing at the same time.

6. After you have finished taking photos with the camera, re-establish the Wi-Fi connection between the camera and the smartphone. Then go back to the Geotagging screen on the smartphone and select the icon on the right that looks like an arrow going to a camera. When the app asks if it should send location data to the camera, say yes. After it sends the data, you can answer yes to the question whether the data can be erased. When the app asks if you should save the location information to the picture files, choose the Write option, which may take much longer than the previous steps. The camera will display a message saying it is writing location data. When that operation is complete, you can terminate the Wi-Fi connection.

7. Now, when you load the images from your memory card into appropriate software, such as Adobe Bridge, you will see the latitude and longitude information recorded in the metadata for the image, as seen in Figure 6-13. You can use that information in mapping software, or in general-purpose software such as Adobe Lightroom, to map the locations of your images, or you can copy the GPS data into a resource such as Google Maps to view the locations. Images that have had location data written to them will have the letters GPS at the top in playback mode, on the detailed display screen.

Figure 6-13. Metadata Screen Showing GPS Information

Raw Processing

The Raw Processing option gives you a powerful set of tools for processing your Raw files right in the camera. As I discussed in Chapter 4, the Raw format gives you great flexibility for adjusting settings such as exposure, White Balance, sharpening, and contrast in post-processing software. But with the D-Lux you don't have to transfer your images to a computer to convert Raw files to JPEGs. You can adjust several settings in the camera and save the altered image as a JPEG, or just convert the Raw file to a JPEG with no alterations if all you need is a file that is easier to send by e-mail or view on another device.

If you're not certain whether a given image was shot with Raw image quality, press the Display button until one of the detailed information screens appears; the Raw label will appear next to the aspect ratio for all Raw shots, as shown in Figure 6-14.

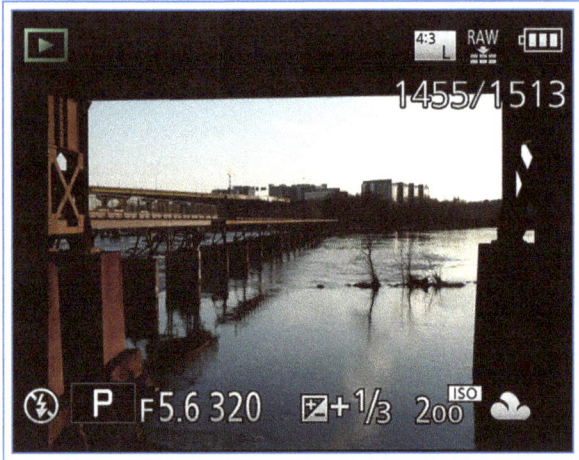

Figure 6-14. Icon Indicating Raw Image

Once you have a single Raw image displayed on the screen in playback mode, highlight Raw Processing on the Playback menu, then press the Menu/Set button twice. The camera will display the Raw Processing screen, as shown in Figure 6-15, overlaid on the image you selected for processing. At the left of the display will be a series of thumbnail images, each with a label displayed to the right. Scroll through those thumbnail images using the control dial or the Up and Down buttons, and press Menu/Set to select the thumbnail that is highlighted with a red frame. Each of those thumbnail images represents an action you can take or a setting you can adjust.

Figure 6-15. Raw Processing Options Screen

For any setting other than Noise Reduction, Intelligent Resolution, and Sharpness, you can press the Display button to switch between the main setting screen, as shown in Figure 6-16, and a comparison screen, as shown in Figure 6-17, where the camera displays several thumbnail images on the same screen so you can compare the effects of different settings as you scroll through them.

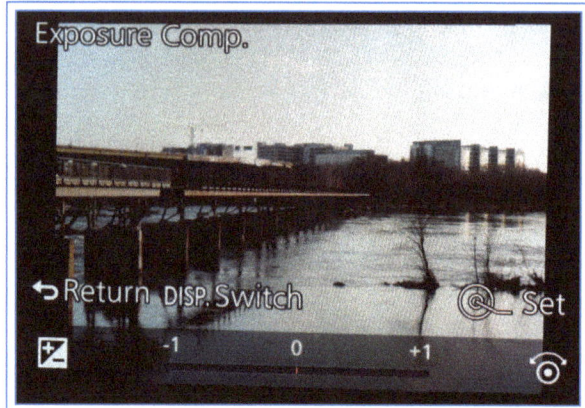

Figure 6-16. Raw Processing Effect Screen

Figure 6-17. Raw Processing Comparison Screen

Also, for any setting, you can press the zoom lever to enlarge the image on the main setting screen so you can see the effects of the adjustment with a magnified view.

Following are descriptions of the items you can adjust.

Setup. If you select this item, the camera will display a sub-menu with 3 items: Reinstate Adjustments, Color Space, and Picture Size. If you select Reinstate Adjustments, the camera will show you the image as it now stands with any adjustments you have made with the other settings. You can then proceed to cancel all of those adjustments if you want. The Color Space option lets you keep the color space setting the image was shot with, or change it to the other option, either Adobe RGB or sRGB. The Picture Size option lets you set the Picture Size to L, M, or S.

Begin Processing. If you select this block, the camera will process all of the adjustments you have set using the other blocks. Before it proceeds to make those changes, it will show you a preview of how the processed image will look before you confirm the operation, as shown in Figure 6-18. If you choose Yes, the camera will save a new JPEG image using all of the

settings you have made. The new image will appear right after the existing Raw image on the camera's display, but it will have an image number at the end of the current sequence on the memory card.

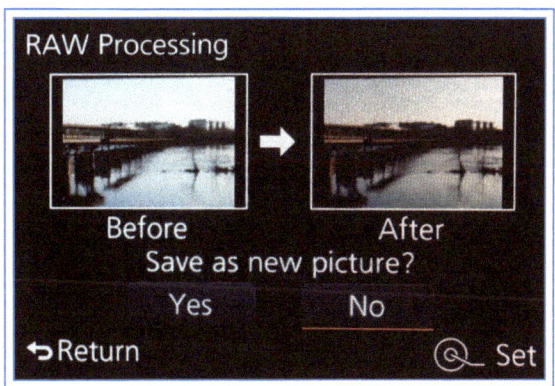

Figure 6-18. Raw Processing Final Processing Screen

White Balance. With this item, the camera will display the Raw image with the complete line of White Balance adjustment icons at the bottom of the screen. As you scroll through those icons, the display will change to show how the image would look with the selected setting. If you select the color temperature option, you can press the Up button to select the numerical color temperature. For any setting, you can press the Down button to get to the screen with color axes for fine-tuning the White Balance appearance.

Exposure Compensation. If you select this adjustment, you will be able to increase or decrease the exposure of the image, but only by up to plus or minus one EV level, in 1/3 EV increments.

Photo Style. With this item, you can change the Photo Style setting to any option you want. If you choose Monochrome, you will also be able to set the Color Tone adjustment and the Monochrome Filter Effect adjustment that simulates the use of a glass filter for black-and-white film. (Those 2 additional adjustments will appear later in the list of Raw Processing options.) If you select any other Photo Style setting, the Color Tone and Filter Effect adjustments will not be available. (The Saturation item will be available in place of the Color Tone adjustment.)

Intelligent Dynamic. The Intelligent Dynamic, or i.Dynamic screen lets you set this adjustment at a level of Off, Low, Standard, or High, regardless of how it was set when the image was captured.

Contrast. This adjustment is somewhat unusual because, ordinarily, it is made as part of the Photo Style adjustment. With the Raw Processing option, it is separated out. With this item, you can adjust the contrast of your Raw image by as many as 5 units positive or negative.

Highlight. On the Recording menu, the Highlight item is included as one aspect of the Highlight Shadow item. With the Raw Processing option, Highlight and Shadow are provided as 2 separate adjustments. If you select this item, you can alter the brightness of the highlights in the image by up to 5 units in either direction.

Shadow. This item is similar to the previous one, but deals with Shadow rather than Highlight adjustments.

Saturation. As noted earlier, this item is available for adjustment if you have selected a Photo Style other than Monochrome. If you selected Monochrome, the Raw Processing menu option includes Color Tone as an adjustment in place of Saturation.

Color Tone. As noted above, if you choose Monochrome for Photo Style, the camera presents this item for adjustment in place of Saturation.

Filter Effect. As discussed earlier, if you choose Monochrome for Photo Style, the Filter Effect item is available to adjust; otherwise, it does not appear.

Noise Reduction. With this item, you can adjust Noise Reduction up to 5 units positive or negative.

Intelligent Resolution. With the Intelligent Resolution, or i.Resolution item, you can set this feature to Off, Extended, Low, Standard, or High.

Sharpness. The last item in the line of boxes for adjustment is Sharpness, which, like Contrast and Resolution, is separated out from the Photo Style adjustment. You can change the level of this item up to 5 units in either direction.

TITLE EDIT

This next option on the Playback menu lets you enter text, numerals, punctuation, and a fairly wide range of symbols and accented characters for a given JPEG image or group of images through a system of selecting characters from several rows. After you select this option from the Playback menu, choose one or more

images to have text added and press Menu/Set to go to the screen with tools for entering text, shown in Figure 6-19. Navigate using the direction buttons to the block that contains the character to be entered. Then cycle through the choices in each block, such as ABC, using the Menu/Set button, and advance to the next space using the control dial. You can toggle between 3 displays of capital letters, lower case letters, and numerals and symbols using the Display button. The maximum length for your caption or other information is 30 characters. You can use the Multi option to enter the same text for up to 100 images. You cannot enter titles for motion pictures, protected pictures (see discussion later in this chapter), or Raw images.

Figure 6-19. Title Edit Text Entry Screen

Once you have entered the title or caption for a particular image, it does not show up unless you use the Text Stamp function, discussed below. The title is then attached to the image, and it will print out as part of the image. There is no way to delete the title other than going back into the Title Edit function and using the Delete key from the table of characters, then deleting each character until the title disappears.

Screen 2 of the Playback menu is shown in Figure 6-20.

Figure 6-20. Screen 2 of Playback Menu

TEXT STAMP

The Text Stamp function takes information associated with a given image and attaches it to the image in a visible form. For example, if you have entered a title or caption using the Title Edit function discussed above, it does not become visible until you use this Text Stamp function to "stamp" it onto the image, as shown in Figure 6-21.

Figure 6-21. Text Stamp in Use on Image

Once you have done this, the text or other characters in the title will print out if you send the picture to a printer. Besides the information entered with the Title Edit function, the Text Stamp function gives you the choice of making the following other information visible: year, month, and day; year, month, day, and time; age of subject (if set); travel date (if set); location (if set). Also, you can apply this function to information from pictures taken with names for Baby 1 or 2 and Pet, if you have entered a name for your baby or pet using the Profile Setup option on the Recording menu, and to pictures that have names registered with the Face Recognition function.

To use this function, highlight Text Stamp on the menu screen and press Menu/Set. On the next screen, choose Single or Multi, and then select the image or images you want to add text to. When you have selected one or more images, press Menu/Set, highlight Set on the next screen, and press Menu/Set. You will then see the screen shown in Figure 6-22, where you can select the items to be imprinted on the image or images.

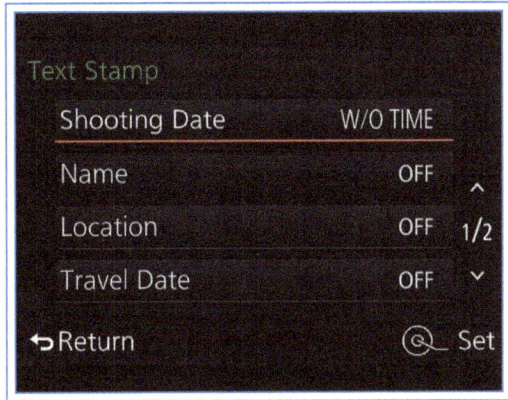

Figure 6-22. Text Stamp Options Screen

When you have made the selections, press the Fn1 button to return to the previous screen, select OK, and press Menu/Set. The camera will ask if you want to save the stamped image as a new picture; select Yes and press Menu/Set to carry out the operation.

This function cannot be used with Raw images, movies, or panoramas. The camera saves the text-stamped image to a new file, so you will still have the original. I have never found this function useful, but if you have an application that could benefit from it, it is available and ready to assist you.

VIDEO DIVIDE

The Video Divide option gives you a basic ability to edit or trim videos in the camera. Using this procedure, you can, within limits, pause a video at any point and then cut it at that point, resulting in 2 segments of video rather than one. You can then, if you want, delete an unwanted segment.

To do this, choose the Video Divide function from the Playback menu. Then, press the Right button to go to the playback screen. If the video you want to divide is not already displayed, scroll through your images using the Left and Right buttons or the control dial until you locate it.

You can recognize videos because they will display the length of the video in the upper right quarter of the screen and a movie camera icon with an up arrow in the upper left, as shown in Figure 6-23. The camera displays all your images here, including stills, so you may have to scroll through many non-videos until you reach the video you want. If you want to narrow the choices down to videos only, choose Video Only for Playback Mode on screen 1 of the Playback menu before selecting the Video Divide menu option.

Figure 6-23. Video Ready for Playback

With the desired movie on the screen, press Menu/Set to start it playing. When it reaches the point where you want to divide it, press the Up button to pause the video. While it is paused, move through it a few frames at a time using the Left and Right buttons, until you find the exact point where you want to divide it.

Once you reach that point, press the Down button to make the cut. You will see an icon of a pair of scissors in the little display of controls at the bottom of the screen. After you press the Down button, the camera will display the message shown in Figure 6-24, asking you to confirm the cut.

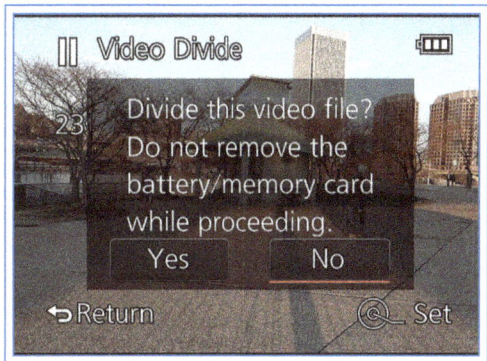

Figure 6-24. Video Divide Confirmation Message

Highlight Yes and press Menu/Set to confirm. Now you will have 2 new videos, divided at the point you chose.

As I noted above, this is a rudimentary form of editing. It can't be used to trim a movie too close to its beginning or end, or to trim a very short movie at all. But it's better than nothing, and it gives you some ability to delete unwanted footage without having to edit the video on your computer.

Time Lapse Video

This option lets you create a movie from a series of shots you took using the Time Lapse Shot feature on screen 4 of the Recording menu. As I discussed in Chapter 4, when you use that feature, the camera will ask you at the end of the process if you want to create a movie from the group of time-lapse shots. If you say no, you can use this option on the Playback menu at a later time to create the movie.

When you select this option, the camera will display any groups of images that were taken with the Time Lapse Shot option. Scroll through those and select the one you want to make into a movie. Then press the Menu/Set button, and the camera will display the screen shown in Figure 6-25, where you can set the recording quality, frame rate, and whether to play the sequence normally or in reverse. Make your choices and press Menu/Set; the camera will then create the video.

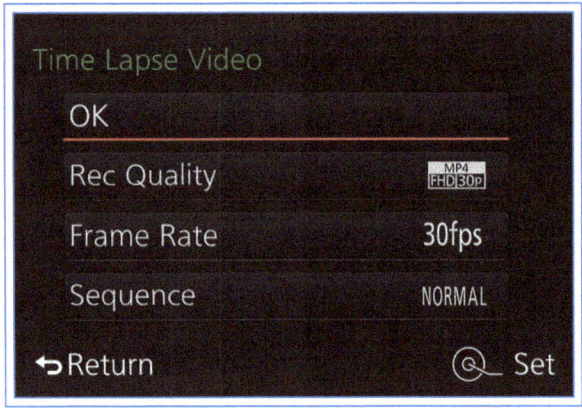

Figure 6-25. Screen to Set Time Lapse Video Quality

Stop Motion Video

This option, similar to the previous one, is for creating a video from images you took using the Stop Motion Shot feature discussed in Chapter 4. As with the Time Lapse Video option, select this option, scroll to the group of shots you want to use to create the video, and select your desired options from the screen that appears, which has the same options as in Figure 6-25.

Resize

This function from the Playback menu is useful if you don't have access to software that can resize an image, and you need to generate a smaller file that you can attach to an e-mail message or upload to a website. After selecting this menu item, on the next screen you choose whether to resize a single image or multiple ones. Then, using the Left and Right buttons, navigate to the image you want to resize, if it's not already displayed on the screen.

Once an image to be resized is on the screen, press the Menu/Set button to start the resizing process. Then, following the prompts on the screen as shown in Figure 6-26, use the Up and Down buttons to highlight the size to reduce the image to.

Figure 6-26. Resize Options Screen

The choices may include M for Medium and S for Small, or just S for Small, depending on the size of the original image. When the option you want to use is highlighted in red, press Menu/Set to carry out the resizing process. The camera will ask you to confirm that you want to save a new picture at the new size.

As with the Text Stamp function, resizing does not overwrite the existing image; it saves a copy of it at a smaller size, so the original will still be available. The new image will be found at the end of the current set of recorded pictures. Raw images, panoramas, protected images, and motion pictures cannot be resized, nor can pictures stamped with Text Stamp. If you want to convert up to 100 images at the same time, select the Multi option and follow the same procedure.

Next, I will discuss the items on screen 3 of the Playback menu, shown in Figure 6-27.

Chapter 6: Playback

Figure 6-27. Screen 3 of Playback Menu

Cropping

This function is similar to Resize, except that, instead of just resizing the image, the camera lets you crop it to show just part of the original image. To do this, select Cropping from the Playback menu and navigate with the Left and Right buttons to the image to be cropped, if it isn't already displayed. Then use the zoom lever to enlarge the image, and use the direction buttons to position the part of the image to be retained.

Figure 6-28. Image Ready to Crop with Cropping Menu Option

When the enlarged portion is displayed as you want, as shown in Figure 6-28, press Menu/Set to lock in the cropping, and select Yes when the camera asks if you want to save the new picture. As with Resize, the new image will be saved at the end of the current set of images, and it will have a smaller size than the original, because it will be cropped to include less information (fewer pixels) than the original. The Cropping function cannot be used with Raw images, motion pictures, panoramas, or pictures stamped with Text Stamp.

Rotate

When you take a picture in a vertical, or portrait orientation by holding the camera sideways, you can set the camera to display it so it appears upright on the horizontal screen, as in Figure 6-29.

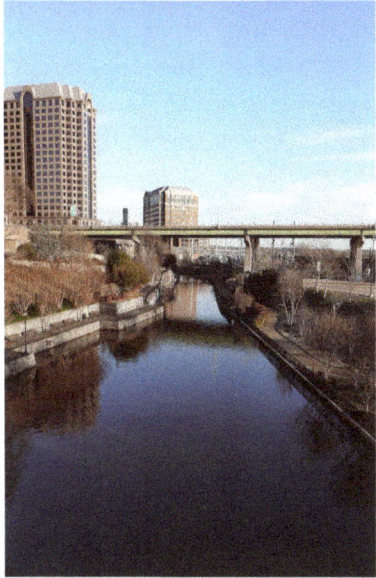

Figure 6-29. Image Displayed in Vertical Orientation

The setting to make such images appear in this orientation is the Rotate Display option, which is discussed next. If you have that option turned on, then the Rotate option becomes available, so you can manually rotate the image back to the way it was taken. If the Rotate Display option is not turned on, then the Rotate option is dimmed and unavailable for selection.

To use this option, select it from the menu and scroll to the image you want to rotate. Then press Menu/Set and the camera will display 2 arrows, as seen in Figure 6-30.

Figure 6-30. Rotate Screen with 2 Arrows for Rotating

Select the top arrow to rotate the image 90 degrees clockwise or the bottom one to rotate it 90 degrees

counter-clockwise and press Menu/Set to do the rotation.

Rotate Display

As I noted above in connection with the Rotate option, when the Rotate Display option is turned on, images taken with the camera turned sideways are automatically rotated so they appear upright on the horizontal display. If you want to rotate such an image so you can see it at a larger size, taking up the full display, use the Rotate menu option, discussed above.

Favorite

I have mentioned this function a couple of times before, because you have the option of viewing just your Favorite pictures or videos in some of the playback modes. You also can delete all images on the memory card except the Favorites.

Here is how to designate images or videos as Favorites. Choose the Favorite option from the Playback menu, and then choose the images to mark as Favorites, either single or multiple images (up to 999), using the same selection process as for other operations discussed above. The camera will display your images, either singly or as thumbnails, and you can mark any image as a Favorite by pressing the Menu/Set button when the image or its thumbnail is displayed. A star will appear on the marked image, as shown in Figure 6-31.

Figure 6-31. Favorite Marking Screen

Once the star appears, press the Fn1 button to exit from this screen. (Don't press Menu/Set on this screen; if you do, the star will be removed.)

When you later display an image or video that was marked as a Favorite, a star appears in its upper left corner, as shown in Figure 6-32, if you are viewing the playback screen that displays full information and the full-sized image. You cannot mark Raw images as Favorites.

Figure 6-32. Image Marked as Favorite

Print Set

The next option on the Playback menu, Print Set, lets you set your images for Digital Print Order Format (DPOF) printing. DPOF is a process developed by the digital photography industry to allow users of digital cameras to specify, on the camera's memory card, which pictures to print and other details, then take the card to a commercial printing shop to have them printed according to those specifications.

With the D-Lux, you select this option from the Playback menu and then select Single or Multi. If you select Multi, the camera displays 6 images at a time on the screen. Using the 4 direction buttons or the control dial, navigate through the images. When you arrive at one you want to have printed, press the Menu/Set button, and you will see a box with the word "Count" followed by a number and up and down arrows. Use the Up and Down buttons to raise (or, later, lower, if you change your mind) the number of copies of that image you want to have printed, as shown in Figure 6-33.

Figure 6-33. Print Set Selection Screen

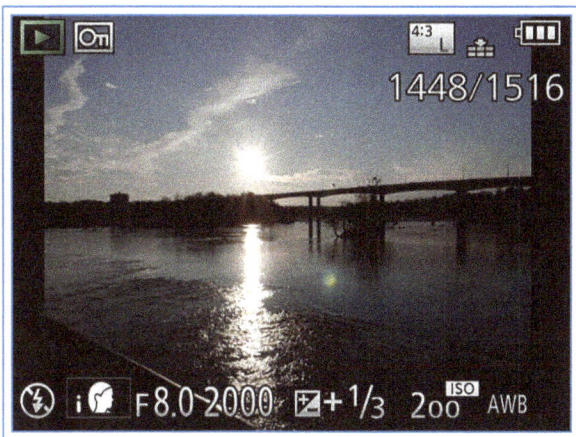

Figure 6-35. Protected Image with Key Icon

In addition, if you press the Right button, the word "Date" is added to the thumbnail image, and the date will be printed on that picture. You can follow the above procedure for a single image by selecting "Single" when you first choose the DPOF option.

DPOF settings cannot be set for Raw images or videos. Once you have set one or more images to print using this menu option, you can use the Cancel option from the Print Set menu to cancel the printing setup.

The final Playback menu options are found on screen 4 of the menu, shown in Figure 6-34.

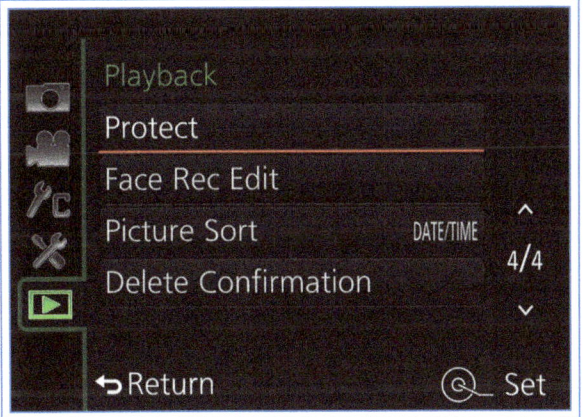

Figure 6-34. Screen 4 of Playback Menu

PROTECT

The first option on screen 4 of the Playback menu is Protect, which locks selected images or videos against deletion. The process is essentially the same as that for the Favorite function: Select the Protect option, and then select Multi or Single. You mark the files you want to protect using the Menu/Set key. When a picture or video is protected in this way, a key icon appears on the left side of the display, as shown in Figure 6-35.

The Protect function works for all types of images, including Raw files and motion pictures. Note, however, that all images, including protected ones, will be deleted if the memory card is re-formatted.

FACE RECOGNITION EDIT

This Playback menu option is of use only if you have previously registered one or more persons' faces in the camera for face recognition. If you have, use this option to select the picture in question, then follow the prompts to replace or delete the information for the person or persons you select. Once deleted, this information cannot be recovered.

PICTURE SORT

With this option, you can choose the order in which the camera displays your images from the memory card. If you chose the default option, File Name, then the camera arranges them in order by folders and then by numbers within the folders. For example, the file names of your images might include entries such as L1000003, L1000010, L1020023, L1030425, etc. If you have taken all of your images with the same camera, all of these images should also appear in chronological order according to when they were taken. However, if you have taken images with several different cameras you may have multiple images with the same file names, or with file names that do not match the order in which the images were taken. In that case you can choose the other option for this menu item, Date/Time. With that option, the images will be displayed in order by the dates and times they were taken.

Delete Confirmation

This final option on the Playback menu has 2 possible settings, as shown in Figure 6-36: "Yes" First or "No" First.

Figure 6-36. Options for Delete Confirmation Menu Item

This option lets you fine-tune how the menu system operates for deleting images. Whenever you press the Delete button to delete one or more images in playback mode and then choose Delete Single, Delete Multi, or Delete All, the camera displays a confirmation screen, as shown in Figure 6-37, with 2 choices: Yes or No.

Figure 6-37. Delete Confirmation Screen

One of those choices will be highlighted when the screen appears; you can then press the Menu/Set button to accept that choice and the operation will be done. You also can use the control dial or the Left or Right button to highlight the other option before you press the Menu/Set button to carry out your choice.

Which setting you choose for this menu item depends on how careful you want to be to guard against accidental deletion of images. If you like to move quickly in deleting images, choose "Yes" First. Then, as soon as the confirmation screen appears, the "Yes" option will be highlighted and you can press the Menu/Set button to carry out the deletion. If you prefer to have some protection against avoiding an accidental deletion, choose "No" First, so that, if you press the Menu/Set button too quickly when the confirmation screen appears, you will only cancel the operation, rather than deleting one or more images.

Unless you use this process often and need to save time, I recommend that you leave this menu item set at the "No" First setting to be safe.

Chapter 7: The Custom Menu and the Setup Menu

In Chapters 4 and 6 I discussed the many options available to you in the Recording and Playback menu systems. The next menu systems to discuss are the Custom and Setup menus, which include options for controlling things such as focus, zoom, and the appearance of the display, as well as date, time, formatting, and audio options. As a reminder, you enter the menu system by pressing the Menu/Set button on the camera's back.

The Custom Menu

After pressing Menu/Set, press the Left button to move the highlight into the left column of menu choices, then use the Up and Down buttons or the control dial to move to the wrench icon with the letter C, as shown in Figure 7-1. Once that icon is highlighted, press the Right button to move to the list of menu options, which occupy 9 menu screens, discussed below. (If the camera is set to Snapshot mode, the Custom menu displays only one screen with 3 items.) If necessary, use the control dial or the Up and Down buttons to navigate to the top of the menu's first screen.

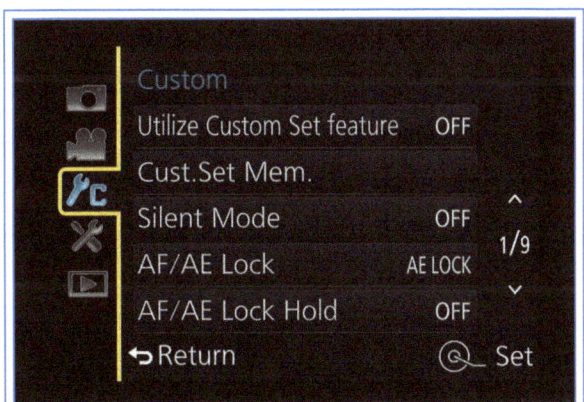

Figure 7-1. Icon for Custom Menu Highlighted

If you have to move forward or backward through several menu screens, you can press the zoom lever to move through them a screen at a time in either direction, or press the Display button to move a screen at a time in the forward direction only.

I will discuss all of the Custom menu items below, starting with the first screen, shown in Figure 7-2.

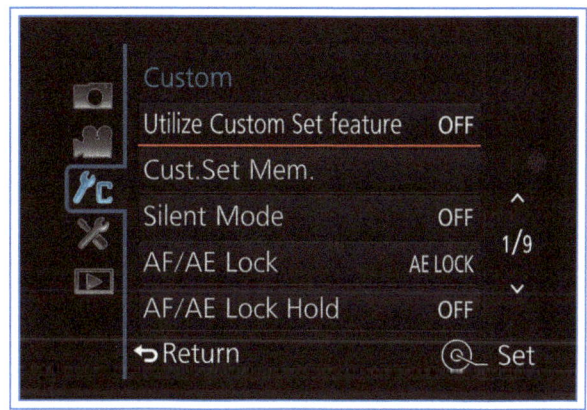

Figure 7-2. Screen 1 of Custom Menu

Utilize Custom Set Feature/Custom Set Memory

I am discussing the first 2 menu options together, because they work together to let you create what amounts to a set of custom shooting modes, with which you can save your preferred settings. This feature gives you a way to quickly change several shooting parameters without having to remember them or use menus or physical controls to set them. The camera lets you record 3 different groups of settings, each of which can be recalled instantly using the Utilize Custom Set Feature option.

Here is how this works. First, you need to have the camera set to recording mode rather than playback mode, so if it's in playback mode, press the shutter button halfway or press the playback button to exit to recording mode. Then, set the camera to Program, Aperture Priority, Shutter Priority, or Manual exposure

mode (You can't use the Custom Set feature in Snapshot mode.)

Next, make all of the menu settings that you want to have stored for quick recall, such as Photo Style, ISO, AF Mode, Metering Mode, White Balance, and the like. Your custom set can include all of the items on the Recording Menu except Face Recognition and Profile Setup; all items on the Custom Menu; and all items on the Motion Picture menu. You cannot include any items from the Setup menu. You can include White Balance, AF Mode, Drive Mode, and ISO, even though they are not set from the menu. You also can include picture effects that are activated using the Filter button. Note though, that you cannot adjust White Balance if you have selected a Filter button effect. So, if you try to add both a White Balance setting and a Filter button effect setting to a saved group, only the Filter button effect setting will be effective.

Once you have all of the settings as you want them, leave them that way and go to the Custom menu. Navigate to Custom Set Memory and press the Right button, which gives you choices of C1, C2, and C3, as shown in Figure 7-3.

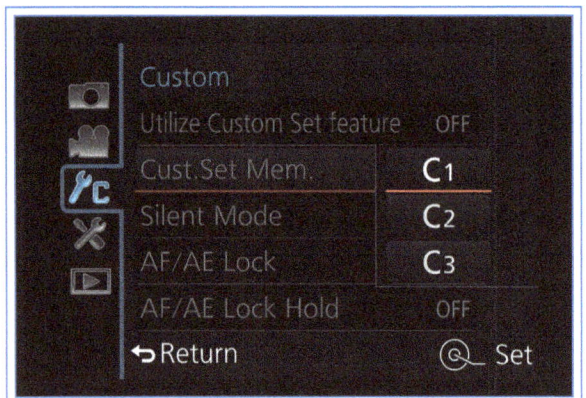

Figure 7-3. Screen to Save Custom Set

Highlight the slot you want to save your settings in and press Menu/Set. The camera will display a message asking you to confirm this action; highlight Yes and press Menu/Set to confirm.

When, at a later time, you want to use your set of saved settings, go to the Custom menu and select Utilize Custom Set Feature. On the sub-menu that appears when you press the Right button, shown in Figure 7-4, select C1, C2, or C3. Once you have selected the custom mode you want, you are still free to change the camera's settings, but those changes will not be saved into the Custom Set Memory unless you go back to the Custom menu and save the changes there with the Custom Set Memory option.

Figure 7-4. Screen to Select Custom Set

When you have finished using the saved settings, be sure to go back to the Utilize Custom Set Feature and select the final option, Off, which will return the camera to the settings it was using before you loaded the saved group of settings and will keep the saved settings from taking effect for further shooting.

If you want to speed up your ability to choose a saved group of settings, go to screen 7 of the Custom menu, choose the Function Button Set option, and assign Utilize Custom Set Feature to one of the 3 Function buttons. Then, when you press that button in recording mode, a small menu for choosing a slot with saved settings will appear at the top of the screen, as shown in Figure 7-5. Note, though, that there is a slight trick to using this approach. When you call up the saved group of settings, you will not be able to use the Function button to turn it off using the Utilize Custom Set Feature, unless you assigned the same Function button to that menu option inside the saved group. So, if you are planning to use a Function button to switch groups of settings often, you should assign the same Function button to call up this menu option within every group of settings you will be using.

Although it has some limitations, Custom Set Memory is a powerful capability, and anyone who has or develops a favorite group of settings would be well advised to experiment with this option and take advantage of its power.

Chapter 7: The Custom Menu and the Setup Menu | 115

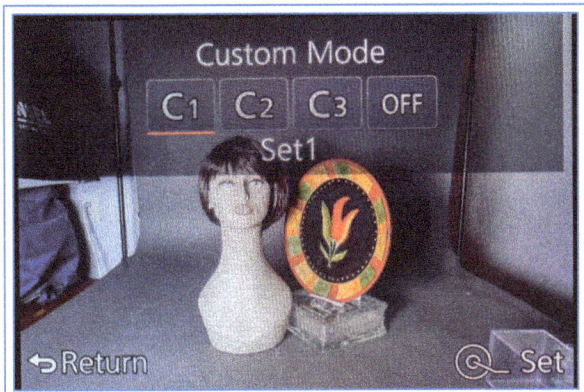

Figure 7-5. Function Button Menu for Custom Select

Silent Mode

The Silent Mode option gives you a quick way to turn off the lights and sounds made by the camera that might distract a subject or cause a disturbance in a quiet area. When you turn this option on, the camera switches to using the electronic shutter, which is quieter than the mechanical shutter; silences all beeps and other sounds for matters such as focus and shutter operation; forces the flash off; and turns off the AF assist lamp. However, the lamp will still light up to indicate use of the self-timer, and the blue Wi-Fi connection lamp will illuminate if you use that feature. If you will often use this feature, you can include it as part of a group of saved settings with the Custom Set Memory option, or you can assign it to a Function button.

AF/AE Lock

This option lets you set the function of the AF/AE Lock button, which is located to the right of the red Motion Picture button on the back of the camera. You can use this menu item, shown in Figure 7-6, to control how that button locks autofocus (AF) and autoexposure (AE) settings.

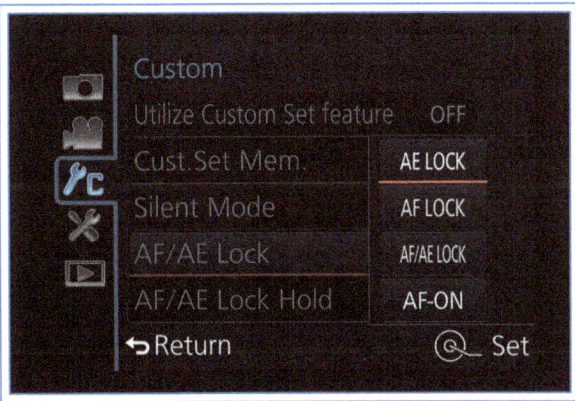

Figure 7-6. AF/AE Lock Options Screen

If you select AE Lock or AF Lock, the camera locks only the one designated setting. If you choose AF/AE Lock, the camera locks both settings at the same time.

The camera will place icons on the recording display to indicate which of the values are locked, once you press the AF/AE Lock button and the values are locked in. The AF Lock icon will appear in the upper right corner and the AE Lock icon in the lower left corner. Figure 7-7 shows the display when both values are locked. It is not possible to lock exposure using the AF/AE button in Manual exposure mode.

Figure 7-7. Recording Display with AE and AF Both Locked

If you select the final option, AF-On, pressing the AF/AE Lock button will cause the camera to use its autofocus system to focus on the subject, using whatever AF Mode setting is in effect to determine what area to focus on. If manual focus is in effect, the camera will still use the autofocus system when you press this button. This is a useful option as backup when you are using manual focus. You also can use it if you have set the Shutter AF option to Off, as discussed below, so pressing the shutter button halfway does not cause the camera to use its autofocus. You will then be able to press the AF/AE Lock button when you need to get the camera to focus again quickly.

AF/AE Lock Hold

This option determines how the AF/AE Lock button operates. If you set AF/AE Lock Hold to On, then, when you press this button and release it, the camera retains the locked value(s). If you set this option to Off, then you have to hold the button down to retain the value(s); when you release it, the locked value(s) will be released. This option is dimmed and unavailable for selection when AF/AE Lock is set to AF-On. With that setting,

pressing the AF/AE Lock button causes the camera to use its autofocus, but not to lock focus, so it is not possible to "hold" the locked setting.

The next items to be discussed are on screen 2 of the Custom menu, which is shown in Figure 7-8.

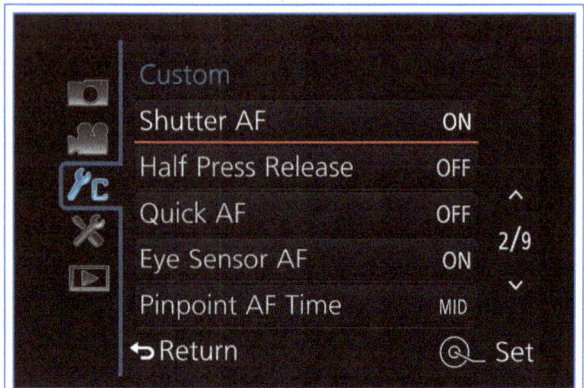

Figure 7-8. Screen 2 of Custom Menu

SHUTTER AF

This option lets you choose whether the camera will use its autofocus when you press the shutter button halfway, or not. With the default setup, with Shutter AF turned on, when the camera is set to an autofocus mode, it will evaluate the focus when you half-press the shutter button. With single autofocus (AFS), the focus will be locked as long as you hold the button in that position; with flexible autofocus (AFF), the camera will refocus if it detects movement, and with continuous autofocus (AFC), the camera will continue to adjust focus as movement occurs.

If you use this menu option to turn Shutter AF off, then the camera will not use its autofocus at all when you half-press the shutter button. There are several reasons why you might choose that setting. First, if you are taking a series of shots at the same distance, such as when you have the camera on a tripod and are taking shots of flat objects for auctions, you might focus once and then have no need to keep focusing. You can avoid using up the camera's battery for repeated uses of the autofocus system by turning Shutter AF off.

Another reason for using this option is if you prefer using the AF/AE Lock button to adjust autofocus. To do that, go to screen 1 of the Custom menu and set the AF/AE Lock menu option to AF-On. Then, when you press the AF/AE Lock button, the camera will adjust autofocus. With this setup, you can adjust the focus whenever you want, and once you have it set as you want it, you can compose your shot and have the camera evaluate exposure without worrying that the camera will reset the focus to a different subject. You will be able to trigger the shutter to take another shot at any time.

Some photographers use this system with the autofocus mode set to AFC for continuous autofocus. Then, they can adjust focus at any time using the AF/AE Lock button, and press the shutter at any time without being concerned about focus. It's probably a good idea to give this setup a try and see if it works well for your type of shooting.

HALF PRESS RELEASE

This option lets you set the camera to capture an image when the shutter button is pressed halfway down, rather than requiring a full press, as is the normal situation. If you turn this setting on when Shutter AF is turned on, the camera will still adjust focus just before the image is captured, so the half-press of the button carries out both the autofocus operation and the image capture. If you have Shutter AF turned off, then you would have to use the AF/AE Lock button to adjust autofocus, with the AF On option turned on for that button.

Using the Half Press Release option can speed up your shooting, because you don't have to go through the sequence of half-press followed by full press of the shutter button; you can just touch the button lightly to capture an image, or a burst of images if the camera is set for burst shooting. This system can work well if you won't be needing to make adjustments to focus or exposure after half-pressing the shutter button. When you are shooting in predictable, steady lighting at a constant distance and you need to shoot quickly, this option can be useful. Also, the ability to trigger the shutter with a light touch can help reduce the risk of motion blur from camera shake.

QUICK AF

This next function on the Custom menu, Quick AF, can be turned either on or off. If you turn this setting on, the camera will focus on the subject whenever the camera has settled down and is quite still, with only minor movement or shake. You do not need to press

the shutter button halfway down to achieve focus; the camera focuses on its own.

The advantage of turning Quick AF on is that you will have a slight improvement in focusing time, because the camera does not wait until you press the shutter button (or the AF/AE Lock button, if it is set for focusing) to start the focusing process. The disadvantage is that the battery will run down faster than usual. So, unless you believe that a split second for focusing time is critical, I would stay away from this setting, and leave this menu option turned off. The camera will still focus automatically when you press the shutter button halfway down; it just will take a little bit longer to bring the subject into focus.

Eye Sensor AF

When this option is turned on and the camera is set to an autofocus mode, the camera will automatically use its autofocus mechanism to adjust focus as soon as your head approaches the eye sensor and turns on the electronic viewfinder. However, the autofocus system will work only once with this system, even if the camera is set for continuous autofocus. So, when you first put the camera up to your eye, the focus will be adjusted for whatever subject the camera is aimed at at that instant. The camera will not readjust the focus unless you then press the shutter button halfway or use the AF/AE Lock button, if that button is set up to adjust focus.

This option can give the autofocus system a head start by bringing the scene into focus with an approximate setting, so it can quickly reach an exact focusing position when you press the shutter button halfway or use the AF/AE Lock button to make the final focus adjustments. I generally leave it turned off, but for snapshots it can be useful to have an approximate first cut at focusing take place as soon as you use the viewfinder.

This option works only when the viewfinder is turned on, either permanently or as your eye approaches it, through use of the EVF button or the Eye Sensor option on screen 9 of the Custom menu.

Pinpoint AF Time

As I discussed in Chapter 4, one of the options for setting Autofocus Mode using the Left button is Pinpoint AF, with which you can set a precise point for the focus area. Then, when you press the shutter button halfway to evaluate focus, the camera focuses at that point and enlarges the display briefly with that point centered, so you can judge the sharpness of the focus. The Pinpoint AF Time menu option controls how long the display stays enlarged when you press the shutter button halfway. The choices are Short (0.5 second), Medium (1.0 second), or Long (1.5 second). If you release the shutter button before the specified time has passed, the display will revert to normal size. Because of that behavior, I prefer to set this option to Long. Then, the display will stay enlarged for a long enough time to let me judge the focus, but I can always release the shutter button early to revert the display to its normal size.

The next items to be discussed are on screen 3 of the Custom menu, shown in Figure 7-9.

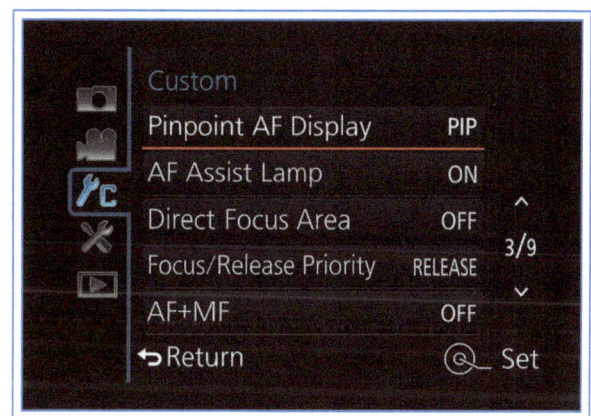

Figure 7-9. Screen 3 of Custom Menu

Pinpoint AF Display

This menu item lets you choose one of 2 options for the size of the enlarged display that appears when you use the Pinpoint option for Autofocus Mode—Full or PIP (picture-in-picture). With Full, the entire display is enlarged by a factor of between 3 and 10 times; with PIP, only the central part of the display is enlarged, by a factor of between 3 and 6 times. You can vary the enlargement factor by turning the control dial when the enlargement is active as you are setting the focus point. That enlargement factor will then take effect when you half-press the shutter button to focus using the Pinpoint AF option.

AF Assist Lamp

The autofocus (AF) assist lamp is the reddish light on the front of the camera, near the lens below the shutter

button and the shutter speed dial. The lamp illuminates when the ambient lighting is dim, to help the autofocus mechanism achieve proper focus by providing enough light to define the shape of the subject. Ordinarily, this option is left turned on for normal shooting, because the light only activates when it is needed because of low-light conditions. However, you have the option of turning it off using the AF Assist Lamp menu option, so it will never turn on to help with autofocus. You might want to do this if you are trying to shoot your pictures without being detected, or without disturbing a subject such as a sleeping animal.

In Snapshot mode, you cannot turn off the AF assist lamp using this menu option, but you can turn it off, along with the flash and camera sounds, using the Silent Mode option on the Custom menu. The lamp does not illuminate when you are using manual focus (unless you have set up the AF/AE Lock button to use the AF-On option and you press that button to cause the camera to autofocus).

Note that the AF assist lamp also serves as the self-timer lamp. Even if you set the AF Assist Lamp menu option to Off, the lamp will still light up when the self-timer is used; there is no way to disable the lamp for that function.

DIRECT FOCUS AREA

This is another option that can be turned either on or off; it is off by default. If you turn it on, then, in recording mode, if you press any of the 4 direction buttons, the camera immediately displays a screen for adjusting the position of the focus area. For example, if you are using autofocus and AF Mode is set to 1-Area, Pinpoint AF, or Face/Eye Detection, then, when you press, say, the Left button, that button immediately activates the focus frame and starts moving it across the display. If you have AF Mode set to 49-Area or Custom Multi, then, when you press a direction button, the camera immediately displays the screen for selecting the focus zones to be included in the focus area. You can then keep pressing any of the direction buttons to adjust the area or use other controls to make other adjustments.

If you are using manual focus with Direct Focus Area turned on, pressing the Left button activates and moves the MF Assist block. However, the other 3 direction buttons retain their normal functions for providing access to ISO, White Balance, and Drive Mode settings.

Direct Focus Area cannot be turned on if any of the Filter button effects are turned on.

This option could be useful if you were in a situation when you need to adjust the focus area often, particularly with the 1-Area or Pinpoint AF options. I would not recommend using it with the 49-Area or Custom Multi options, because you need to do considerable adjusting with those options, and a split second of added speed will not be of that much use.

I do not use this option myself, because it is so easy to adjust the focus area without it. Just press the Left button to bring up the AF Mode option, then press the Down button to get to the screen for moving the focus frame. Also, if you turn on Direct Focus Area when using autofocus, you lose the other functions of the direction buttons while this option is in effect. So, if you wanted to set White Balance or ISO, you would have to use the Quick Menu, assign those functions to another button or to the control ring, or turn off this menu option before making that adjustment.

FOCUS/RELEASE PRIORITY

You can set this option to either Focus (the default option) or Release. If it is set to Focus, then the camera will not take a picture until focus has been confirmed, when autofocus is in effect. So, if you aim the camera at a subject that is difficult for the autofocus system to bring into sharp focus, such as an area with no sharp features in dim lighting, the camera may display a red focus frame and beep 4 times, indicating focus was not achieved. In that situation, if this menu option is set to Focus, the camera will not take the picture when you press the shutter button. If you set this option to Release, then the camera will take the picture even if it is not in focus. If you are using manual focus, then the camera will take the picture regardless of focus, even if you set the priority to Focus.

The use of this option is a matter of personal preference and the situation you are faced with. If you are taking images of a one-time event, you may want to use the Release option so you don't miss a shot just because focus is slightly off. It's much better to get an image that is slightly out of focus than no image at all. But if you have time to make sure focus is sharp, you can use

Chapter 7: The Custom Menu and the Setup Menu | 119

the Focus option to make sure you have focus properly adjusted before you capture an image.

This option also has an impact on the speed of burst shooting. As I discussed in Chapter 5, if this option is set to Focus, shooting may be slowed down as the camera attempts to adjust focus before recording each image, when you are using a burst setting with continuous focus adjustments.

AF + MF

This is an on-or-off option that is turned off by default. If you turn it on, then, when the autofocus mode is set to AFS, for single autofocus, once you have pressed the shutter button halfway to lock focus, while you are holding the button in that position, you can turn the control ring to fine-tune the focus manually. This option also takes effect if you have locked focus with the AF/AE Lock button, when that button is set to lock autofocus or to the AF-On setting through screen 1 of the Custom menu.

This option is useful when, for example, you have locked focus on a group of small objects, and you want to make sure the focus is precisely set on one of those objects, such as on an object behind the others, or on a portion of one of them. Once the autofocus system has locked on the group, just start turning the control ring while keeping the shutter button pressed halfway (or the AF/AE Lock button pressed, if applicable) to adjust the focus manually until you have it set exactly as you want.

Figure 7-10 shows screen 4 of the Custom menu.

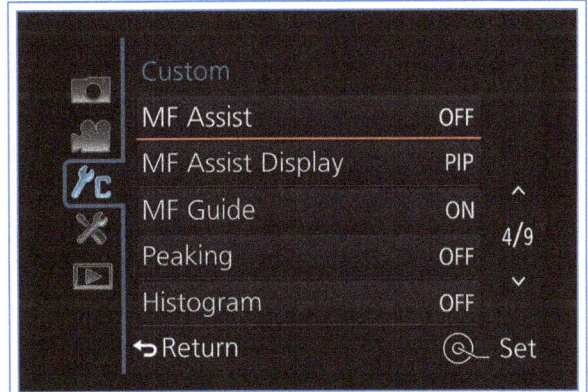

Figure 7-10. Screen 4 of Custom Menu

Manual Focus (MF) Assist and MF Assist Display

These next 2 Custom menu options let you set whether and how the recording screen display is magnified when you're using manual focus. With the MF Assist option highlighted, press the Right button to pop up the sub-menu that lets you choose you choose 1 of 4 settings, as shown in Figure 7-11.

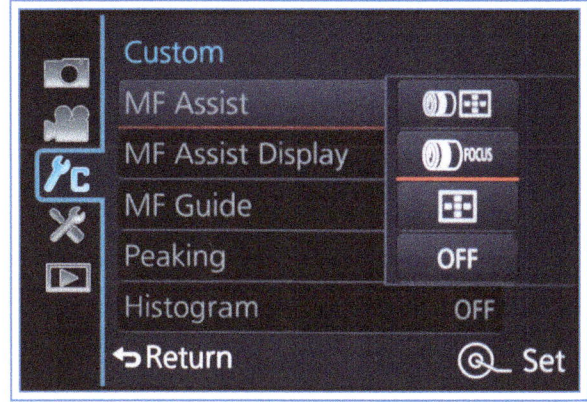

Figure 7-11. MF Assist Options Screen

If you choose Off, there is no magnification when you press the Left button to activate the MF Assist focus frame or turn the control ring to adjust focus. If you choose the top option, which shows icons for the control ring and the AF Mode button (Left button), then, when you start turning the control ring to focus or you press the Left button, the screen will immediately be magnified to help you adjust the focus.

With the second option, turning the control ring will immediately magnify the display, but pressing the AF Mode button will not immediately magnify the screen, though it will still activate the manual focus assist frame, so you can move that frame around the display. With the third option, pressing the button will immediately enlarge the display, but turning the control ring will not immediately enlarge the display, though it will still adjust the manual focus.

With the Off setting, when you activate the MF Assist frame and move it around the display, once you press Menu/Set to set the frame in place, the display will be magnified in the area where the frame is located.

The MF Assist Display menu option lets you set the area of magnification with MF Assist to Full or PIP (picture-in-picture). If you choose Full, the magnification will take up the whole display and will vary between 3 and

10 times normal; you control that factor by turning the control dial when the display is magnified. If you choose PIP, the enlargement factor varies between 3 and 6 times normal.

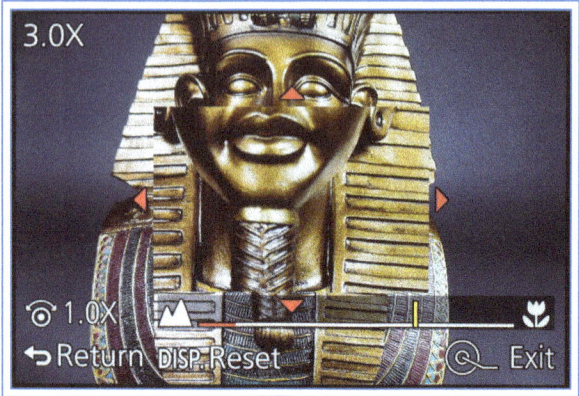

Figure 7-12. MF Assist Magnified Screen

As soon as you press the Left button, turn the control ring, or press Menu/Set to start the magnification (depending on the settings discussed above), the display will appear similar to Figure 7-12, which shows the MF Assist display when the PIP setting is in effect.

You can use all 4 direction buttons to move the focus area around the display, and you can turn the control dial to change the magnification factor. To reset the focus point to the center of the display, press the Display button. To dismiss the MF Assist display, press the shutter button halfway or press the Menu/Set button. Or, if you turned the control ring to start the magnification, the screen will return to normal size on its own after about 10 seconds. You can then press the Left button or turn the control ring (depending on menu settings) to bring the MF Assist display back on the screen if you want, or you can just press the shutter button to take the picture.

The MF Assist option is not available for recording motion pictures or when Digital Zoom is activated.

MF Guide

This option is another one related to the use of manual focus. If it is turned on, then, when you are turning the control ring to adjust focus, the camera displays a scale at the bottom of the screen with an indicator that shows the approximate range of the focus distance along the scale from far to near, with no numerical value for the distance. With this option turned off, that scale does not appear. An example of this scale is shown in Figure 7-13.

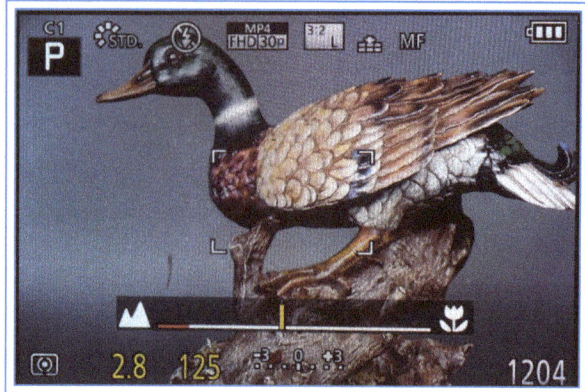

Figure 7-13. MF Guide on Display

Peaking

This menu option controls another useful feature for assisting with manual focus. The Peaking feature, when it is turned on, places colored pixels on the screen at areas that the camera determines are in sharp focus. As you turn the control ring to adjust focus, you can watch for the colored areas to reach their maximum area. When you see the largest areas of glowing pixels, focus will be sharp for the areas where those pixels appear.

Figure 7-14. Peaking Main Options Screen

The Peaking menu item has 3 main options: On, Off, and Set, as shown in Figure 7-14. In most cases, I leave it turned on, because it operates only when manual focus is used, and I find it to be helpful for most manual focusing situations. The Set option has 2 sub-options: Detect Level and Display Color, as shown in Figure 7-15.

Chapter 7: The Custom Menu and the Setup Menu

Figure 7-15. Peaking Sub-options Screen

The Detect Level can be set to High or Low. If you set it to High, the camera will require a higher degree of sharpness before it places pixels at a given focus area. With that setting, there will be fewer Peaking pixels displayed than with the Low setting. You may find that it is easier to gauge the focus with fewer pixels, because you can adjust focus until those few pixels appear. However, in some situations, such as with objects that are lacking in straight lines or sharp features, you may find that it is preferable to set Detect Level to Low, so there will be more Peaking pixels visible.

With the Display Color sub-option, you can choose light blue, yellow, or green for the Peaking color if Detect Level is set to High, and you can choose dark blue, orange, or white if the level is set to Low. It is a good idea to choose a color that contrasts with the scene you are photographing, so you can distinguish the Peaking pixels from other parts of the image.

Figure 7-16 is a composite image that illustrates the use of this feature. The left side shows the view with Peaking turned off, and the right side with Peaking turned on with Detect Level set to Low.

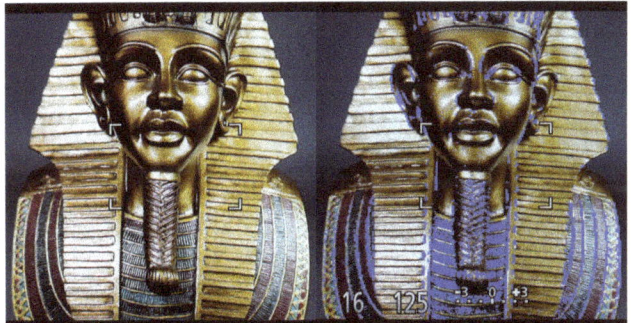

Figure 7-16. Left Image: Peaking Off; Right Image: Peaking On at Low Detect Level

As noted above, Peaking operates only when the camera is set to manual focus. However, if you set the AF/AE Lock button to the AF-On function on screen 1 of the Custom menu, Peaking pixels will appear when you press that button to cause the camera to use autofocus. Peaking also operates if you adjust manual focus using the AF+MF option, discussed earlier in this chapter. Peaking does not operate when the Rough Monochrome Filter effect setting is in use.

HISTOGRAM

The next menu option, Histogram, controls the display of the histogram in recording mode. A histogram is a graph showing the distribution of dark and bright areas in the image that is being viewed on the camera's screen. The darkest blacks are represented by vertical bars on the left, and the brightest whites by vertical bars on the right, with continuous gradations in between.

If an image has a histogram in which the pattern looks like a tall ski slope coming from the left of the screen down to ground level in the middle of the screen, that means there is an excessive amount of black and dark areas (tall bars on the left side of the histogram), and very few bright and white areas (no bars on the right). The bottom graph in Figure 7-17 illustrates this situation, using a playback histogram as an example.

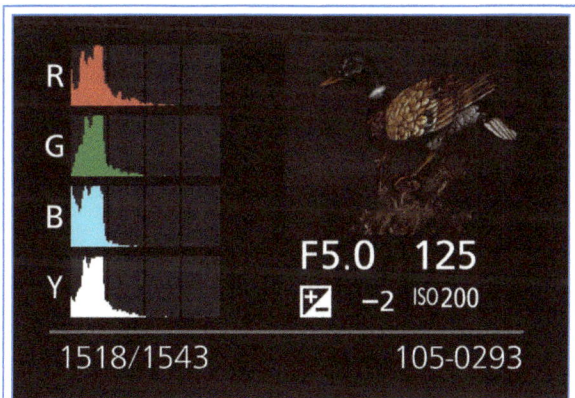

Figure 7-17. Histogram for Underexposed Image

A pattern moving from the middle of the graph up to peaks at the right side of the graph would mean just the opposite—too many bright and white areas, as in the histogram shown in Figure 7-18.

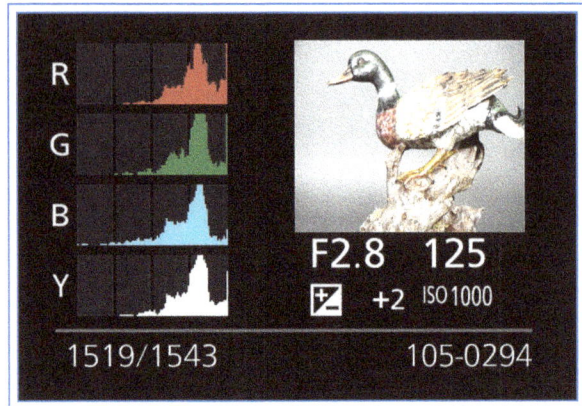

Figure 7-18. Histogram for Overexposed Image

A histogram that is "just right" would be one that starts low on the left, gradually rises to a medium peak in the middle of the graph, then moves gradually back down to the bottom at the right. That pattern indicates a good balance of whites, blacks, and medium tones. An example of this type of histogram is shown in Figure 7-19.

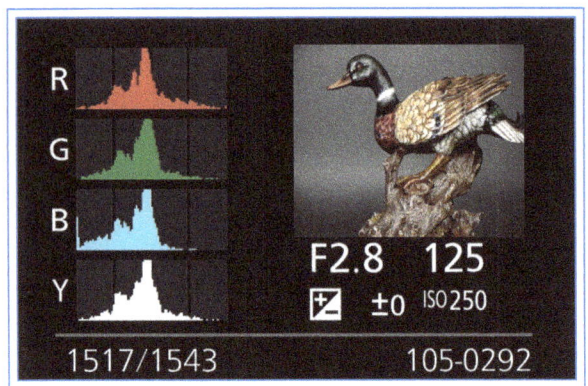

Figure 7-19. Histogram for Normally Exposed Image

In playback mode, the D-Lux includes one display screen in playback mode that shows the histogram for the image being displayed. The camera does not, by default, display the histogram for the live view in recording mode. To turn on the histogram when you are shooting, you need to use this menu option.

The Histogram menu option has only 2 choices: On or Off. If you turn the histogram on, it will appear on the camera's display in recording mode, if a detailed display screen has been selected using the Display button, as shown in Figure 7-20.

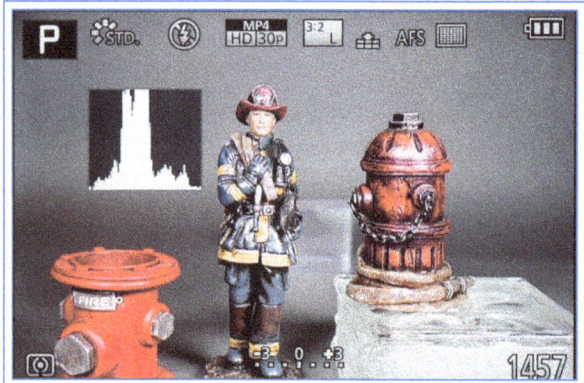

Figure 7-20. Recording Mode Histogram

The histogram does not display in Snapshot mode. When the histogram is first activated, it appears in a red frame with arrows indicating that you can move it to any position on the display. Once you have it located where you want it, press Menu/Set to lock it in place. While it is movable, press the Display button to reset it to the center of the display. If you need to move it after it has been locked in place, go back to this menu option and select On for the Histogram item.

The histogram is an approximation, and you should not rely on it too heavily. It provides some information as to how evenly exposed your image is likely to be. (Or, for playback, how well exposed it was.) If the histogram is displayed in orange, that means the recording and playback versions of the histogram will not match for this image, because the flash was used, or in a few other situations.

Next, I will discuss the items on screen 5 of the Custom menu, shown in Figure 7-21.

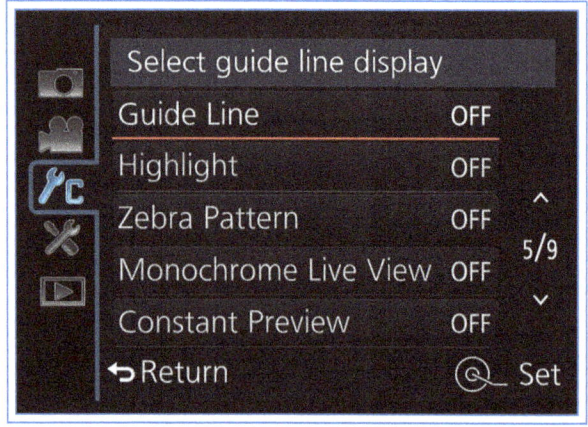

Figure 7-21. Screen 5 of Custom Menu

Guide Line

This option lets you set grid lines to be displayed on the LCD screen (or in the electronic viewfinder) to assist you with the composition of your pictures. Once you select Guide Line from the Custom menu, you get to a screen with 4 options: Off, and 3 patterns of lines, as shown in Figure 7-22.

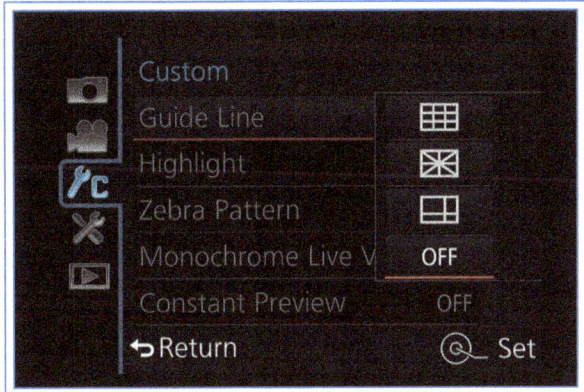

Figure 7-22. Guide Line Options Screen

If you choose Off, no grid lines will be displayed. If you choose the top option, the camera will display a grid that forms nine equal rectangles on the screen. This choice can help you line up subjects, including the horizon, along straight lines. The second option for grid lines is a pattern of 16 rectangles along with a pair of intersecting diagonal lines, which can help you locate your subject along diagonals as well as along horizontal or vertical lines. Finally, with the third option, the camera displays just 2 intersecting lines, one horizontal and one vertical, and lets you set their positions using the direction buttons. This option can be useful if you need to compose your shot with an off-center subject.

When any of the Guide Line options is turned on, the grid lines will display whenever the camera is in recording mode, regardless of the shooting mode. They will not display when you select the display screen that is blank or the display screen that shows only shooting information without the live view. An example of the second option as displayed is shown in Figure 7-23.

Figure 7-23. Guide Line Option 2 In Use

Highlight

This feature produces a flashing area of black and white on areas of the image that are over-saturated with white, indicating they may be too bright. The flashing effect takes place only when you are viewing the pictures in Auto Review or in playback mode. That is, you will see the Highlight warning only when the image appears briefly on the screen after it has been recorded (Auto Review) or when you play the picture in playback mode. The purpose of this feature is to alert you that your picture may be washed out (overexposed) in some areas, so you may want to reduce the exposure for the next shot. If you find that sort of warning distracting, just turn this feature off. The flashing does not occur on one playback screen that shows the image only, with no information. So, even if this option is turned on, you can see your image without the flashing, by pressing the Display button to view that screen.

Zebra Pattern

This feature helps you gauge whether your image or video will be overexposed by setting the D-Lux to display a black-and-white-striped "zebra" pattern on the screen in recording mode. You can select either left-slanting or right-slanting stripes to match the scene as well as possible, and you can set either type of stripes to a numerical value from 50% to 105% in 5% increments. Those numbers are a measure of relative brightness or exposure, with 0 representing black and 100 representing bright white.

To make the settings, select the menu option and pop up the menu with sub-options of Zebra1, Zebra2, Off, and Set, as shown in Figure 7-24.

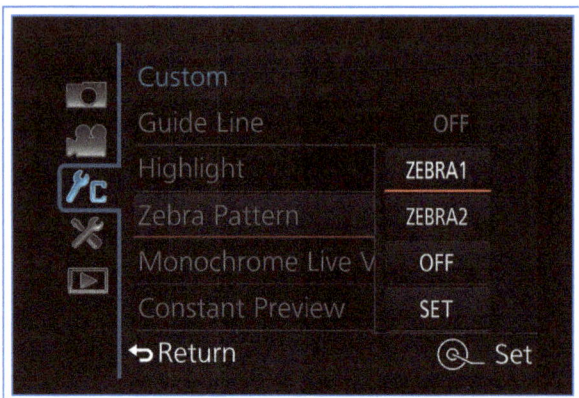

Figure 7-24. Zebra Options Screen

Figure 7-25. Zebra Example at Setting of 75

Zebra1 generates stripes that slant from lower left to upper right and appear to move down to the right; Zebra2 generates stripes in the opposite direction. Use the Set option to set a numerical level for either Zebra1 or Zebra2, and then choose Zebra1 or Zebra2 from the menu to display that pattern on the screen.

When you turn this option on to any level less than about 90, you very likely will see, on some parts of the display, the "zebra" stripes that give this feature its name. When you see the stripes, that means the part of the image where the stripes appear is at or above the brightness level that was set for the stripes. For example, if you select stripes set to the 75% level and aim the camera at the scene, the stripes will appear on any part of the display where the brightness level reaches 75% of bright white.

There are various approaches to using these stripes, which originated as a tool for professional videographers. Some photographers like to set the zebra function to 90% and adjust the camera's exposure so the stripes just barely start to appear in the brightest parts of the image. Another recommendation is to set the option to 75% for a scene with Caucasian skin, and expose so that the stripes just barely appear in the area of the skin.

In Figure 7-25, I set the pattern to Zebra1 at 75% and exposed to have the stripes barely begin to appear on the mannequin's face.

Zebra Pattern is a feature to consider, especially for video recording, but the D-Lux has an excellent metering system, including both live and playback histograms, so you can manage without this option if you don't want to deal with its learning curve.

Monochrome Live View

When you turn this feature on, the camera converts the display to a black-and-white view of the scene it is aimed at. You can use this feature if it might assist you in concentrating on composition and geometry in your image, without being distracted by colors. You also might find it easier to adjust manual focus with this view, because you can turn on Peaking with a color that will contrast clearly with all parts of the display. The monochrome view does not affect the recorded image, which will be in color unless you have also selected a monochrome setting for the final image using the Photo Style menu option or the Filter button.

Constant Preview

This option lets you see a preview of the effects of your exposure settings when the camera is in Manual exposure mode. When you turn this option on with the camera in that recording mode and then adjust shutter speed, aperture, or ISO, the display will grow darker or brighter to show how the settings would affect the final image. The display also will show how the aperture setting would affect the depth of field.

For example, if you set shutter speed to 1/125 second, aperture to f/8, and ISO to 1600 in a moderately lighted room, with this option turned off, the camera's display will appear normal, showing the scene clearly. If you then press the shutter button halfway (assuming default settings for focus and shutter behavior), the

display will grow dark and you will see more items in focus, reflecting the effects of the current settings. If you then turn this menu option on, you will see the same view you did when you pressed the shutter button halfway, even before pressing that button.

This setting can help if you need to see exactly what effect the current settings will have. However, in some situations it is better to leave this option turned off. For example, if you are shooting an image using manual flash in Manual exposure mode, the camera will not realize that you are using flash, and the display screen may be completely dark with the settings you are using. In that situation, you would not be able to see the display to compose your image with this option activated, so you should leave Constant Preview turned off.

If you have the Fn1 button set to its default function of Preview and have the Constant Preview option turned on, pressing the Fn1 button in Manual exposure mode will not activate the Preview function, because it is already in effect through this menu option.

The next items to be discussed are on screen 6 of the Custom menu, shown in Figure 7-26.

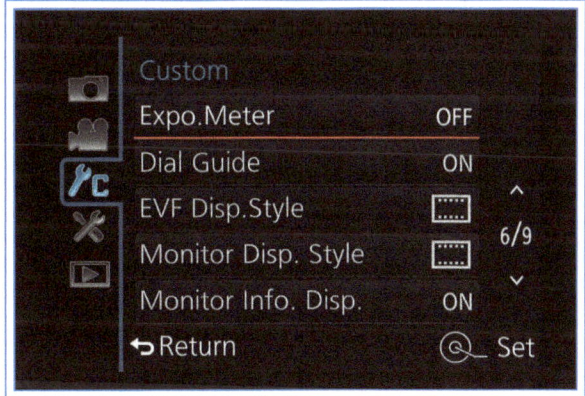

Figure 7-26. Screen 6 of Custom Menu

Exposure Meter

This feature gives you the option of having the camera display its Exposure Meter feature, which is a set of 2 graphical dials that appear when you are adjusting shutter speed, aperture, exposure compensation, or Program Shift, as shown in Figure 7-27.

Figure 7-27. Exposure Meter Option In Use

I find this display distracting and not all that helpful, so I leave it turned off, but you might want to try using it to see if it is useful in some situations.

Dial Guide

When this option is turned on, the camera places a small diagram in the lower right corner of the display for a few seconds that shows the current functions of the control ring and control dial. The diagram appears when you switch the recording mode by turning the control ring or shutter speed dial to the A setting, or away from the A setting.

Figure 7-28. Dial Guide Option In Use

For example, in Figure 7-28, the display shows that the control ring controls step zoom and the control dial controls Program Shift, because the camera is in Program mode. If you move the aperture ring or shutter speed dial to change the recording mode, the display will change accordingly and appear for another few seconds. I do not find this display helpful, and it is mildly distracting, so I generally leave it turned off.

EVF Display Style

This option controls how various informational icons are displayed in the viewfinder. There are 2 choices, indicated by graphic icons. With the top choice, known

as live viewfinder style, several of the icons, including those for recording mode, battery status, metering mode, and number of images remaining, are displayed outside of the live view area, so you can see more of the live view with no icons blocking the view. In addition, the Metering Mode icon and a few others remain on the display even when the no-information screen is selected. With the bottom choice, known as monitor style, all of the icons are placed within the live view area and that area extends farther down to accommodate them. I find the differences between these 2 views to be minimal, but this is one way to tweak the viewfinder's operation if you want to.

Monitor Display Style

This option is the same as the previous one, except that it applies to the LCD display, rather than the viewfinder. For this setting, I prefer using the bottom option, which places all of the icons within the live view of the image, so you have a slightly larger view of the scene. I find that the icons do not significantly block the view. I also like having the option of selecting one recording display with no information at all, without having the Metering Mode and a few other icons remaining on the screen.

Monitor Information Display

This option lets you choose whether or not to include the information-only display among the screens that the camera displays on the LCD (but not in the viewfinder) in recording mode when you press the Display button. If you turn this option on, then the camera includes the screen shown in Figure 7-29, which displays your recording settings, including recording mode, ISO, exposure compensation, Quality, Photo Style, White Balance, Metering Mode, images remaining, and other settings. It displays the aperture and shutter speed once they are determined by your settings or by the camera's metering.

As I discussed in Chapter 5, if you press the QM button when this screen is displayed, you can adjust the various settings as you scroll through them.

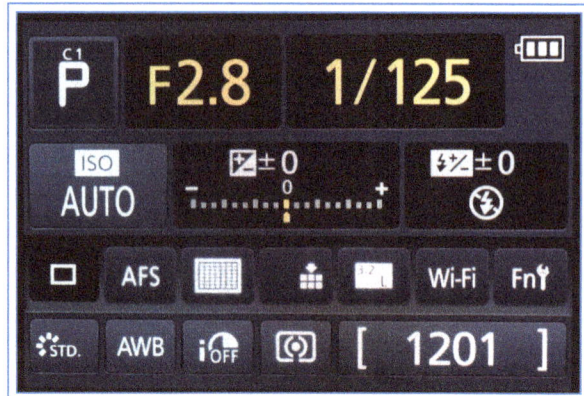

Figure 7-29. Recording Display: Monitor Information

This display does not include any view of the image; the idea is that you will use this display for information (or for Quick Menu adjustments), and use the viewfinder to view the scene. If you don't want to include this screen in the cycle of displays, just turn the option off using this menu item.

Next, the items on screen 7 of the Custom menu are shown in Figure 7-30.

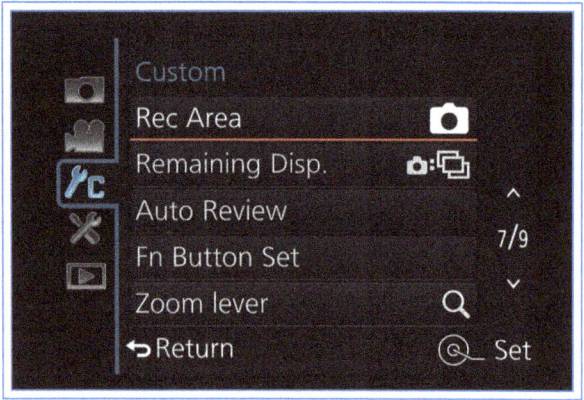

Figure 7-30. Screen 7 of Custom Menu

Recording Area

This first option on screen 7 of the menu lets you set the camera to display the live view showing the recording area used for still photos or the area used for motion pictures. For still pictures, that area is determined by the setting of the aspect ratio switch; for motion pictures, it is determined by the Recording Quality option on the Motion Picture menu's first screen. For still images, there are 4 options: 3:2, 16:9, 1:1, and 4:3. For motion pictures there are only 2 choices: 4:3 for the VGA setting and 16:9 for all other settings.

The reason for having this menu option available is that the D-Lux does not ordinarily show the area available

for motion picture recording until you press the red Motion Picture button to start the recording. So, if the aspect ratio switch is set for, say, 3:2, and the movie quality is set to HD, you will not see the actual shape of the motion picture recording screen until the recording starts, so you will not be able to compose the scene on the camera's monitor or in the viewfinder properly. But, if you set the Recording Area menu option to the Motion Picture option, then you will see the available recording area on the camera's screen before you start the recording.

The choice here depends on whether you are planning to capture still images or record motion picture sequences in your shooting session. To make the choice, just use this menu item to select the icon for the still camera or the icon for a movie camera.

Remaining Display

This feature lets you choose whether the camera's display shows how many still images can be taken with current settings, as shown in Figure 7-31, where the display in the lower right corner of the screen shows the number of still images that can be recorded (1201 in this case), or how much time is available for video recording.

Figure 7-31. Recording Display Showing Number of Images Remaining

Again, as with the previous menu option, your choice may depend on whether you are shooting mostly stills or videos.

Auto Review

This option controls how your images are displayed immediately after they have been recorded by the camera. There are 2 main settings: Duration Time and Playback Operation Priority, as shown in Figure 7-32.

For Duration Time, the possible settings are Off, 1 second, 2 seconds, 3 seconds, 4 seconds, 5 seconds, or Hold. These choices are fairly self-explanatory. After the shutter button is pressed, the image appears on the screen (or not) according to how this option is set. If you set it to Hold, the image stays on the screen until you press the shutter button halfway.

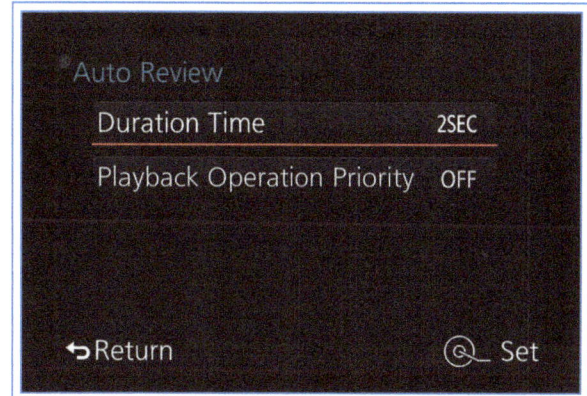

Figure 7-32. Auto Review Main Options Screen

The Playback Operation Priority sub-option, which can be set either on or off, determines how the camera reacts to button presses when Auto Review is in effect. For example, if Duration Time is set to 5 seconds and Playback Operation Priority is turned on, then the buttons will react as if the camera were in playback mode, if you press a button during the 5 seconds the image is on the screen. So, if you press the Left button, the camera will display the previous image on the memory card, and if you press the Fn1/Delete button, the camera will prompt you for deleting the image. Once you press a button in this situation, the camera will remain in playback mode until you purposely exit from it by pressing the shutter button halfway or another method.

If, instead, Playback Operation Priority is turned off, then, if you press a button while an image is displayed during the 5 seconds, that button will switch the camera into recording mode and will have the effect it normally has in that mode. For example, if you press the Left button, the camera will display the screen for choosing an autofocus mode.

If you choose Hold for the Duration Time, then the camera automatically turns on Playback Operation Priority.

Auto Review does not work when recording motion pictures.

FUNCTION BUTTON SET

As I discussed in Chapter 5, the D-Lux has 3 Function buttons, designated as Fn1, Fn2, and Fn3. Each of those buttons has a particular function assigned to it by default, but you can change that assignment to any one of numerous other options for each button. To do that, you use the Function Button Set menu option.

When you highlight this option and press the Menu/Set button or the Right button, the camera will display the special screen shown in Figure 7-33.

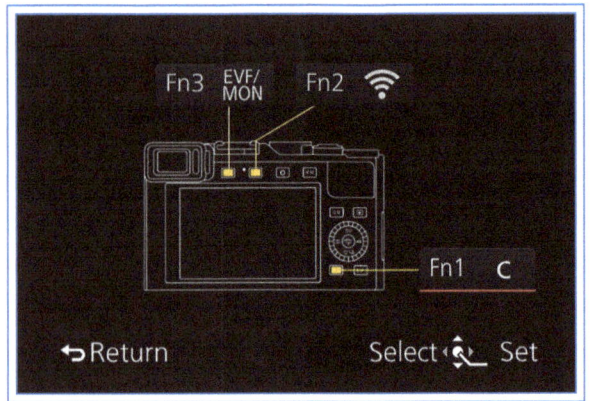

Figure 7-33. Special Screen for Assigning Functions to Function Buttons

On that screen, turn the control dial or press the Up and Down buttons to move the highlight to the button whose assignment you want to change, and press Menu/Set. You will then see a display like that in Figure 7-34, which highlights the current setting for that button on a sub-menu screen. You can scroll through that series of 10 screens until you find the new setting you want to make, and press Menu/Set to confirm it. I discussed the possible settings in Chapter 5.

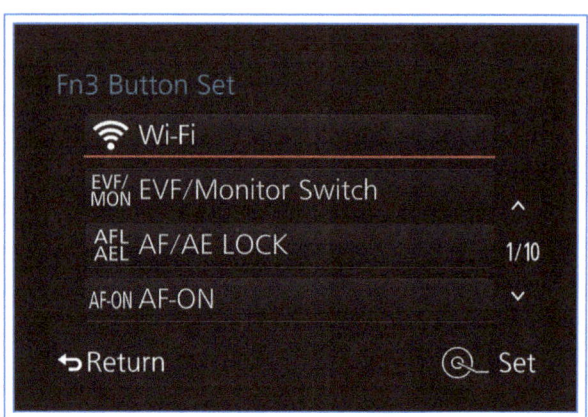

Figure 7-34. Screen 1 of Function Button Options

As a reminder, the available settings are shown in Table 7-1.

Table 7-1. Options That Can Be Assigned to Function Buttons Fn1, Fn2, and Fn3

Recording Menu and Recording Functions Not on Menu			
Wi-Fi (Fn2 or Fn3 only)	EVF/Monitor	AF/AE Lock	AF-ON
Preview	Level Gauge	Focus Area Set	Cursor Button Lock
Photo Style	Picture Size	Quality	AFS/AFF/AFC
Metering Mode	Highlight Shadow	i.Dynamic	i.Resolution
HDR	Shutter Type	Flash Mode	Flash Adjust.
i.Zoom	Digital Zoom	Stabilizer	Sensitivity
White Balance	AF Mode/MF	Drive Mode	Restore to Default
Motion Picture Menu			
4K Photo	Motion Pic. Set	Picture Mode	
Custom Menu			
Utilize Custom Set feature	Silent Mode	Peaking	Histogram
Guide Line	Zebra Pattern	Monochrome Live View	Rec Area
Zoom lever			

Don't forget that several of these items, including Photo Style, Motion Picture Setting, Quality, AFS/AFF/AFC, and Metering Mode, also can be adjusted using the Quick Menu system by just pressing the QM button and then navigating through the easy-access menu that appears.

Also, although most of the items that can be assigned to the Function buttons also can be reached through the menu system, there are some items that cannot be reached that way: Preview, Focus Area Set, Cursor Button Lock, and AF Mode/MF. I discussed those settings in Chapter 5.

As I mentioned in Chapter 5, the Fn1 button cannot be assigned to the Wi-Fi option.

Zoom Lever

This final option on screen 6 of the Custom menu lets you control how the zoom lever operates. By default, this lever zooms the lens continuously through its full range of focal lengths, which is 24mm to 75mm without any enhanced zoom settings. If you choose the second option here, the zoom lever uses step zoom, which allows the lever to zoom only to several preset zoom ranges: 24mm, 28mm, 35mm, 50mm, 70mm, and 75mm, when no enhanced zoom settings are in use. It will not stop at any other focal length.

As I discussed in Chapter 5, by default, the control ring is assigned to control step zoom in Program mode, Aperture Priority mode, and Snapshot mode; in other modes it controls intermediate shutter speeds. However, you can change the ring's assignment to other options, including step zoom or normal zoom.

My preference is to leave the zoom lever with its normal operation of zooming through the full range of focal lengths, rather than limiting it to the step zoom increments, partly because the control ring is available for step zoom by default in several shooting modes. But this option is available if you want to use it.

The next settings to discuss are on screen 8 of the Custom menu, shown in Figure 7-35.

Figure 7-35. Screen 8 of Custom Menu

Control Ring

This first option on screen 8 of the menu lets you set the function or functions of the control ring, the large ring around the lens. As I discussed in Chapter 5, whenever the camera is set to manual focus mode, the control ring is used to adjust focus. When the camera is set to an autofocus mode, the control ring can control other options, according to how it is set. By default, in Shutter Priority and Manual exposure modes, turning the control ring selects shutter speeds other than those that are printed on the shutter speed dial, such as 1/1300 second and 1/5 second. In Snapshot mode, Aperture Priority mode, and Program mode, the control ring operates the step zoom feature.

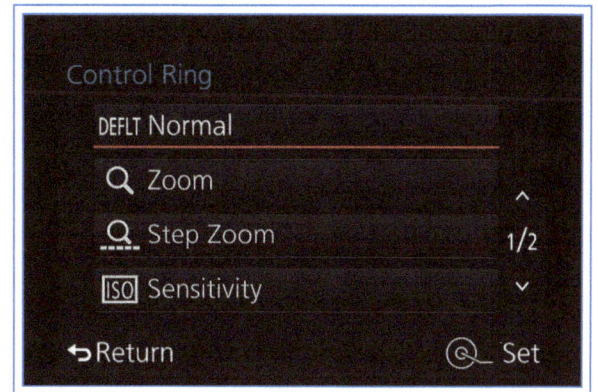

Figure 7-36. Screen 1 of Control Ring Menu Options

This menu option, whose first of 2 screens is shown in Figure 7-36, lets you choose whether to leave the ring set to its default settings, or to one of the following options: Zoom; Step Zoom; Sensitivity (ISO); White Balance; Filter Select; or Not Set. The zoom function causes the ring to zoom continuously through all focal lengths, rather than using the specific steps of step zoom. If you choose one of these settings, the control ring will have that assignment in all shooting modes. However, it always will control manual focus, whenever the camera is set to manual focus mode.

My preference is to use the default settings, but it is useful to have the choice of setting the ring to control a setting such as ISO or Filter Select if you expect to be adjusting those settings frequently during a particular shooting session.

Zoom Resume

If you turn on zoom resume, then, after you turn the camera off and back on, the lens will return to its last zoom position. If you leave this setting turned off, the lens will zoom out to its 24mm setting when the power is turned back on. This option is convenient if you need to use a particular focal length, such as 60mm, for a

series of shots that will be interrupted by turning the camera off for periods of time.

Quick Menu

This option gives you the ability to customize the settings that are available from the Quick Menu. As I discussed in Chapter 5, when you press the QM button, the camera displays an easy-access menu system that lets you select various settings quickly. By default, the Quick Menu includes 9 settings: Photo Style, Motion Picture Setting, Picture Size, Quality, AFS/AFF/AFC, AF Mode, Metering Mode, Sensitivity, and White Balance. To keep those settings in place or restore them after custom settings have been used, just select the Preset option for this menu item. If you want to set up the Quick Menu with your own selection of settings, select the Custom option for this menu item.

Once you have selected Custom for the Quick Menu item, exit this menu system and press the QM button. On the screen that appears, use the Down button to move to and highlight the tool icon at the lower left of the display, as shown in Figure 7-37.

Figure 7-37. Custom Icon Highlighted for Quick Menu

Press Menu/Set, and the camera will display the Q. Menu Customize screen, as shown in Figure 7-38.

Figure 7-38. Quick Menu Customize Screen

On that screen, navigate through the icons at the top of the display until you find the icon for a setting you want to install in the Quick Menu. With that icon highlighted, press Menu/Set and the camera will prompt you to move to the "desired position." At that point, one of the icons in the bottom row will be highlighted; use the control dial or the Left and Right buttons to move that highlight to the position where you want to locate the setting whose icon you selected from the top rows. If there is no blank space available in the bottom row, just highlight an occupied space and press Menu/Set; the new icon will replace the existing one.

A button Switch

This option lets you control the way the A button on top of the camera operates. By default, when you press that button quickly, the camera switches into or out of Snapshot mode. With this option, you can change the button's behavior from Single Press to Press and Hold. With that setting, you have to hold down the button for about a second to carry out the change in recording modes. I prefer the Press and Hold option, because it avoids the problem of accidentally changing modes through the mistaken press of a button, while still letting you easily switch modes when you need to.

Video Button

You can use this option to lock out the operation of the red Motion Picture button, or Video button, as it's called on the menu. If you turn this option on, the button operates normally to start and stop the recording of a motion picture. If you turn it off, the button will not operate at all and the camera will display an error message if you press it. This is a convenient option to have available, because it is easy to press this button by mistake when you are trying to press the AF/AE Lock button.

Finally, there is only one item on screen 9 of the Custom menu, shown in Figure 7-39.

Chapter 7: The Custom Menu and the Setup Menu | 131

Figure 7-39. Screen 9 of Custom Menu

Eye Sensor

This last item on the Custom menu has 2 sub-options with controls for the operation of the eye sensor, the small slot at the right of the viewfinder that detects the presence of your eye (or another object). Those sub-options are Sensitivity and EVF/Monitor Switch, as shown in Figure 7-40.

Figure 7-40. Eye Sensor Options Screen

You can set Sensitivity to High or Low. I have not found much difference between these settings. If you find that the eye sensor is triggering the switch from LCD to viewfinder when you don't want it to, you can try setting this option to Low to see if that helps.

The other setting for this menu option is EVF/Monitor Switch. There are 3 possible choices for this item: EVF/Monitor Auto, EVF, and Monitor. With the first choice, the camera will switch automatically between using the LCD screen and using the viewfinder as your eye moves away from or approaches the eye sensor. If you choose EVF, the viewfinder will always be in use; if you choose Monitor, the LCD display will always be in use.

I find it convenient to use the EVF/Monitor Auto option, so the camera will switch to using the viewfinder whenever my head comes near to the viewfinder. However, in some cases, such as if you are doing close-up shots from a tripod, you might want to leave the monitor always in use, even though your head may come near to the camera as you adjust a setting. Or, you might want to set the viewfinder to be in effect at all times when you don't want to have the LCD display illuminate to distract those around you.

You can also switch the behavior of the eye sensor by pressing the EVF button, assuming it remains assigned to this option.

The Setup Menu

The Setup menu, designated by the tools icon (wrench and screwdriver), has 5 screens of options for adjusting settings having to do with general camera functions. Its first screen is shown in Figure 7-41.

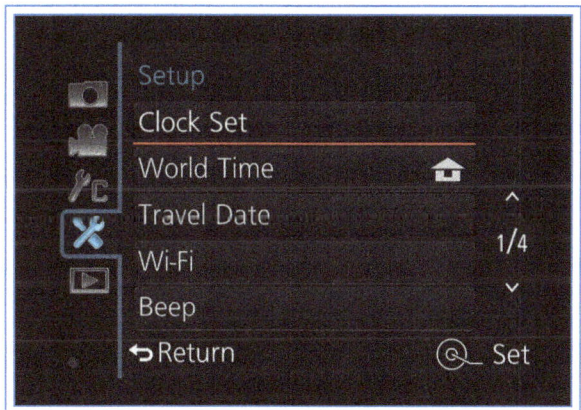

Figure 7-41. Screen 1 of Setup Menu

Clock Set

When you use your D-Lux camera for the first time, it should prompt you to set the clock. If it does not do so, or if you later need to adjust the date and time, use this menu option. When you select it and press the Right button or Menu/Set, the camera will display a screen like that shown in Figure 7-42.

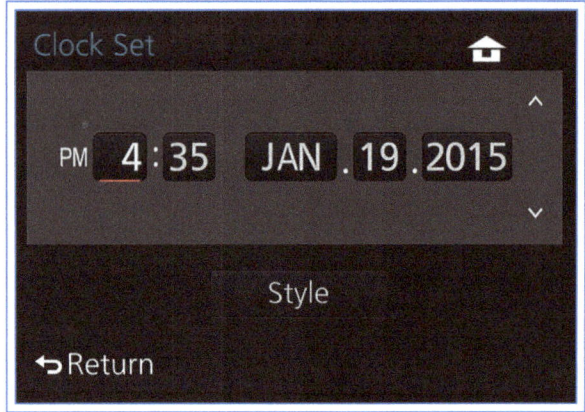

Figure 7-42. Clock Settings Screen

On that screen, navigate through the blocks for time and date using the control dial or the Left and Right buttons, and adjust the settings with the Up and Down buttons. You can then highlight the Style block to select the order for month, day, and year and whether to use 24-hour format for the time. When everything is set properly, navigate to the Set block in the lower right corner of the display and press Menu/Set to confirm the settings. (The Set block appears only if some change has been made.)

World Time

This is a handy function when you're traveling to another time zone. Highlight World Time, and press the Right button to access the next screen. If you haven't used this menu item before, you'll be prompted to select the Home area. If so, press Menu/Set and then use the Left and Right buttons or the control dial to scroll through the world map as shown in Figure 7-43, and use the Menu/Set button to set your Home area.

Figure 7-43. World Time Map

Then, on the World Time screen, shown in Figure 7-44, use the Up button to highlight Destination, and again scroll through the world map to select the time zone you will be traveling to.

Figure 7-44. World Time Screen to Set Destination and Home

The map will show you the time difference from your Home time. Press Menu/Set to select this zone for the camera's internal clock. Then, any images taken will reflect the correct time in the new time zone. When you return from your trip, go back to the World Time item and select Home to cancel the changed time zone setting.

Travel Date

This menu item has 2 sub-options for entering information when you take a trip, so the camera can record that information with your images. First, Travel Setup lets you set a range of dates for the trip, so the camera can record which day of the trip each image was taken. Then, when you return from your trip, if you use the Text Stamp function to "stamp" the recorded data on the images, the images will show they were taken on Day 1, Day 2, etc., of the trip. The date entries for Travel Setup are self-explanatory; just follow the arrows and the camera's prompts.

After you set departure and return dates, you also can set the location, which will display along with the day number. To do that, after setting up the dates, select Location from the Travel Date menu item and then select Set from the sub-menu, as shown in Figure 7-45.

Chapter 7: The Custom Menu and the Setup Menu | 133

Figure 7-45. Travel Date Screen

The camera will display a screen where you can enter the name of the location using the same text-entry tools as are used for the Text Edit item, discussed earlier.

Wi-Fi

This option is used to set up a Wi-Fi connection with the D-Lux. I will discuss the Wi-Fi operations of the camera in Chapter 9.

Beep

This last option on screen 1 of the Setup menu lets you adjust several sound items. First is the volume of the beeps the camera makes when you press a button, such as when navigating through the menu system. You can set the beeps to off, normal, or loud, as represented by the icons shown in Figure 7-46. It's nice to be able to turn the beeps off if you're going to be in an environment where such noises are not welcome.

Figure 7-46. Beep Volume Options Screen

Second is the volume of the shutter operation sound. Again, it's good to be able to mute the shutter sound. Finally, you can choose from 3 shutter sounds. If you want to silence all sounds quickly, while also disabling the flash and the AF assist lamp, use the Silent Mode option on screen 1 of the Custom menu.

Screen 2 of the Setup menu is shown in Figure 7-47.

Figure 7-47. Screen 2 of Setup Menu

Live View Mode

This option lets you choose either 30 fps (the default) or 60 fps for the operation of the camera's LCD display screen. The setting of 30 frames per second emphasizes quality, but the display may not always refresh quickly enough to keep up with a fast-moving subject. In addition, with some settings, such as the Rough Monochrome or Silky Monochrome settings for Filter effect, the display slows down as the camera processes the effect. If you choose the 60 fps setting, the display will be better able to show any action smoothly, or to maintain a smooth appearance as you pan across the scene. The quality of the display may suffer slightly, but not badly. So, if you find the display stuttering or smearing, you may want to try the 60 fps option.

This setting does not affect the viewfinder, which always uses the 60 fps setting.

Monitor Display/Viewfinder

This menu option is unusual because its name changes depending on whether you are viewing the menu on the LCD monitor or in the viewfinder. If you are viewing it on the monitor, it is called Monitor Display; if you are using the viewfinder, it is called Viewfinder. It operates the same way in either case. However, if you make adjustments to this item while using the monitor, those adjustments will affect only the monitor. You can make separate adjustments while using the viewfinder, and those adjustments will affect only the viewfinder.

As shown in Figure 7-48, This option has 5 linear scales for making adjustments. Use the Up and Down buttons to select a scale, and then use the Left and Right buttons or the control dial to adjust the settings on the scale for each item. The normal settings are in the middle of the scale; move the red blocks to the left of the scale to decrease a setting, or to the right to increase the value.

Figure 7-48. Monitor Display Options Screen

Starting from the top, the scales control brightness, contrast, saturation, red tint, and blue tint. When you have made your adjustments on each scale, you have to press the Menu/Set button to make them take effect.

I have never found a need to adjust the settings for either the LCD display or the viewfinder, but if you find the color, contrast, or brightness of either display is not to your liking, you can use these adjustments as you wish.

MONITOR LUMINANCE

This setting affects the brightness of the LCD screen but not the viewfinder, though you can adjust it while using the viewfinder. This setting is different from the brightness setting of the previous option in that it provides on-or-off adjustments, rather than a sliding scale. As shown in Figure 7-49, this menu item has 4 settings, each accompanied by an asterisk: A, 1, 2, and 3.

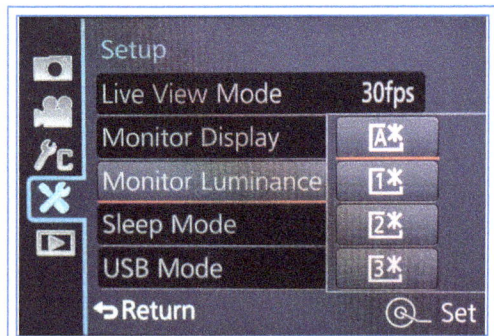

Figure 7-49. Monitor Luminance Options Screen

With the A (Auto) setting, the brightness will adjust according to ambient lighting conditions. With the 1 setting, the screen becomes extra-bright to compensate for sunlight or other conditions that make it hard to see the screen. It reverts to normal after 30 seconds, but you can press any control button to restore the brightness. The 2 setting provides standard illumination, and the 3 setting sets the display to a dimmer level than normal.

Using the A or the 1 setting decreases battery life. If you find it hard to see the screen in bright sunlight and don't want to use the viewfinder, you might want to try the 1 setting to see if the added brightness gives you enough visibility to compose your shots or view your recorded images clearly.

I use the A setting myself, and always keep an extra battery handy.

SLEEP MODE

The Sleep Mode option puts the camera into a dormant state after a specified period of not using any of the camera's controls. The period can be set to 1, 2, 5, or 10 minutes, or the option can be turned off, in which case the camera never turns off automatically (unless it runs out of battery power). To cancel Sleep Mode, press the shutter button halfway and the camera will come back to life. Sleep Mode does not turn off the camera during a slide show or when the AC adapter is connected, or during the recording or playback of a motion picture, along with a few other situations.

USB MODE

If you are going to connect the camera directly to a computer or printer, you need to go to this menu item and select the appropriate setting from the choices shown in Figure 7-50: Select on Connection, PictBridge (for connecting to a printer), or PC.

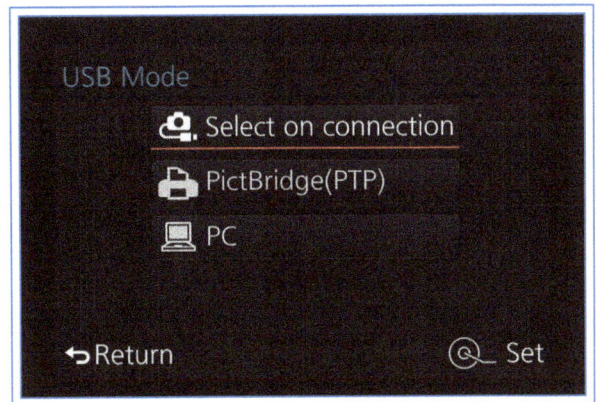

Figure 7-50. USB Mode Options Screen

If you choose Select on Connection, you don't select the setting until after you have plugged the USB cable into the device to which you are connecting the camera. The D-Lux connects to a computer using the USB 2.0 connection standard, assuming your computer has a USB port of that speed. (If not, the camera will still connect at the slower speed of the computer's older USB port.)

Screen 3 of the Setup menu is shown in Figure 7-51.

Figure 7-51. Screen 3 of Setup Menu

TV Connection

This menu item has 3 sub-options: TV Aspect, HDMI Mode, and HDTV Link. The TV Aspect option is available only when you are connecting the camera to a TV by means of an audio-visual cable. The only choices are 16:9 for widescreen or 4:3 for fullscreen. You can use this setting to provide the appropriate shape for the screen, depending on whether most of your images are fullscreen (4:3 and similar settings) or widescreen (16:9). If you are playing videos, they will all be widescreen unless you recorded some using the VGA setting.

The HDMI Mode option sets the output resolution for the images that are sent to an HDTV when the camera is connected to the TV with a micro HDMI cable. The available choices are Auto, 4K, 1080p, 1080i, 720p, and 480p. Ordinarily, if you select Auto the images should appear properly on the HDTV. If they do not, you can try one of the other settings to see if the display improves.

The HDTV Link option is for use when you are connecting the D-Lux to a compatible HDTV set using a micro HDMI cable. If you leave this option turned off, then the operations of the camera are controlled by the camera's own controls. If you turn it on, then the TV's remote control can also control the operations of the camera, so you can play slide shows or review individual images and movies.

Menu Resume

This menu item can be set either on or off. When it is turned on, whenever you enter the menu system, the camera displays the last menu item you had selected previously. When this option is turned off, the camera always starts back at the top of the first screen of the Recording menu. If there is a particular menu item you need to adjust often, this option can be of considerable use, because you can just press the Menu/Set button and the item will appear, ready for you to make your setting. For example, if you are in a situation where you need to change the Metering Mode frequently, turn on Menu Resume. Then, whenever you need to get back to the Metering Mode setting, just press Menu/Set, and the item will be there at your fingertips. (Of course, you also could set a Function button to bring up this option, or you could use the Quick Menu, but this is one other approach to consider.)

Menu Information

This option lets you turn on or off the display of information at the top of each menu screen, which provides a line of informative text explaining the function of whichever menu item is currently highlighted. For example, Figure 7-52 shows this feature in use when the Digital Zoom option is highlighted on screen 6 of the Recording menu.

Figure 7-52. Example of Menu Information Option in Use - for Digital Zoom

Most of the entries are too long to fit on one line, and they scroll across the display. There are entries for all of the main menu items and for many of the sub-options as well. I find this feature to be very helpful and it is not obtrusive, so I usually leave it turned on.

Language

This option gives you the choice of language for the display of commands and information on the LCD screen. My U.S. version of the camera offers 23 choices, the first 4 of which are shown in Figure 7-53. Presumably, models sold elsewhere may offer other choices. If your camera happens to be set to a language that you don't read, you can find the language option by going into the Setup menu (look for the tools icon), and then scrolling to this option, which is marked by a little icon showing a man's head with a word balloon. It is the final option on screen 3 of the Setup menu.

Figure 7-53. Language Options Screen

Version Display

This item has no settings; when you select it, it displays the version of the camera's firmware that is currently installed. As I write this, my D-Lux has version 1.0 of the firmware installed, as shown in Figure 7-54.

Figure 7-54. Firmware Version Screen

Firmware is somewhat like both software and hardware; it is the programming electronically recorded into the camera, either at the factory or through your computer if you upgrade the firmware with an update provided by Leica. A new version of the firmware can fix bugs and can even provide new features, so it's a good idea to check the Leica website periodically for updates. Instructions for installing an update are provided on the website. The process usually involves downloading a file to your computer, saving that file to an SD card formatted for the camera, then placing that card in the camera so the firmware can be installed.

Screen 4 of the Setup menu is shown in Figure 7-55.

Figure 7-55. Screen 4 of Setup Menu

Self Timer Auto Off

This next option controls whether the self-timer remains set after you turn the camera off and back on. If this option is turned on, then, when the camera turns off, the self-timer will be deactivated and will not be in effect when the camera is turned on the next time. If

this option is turned off, then the self-timer will remain in effect even after the camera has been powered off.

How you use this feature depends on your particular needs. If you often use the self-timer, it can be convenient to leave it activated so it will be ready the next time you turn on the camera. Or, if you use it rarely, you can turn this option on so the self-timer will not be in effect when you don't want it.

Number Reset

This function lets you reset the folder and image number for the next image to be recorded in the camera. If you don't use this option, the numbers of your images will keep increasing until they reach 999, even if you change to a different memory card. If you want each new card to start with images numbered from 1 up, use the Number Reset function each time you start a new card, or a new project for which you would like to have freshly numbered images. I prefer not to reset the numbers, because I find it easier to keep track of my images if the numbers keep getting larger; I would find it confusing to have images with duplicate numbers on my various SD cards.

Reset

This menu option resets all Recording menu settings to their original states, and also resets all Setup menu settings to their original states. This is a convenient way to get the camera back to its default mode, so you can start with fresh settings before you experiment with new ones. The camera prompts you twice, asking if you want to reset all Recording menu settings, and then all Setup menu parameters. Folder numbers and date and time settings will not be reset by this option.

Reset Wi-Fi Settings

This option resets all Wi-Fi settings for the camera. You might want to use this option if you are selling your camera, to avoid giving away information about your wireless networks. You also might want to use this option if you are having trouble getting the Wi-Fi settings configured and you want to make a fresh start.

Format

This is one of the more important menu options. Choose this process only when you want or need to completely wipe all of the data from a memory card. When you select the Format option, the camera will ask you if you want to delete all of the data on the card, as shown in Figure 7-56.

Figure 7-56. Format Confirmation Screen

If you reply by selecting Yes, the camera will proceed to erase all images and videos, including any that have been locked using the Protect option on the Playback menu. It's a good idea to use this command with any new memory card you place in the camera for the first time so the card will be properly formatted to store new images and videos.

Chapter 8: Motion Pictures

A few years ago, the video recording features of compact cameras seemed to be included almost as afterthoughts, so the user would have some ability to record video clips but without many advanced features. Recently, though, camera makers, including Leica and Panasonic, have increased the sophistication of the video functions of small cameras to a remarkable level. The D-Lux is not ready to take the place of a dedicated video camera for professional productions, because it lacks features such as live HDMI output and jacks for external microphones. But in terms of pure video recording capability, it has great abilities. I will discuss how to take advantage of those features in this chapter.

Basics of D-Lux Videography

In one sense, the fundamentals of making videos with the D-Lux can be reduced to 4 words: "Push the red button." Having a dedicated motion picture recording button makes things easy for users of this camera, because anytime you see a reason to record a video clip, you can just press that easily accessible button while aiming at your subject, and you will get results that are likely to be usable. So, if you're more of a still photographer and not particularly interested in movie-making, you don't need to read further in this chapter. Be aware that the red button exists, and if a newsworthy event starts to unfold before your eyes, you can press the button and get a serviceable record of the action.

But for those D-Lux users who would like to delve further into their camera's motion picture capabilities, there is considerably more information to discuss.

Here are 2 introductory notes: First, I am located in the United States, where the D-Lux comes set up for NTSC video, using the standard frame rate of about 30 or 60 frames per second (fps). The version of the camera sold in Europe and some other locations is set up for PAL video, using frame rates of 25 or 50 fps. So, if you are using a PAL version of the camera, be aware that references in this book to 30 or 60 fps should be read as 25 or 50 for your model.

Second, there are limitations on motion picture recording time with the D-Lux. Like most cameras that are designed primarily for still photography, this camera has limits on recording length that are required in order to meet tariff requirements in some locations, to avoid having the camera classified as a video camera. With the D-Lux, this means you cannot record a single video sequence longer than 29 minutes and 59 seconds in any format. There also is a 4 GB limitation on file size. Therefore, for recordings using the FHD quality setting, the recording time will be shorter than normal. Finally, when recording with 4K quality, the limit is 15 minutes. Of course, you can always start another video recording after the first one ends, but you cannot record a single video that exceeds the above limits in duration.

Quick Start for Motion Picture Recording

First, I will list some basic steps for recording a motion picture sequence if you don't need to make many settings, but just want to get a clear record of the action.

1. Turn the camera on and let the lens cap dangle by its string.
2. Turn the aperture ring and shutter speed dial to their A positions.
3. Press the A button on top of the camera until the red A icon appears in the upper left corner of the display.
4. Press the Menu/Set button, go to the Motion Picture menu (icon of movie camera at left of

menus), and highlight the Recording Quality item as shown in Figure 8-1.

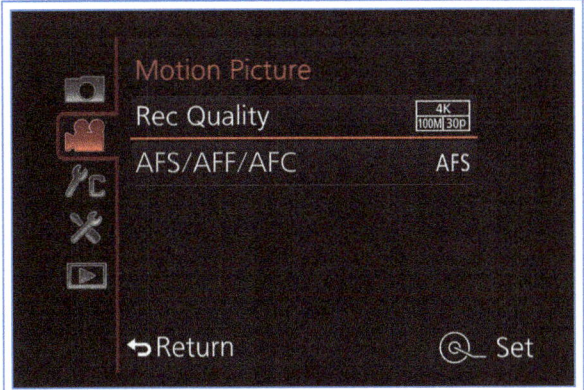

Figure 8-1. Recording Quality Menu Option Highlighted

5. Press the Menu/Set button to select it, and, on the next screen, scroll all the way to the next-to last option, for HD/10M/30P, as shown in Figure 8-2. Press Menu/Set to select it.

Figure 8-2. Recording Quality Options Screen - HD Highlighted

6. Move down to the AFS/AFF/AFC item and select AFS.

7. Aim the camera at your subject and zoom the lens to the desired focal length.

8. Press and release the red Motion Picture button, hold the camera steady, and record your video. Zoom if necessary, but try to keep zooming to a minimum.

9. To take a still picture during the video recording, just press the shutter button.

10. Press and release the Motion Picture button to stop the recording.

With those steps, the result should be a video sequence with excellent image quality and sound, and relatively easy to work with on a computer. But there are other settings you can use for more advanced techniques, which I will discuss in the rest of this chapter.

General Settings for Motion Picture Recording

One of the great things about the video features of the D-Lux is that there is less complication with this camera than with many other compact models. With some other models, the recording modes do not work the same way for recording videos as they do for recording still images, and there are numerous other features that do not function normally when recording video. With the D-Lux, you can use the still-image recording modes for recording video and get the results you would expect. There are some features that work differently for video shooting, but those differences are not that drastic. In the next 2 sections, I will discuss the various settings you can make for exposure and focus; after that, I will discuss the available menu options and other settings.

EXPOSURE

With the D-Lux, you do not have to worry about selecting a special shooting mode for motion picture recording, and you do not have to keep track of many limitations. You can set the camera to any one of its recording modes—Snapshot, Program, Aperture Priority, Shutter Priority, or Manual exposure—and record movies using that mode, just as if you were shooting still images.

If you want the camera to make most decisions for you, set the camera to any shooting mode and press the A button to turn on Snapshot mode. The camera will adjust exposure as you shoot and use its scene-detection programming to try to optimize its settings for the subject you are recording. You can adjust exposure compensation by turning the exposure compensation dial either before or during the recording.

If you want to have more access to the camera's wide variety of menu options, choose Program mode. The camera will still adjust both aperture and shutter speed automatically according to the lighting conditions and you will be able to adjust settings such as White Balance, ISO, Metering Mode, and others.

If you use Aperture Priority mode, by setting the shutter speed dial to its A position and turning the aperture ring to set an aperture value, the camera will maintain the aperture you set and adjust the shutter speed automatically. You will have access to many menu options, and you also can adjust the aperture, either before or during recording. With this ability, you can set the aperture to a wide value, such as f/1.7, to blur the background, or to a narrow value, such as f/11, to maintain a broad depth of field.

Also, you may be able to produce a fade-in or fade-out effect by varying the aperture setting during the recording. For example, if you are shooting at f/1.7 with ISO set to 200 in fairly dim indoor lighting, you may be able to gradually close the aperture down to f/16, making the picture fade to black. One problem with adjusting the aperture ring during video recording is that the sound of the clicking ring is quite audible on the sound track. This is not a problem if you are going to record a separate sound track later, but if you need to use the sound recorded by the camera, you will have to take this issue into account.

With Shutter Priority mode, the situation is similar. You can adjust many settings, and you can set the shutter speed as you want it. However, the shutter speed settings for motion picture recording work differently than for still images. As I will discuss later in this chapter, the frame rates for recording video with this camera (in the United States) are 60 fps, 30 fps, and 24 fps. Therefore the camera is recording at least 24 frames every second, which amounts to a shutter speed of no slower than 1/24 second. Because of this situation, the slowest shutter speed available for video recording is 1/25 second when you are using the 24 fps speed and 1/30 second for the other speeds. (When you use the 60 fps setting, the camera converts it to 30 fps for playback, so it can use the 1/30 second shutter speed.)

In addition, you can use the super-fast settings for shutter speed that are available with the electronic shutter, ranging to as fast as 1/16000 second. To do that, turn the shutter speed dial to the 4000 setting and turn the control dial on the back of the camera to select the faster speeds. As with Aperture Priority mode, you can adjust the shutter speed either before or during the recording, and you can cause a fade-out effect by moving it to a very fast value during the recording. As with the aperture ring, though, the shutter speed dial makes a good dial of noise on the sound track, so you should avoid adjusting shutter speed during recording if you need to use the live sound track for your video.

Finally, you can use Manual exposure mode, and adjust both aperture and shutter speed before or during the recording. The considerations are the same as for Aperture Priority and Shutter Priority mode, though, of course, you have more flexibility because you can adjust both values. Unfortunately, though, you cannot use Auto ISO when recording video in Manual exposure mode. The camera will reset the ISO to a numerical value. You can, however, adjust the ISO setting to another specific value, even during video recording.

Focus

Your focus options while recording video are somewhat more limited than for shooting still images, but they still give you considerable flexibility. First, you can use manual focus for video recording with all shooting modes, including Snapshot, and you can use Peaking to assist in achieving sharp focus. The control ring adjusts focus smoothly, so you can carry out a very nice pull-focus operation to bring an object into or out of focus while you record. However, the enlarged display of the MF Assist option is not available during movie recording.

You also can use autofocus. In Snapshot mode, the camera will automatically use continuous autofocus during video recording, if the focus switch is at an AF position. In the other recording modes, you have a choice, which is controlled using the Motion Picture menu. On screen 1 of that menu, you can set the focus mode to AFS, AFF, or AFC, for single, flexible, or continuous autofocus. However, the focus method is also controlled by a second menu option, Continuous AF, on screen 2, which can be turned either on or off. If you turn Continuous AF on, then it doesn't matter what you choose for AFS/AFF/AFC. The camera will adjust focus continuously as the distance to the subject changes. If you turn Continuous AF off, then you need to press the shutter button halfway to focus, and you can cause the camera to refocus at any time by pressing the button again. This focusing operation does not add any sounds to the sound track.

Other Settings

You likely will get excellent results if you use the camera's default settings and shoot your video using Snapshot mode and following the guidelines for exposure and focus discussed above. But there are numerous other settings you can make with the camera's physical controls and the menu system. I will discuss those settings next, so you can take advantage of the flexibility they provide for motion picture recording with the D-Lux.

The Motion Picture Menu

First, I will discuss the one menu system I have not discussed before—the Motion Picture menu, which is designated by the movie camera icon, just below the icon for the Recording menu, as shown in Figure 8-3.

Figure 8-3. Motion Picture Menu Icon Highlighted

Before I discuss the individual items on the menu, there are a couple of general points to mention. First, the menu has 3 screens in the more advanced (PASM) modes, but only 1 screen with 2 items when the camera is in Snapshot mode. In that mode, the only Motion Picture menu settings you can adjust are Recording Quality and AFS/AFF/AFC.

Second, when the full Motion Picture menu is available, 8 of the items on that menu also appear as items on the Recording menu: Photo Style, AFS/AFF/AFC, Metering Mode, Highlight Shadow, i.Dynamic, i.Resolution, i.Zoom, and Digital Zoom. These settings are included on the Motion Picture menu for convenience in setting them. You actually can adjust any of these 8 settings using either menu system, and the adjustment will take effect for both menus at the same time. So, for example, if you set Photo Style to Monochrome on the Recording menu, you can then go to the Motion Picture menu and you will see that the Photo Style setting on that menu has changed to Monochrome. Or, if you turn on Digital Zoom on the Motion Picture menu, you will see that Digital Zoom has been activated on the Recording menu as well.

With that introduction, following is the list of all items that can appear on the Motion Picture menu, whose first screen is shown in Figure 8-4.

Figure 8-4. Screen 1 of Motion Picture Menu

I will not include detailed information here for the settings that also appear on the Recording menu; for more information about them, see Chapter 4.

Photo Style

This setting lets you choose the "look" of your footage. It works the same as it does for still photos. The choices are Standard, Vivid, Natural, Monochrome, Scenery, Portrait, and Custom. For more details, see Chapter 4.

4K Photo

This second menu item provides a powerful tool for your still photography, using the camera's advanced video capability. As I will discuss later in this chapter, the D-Lux can record 4K video, which is sometimes referred to as UHD, or ultra high definition, with about 4 times the resolution of normal HD video. Because of the high resolution of this video format, it is possible to capture individual frames from it and use those frames as high-quality still photos. The still images have a resolution of about 8 megapixels (MP), which is only slightly less than the resolution of JPEG images taken by the D-Lux with the Large setting. (Large JPEG images range from 10 MP to 12.5 MP in size.)

The problem with capturing a still image from normal 4K video footage is that, when recording video in that format, the camera uses settings that are optimized for

video, not stills. In particular, it uses the 16:9 aspect ratio and a shutter speed that is often in the range of 1/30 second or 1/60 second. If you use the 4K Photo menu option, you can set the camera to record 4K video using settings that are optimized for capturing still images. You can set the aspect ratio to any of the available settings (3:2, 16:9, 1:1, or 4:3) using the aspect ratio switch, and, if the camera is selecting the shutter speed (in Program or Aperture Priority mode) it will try to choose a faster shutter speed than it would otherwise, to maximize the quality of the still images. Of course, you can choose Shutter Priority or Manual exposure mode and set the shutter speed yourself. If you do, you should choose a shutter speed of 1/100 second or faster for stationary subjects and 1/500 second or faster if possible for action shots to maximize the quality.

One way of looking at this option is that it gives you a greatly enhanced capability for burst shooting. With the D-Lux's Drive Mode settings, you can shoot high-quality images at 11 frames per second for limited bursts, but with the 4K photo option you can shoot at 30 fps for long stretches of time.

Figure 8-5. Example Image Taken with 4K Photo Setting

You can use this technique to capture excellent portraits with the possibility of a wide range of changes in facial expression. You also may be able to capture great action shots.

Figure 8-5 is a shot I captured using this setting to record footage of a bird helping itself to seeds at a feeder. The bird flitted around the feeder very quickly, and I found the 4K Photo option to be a great way to capture the subject in a clear pose.

In order to record 4K video with the D-Lux, Leica states that you need to use an SD card with a speed of UHS Class 3. Some users have reported that they successfully used this option with cards rated in Class 10 for speed, but I prefer not to take the chance that the card will not be able to perform adequately under all conditions. I recommend that you get a card in UHS Speed Class 3.

When you have this menu option selected, the camera cannot record still images, only 4K videos. In fact, if you press the shutter button with this menu option selected, the camera will start recording a 4K video; if you press the shutter button again, the video recording will end. You also can start and stop the 4K video recording with the red Motion Picture button.

I will discuss the process for saving still images from the recorded video footage later in this chapter.

Recording Quality

This menu option determines the resolution and data rate of the videos you record with the D-Lux camera. You do not have to choose a format, such as AVCHD versus MP4; all videos are recorded using the MP4 format. That is a standard format that is compatible with virtually all modern video editing programs; the files are easy to manipulate using a computer.

The choices for Recording Quality, in descending order of quality, are 4K/100M/30p; 4K/100M/24p; FHD/28M/60p; FHD/20M/30p; HD/10M/30p; and VGA/4M/30p. Each of these choices has 3 components: overall quality category; bit rate; and frame rate.

The 4 choices for overall quality are 4K, FHD, HD, and VGA. The standard known as 4K, sometimes called UHD for ultra HD, is a relatively recent option for HDTVs as well as for consumer video cameras. The 4K stands for 4,000, meaning each frame has a horizontal resolution of about 4,000 pixels. A standard HDTV outputs frames with a horizontal resolution of 1920 pixels and a vertical resolution of 1080 pixels. A 4K TV frame has a horizontal resolution of 3840 and a vertical resolution of 2160. The overall resolution of the 4K TV image is about 8 megapixels, while the resolution of full HDTV is about 2 megapixels, so a 4K picture has 4 times the resolution of full HDTV.

Of course, to get the full benefit of 4K video footage, you need to view it on a 4K-capable TV set or monitor. However, if your editing software permits, you can shoot using the 4K format and then convert it to the more standard 1080 format for ordinary HDTV sets. With that approach, your video footage will contain

considerably more detail than if you just recorded it using one of the 1080 formats.

There is one caveat about recording with the 4K quality setting: As noted earlier in this chapter, according to Leica you have to use a memory card of the fastest speed class, which is UHS Speed Class 3.

The second level of overall quality, is FHD, for full high definition. This selection results in a video frame with a resolution of 1920 by 1080 pixels. As noted above, this is the resolution of most HDTV sets today. This is a very high-quality option, and will yield excellent results for most purposes.

The third quality level, HD, results in a video frame with a resolution of 1280 by 720 pixels. This option, like the 2 previous ones, is also an HD resolution, in the traditional widescreen shape, but with fewer pixels. It provides lower resolution, with an image not quite as sharp as the ones listed above.

The lowest quality level, VGA, is a low-resolution format that provides only 640 by 480 pixels, in the fullscreen shape of an older computer monitor or standard TV set. This option is suitable if you need to make an inventory of possessions or some other non-critical video recording. It also can be useful if you need a video recording with a small file size that can be sent by e-mail.

The second specification for each video format gives the bit rate in megabits per second. The higher the number, the higher the quality, because the camera records a greater amount of data to create each frame of the video recording. Therefore, the option with a bit rate of 100M, which records approximately 100 megabits of data per second, yields the greatest quality.

The third specification for each format reports the frame rate, in frames per second. The "p" after each number means that this format is progressive, as opposed to interlaced. (An interlaced format would end with the letter "i".) With progressive formats, the camera records full frames of information; with interlaced formats, the camera records fields, or half-frames, and then interlaces them to form full video frames. In the United States the normal rate for recording and playing back video is about 30 frames per second (fps). So, for example, the 4K/100M/30p option yields 4K video with the normal frame rate, recording 30 full frames of video each second. The FHD/24M/30p format yields full HD video at that same rate.

The 24p option is provided for those users who like to use a 24 fps video format. That frame rate is the one traditionally used by film-based movie cameras, and some people believe that using this standard provides a more "cinematic" appearance than the 30 fps option.

With the FHD/28M/60p standard, the D-Lux records 60 full frames per second. The 60 frames are later translated into 30 frames for playback at the standard rate of 30 fps. However, if you want to, and your video editing software has this capability, you can play back your 60p footage in slow motion at one-half the normal speed and still maintain full HD quality. This possibility exists because the 60p footage is recorded with twice the number of full frames as 30p footage, so the quality of the video does not suffer if it is played back at one-half speed. (With other video formats, playback at half speed will appear choppy or jerky, because not enough frames were recorded to play back smoothly at that speed.) So, if you think you may want to slow down your footage significantly with a computer for playback, you should choose the 60p setting.

To sum up the choices, if you are not planning to record using the 4K setting, the other video formats give you excellent options. You can record in full HD with a 28 megabit-per-second bit rate, giving you excellent quality. You can choose 60p for highest quality and the ability to produce slow-motion footage at one-half speed, or the more standard 30p option. If you would like to work with smaller files that still produce excellent quality, you can choose to record with the HD/10M/30p option, which records using HD rather than FHD, meaning the image size is 1280 x 720 pixels, rather than 1920 x 1080. If you need only a very basic video record with small file size, you can choose VGA.

AFS/AFF/AFC

This next menu option, as discussed earlier, mirrors the same setting on the Recording menu. It really does not matter which one of these choices you select for purposes of video recording, so you should select the option that you will want to use for recording still images. The camera's autofocus behavior for video recording is controlled by the Continuous AF menu option, discussed later in this chapter. If you have Continuous AF turned off, the camera will not focus

on its own during video recording; you have to press the shutter button halfway to cause the camera to use its autofocus mechanism. If you have Continuous AF turned on, then the camera will focus continuously during video recording. (Of course, the focus switch has to be set to the AF or AF Macro setting for the camera to use autofocus at all.)

Picture Mode

When you are recording video footage with the D-Lux, you can press the shutter button during the recording to take a still picture, with certain limitations. This menu option controls the settings the camera uses for those still pictures. There are 2 options, as shown in Figure 8-6: Motion Picture Priority (top icon) and Still Picture Priority (bottom icon).

If you choose the first option, the still picture will be captured as a JPEG with Small size, no matter what menu settings are in effect for still image recording. With this setting, the camera can record up to 30 still images while recording the video, without disrupting the video recording. With the second option, the camera will take the still picture using the settings made through the Recording menu for Picture Size and Quality, but you can take only 4 images during the video recording, and each time you do there will be a very brief interruption in the audio of the video recording. Also, the camera's display will black out briefly while the still image is being recorded.

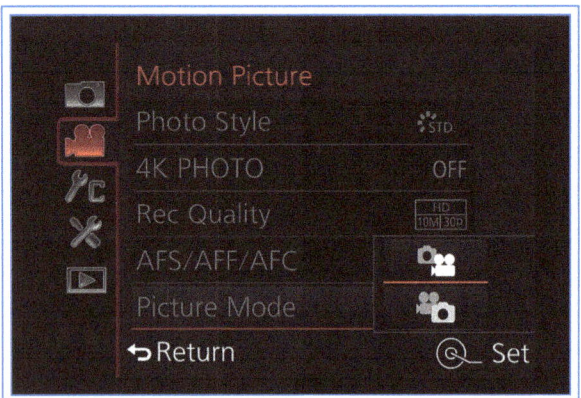

Figure 8-6. Picture Mode Menu Options Screen

There are some limitations on recording still images during video recording. First, all images will be in the 16:9 aspect ratio. Second, you cannot record still images while recording video with 4K or VGA quality. (These limitations do not apply when you use the 4K Photo option, discussed earlier, which provides a special way to record high-quality still images from video files.)

Continuous AF

As I noted earlier in this chapter, this setting controls how the camera uses its autofocus during video recording, assuming you have the focus switch set to either the AF or the AF Macro setting. If this menu option is turned on, the camera will adjust its focus continuously as the distance to the subject changes. If it is turned off, the camera will use its autofocus only when you press the shutter button halfway.

Metering Mode

This menu option gives you access to the same 3 metering methods found on the Recording menu: Multiple, Center-weighted, and Spot. As with several other Motion Picture menu options, this one mirrors the same item on the Recording menu; if either one is changed, the corresponding entry on the other menu is changed to the same setting.

Highlight Shadow

This option, also, is identical to the corresponding one on the Recording menu.

Intelligent Dynamic

This setting works the same as the similar setting on the Recording menu and mirrors its setting.

Intelligent Resolution

This setting also works the same as its still-photo counterpart.

Intelligent Zoom

This setting is another one that is no different from the version on the Recording menu.

Digital Zoom

This is another setting that's the same as that on the Recording menu.

Microphone Level Display

This is one of the few settings that apply only to video recording. If you turn it on, the camera puts 2 small graphic audio meters in the lower left corner of the display, as shown in Figure 8-7.

Chapter 8: Motion Pictures | 145

Figure 8-7. Audio Level Meters on Display

Those meters react to changes in the audio levels being recorded by the left and right sides of the stereo microphone built into the camera. You can use those meters to decide whether you need to adjust the audio recording level using the next menu option.

Microphone Level Adjustment

This option displays a pair of graphic audio meters in the middle of the screen, as shown in Figure 8-8, so you can test the audio input level and adjust it. (These meters are temporary, for the purpose of level adjustment, unlike the meters set by the previous menu option, which remain in place on the display screen during video recording.)

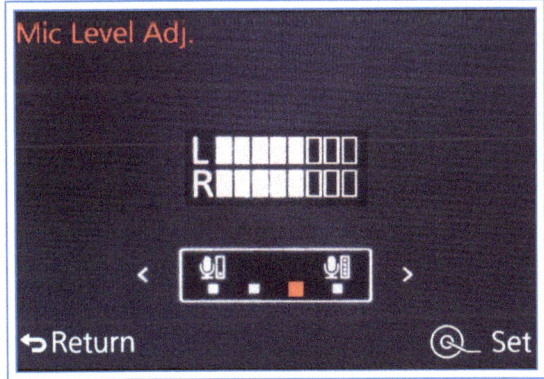

Figure 8-8. Mic Level Adjustment Meters on Display

With this display on the screen, aim the camera at your subject and adjust the audio level using the Left and Right buttons or the control dial. More of the empty blocks on the display will turn white as the volume of the test sound increases. There are only 4 levels of adjustment available, so there is not much leeway for increasing or decreasing the level.

Wind Cut

This last setting on the Motion Picture menu can be turned on or off. If it is turned on, the camera attempts to reduce the noise from wind while recording a video sequence. This processing may have an adverse effect on the quality of the audio, though. If you are recording casual scenes from a vacation, I would recommend turning this option on when recording in a windy area. If you will be using video-editing software, though, you may want to turn this setting off, because it can reduce some wanted sounds, and you can adjust the sound track later with your software to minimize the unwanted sounds.

Using External Microphones

Although the D-Lux has excellent features for recording video, Leica did not include a jack for accepting an external microphone, which makes it challenging to record high-quality audio. The stereo microphone built into the D-Lux records good-quality sound, but, with the superior video quality available with this camera, you may want to record audio using higher-quality microphones.

Fortunately, it is not difficult to do this with the D-Lux, using current technology and software. The best solution I have found is to use a separate digital audio recorder and then synchronize the sound from the recorder with the video from the camera.

This system, often called double-system or dual-system sound recording, would have seemed more complex than I wanted to handle a few years ago. It probably would have involved using a clapper board to mark the first point of synchronization and a laborious process to synchronize the audio and video tracks using time code.

Now, though, if you use good equipment and software, it can be easy to use this type of system. I'll outline the steps I used; you may find equivalent techniques that work as well.

1. Get a good digital recorder like the Zoom H1, the Zoom H6, the Shure VP83F, the Tascam DR-40, or the Tascam DR-100mkII, which is discussed in Appendix A.

2. Make sure the camera is set to record audio at a reasonable level by setting the Microphone Level

Adjustment option on screen 3 of the Motion Picture menu.

3. Set the external recorder to record high-quality audio in a .wav file and place it, or one or more microphones connected to it, in a location to receive the sound clearly.

4. Start the audio recorder, then start the camera recording video and audio.

5. When the recording is done, load the video file and its attached sound track, along with the separate audio file from the external recorder, into a video-editing program such as Adobe Premiere Pro CC, Final Cut Pro, or others. You also can use Plural Eyes, a program from redgiant.com that synchronizes audio and video. The software will compare the waveforms from the camera's sound track and the external audio track to move them into sync. With Premiere Pro CC, which I use, the procedure is to select the video track and the 2 audio tracks, right-click on them, and select Synchronize-Audio-Mix Down. The software will move the external audio track into sync with the video track.

6. Once the external audio track has been synchronized with the video track, you can delete the audio track recorded by the camera.

Of course, this system introduces more complexity and expense into your video-recording process. But, if you want the highest quality audio for your movies, it is worth exploring this method.

PHYSICAL CONTROLS

Next, I will discuss your options for using the camera's physical control buttons, switches and dials in connection with video recording. There are a lot of these controls, and the situation is complicated because each of the 3 Function buttons can be assigned to any of about 40 options. (There are differences for some buttons; for example, only the Fn2 or Fn3 button can be assigned the Wi-Fi function.) Table 8-1 lists all of the physical controls and shows whether their settings will have an effect during video recording, as well as whether the control can be activated during video recording. For the Function buttons, the table lists all of the possible assignments.

Table 8-1. Use of Physical Controls of D-Lux Camera Before and During Video Recording

Control	Effective if Used Before Recording	Can Be Used During Recording	Remarks
Aperture Ring	Yes	Yes	
Shutter Speed Dial	Yes	Yes	
Control Dial	Yes	Yes	Adjust Shutter Speed
A button	Yes	No	
Exposure Comp. Dial	Yes	Yes	
Filter Button	Yes	No	Some Limits
Zoom Lever	Yes	Yes	
Control Ring	Yes	Yes	
Q. Menu Button	Yes	No	
ISO Button	Yes	Yes	Auto, 200-6400 Only
WB Button	Yes	No	
Drive Mode Button	No	No	
Autofocus Area Btn	Yes	Yes	
Display Button	Yes	Yes	
Aspect Ratio Switch	Yes	No	With 4K Photo Only
Focus Switch	Yes	Yes	
Menu/Set	Yes	No	Cannot Access Menus
Settings Assigned to Function Buttons			
Wi-Fi	No	No	
EVF/Monitor	Yes	Yes	

AF/AE Lock	Yes	No	
AF-On	Yes	No	
Preview	No	No	
Level Gauge	Yes	Yes	
Focus Area Set	Yes	Yes	
Cursor Button Lock	Yes	No	
Photo Style	Yes	No	
Picture Size	No	No	
Quality	No	No	
AFS/AFF/AFC	Yes	Yes	
Metering Mode	Yes	No	
Highlight Shadow	Yes	No	
i.Dynamic	Yes	No	
i.Resolution	Yes	No	
HDR	No	No	
Shutter Type	Yes	No	
Flash Mode	No	No	
Flash Adjustment	No	No	
i.Zoom	Yes	No	
Digital Zoom	Yes	No	
Stabilizer	Yes	No	Normal Only
Sensitivity	Yes	Yes	Auto, 200-6400 Only
White Balance	Yes	No	
AF Mode/MF	Yes	Yes	AF Mode Only
Drive Mode	No	No	
4K Photo	Yes	No	
Motion Pict. Setting	Yes	No	
Picture Mode	Yes	No	
Utilize Cust. Set Feat.	Yes	No	
Silent Mode	Yes	No	
Peaking	Yes	Yes	
Histogram	Yes	Yes	
Guide Line	Yes	No	
Zebra Pattern	Yes	Yes	
Monochr. Live View	Yes	Yes	
Recording Area	Yes	No	
Zoom Lever	No	No	

As you can see from the above table, there are many options for controlling the camera with the physical controls before and during video recording, though there are some limitations. For example you can adjust ISO using the ISO button or a Function button assigned to that setting, but you can only set it to Auto ISO or a value from 200 through 6400; you cannot use the lowest or highest settings or the Intelligent ISO feature. The ISO Limit setting on the Recording menu does not apply for video recording. You can switch focus mode between autofocus and manual focus, even during recording, and you can move the autofocus area around the display during recording. You also can turn on or off the Zebra patterns, the Histogram, or the Peaking feature for manual focus.

You can use the Filter button before recording to select a picture effect, but you cannot use the button during

the recording. You cannot record a motion picture using the Rough Monochrome, Silky Monochrome, Soft Focus, Star Filter, or Sunshine effect. You cannot record a video at 4K quality using the Miniature setting. When you use the Miniature effect for a motion picture, the camera does not record sound, and the footage is recorded at about one-tenth the normal speed, resulting in playback that is speeded up ten times faster than normal to help simulate the appearance of a tabletop model layout.

Recommendations for Recording Video

Now that I have covered the essentials of how to record video footage with the D-Lux, here are some recommendations for how to approach that process. For everyday use, such as for video clips of a vacation trip or a birthday party, it's probably a good idea to stick with the Snapshot recording mode and, on the Motion Picture menu, set Recording Quality to HD/10M/30p. In that way, the result should be excellent-quality video, well exposed, and ready to show on an HDTV (or standard TV) or to edit in your favorite video-editing software.

If you aren't ready to deal with a whole host of manual settings, but would like to add some flashy coloring to your movie scenes, consider shooting in Program mode, and use the Filter button to select a picture effect such as Impressive Art. If you would like to produce slow-motion footage, use the FHD/28M/60p setting and slow the footage to one-half speed using your editing software. Of course, if you want to take advantage of the latest advances in video recording, use the 4K option and capture video with super-high resolution.

The possibilities for creativity with the D-Lux's movie-making apparatus are, if not unlimited, at least sufficient to provide a framework for a great array of experimentation. So consider the options, and don't hesitate to press the red Motion Picture button when inspiration strikes.

Motion Picture Playback and Editing

To play a motion picture in the camera, display the file you want and press the Up button to start playback, as indicated by the movie camera icon and up arrow, shown in Figure 8-9. (If the icons have disappeared, press the Display button to bring them back on the display.) The motion picture will start to play. The camera will briefly display in the lower right corner an icon showing the controls: Up button for playback/pause; Right button for fast forward or frame advance when paused; Down button for stop; and Left button for fast backward or frame reverse when paused. Either during playback or when playback is paused, you can adjust the volume using the control dial.

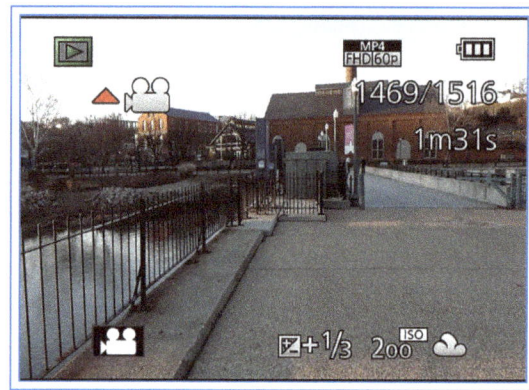

Figure 8-9. Movie Ready for Playback

You cannot do much editing of a video in the camera, but you can trim its length or split it into 2 segments To do that, follow the steps below.

1. Find the movie you want to divide and display it in playback mode. (You can use the Playback Mode menu option on the Playback menu to find all videos.)

2. Press the Menu/Set button and select Video Divide from the Playback menu.

3. Press the Menu/Set button to start playing the video in the camera.

4. Press the Up button to pause the video at the approximate place where you want to divide it.

5. Use the Right and Left buttons to locate the splitting point more precisely.

6. When you are satisfied with the position, press the Down button to divide the video into 2 sections, as indicated by the scissors icon in the group of icons in the lower right corner of the display, as shown in Figure 8-10.

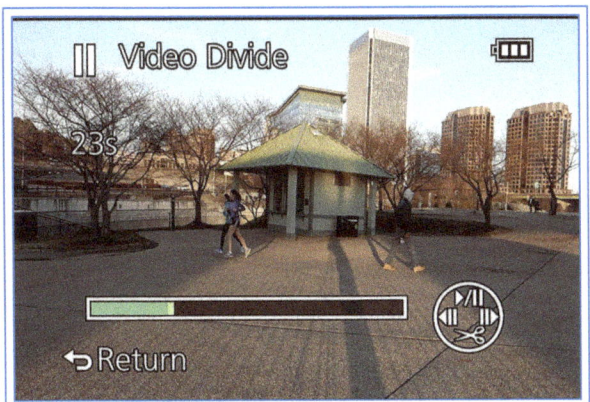

Figure 8-10. Scissors Icon for Video Divide Option

7. The camera will display a message asking you to confirm the operation. If you confirm it, the camera will divide the video into 2 parts. You will then have 2 separate video files; the original will no longer exist. You can delete either segment if you want, or keep them both.

You also can save a still image from a video file. To do that, follow the steps below.

1. Find the video that contains the image you want and start playing it in the camera.

2. At the approximate place where the image is located, press the Up button to pause the video.

3. Use the Right and Left buttons to find the location of the desired image.

4. Press the Menu/Set button, and the camera will display a message asking if you want to save this image, as shown in Figure 8-11.

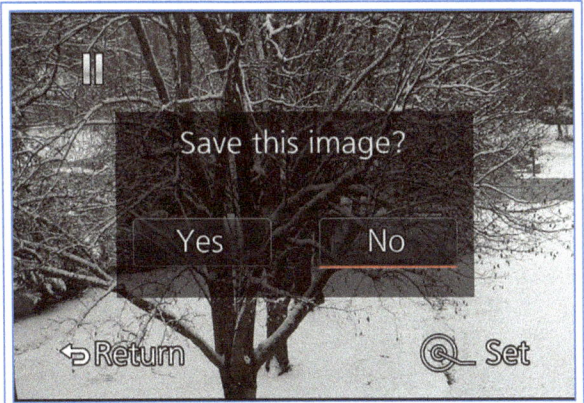

Figure 8-11. Confirmation Screen to Save Frame from Video

If you confirm the operation, the camera will save the image in Standard quality with an aspect ratio of 16:9. The image's size will be 8 MP if the video was recorded with 4K quality, or 2 MP for other quality settings. You cannot save an image from a VGA video.

If you want to save a higher-quality still image from a video file, you have to capture the video footage with the 4K Photo setting turned on. Use the following steps.

1. Insert an SD card rated as UHS Speed Class 3 into the camera.

2. On screen 1 of the Motion Picture menu, set the 4K Photo option to On.

3. Set the aspect ratio switch to the position you want for the still images that will be saved.

4. For best results with the still images, use Shutter Priority mode and set the shutter speed to 1/100 second or faster if possible.

5. Record the video using these settings. While recording, you can press the Fn2 button at any time to mark a place where you will want to save a still image later. You can create up to 40 markers per video file.

6. When playing back the video, press the Up button to pause where you want to create a still image. Press the Fn2 button followed by the Right or Left button while paused to move to the next or previous marker you created during recording.

7. When you have found the desired location for the still image, press the Menu/Set button; the camera will ask if you want to save the image. Highlight Yes and select it to confirm. The camera will create an 8 MP image with Fine quality in the aspect ratio you selected.

EDITING WITH A COMPUTER

You can edit video files from the D-Lux camera using most standard editing software that has been updated to handle recent video formats. For example, I have found it easy to import all formats of video from the D-Lux into the iMovie software on my Macintosh. One way to do that is to copy the video files from your camera's memory card to your computer. The MP4 files are easy to find on the card; they are in the same folders as the still images. For example, an SD card I am using now has .rwl (Raw), .jpg (JPEG), and .mp4 files in a folder whose path is LEICA:DCIM:108LEICA.

I have had no major problems using the videos I recorded using the 4K quality setting. Because those files use the .mp4 format, they can be imported just like ordinary MP4 files. Of course, they contain a great deal more data than ordinary files, so they may play in a slow and choppy manner in software such as Movie Maker or iMovie, but they can be imported and edited. Using more sophisticated software, such as Adobe Premiere Pro CC, I had no problem importing, playing and editing the 4K video files on my Macintosh.

Chapter 9: Wi-Fi and Other Topics

Using Wi-Fi Features

The Leica D-Lux camera has a solid set of features for using Wi-Fi (wireless) networks to transfer images and videos to smartphones and tablets or to control the camera remotely from such devices. You also can upload images directly from the camera, smartphone, or tablet to social networks in some situations. There are several possibilities for making and using wireless connections, and I will not discuss all of them. The Leica user's guide provides general guidance in this area. I will discuss the steps that worked for me to accomplish various Wi-Fi related activities.

Connecting to a Smartphone or Tablet Without NFC

There are 2 ways you can set up the camera to connect wirelessly with your smartphone or tablet: You can either use the Wi-Fi menu item on screen 1 of the Setup menu or you can press the Fn2 button, assuming it is assigned the Wi-Fi function. (You also can assign the Fn3 button to the Wi-Fi option if you prefer using that button.)

I will discuss the steps for using the menu option to connect with an iPhone, which does not use the NFC system for connecting by touching devices together. (I'll discuss NFC later in this chapter.) For later connections, you will not need to follow all of these steps, as noted in Step 10, below. The steps are similar for an Android device, except that the screen may appear different, and, for example, you use Google Play instead of the App Store to download the Leica Image Shuttle app.

1. Go to the App Store for iOS devices, and install the Leica Image Shuttle app, whose icon is indicated by the arrow in Figure 9-1.

Figure 9-1. Leica Image Shuttle App Icon on iPhone Screen

2. On the camera, go to screen 1 of the Setup menu and select Wi-Fi, then Wi-Fi Function; the Wi-Fi connection lamp should turn solid blue.

3. The camera will display the screen shown in Figure 9-2, letting you choose either a new connection or a previous one from your history or from your Favorites. The second 2 options will be dimmed and unavailable if you have not previously made a connection or added one to your Favorites.

Figure 9-2. Screen to Select New Connection or Previous Destination for Wi-Fi

4. Choose New Connection, and the camera will display a screen like that in Figure 9-3, with several options. For now, select Remote Shooting & View.

Figure 9-3. Screen to Set Up New Wi-Fi Connection

5. The camera will display a screen like that in Figure 9-4, giving the choice of using a QR code or using the SSID and password to make the connection.

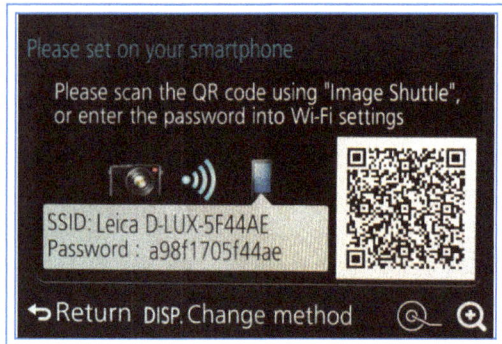

Figure 9-4. Screen to Select QR Code or SSID

6. To use the QR code, press Menu/Set, and the camera will display the QR code at a larger size. On the iPhone, start the Image Shuttle app and select QR code. Hold the phone with its camera lens aiming at the larger QR code, and the Leica Image Shuttle app will automatically take a picture of the QR code.

7. The smartphone will display a screen asking you to install the Image Shuttle app profile; select Install, then Install Now, then Done; enter the passcode for the smartphone if prompted.

8. Press the Home button on the iPhone to close the browser window, then go to the Settings app on the iPhone, select Wi-Fi, and select the SSID (network ID) sent by the camera. That ID should be Leica D-Lux, followed by several other characters, such as Leica D-Lux-5F44AE, as shown in Figure 9-5.

9. Open the Leica Image Shuttle app on the iPhone. You can now proceed to control the camera from the phone, or to transfer images between the devices.

10. Once you have gone through the above process to establish a connection, you will not have to go through the same steps to make that connection. Instead, just select Wi-Fi from the Setup menu, and then Wi-Fi Function on the next screen. Then, on the next screen after that, choose Select a Destination from History, as shown in Figure 9-2.

Figure 9-5. Wi-Fi Settings Screen on iPhone

11. You will then see a screen from which you can select a previously established connection, and go directly to that connection. (You also may be able to press the Wi-Fi button to call up that screen.)

CONNECTING TO A SMARTPHONE OR TABLET WITH NFC

If the smartphone or tablet you are connecting the camera to has NFC capability, you can connect to it without going through all of the above steps. NFC stands for near field communication, a protocol that allows 2 devices to establish a wireless connection when you touch them together with their NFC antennas in very close proximity. In practice, this means you need to touch the active NFC points on the devices to each other.

As of this writing, only certain Android-based smartphones and tablets have NFC capability for this purpose. The latest iPhones have NFC built in, but only for use with the Apple Pay payment system, for the time being at least.

If you have a smartphone or tablet with NFC, you don't have to use that system; you can still connect the device

Chapter 9: Wi-Fi and Other Topics | 153

to the D-Lux camera using the Wi-Fi button or the menu system. But if you want to use NFC, here are the steps to follow:

1. On the D-Lux, go to the Wi-Fi item on screen 1 of the Setup menu, and select Wi-Fi Setup, then set NFC Operation to On, as shown in Figure 9-6. Then set the next option below that, Touch Sharing, to On.

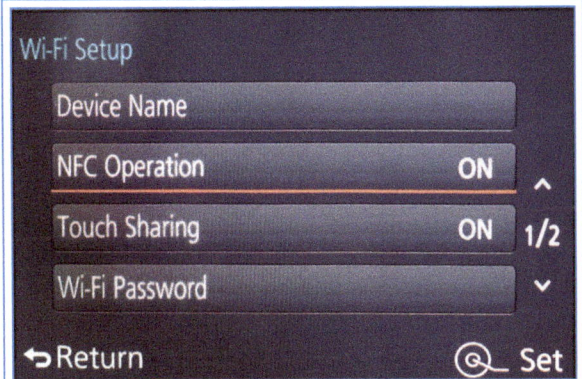

Figure 9-6. NFC Operation Menu Option Turned On

2. On the Android device, go to the Settings app and make sure NFC is turned on. Also, make sure the Leica Image Shuttle app is installed.

3. Open the Image Shuttle app on the Android device. It will display a screen like that in Figure 9-7, telling you to hold the NFC areas of the devices together.

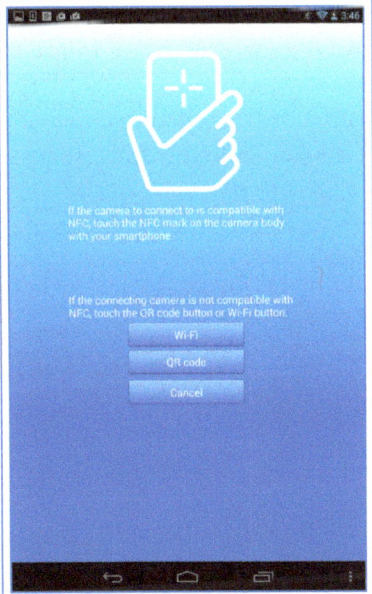

Figure 9-7. Message on Nexus Tablet for Using NFC Connection

On the Google Nexus 7 tablet, for example, the NFC area is on the back of the tablet, as shown in Figure 9-8.

Figure 9-8. NFC Active Area on Nexus 7 Tablet

On the camera, the NFC area is on the left side, as shown in Figure 9-9.

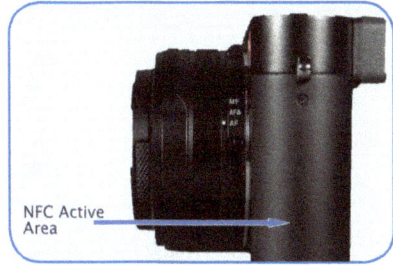

Figure 9-9. NFC Active Area on Left Side of Camera

4. After you hold the devices together, the camera may display a message asking if you want to establish a connection by NFC, as shown in Figure 9-10. When you touch the devices together again, the camera will display a Connecting message, and then the connection will be established.

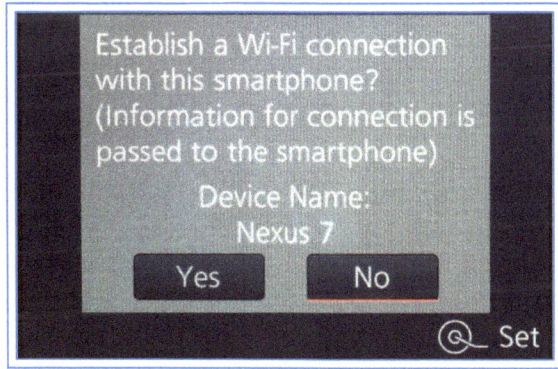

Figure 9-10. Message on D-Lux As NFC Connection is Being Established

You can then proceed to control the camera from the Android device, or transfer images between the devices, as described below.

Controlling the Camera with a Smartphone or Tablet

Once you establish a connection between the camera and the smartphone, with or without NFC, you can use the Leica Image Shuttle app on the phone to control the camera.

Figure 9-11. Message on iPhone When Wi-Fi Connection Established

Select the Live Control icon at the lower left of the phone's screen, as shown in Figure 9-11, and you will see a display on the phone like that in Figure 9-12. You can touch the icons on this screen to zoom the lens in and out; focus manually or with autofocus; change the mix of icons on the display with the DISP. icon; and get access to various other settings, including Photo Style, Filter Select, 4K Photo, Picture Size, Quality, Metering Mode, Video Recording Quality, and Stop Motion Animation, by pressing the Q. Menu icon.

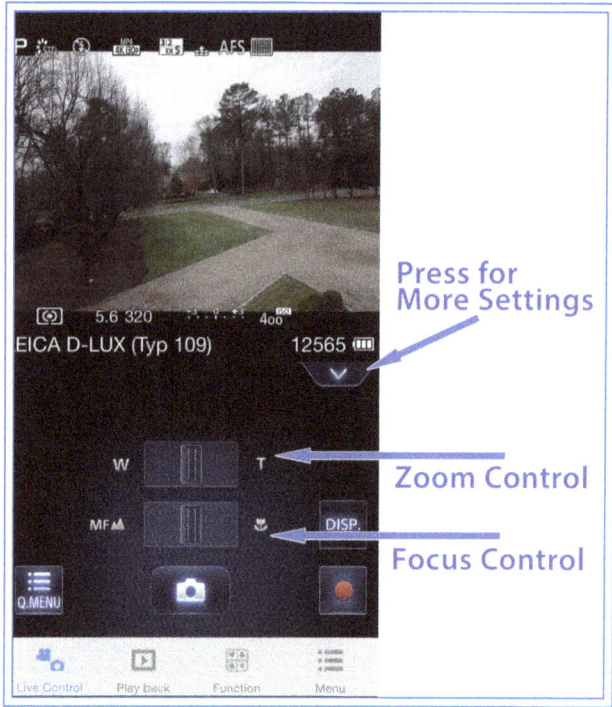

Figure 9-12. Initial Live Camera Control Settings

To take a picture, press the camera icon at the center bottom. To record a video, press the red button in the lower right corner.

If you press the down-pointing arrow shown in Figure 9-12, you will get access to additional settings, as shown in Figure 9-13. The touch focus icon causes the camera to focus where you touch the screen; the touch exposure icon does the same for exposure. The Drive Mode icon lets you select burst shooting, exposure or aspect bracketing, or the self-timer, and the focus mode icon lets you choose Face/Eye Detection, Tracking, 49-Area, 1-Area, and other options.

Chapter 9: Wi-Fi and Other Topics | 155

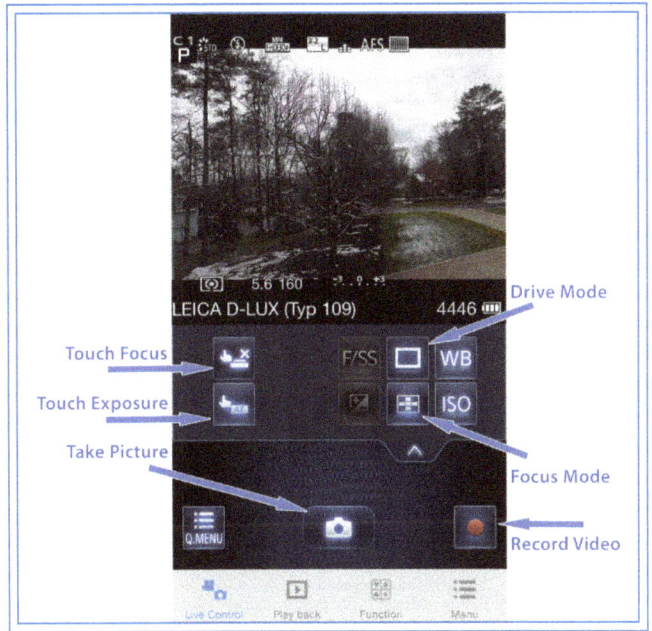

Figure 9-13. Additional Settings for Live Camera Control

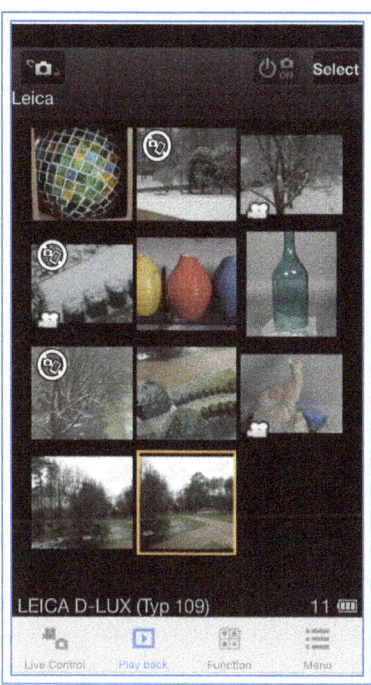

Figure 9-14. Display of Camera Images on iPhone Screen

The WB and ISO icons let you set White Balance and ISO. Note, though, that the F/SS and exposure compensation icons are dimmed and cannot be selected. As of this writing, those functions are not available for remote control of the D-Lux by smartphone. That situation could change through a firmware upgrade, so you may want to check the Leica website for future updates for those functions.

SENDING IMAGES AND VIDEOS TO SMARTPHONE OR TABLET

Once the D-Lux is connected to your smartphone or tablet, instead of controlling the camera from your device, you can choose the second option at the bottom of the Leica Image Shuttle app, Play Back. When you select that icon, you will see a display on the phone similar to that in Figure 9-14.

This screen shows thumbnail versions of the images and videos currently stored on the camera's memory card. You can scroll through them by flicking up and down the screen. It may take quite a while for all of the images and videos to load.

The thumbnails that have a movie camera icon in the lower left corner represent motion picture files. Other thumbnails may have an icon showing a camera and a phone with a line through the circle around them; that icon means that image or video cannot be transferred to the phone. In Figure 9-14, there are 3 thumbnails with that icon; those thumbnails represent Raw images and a 4K video, which cannot be transferred to a phone or tablet.

If you want to transfer one of the images or videos to your phone, first, tap on it to enlarge it on the display, as shown in Figure 9-15. If it is a video that can be played on the phone, you can press the Play icon on the phone's display to play it.

Figure 9-15. Individual Image Selected for Transfer

If you select the icon at the lower left, showing an arrow going to a phone, the phone will display a message saying it is copying the file. You will then have a copy of that image or video in the standard area for photos or videos on the phone.

On the main playback screen in the Image Shuttle app (Figure 9-14), you can tap the camera icon in the upper left corner to switch between viewing the images and videos from the camera and those stored on the phone or tablet. Also on that screen, if you press the Select icon in the upper right corner, you can then mark images and videos with green check marks by tapping them; once you have selected them, you can select the download icon (arrow going to phone) at the bottom of the screen to download them to the phone or tablet.

If you prefer, you can use another method to transfer images from the camera to a smartphone or tablet over Wi-Fi. To do that, press the Wi-Fi button or select Wi-Fi from the Setup menu and choose Wi-Fi Setup. On the next screen, shown in Figure 9-3, choose Send Images While Recording or Send Images Stored in the Camera. The camera will then prompt you to connect to your smartphone using a Wi-Fi network. If your network supports WPS, select that option on the camera and then press the WPS button on the network router to establish the connection. Otherwise, you will have to select the network from a list on the camera's display and enter the password. Then, you can connect the camera to the phone to transfer images.

If you select the third icon at the bottom of the Image App screen in Figure 9-14, labeled Function, you can select Geotagging. I discussed Geotagging in Chapter 6. Basically, that function lets you transmit location data from your smartphone to the camera by creating a synchronized GPS log on the phone and later uploading the data from that log to the camera.

If you select Menu, the final icon at the lower right of the Image App's main screen, you will see the screen shown in Figure 9-16, with options for the connection destination, playback settings, and other items. With the Playback Settings option, you can set the size for images copied from the camera or uploaded to websites.

Figure 9-16. Menu of Options for Leica Image Shuttle App

UPLOADING IMAGES TO SOCIAL NETWORKS (ANDROID ONLY)

If you are using a smartphone or tablet that uses the Android operating system, you can transfer images from the camera directly to social networks through that device. Here are the basic steps to do this.

1. Connect the Android phone or tablet to the camera, using the NFC procedure or through the menu system, as described above.

Chapter 9: Wi-Fi and Other Topics | 157

2. In the Leica Image Shuttle app on the phone or tablet, select Play Back, and then select an individual image or multiple images from the screen of images that are displayed.

3. Tap on the Sharing icon at the bottom of the Android device's screen, and a menu will pop up showing all the destinations to which the image or images can be sent, as shown in Figure 9-17. Tap on the one you want, and the selected images will be sent wirelessly.

Figure 9-18. Macro Image Taken at Minimum Focusing Distance

The D-Lux, like many modern cameras, has a special capability for shooting in macro mode. To use this mode, you have only one basic setting to change: Move the autofocus switch on the left side of the lens barrel to its middle position, for Autofocus Macro, with the flower icon, indicating macro, as shown in Figure 9-19.

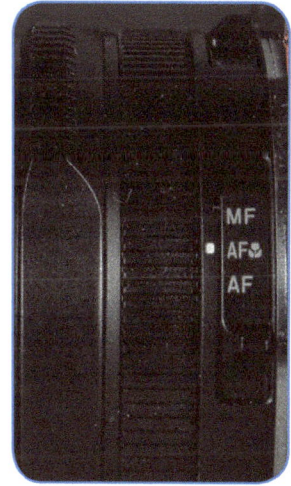

Figure 9-19. Focus Switch at AF Macro Position

Figure 9-17. Nexus Tablet Screen for Sending Images to Social Networks

Macro (Closeup) Shooting

Macro photography is the art or science of taking photographs when the subject is shown at actual size (1:1 ratio between size of subject and size of image) or slightly magnified (greater than 1:1 ratio). So if you photograph a flower using macro techniques, the image of the flower on the camera's sensor will be about the same size as the actual flower. You can get wonderful detail in your images using macro photography, and you may discover things about the subject that you had not noticed before taking the photograph. For example, I used the D-Lux to take a photograph of an orchid at a distance close to the minimum focusing distance, with the lens at its 24mm wide-angle setting. The result, shown in Figure 9-18, provides a detailed view of the subject. The background is blurred, which is helpful to reduce distractions.

With the autofocus switch in Macro position, the camera can focus as close as 1.2 inch (3 cm) from the subject, when the zoom lever is pushed all the way to the wide-angle setting. With the lens zoomed in for its full optical zoom, the camera can focus as close as about 1 foot (30 cm) in Macro mode. If the camera is not set to Macro mode, then the closest focusing point is about 1.6 foot (50 cm) at either end of the zoom range.

You don't have to use the Macro setting to take macro shots; if you use manual focus by moving the focus switch to its lowest position (MF), you can also focus on

objects very close to the lens. You do, however, lose the benefit of automatic focus, and it can be tricky finding the correct focus manually.

When using the Macro setting, you should use a tripod, because the depth of field is very shallow at close distances and you need to keep the camera steady to take a usable photograph. It's also a good idea to use the self-timer. If you do so, you will not be touching the camera when the shutter is activated, so the chance of camera shake is minimized. If you want to use flash, you could consider using a special unit designed for close-up photography, such as a ring flash that is designed to provide even lighting surrounding the lens. You also could use the supplied flash unit or another compatible flash, and just use a small piece of translucent plastic or a light-colored cloth to diffuse the flash.

One question you may have is: If the camera can focus down to 3 centimeters and out to infinity in Macro mode, why not just leave it set in Macro mode? The answer is that in Macro mode, the focusing system is set to favor short distances, and it is not as responsive in focusing on farther objects. So in Macro mode you may notice that it takes more time than usual to focus on subjects at greater distances. If you don't need the fastest possible focusing, you can just leave the camera set to AF Macro at all times, if you want the whole range of focusing distances to be available.

Infrared Photography

Infrared photography involves recording images illuminated by infrared light, which is invisible to the human eye. The resulting photographs can be spectacular, producing scenes in which green foliage appears white and blue skies appear eerily dark.

To take infrared photographs, you need a camera that can "see" infrared light. Many modern cameras include internal filters that block infrared light. However, some cameras do not, or block it only partially. (You can do a quick test of any digital camera by aiming it at the light-emitting end of an infrared remote control and taking a photograph while pressing a button on the remote; if the remote's light shows up as bright white, the camera can "see" infrared light at least to some extent.)

The D-Lux is quite capable of taking infrared photographs. To use this capability, you need to get a filter that blocks most visible light but lets infrared light reach the camera's light sensor. (If you don't, the infrared light will be overwhelmed by the visible light, and you'll get an ordinary picture based on visible light.)

The infrared filter I use is the Hoya R72. You need to find one with a 43mm diameter, because that is the diameter of the area threaded for filters on the lens of the D-Lux. When you attach the very dark red R72 filter to the D-Lux, a great deal of visible light from the scene is blocked. I have found that this reduction in light causes some problems for the camera's ability to set automatic exposure and White Balance. With experimentation, though, you can get an interesting result.

For the image in Figure 9-20, I aimed the camera at green bushes in bright sunlight to set a custom White Balance that would yield the characteristic white appearance of green grass and leaves.

Figure 9-20. Infrared Image, f/5.6, 0.8 sec, ISO 3200

I used Manual exposure mode and adjusted the shutter speed and aperture until I could see the image clearly in the viewfinder. I ended up with an exposure for 0.5 second at f/4.0, with ISO set to 2000.

This sort of infrared photography often is most successful in the spring or summer when there is a rich variety of green subjects available outdoors.

Digiscoping and Astrophotography

Astrophotography involves photographing sky objects with a camera connected to (or aiming through) a telescope. Digiscoping is the practice of using a digital

camera with a spotting scope to get shots of distant objects such as birds and other wildlife.

There are many types of scope and several ways to align a scope with the D-Lux's lens. I will not describe all of the methods; I will discuss the approach I have used and hope it gives you enough information to explore the area further.

I used a Meade ETX-90/AT telescope with the camera connected to its eyepiece. To make that connection, you need adapter rings that let you connect the camera's lens to the telescope's eyepiece. You can get the proper adapter rings for the D-Lux by purchasing the 43mm Digi-Kit, part number DKSR43T, from the online site telescopeadapters.com. That is the setup shown in Figure 9-21. I used that setup to take the picture of the moon shown in Figure 9-22.

Figure 9-21. D-Lux Camera Attached to Adapter for Telescope or Spotting Scope

Figure 9-22. Moon, f/7.1, 1/500 Sec., ISO 400

For this image, I set the camera to Manual exposure mode with settings of f/7.1 at 1/500 second, with ISO set to 400. I used a fast shutter speed because the magnification from the telescope made the image very jiggly. I used manual focus, and adjusted the telescope's focus control until the image appeared sharp on the camera's LCD. I used the MF Assist option, so I could fine-tune the focus with an enlarged view of the moon's craters, with Peaking turned on also. When focus was sharp, I saw bright blue pixels around the edges of craters, which made focusing easier than relying on the normal manual focus mechanism, even with MF Assist activated.

I set the self-timer to 2 seconds to minimize camera shake. I set Quality to Raw & JPEG so I would have a Raw image to give extra latitude in case the exposure seemed incorrect. As you can see in Figure 9-22, the camera did a good job of capturing the half moon. Because of the large sensor and relatively high resolution of the camera, this image can be enlarged to a fair degree without deteriorating.

You can use a similar setup for digiscoping. I attached the D-Lux to a Celestron Regal 80F-ED spotting scope, shown in Figure 9-23, using the same eyepiece I used with the telescope.

Figure 9-23. D-Lux Attached to Celestron Regal 80F-ED Spotting Scope

Figure 9-24 is a shot I took with the D-Lux through this scope. I used Program mode with an exposure of 1/500 second at f/6.3, with ISO set to 1000. I turned on continuous shooting to catch various views of the birds.

Figure 9-24. Image Taken with D-Lux Connected to Celestron Spotting Scope

Street Photography

One of the reasons many users prize the D-Lux is because it is well suited for street photography—that is, for shooting candid pictures in public settings, often surreptitiously. The camera has several features that make it well-suited for this type of work—it is lightweight and unobtrusive in appearance, so it can easily be held casually or hidden in the photographer's hand. Its 24mm equivalent wide-angle lens is excellent for taking in a broad field of view, for times when you shoot from the hip without framing the image carefully on the screen. Its f/1.7 lens lets in plenty of light, and it performs well at high ISO settings, so you can use a relatively fast shutter speed to avoid motion blur. You can make the camera completely silent by turning off the beeps and shutter sounds, and by using the electronic shutter.

Here are some suggested settings you can start with and modify as you see fit. To get the gritty "street" look, set Photo Style to Monochrome, but dial in -2 Noise Reduction and -1 Sharpening. Use Raw plus Fine JPEG to give you a good image straight out of the camera while preserving your post-processing options. Set aspect ratio to 4:3. Set ISO to 800 for good image quality while boosting sensitivity enough to stop action with a fast shutter speed. Turn on burst mode at the High setting so you'll get several images to choose from for each shutter press.

When you're ready to start shooting, go into manual focus mode and set the focus to approximately the distance you expect to shoot at, such as 6 feet (2 meters) on the MF scale. On screen 1 of the Custom menu, go to the AF/AE Lock item and set it to AF-On. Then, when you're ready to snap a picture, use the AF/AE Lock button to make a quick fine-tuning of the focus. For exposure, set the camera to Aperture Priority mode, with the aperture set to about f/4.5. When shooting at night, you may want to open the aperture a bit wider, and possibly boost the ISO to 1600. You will probably want to leave the lens zoomed back to its full wide-angle position, both to increase the depth of field and to take in a wide angle of view.

For Figure 9-25, I took a different approach, using Program mode to capture a quick shot as these 2 men walked past me on the street, when I didn't have much time to make settings.

Figure 9-25. f/3.2, 1/125 sec, ISO 200

Appendix A: Accessories

When people buy a new camera, especially a fairly sophisticated model like the D-Lux, they often ask what accessories they should buy to go with it. The D-Lux community is fortunate in that there are quite a few options available. I will hit the highlights, sticking mostly with items I have used.

Cases

There are endless types of camera case on the market.

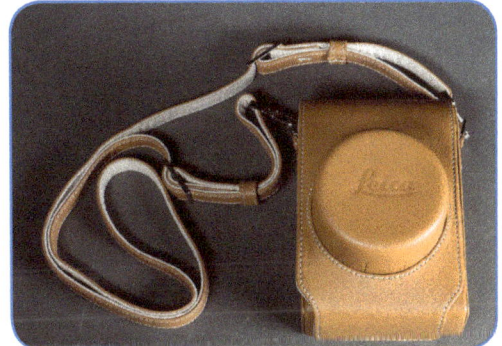

Figure A-1. Leica Leather Case, Closed

For those who like to get the official case that is designed for their camera, there is the Leica leather case, model number 18 821, shown in the cognac color in Figures A-1 and A-2.

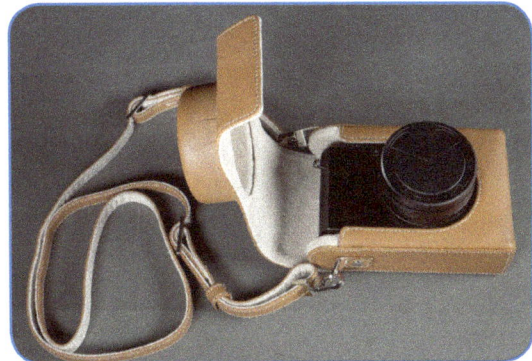

Figure A-2. Leica Leather Case, Open

I like this case for several reasons. It is made of real leather, has an excellent feel, and protects the camera well. Also, the case opens and closes quickly with a magnetic flap that attaches securely. The case can hold the camera with the Leica automatic lens cap attached, as shown here.

However, much as I like the official case, I usually like to keep my camera in a case or bag that has room for extra batteries, battery charger, flash, filters, and other items, which the official case lacks.

With the D-Lux, I have been using the BlackRapid SnapR 35, shown in Figure A-3. It includes a flexible pouch that has plenty of room for the camera. Its unusual feature is that it comes with a strap that fastens to the camera's tripod socket. That strap then is threaded over the neck strap for the case, so you can pull the camera out of the case quickly, and it is secured by the strap attached to the camera's bottom.

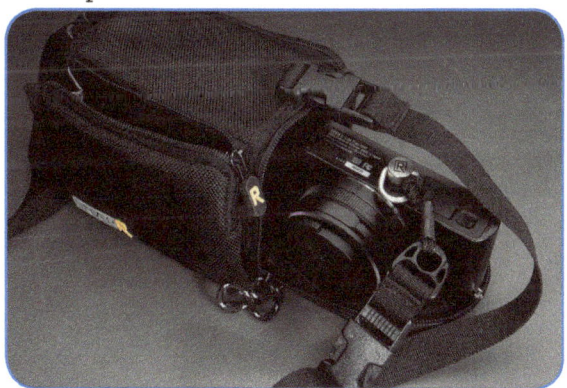

Figure A-3. BlackRapid SnapR 35 Case with D-Lux

The case has zippered pockets on the sides for carrying filters, batteries, and other small accessories.

When I need to carry more equipment, I often use a waist pack like the Eagle Creek model shown in Figure A-4, which has plenty of room for the camera and accessories, as well as small water bottles and other items for a day trip.

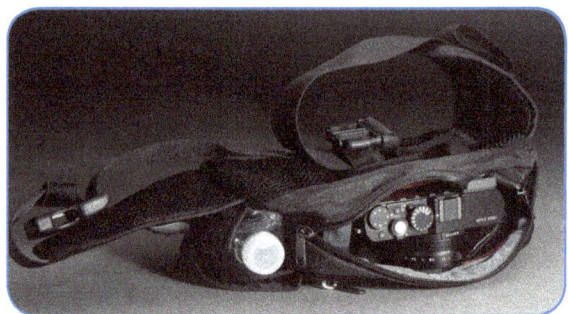

Figure A-4. Eagle Creek Waist Pack with D-Lux

Of course, there are many other possibilities; these are just a few items that have worked well for me.

Batteries

Here's one area where you should go shopping either when you get the camera or very soon afterwards. I use the camera pretty heavily, and I run through batteries quickly. You can't use disposable batteries, so if you're out taking pictures and the battery dies, you're out of luck unless you have a spare battery (or an AC adapter and a place to plug it in; see below). The Leica battery, model number BP-DC15, costs about $125.00 at the time of this writing. To save money, you can use the equivalent Panasonic battery, model number DMW-BLG10PP, which costs about $45.00, and you can find third-party replacement batteries from brands such as Wasabi, as shown in Figure A-5, for considerably less.

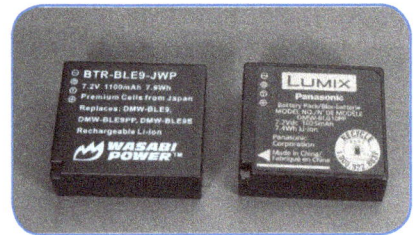

Figure A-5. Wasabi and Panasonic Batteries for D-Lux

I have used the Panasonic and Wasabi batteries extensively in my D-Lux with no problems.

AC Adapter

The other alternative for powering the D-Lux is an AC adapter. Leica does not sell one for this model, but Panasonic sells one for the Lumix LX100 camera, and that adapter works with the D-Lux camera also. This accessory serves well in terms of providing a constant source of power to the camera. However, it is somewhat inconvenient to use. With the D-Lux, you need to obtain not only the AC adapter, model no. DMW-AC10, but also another device called the "DC Coupler," model number DMW-DCC11. That device looks like a battery, but it has a connecting port in its side. The adapter and the coupler are shown together ready to be connected to the camera in Figure A-6.

Figure A-6. Panasonic AC Adapter with DC Coupler

You have to insert the DC Coupler into the battery compartment of the camera, then close the battery door, open up a small flap in that door, and connect the cord from the AC adapter to the port in the DC Coupler, as shown in Figure A-7.

Figure A-7. Cord of DC Coupler from AC Adapter Inserted into D-Lux Camera

This is not a very efficient (or economical) system, at least from the standpoint of the user. It is a clunky arrangement, and you can't get access to the memory card while the AC adapter is plugged in. But, if you need constant power for a long period of time, this is the only way to get it.

I should emphasize that providing power to the camera is all this adapter does. It does not act as a battery charger, either for batteries outside of the camera or for batteries while they are installed in the camera. It is strictly a power source for the camera. It may be useful if you are doing extensive indoor work in a studio or laboratory setting, to eliminate the trouble of constantly charging batteries. It also could be useful

for a lengthy series of time-lapse or stop-motion shots. For everyday applications and still shooting, though, the AC adapter should not be considered a high-priority purchase.

Viewfinders

The D-Lux is equipped with an excellent built-in electronic viewfinder, so you are not likely to need to purchase an external one. However, if you prefer on occasion to use a traditional optical viewfinder, you can purchase one made by Panasonic, model number DMW-VF1, that fits into the hot shoe of the D-Lux, as shown in Figure A-8. There are other optical viewfinders that work well with the D-Lux. For example, Figure A-9 shows a Voigtlander 28mm model. Voigtlander also makes 35mm versions, and Leica makes some as well, though they are expensive.

Figure A-8. Panasonic Optical Viewfinder DMW-VF1

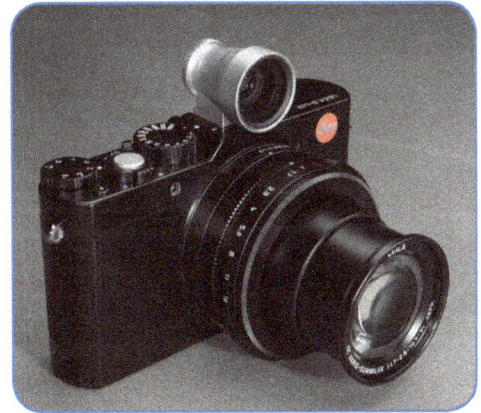

Figure A-9. Voigtlander 28mm Optical Viewfinder on D-Lux

When you use a viewfinder like this, you will probably want to use the step zoom feature of the D-Lux, discussed in Chapters 5 and 7, so you can zoom the lens precisely to the 28mm focal length (or other focal length of that particular viewfinder). In that way, the viewfinder will be using the same angle of view as the camera's lens.

If you use an optical viewfinder rather than the LCD screen, you can turn off the D-Lux's screen, thereby saving battery power and extending the number of images you can record before changing batteries. Or, you can use the Monitor Information Display option on screen 8 of the Custom menu to include the information-only screen in the cycle of screens displayed on the LCD by pressing the Display button.

Add-on Filters and Lenses

One excellent feature of the D-Lux camera is that the front of its lens is threaded to accept standard 43mm filters. You can attach any one of numerous filters or other accessories. You might want to use a neutral density filter to enable the use of slow shutter speeds to blur moving water in streams, or to allow the use of wide apertures to blur backgrounds. You can use polarizing filters to enhance the appearance of the sky, and you can use an infrared filter, as discussed in Chapter 9, to capture infrared images. You can attach an adapter that lets you connect the D-Lux to a telescope or spotting scope, or you can use close-up lenses to enhance the macro capability of the lens.

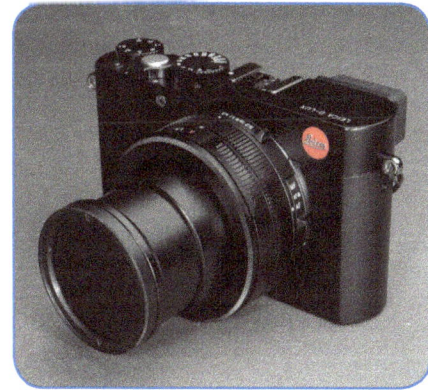

Figure A-10. Hoya R72 Infrared Filter on Lens of D-Lux

Figure A-10 shows the D-Lux with an infrared filter attached to the lens.

External Flash Units

Whether to buy an external flash unit depends on how you will use the D-Lux. For everyday snapshots not taken at long distances, the supplied flash unit should suffice. It works automatically with the camera's

exposure controls to expose images well. It is limited by its low power, though.

If you need more flash power, there are several options. One unit that works quite well with the D-Lux is the Leica CF22, shown in Figure A-11, a small unit that fits well with the camera in terms of looks and function.

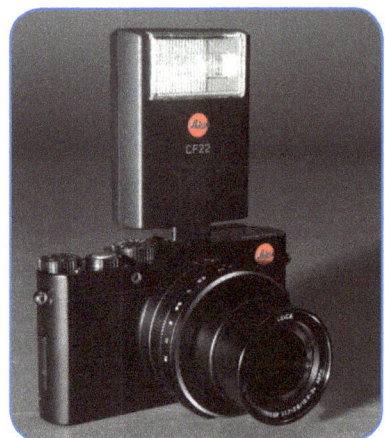

Figure A-11. Leica CF22 Flash on D-Lux

The CF22 fits into the camera's hot shoe and is not terribly bulky. It communicates automatically with the camera in the same ways that the supplied flash does.

One drawback with the CF22 is that it is a single unit with no rotating flash head, so there is no possibility of bouncing the flash off the ceiling or pointing it anywhere other than where the camera is pointing.

A similar small flash unit is the Panasonic DMW-FL220, shown in Figure A-12.

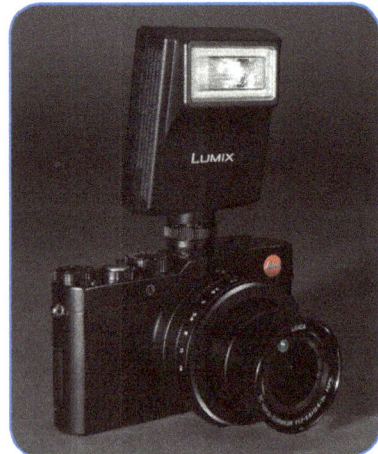

Figure A-12. Panasonic DMW-FL220 Flash on D-Lux

You also can use one of the larger compatible units from Panasonic. Figure A-13 shows the DMW-FL360L attached to the camera's hot shoe.

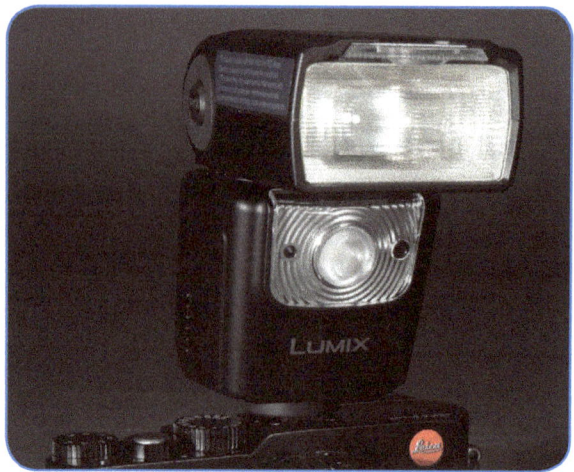

Figure A-13. Panasonic DMW-FL360L Flash on D-Lux

The FL360L functions like the flash that comes with the camera, but it is more powerful and has a flash head that rotates and swivels. If you want a more powerful unit with similar features, you can use the Panasonic DMW-FL580L, not pictured here.

If you want to use an off-camera flash unit, you can use a wireless trigger, which sends a radio signal to a receiving unit. One inexpensive way to use this sort of setup is with the CowboyStudio wireless flash trigger and receiving unit, model number PT-04, shown in Figure A-14.

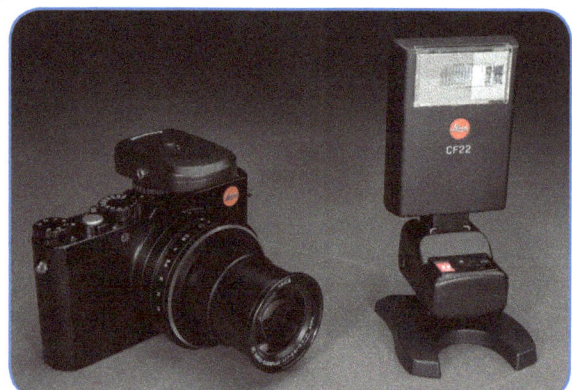

Figure A-14. CowboyStudio Wireless Flash Trigger and Receiver

You attach the transmitter to the camera and the receiver to the off-camera flash, making sure the units are both set to the same channel. The D-Lux detects the trigger and treats it like an on-camera flash, though, of course, there is no TTL or automatic exposure with this unit. This system works well when you set the camera to Manual exposure mode.

The off-camera flash, in this case a Leica CF22, also has to be set to its manual mode. When you trigger the

shutter on the camera with the transmitter attached, the wireless receiver fires the off-camera flash.

Finally, one more way to use powerful external flash units with the D-Lux is to use optical slaves, which detect the light from the camera's small flash and fire their own flash when the camera's flash is fired. One excellent unit with optical slave capability is the LumoPro LP180, shown in Figure A-15.

Figure A-15. LumoPro LP180 Flash

As with the radio trigger system, you need to set the camera to Manual exposure mode. There are other flash units with similar capability, such as the Yongnuo YN-560 III. There also are separate optical slave units, to which you can attach any compatible flash unit.

When you use one of these flash units off the camera, it often is useful to use a softbox to diffuse the light, as shown in Figure A-16, which shows the Yongnuo flash mentioned above with a Photoflex Lite-Dome XS softbox.

Figure A-16. Photoflex Lite-Dome XS Softbox Attached to Yongnuo Flash

Finally, one other item that is not a flash unit can be useful for supplemental lighting, especially for taking video—a continuous lighting unit like the one shown in Figure A-17.

Figure A-17. LED Video Light on D-Lux

This battery-powered light, which fits nicely in the camera's accessory shoe, has 160 LEDs that can be continuously dimmed or brightened using a rotary control on the side. The light is larger than the camera, but it is not very heavy, so it doesn't overwhelm it. It is relatively inexpensive and it is available under various brand names; search for it using the term CN-160.

Automatic Lens Cap

The D-Lux camera ships with a standard lens cap that clips on to the end of the lens and is designed to be attached to the camera using a supplied piece of elastic string. This system works well enough, but it is somewhat inconvenient because you have to remember to remove the lens cap before you start shooting, and the cap dangles beside the camera in a way that can be distracting. Leica provides a solution in the form of a replacement—an "automatic" lens cap, model number 18 548. That item, however, has a list price of $90.00. You can get the same solution for a lower cost by using the Panasonic version, model no. DMW-LFAC1, which currently sells for about $40.00. You also can get a similar cap made by a company called JJC, whose website is at www.jjc.cc. That cap, which is less expensive than the Panasonic cap, is sold through Amazon.com and various other online sellers.

Figure A-18. Automatic Lens Cap in Closed Position

As shown in Figures A-18 and A-19, the automatic lens cap replaces the existing one, and has leaves that open automatically when the lens extends to push through them. The leaves close when the camera is turned off or the lens retracts, as it does after a while in playback mode.

Figure A-19. Automatic Lens Cap in Open Position

To install this cap, you have to remove the front lens ring, which twists off easily. Then you twist the automatic lens cap on in place of the front ring.

I originally tried this accessory just so I could write about it in this book, but I soon found that it made a considerable difference in my enjoyment of the camera. It is quite a relief to be able to turn the camera on or off without having to worry about attaching or removing the lens cap.

Leica Hand Grip

Although the Leica D-Lux camera has a beautiful appearance and is generally easy to handle, some photographers find it a bit difficult to get a firm grasp of the camera because of its smooth body. Leica offers a useful, though expensive, solution to this problem in the form of a special hand grip accessory. This item, shown in Figures A-20 and A-21, is a solidly constructed metal extension that screws into the tripod socket on the bottom of the camera. The grip then extends up along the right side of the camera, giving you a definite place to get a firm grip of the D-Lux.

Figure A-20. Leica Hand Grip

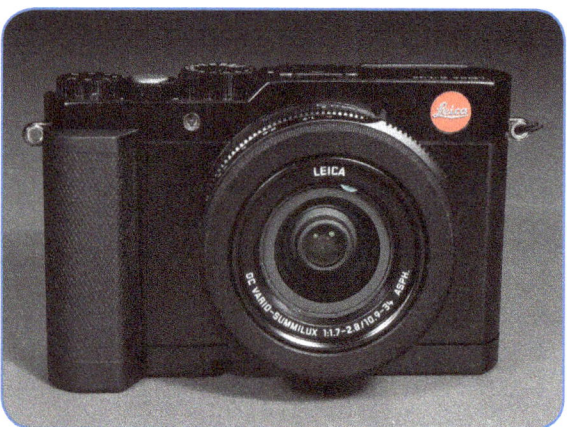

Figure A-21. Leica Hand Grip on D-Lux Camera

As I noted, this item is quite expensive, selling for $160.00 at the time of this writing. Also, it blocks access to the compartment for changing the battery or the memory card. But, if you want to have a firm area for holding the camera, you may want to consider this accessory.

External Microphones

As I discussed in Chapter 8, the D-Lux camera has excellent video features but it has no provision for connecting an external microphone for high-quality audio. Although the built-in microphone records good-quality audio, you can get better results if you use an external audio recorder and synchronize the audio track from that recorder with the sound recorded by the camera.

One excellent piece of equipment for this purpose is the Tascam DR-100MkII recorder, shown in Figure A-22.

Figure A-22. Tascam DR-100MkII Digital Audio Recorder

This recorder includes 2 sets of high-quality microphones, one set that is omnidirectional for recording lectures or classes, and another that is directional for recording concerts or other performances. The recorder also has 2 XLR inputs where you can connect high-quality microphones of your choice. There are many other options that will work for this purpose, depending on your budget and needs, including the Shure VP83F, the Tascam DR-40, the Zoom H1, and the Zoom H6.

Appendix B: Quick Tips

In this section, I'm going to include some tips and hints for using the D-Lux that might be useful as reminders. My goal is to give you small chunks of information that might help you in certain situations, or that might not be obvious to everyone.

Always check the aspect ratio and focus switches. It's great to use the Custom Set Memory capability to store your favorite groups of settings in the 3 available slots. But remember that you can't store the setting of the aspect ratio switch or the focus switch, because they are physical controls. Whenever I use the Utilize Custom Set Feature option to activate a group of settings, I also quickly check to be sure the aspect ratio switch is where I want it and that the focus switch is set properly. It's a good idea to check those 2 controls before any shooting session, actually.

Use the movable autofocus area in conjunction with Spot metering. When you do this, using an AF Mode setting such as 1-Area or Pinpoint, you can move the focus and metering area together around the screen with the direction buttons, so you can focus and meter a small, specific area of your scene. This procedure can add precision to your metering and focusing, and give you more control over your results.

Use Manual exposure mode with Auto ISO. Not all cameras let you use Auto ISO with Manual mode. This feature lets you keep aperture and shutter speed at fixed values, while the camera adjusts ISO to obtain a normal exposure. This is useful, for example, when you need to stop action with a fast shutter speed and also control depth of field with a narrow aperture.

Diffuse your flash. If you find the supplied flash produces light that's too harsh for macro or other shots, try using a piece of translucent plastic as a flash diffuser. Hold the plastic up between the flash and the subject. An approach you can try when using fill-flash outdoors is to use the Flash Adjustment menu setting to reduce the intensity of the flash by -2/3 EV.

Use the self-timer to avoid camera shake. The D-Lux has a self-timer capability that is very easy to use; just press the Down button, scroll to the self-timer item, and choose your setting. This feature is not just for group portraits; you can use it whenever you'll be using a slow shutter speed and you need to avoid camera shake. It can be useful when you're doing macro photography, digiscoping, or astrophotography, also.

Use the 4K Photo option as a type of burst shooting. With this option, on screen 1 of the Motion Picture menu, you can set the camera to capture 4K-quality video that can generate a high-quality still image from each frame. In effect, this means you have a burst shooting mode, with Large-sized images and continuous focusing, at a rate of 30 frames per second (in the United States and other areas that use the NTSC video standard; 25 fps elsewhere). You have to use an SD card with a speed in UHS Speed Class 3, but this is an excellent capability for getting great action shots, shots of wildlife, and other opportunities.

Create a custom autofocus zone that uses the entire focusing area. Although the D-Lux has an AF Mode setting called 49-Area, that setting actually uses no more than 9 of the 49 possible focus zones. If you want to have a setting that uses the full extent of the display area, you have to create it yourself. To do that, press the Left button and use the Custom Multi option to create a focus setting with all 49 zones. Chapter 5 explains how to do this.

Use the zoom lever and the Display button to speed through menu screens. This is a small item, but it can save you a lot of time when you need to scroll through menus with as many as 9 screens. When a menu screen is displayed, press the zoom lever in either direction to move forward or backward a full screen at a time. You also can press the Display button to move a screen at a time, in the forward direction only.

Be careful of using Raw for Quality when shooting with Filter button effects. The D-Lux will let you have Quality set to Raw when shooting with picture effects that are accessed through the Filter button, such as Silky Monochrome, Impressive Art, Miniature, and others. The recorded images will appear to have the effects added when viewed in the camera, but that is only because a small JPEG file is embedded in the Raw file. When you open the Raw file on a computer, the picture effect will not be there. You can try to recreate it using software settings, but I have not found any way to recover the full effect as recorded by the camera. So, you might think you have taken some great shots using creative effects, but when you view them on your computer the effects will have disappeared. To avoid this problem, shoot using JPEG (Fine), or, probably the best option, Raw & JPEG for Quality.

Use the in-camera processing features before transferring images. The D-Lux has a good set of options for transferring images using Wi-Fi to a smartphone or tablet. Before you do that, you may want to use options on the Playback menu such as Raw Processing, Cropping, and Resize in order to send images at the optimal size and with the appearance you want.

Use the remote control capability of the Leica Image Shuttle app. With this app, you can take self-portraits and capture images and videos of birds and other subjects while controlling the camera from a distance through a wireless network. Set the camera on a good tripod near a bird feeder to catch great shots of birds, or set the camera in a good location to record video of a school play while you sit nearby and control the camera from your smartphone. You can change settings on the camera while it is under remote control, and use functions such as burst shooting and stop motion animation.

Appendix C: Resources for Further Information

Photography Books

A visit to any large general bookstore or library, or a search on Amazon.com or other sites, will reveal the vast assortment of currently available books about digital photography. Rather than trying to compile a long bibliography, I will list a few books that I have found especially helpful.

C. George, *Mastering Digital Flash Photography* (Lark Books, 2008)

C. Harnischmacher, *Closeup Shooting* (Rocky Nook, 2007)

H. Horenstein, *Digital Photography: A Basic Manual* (Little, Brown, 2011)

D. Sandidge, *Digital Infrared Photography Photo Workshop* (Wiley, 2009)

S. Seip, *Digital Astrophotography* (Rocky Nook, 2008)

Websites

Following are several sites that are useful for finding further information about the D-Lux or about digital photography in general

Digital Photography Review

http://www.dpreview.com/forums/1038

This is the current web address for the "Leica Talk" forum within the dpreview.com site. Dpreview.com is one of the most established and authoritative sites for reviews, discussion forums, technical information, and other resources concerning digital cameras. If you have a question about a feature of the D-Lux, there is a good chance you can find an answer through this forum.

http://forums.dpreview.com/forums/forum.asp?forum=1033

This is the current web address for the "Panasonic Compact Camera Talk" forum within the dpreview.com site. It can be helpful to check this forum for information about the Panasonic Lumix DMC-LX100 camera, which is very similar to the Leica D-Lux (Typ 109). The Panasonic forum is very active, and you may find additional useful tips and advice there that is applicable to the D-Lux.

Official Leica Site

http://us.leica-camera.com

This is the main page for the Leica camera site, where you can find product information and support information.

http://us.leica-camera.com/Service-Support/Support/Downloads

This is the web address for a page where you can download the instruction manual for the D-Lux (Typ 109) and other Leica cameras.

http://us.leica-camera.com/Photography/Compact-Cameras/Leica-D-Lux-Typ-109

This is the address for the product page for the D-Lux camera.

Other Useful Sites

http://www.wrotniak.net/photo/infrared/

This site provides helpful information about infrared photography with digital cameras.

http://www.cambridgeincolour.com

This site is an excellent resource for general information about a wide range of photographic topics.

http://whiteknightpress.com

At this site, I provide updates, corrections, customer support, and other information useful to readers of this book.

Reviews of the D-Lux

Following are links to written reviews of the D-Lux:

http://www.photographyblog.com/reviews/leica_d_lux_typ_109_review/

http://www.imaging-resource.com/PRODS/leica-d-lux-typ-109/leica-d-lux-typ-109A.HTM

http://www.slack.co.uk/2014/D-Lux.html

http://www.pcmag.com/article2/0,2817,2475206,00.asp

http://www.techradar.com/us/reviews/cameras-and-camcorders/cameras/compact-cameras/leica-d-lux-typ-109-1276893/review

http://blog.mingthein.com/2014/11/12/opinion-review-the-panasonic-lx100-leica-d-lux-109/

http://cameradecision.com/review/Leica-D-Lux-Typ-109

Videos

http://youtu.be/whdF3ZNpHKQ

The above video gives a good overview of the D-Lux along with some tips for its use.

http://youtu.be/7mqOYCQnHJ4

The above video is another fairly detailed review of the D-Lux.

Index

Symbols

4K motion picture recording 142
 requirement of high-speed memory card for 4
4K Photo option (Motion Picture menu) 86, 141–142, 168
 inability to capture still images 142
 requirement of UHS speed class 3 memory card 86, 142, 168
35mm-equivalent focal length 7–8, 36

A

A button 64
 setting to require longer press of button 64, 130
A Button Switch menu option 64, 130
AC adapter
 Panasonic model no. DMW-AC10 162
Adobe Lightroom software 33, 37
Adobe Photoshop software 43
 using for HDR photography 86
Adobe Premiere Elements software 17
Adobe Premiere Pro CC software 146
AF/AE Lock button 91
 incompatibility with certain settings 91
 using to cause camera to autofocus 116
AF/AE Lock Hold menu option 115–116
AF/AE Lock menu option 91, 115
AF assist lamp 117–118
 operation as self-timer lamp 118
AF Assist Lamp menu option 117–118
AF Macro focus option 157
AF + MF menu option 119
AF Mode/MF option 97
AF Mode setting 78–84
 1-Area 82–83
 49-Area 80–81
 AF Tracking 79
 Custom Multi 80–82, 168
 Face/Eye Detection 78–79
 switching to different face 79
 moving the focus frame or focus area 83
 options available in Snapshot mode 78
 Pinpoint 82–83, 117
AF-On menu option 116
AFS/AFF/AFC menu option 12–13, 38
AFS/AFF/AFC option (Motion Picture menu) 140, 143
Aperture Priority mode 24–26
Aperture ring 61

Aperture values
 range of 26, 29, 61
Aspect Bracket option 87–88
 incompatibility with other settings 87
Aspect ratio 60
 cropping of pixels for each setting 35, 60–62
 relationship to Picture Size 35–36
Aspect ratio switch 60
Astrophotography 158–159
Audio recorders, external
 Shure VP83F 166
 Tascam DR-40 166
 Tascam DR-100mkII 166
 Zoom H1 166
 Zoom H6 166
Audio-video cable
 Panasonic model no. DMW-AVC1 8
Auto Bracket option 40–41, 86–87
 incompatibility with other settings 87
 setting order of shots 40, 87
 setting single or burst mode 40, 87
 using for HDR photography 86–87
Auto Exposure Compensation menu option 52, 64
 using with flash 52
Autofocus mode
 selecting single or continuous autofocus 38
Auto ISO setting 54–55
 using with Manual exposure mode 29, 168
Auto Review menu option 98, 127–128
Auto White Balance setting 74

B

Baby
 setting up profile with name and age 58–59
Backlight compensation 20
Battery, model no. BP-DC15 162
 charging 3
 inserting into camera 4–5
 replacement version by Wasabi 162
Beep menu option 133
Blurred background
 how to achieve 25–26
Burst Rate menu option 40
Burst shooting 84–87
 effect of using fast memory card 85
 high (H) setting 85
 incompatibility with other settings 86
 low (L) setting 85
 medium (M) setting 85
 super-high (SH) setting 84
 playback of images 84
 using 4K Photo menu option for burst shooting 86, 168

C

Calendar index screen of images 98
Canon 430 EX II flash unit

Index

using with D-Lux camera 49
Cases
　BlackRapid SnapR 35 161–162
　Eagle Creek waist pack 161
　Leica leather, no. 18821 161
Celestron Regal 80F-ED spotting scope
　connecting to D-Lux camera using adapter rings 159
Clock Set menu option 132–133
Color Space menu option 56
Color temperature 74
　Kelvin values for various light sources 74
Color tone adjustment for monochrome setting 33
Constant Preview menu option 29–30, 96, 124–125
Continuous AF option (Motion Picture menu) 140, 143, 144
Continuous lighting LED light 165–166
Contrast
　adjusting 32
Control dial
　uses of 73
Control ring 61
　functions controlled by 61–62, 129–130
Control Ring menu option 129
Controls on back of camera 7
Controls on bottom of camera 8
Controls on front of camera 7
Controls on left side of camera 8
Controls on right side of camera 8
Controls on top of camera 6–7
Cropping menu option 109, 169
Cursor Button Lock option for Function button 97
Custom menu
　in general 113
Custom Set Memory menu option 113–114
　settings that can be saved 113

D

Date and time
　displaying on camera's screen 93
　setting 8–9, 132–133
DC Coupler
　Panasonic model no. DMW-DCC11 162
Delete Confirmation menu option 112
Depth of field 25–26
Dial Guide menu option 125–126
differences between viewfinder and LCD 92
Diffraction effect 25
Digiscoping 159
Digital Zoom menu option 56–57
　incompatibility with other settings 56
Digital Zoom option (Motion Picture menu) 144
Diopter adjustment dial 72
Direct Focus Area menu option 118
　incompatibility with Filter button effects 118
　using with manual focus 118
Display button
　uses of 91, 93

using to navigate quickly through menu screens 31, 93, 168
Display screens produced by pressing Display button
　playback mode 92–93
　recording mode 91–93
Down button
　uses of 83, 90
DPOF (Digital Print Order Format) 110
Drive Mode 83–93
　turning off all burst shooting 83

E

Electronic shutter
　using 48–49
Enlarging images in playback mode 99
EV (exposure value) scale
　in Manual exposure mode 28
EVF button
　using to switch between viewfinder and monitor 72
EVF Display Style menu option 125
EVF/Monitor Switch menu option 72, 131
Exposure compensation
　not available with Manual exposure mode 64
　procedure for using 13
Exposure compensation dial 64–65
Exposure Meter menu option 125
Extended ISO menu option 55
Extended Optical Zoom feature 35–36
Eye sensor 72
Eye Sensor AF menu option 72, 117
Eye Sensor menu option 72, 117, 131–132

F

Face Detection option. See also AF Mode setting
　relationship to Metering Mode option 39
Face Recognition Edit menu option 111
Face Recognition menu option 57–58
Favorite menu option 110–111
Fill-flash. See Forced On setting for flash
Filter button
　using to activate picture effects 64
Filter button picture effects 42, 64–75
　Bleach Bypass 70
　Cross Process 69–70
　Dynamic Monochrome 67
　Expressive 66
　Fantasy 71
　High Dynamic 68
　High Key 66
　Impressive Art 68
　incompatibility with other settings 65, 147, 169
　Low Key 67
　making adjustments to effects 65
　Miniature Effect 70–71
　　using for motion pictures 70, 148
　Monochrome 67
　No Effect setting 64

Old Days 66
One Point Color 71–72
Retro 66–67
Rough Monochrome 68
Sepia 67
Silky Monochrome 68
Soft Focus 70
Star Filter 71
Sunshine 72
Toy 69
Toy Pop 69
using when shooting panoramas 66
various displays of effects menu 64–65
Filter effect adjustment for monochrome setting 33
Filters
 attaching to lens of D-Lux camera 163
Final Cut Pro software 146
Firing Mode menu option 49–50
Firmware
 displaying version of 136
 upgrading 136
Flash
 general procedure for using 14
Flash Adjustment menu option 52
Flashing areas in playback mode 123
Flash menu option 49–57
Flash Mode menu option 50–52
Flash Synchro menu option 51–52
Flash units, external
 Leica CF-22 49, 51, 164
 LumoPro model no. LP180 165
 Panasonic model no. DMW-FL220 163
 Panasonic model no. DMW-FL580L 164
 Yongnuo YN-560 III 165
Flash unit supplied with D-Lux camera 49
 diffusing light from 168
Focal length of lens 7
Focus Area Set option for Function button 96
Focus frame
 moving 83, 118
Focus mode
 selecting 11–13, 62
Focus range 62, 157
Focus/Release Priority menu option 86, 118–119
 relationship to burst shooting 119
Focus switch 62
Forced Off setting for flash 51
Forced On setting for flash 50–51
Forced On with Red Eye setting for flash 50
Format menu option 137
Function buttons
 assigning functions to 95–98, 128–129
 Fn1 button
 other uses of 94
 using as Cancel button 94
 using to delete images 93–94
 Fn2 button

 uses of 94
 using as Wi-Fi button 94–95
 Fn3 button
 using as LVF button 94
 in general 93
Function Button Set menu option 128–129

G

Geotagging 101–104
GPS data
 adding to images 101–104
Guide Line menu option 123

H

Half-Press Release menu option 116–117
HDMI Mode menu option 135
HDMI output
 lack of in recording mode 1
HDR (high dynamic range) photography 28–29, 43, 43–44
 using Auto Bracket option for 86–87
HDR menu option 43–45
HDTV Link menu option 135
HIghlight menu option 123
Highlight Shadow menu option 40–41
Highlight Shadow option (Motion Picture menu) 144
Histogram menu option 121–123
Hoya R72 infrared filter 158

I

iHandheld Night Shot menu option 42–43
iHDR menu option 43
Image sensor
 cropping of images from 35
iMovie software 17
Index screens of images 98–99
Infrared photography 158–159
Intelligent Dynamic (i.Dynamic) menu option 41
Intelligent Dynamic option (Motion Picture menu) 144
Intelligent ISO 54–55
 incompatibility with other settings 27, 54
Intelligent Resolution (i.Resolution) menu option 42–43
 use in connection with Intelligent Zoom option 56
Intelligent Resolution option (Motion Picture menu) 144
Intelligent Zoom (i.Zoom) menu option 56
 incompatibility with other settings 56
Intelligent Zoom option (Motion Picture menu) 144
Internal memory
 lack of with D-Lux camera 4
ISO
 effects of high setting on image quality 54
 procedures for setting 53–55
 range of settings 53
 setting value below 200 55
ISO Increments menu option 55
ISO Limit Set menu option 54–55
 not applicable for video recording 147

Index

J

JPEG image format 21

K

Kelvin units 74

L

Language for menus 136
 setting 9
Language menu option 136
LCD Display (Monitor)
 adjusting brightness and colors 133
Left button
 uses of 78–79, 83
Leica D-Lux Typ 109 camera
 advantages of 1
 disadvantages of 1
 items that ship in box 3
Leica Image Shuttle app 101, 151
 using for remote control of camera 154–155, 169
 using to transfer images or videos from camera to device 155–157
Lens
 automatic retraction of 91
Lens cap
 attaching to camera with lens cap string 3
 automatic 3
 JJC version 165
 Leica model no. 18 548 165
 Panasonic model no. DMW-LFAC1 165
Live View Mode menu option 133
Location Logging menu option 101–104
Locking controls 97
Locking exposure 39
Lomography 69
Long Shutter Noise Reduction menu option 55

M

Macro photography 157–159
 minimum focusing distance 157
Manual exposure mode 28–30
 using Auto ISO setting with 29
 viewing effects of settings in 29
Manual Flash Adjustment menu option 50, 52
Manual focus 12–13
 aids to focusing 83
 options for magnifying screen 119–120
 using along with autofocus 119
Meade ETX-90/AT telescope 158
Mechanical shutter
 using 48
Memory card
 capacity for storing images and videos 5
 capacity for storing motion pictures 5
 formatting 137
 inserting into camera 6
 speed of 4, 5
 various types of 4
Menu Information menu option 135
Menu Resume menu option 30, 135
Menus
 dimmed appearance of unavailable options 31
 list of 30
 navigating in 31, 168
Menu/Set button
 uses of 90
Metering Mode menu option 38–40
 moving Spot metering frame 39
Metering Mode option (Motion Picture menu) 144
MF Assist Display menu option 119
MF Assist frame
 activating 83
MF Assist menu option 83, 119–120, 159
 incompatibility with other settings 120
MF Scale menu option 120
Micro HDMI cable
 using to connect camera to HDTV 135
Microphone
 built-in 7
Microphone Level Adjustment option (Motion Picture menu) 144
Microphone Level Display option (Motion Picture menu) 144
Monitor Display menu option 133
Monitor Display Style menu option 126
Monitor Information Display menu option 126–127, 163
Monitor Luminance menu option 134–135
Monochrome Live View menu option 124
Monochrome setting for Photo Style
 adjusting parameters for 33
 using with Quality set to Raw 33–34
Moon
 photographing through telescope 159–160
Motion Picture button 91
 disabling use of 91, 130
Motion Picture menu 140, 141–147
 interaction of options with those on Recording menu 141
 limited options in Snapshot mode 141
Motion picture recording
 capturing still images during recording 144–145
 effects of physical controls 146–149
 effects of recording mode on
 Aperture Priority mode 140
 Manual exposure mode 140
 inability to use Auto ISO 140
 Program mode 139
 Shutter Priority mode 140–141
 focus options with 140
 general procedure 15–16
 general recommendations 148
 limits on duration of recordings 5, 138
 producing fade-in or fade-out effect 140
 quick start guide 138

range of shutter speeds available 140–141
using external microphones 145
Motion pictures
 editing in camera 107–108, 148–149
 editing with computer 149–150
 saving still frame from 17
MP4 video format
 location of files on memory card 149
Multiple Exposure menu option 45–47

N

NFC active area on camera 8
NFC (near field communication) 152
Noise reduction
 adjusting 32
NTSC video standard 138
Number Reset menu option 137

O

On/Off switch 63
Optical slave flash unit
 using with D-Lux camera 165

P

PAL video standard 138
Panasonic DMW-FL220 flash unit
 using with D-Lux camera 49
Panorama Direction menu option 48, 89
Panoramas 89–91
 incompatibility with other settings 89
 sizes of images 89
PASM modes 18
Peaking menu option 120–121
Pet
 setting up profile with name and age 58–59
PhotoAcute software 86
Photomatix Pro software 44, 86
Photo Style menu option 32–36
 adjusting parameters for 32–33
 chart of sample images 33
 descriptions of settings 34
 saving a custom setting 34–35
Photo Style option (Motion Picture menu) 141
Picture Mode option (Motion Picture menu) 144–145
Picture Size menu option 35–37
 availability when shooting with Raw & JPEG 35
 relationship to zoom range 35–36
Picture Sort menu option 111
Pinpoint AF Display menu option 82–83, 117
Pinpoint AF Time menu option 83, 117
Playback
 burst taken with SH setting 84
 motion pictures 148
 adjusting volume 17, 148
 basic procedures 17–18
 still images

 basic procedures 15–16, 98
Playback button 91, 98
Playback menu
 in general 99
Playback Mode menu option 101
Preview option for Function button 95–96, 125
Printing images from camera 110
Print Set menu option 110
Profile Setup menu option 58–59
Program mode 23–25
Program Shift 23–24
Protect menu option 111

Q

Quality menu option 36–37
Quick AF menu option 116
Quick Menu 58–59
 customizing settings on 130–131
 using with Monitor Information Display screen 59, 126
Quick Menu button 91
Quick Menu menu option 59, 130–131
QuickTime software 17

R

Raw images
 converting to JPEG in camera 103–106
Raw & JPEG option 37
Raw Processing menu option 103–106, 169
Raw setting for Quality
 advantages and disadvantages of 37
 effect on Photo Style setting 33–34
 incompatibility with other settings 31, 35, 37, 65, 169
 .rwl extension of image files 37
 size of Raw image files 37
Rear-curtain flash. See Flash Synchro menu option
Recording Area menu option 126
Recording menu
 in general 30–32
 limited options in Snapshot mode 31
 navigating in 31
Recording modes
 list of 18
Red eye effect 50, 53
Red-eye Removal menu option 53
Remaining Display menu option 127–128
Remote control of camera by smartphone or tablet 155–156, 169
Reset menu option 137
Reset Wi-Fi Settings menu option 137
Resize menu option 108, 169
Restore to Default option for Function buttons 97
Right button
 uses of 74, 78
Rotate Display menu option 110
Rotate menu option 109–110

S

Saturation
 adjusting 32
Scene detection 19–20
SD card
 capacity of 4
SDHC card
 capacity of 4
SDXC card
 capacity of 4
Second-curtain flash. See Flash Synchro menu option
Sekonic Prodigi color temperature meter 75
Self-timer 88–89
 illumination of AF assist lamp with 118
 incompatibility with other settings 89
Self Timer Auto Off menu option 88, 136
Self-timer menu option 40
Setup menu
 in general 131
Sharpness
 adjusting 32
Shutter AF menu option 116
Shutter button 63
Shutter sound
 selecting 133
Shutter speed dial 63
Shutter speeds
 effect of for stopping action or blurring motion 26
 range of 24, 26, 29, 48
 setting intermediate values 27–28, 63
Shutter Type menu option 48–49
Silent Mode menu option 49, 115
Simultaneous Record w/o Filter menu option 42, 64
Sleep Mode menu option 63, 134
Slide Show menu option 99–101
Slow Sync setting for flash 50–51
Snapshot mode 19–23
 AF Mode settings available in 78
 Recording menu settings available in 20–23
 settings automatically activated in 19
 settings that cannot be adjusted in 19, 32, 39, 49, 52, 54
Softbox
 Photoflex Lite-Dome XS 165
 using to diffuse light from external flash 165
Sounds of camera
 silencing 115, 133
Spot metering
 moving frame around display 39, 168
Stabilizer menu option 56
Step-by-step guides
 adding GPS data to images 101–103
 basis picture taking 10–12
 connecting to device by Wi-Fi with NFC 152–154
 connecting to device by Wi-Fi without NFC 151–153
 creating Custom Multi autofocus frame 80–81
 preliminary steps before taking pictures 19
 quick start for motion picture recording 138
 saving still image from 4K video 149
 saving still image from video 149–150
 splitting video into 2 segments 148
 using external microphones for video recording 145
Step zoom 62, 129–130, 163
 using with zoom lever 62
Stop Motion Animation menu option 47–48
Stop Motion Video menu option 108
Street photography 160–161

T

Tables
 effects of physical controls for video recording 146–147
 numbers of images stored on 32 GB card 5
 options that can be assigned to Function buttons 95, 128
 recording modes of the D-Lux 18–19
 results of burst shooting tests 85
 shutter speed equivalents 27
 suggested settings for Snapshot mode 22
Tascam DR-100mkII audio recorder 145, 166
Telescope
 attaching D-Lux camera to with adapter rings 158
Text
 adding to images 105–106
Text Stamp menu option 106–107
Time exposure 63
 procedure for setting 29
Time Lapse Shot menu option 46–47
Time Lapse Video menu option 108
Time zone
 setting different one for travel 132
Title Edit menu option 105–106
Travel Date menu option 132–133
T setting for shutter speed 29, 64–67
TV Aspect menu option 135
TV Connection menu option 135

U

Up button
 uses of 73–74
USB Mode menu option 134–135
Utilize Custom Set Feature menu option 113–114, 168
 assigning to Function button 114

V

Version Display menu option 136
Video Button menu option 91, 130
Video Divide menu option 107–108
Viewfinder 72
 adjusting brightness and colors 133
 adjusting for vision with diopter adjustment dial 72
 switching view with LCD screen 72, 131
Viewfinder menu option 133
Viewfinders, optical
 Panasonic model no. DMW-VF1 163

Voigtlander 28mm model 163

W

White Balance 74–79
 adjusting in Raw processing software 76
 available settings 74–76
 chart of images with various settings 76–77
 fine-tuning with color axes 76–77
 setting by color temperature 75–76
 setting custom value 74–75
White Balance bracketing 77–78
 incompatibility with other settings 78
Wi-Fi connection lamp 94
Wi-Fi connection to smartphone or tablet
 establishing 151–155
Wi-Fi menu option 133
Wind Cut option (Motion Picture menu) 145
Windows Movie Maker software 17
Wireless flash trigger
 CowboyStudio model no. PT-04 164
World Time menu option 132

Z

Zebra Pattern menu option 123–124
Zoom lever 63–64
 using to enlarge image in playback mode 99
 using to navigate quickly through menu screens 31, 63, 168
 using with step zoom 62
Zoom Lever menu option 129–130
Zoom range
 relationship to Picture Size setting 35–36
Zoom Resume menu option 129–130